MAKING
THE MET

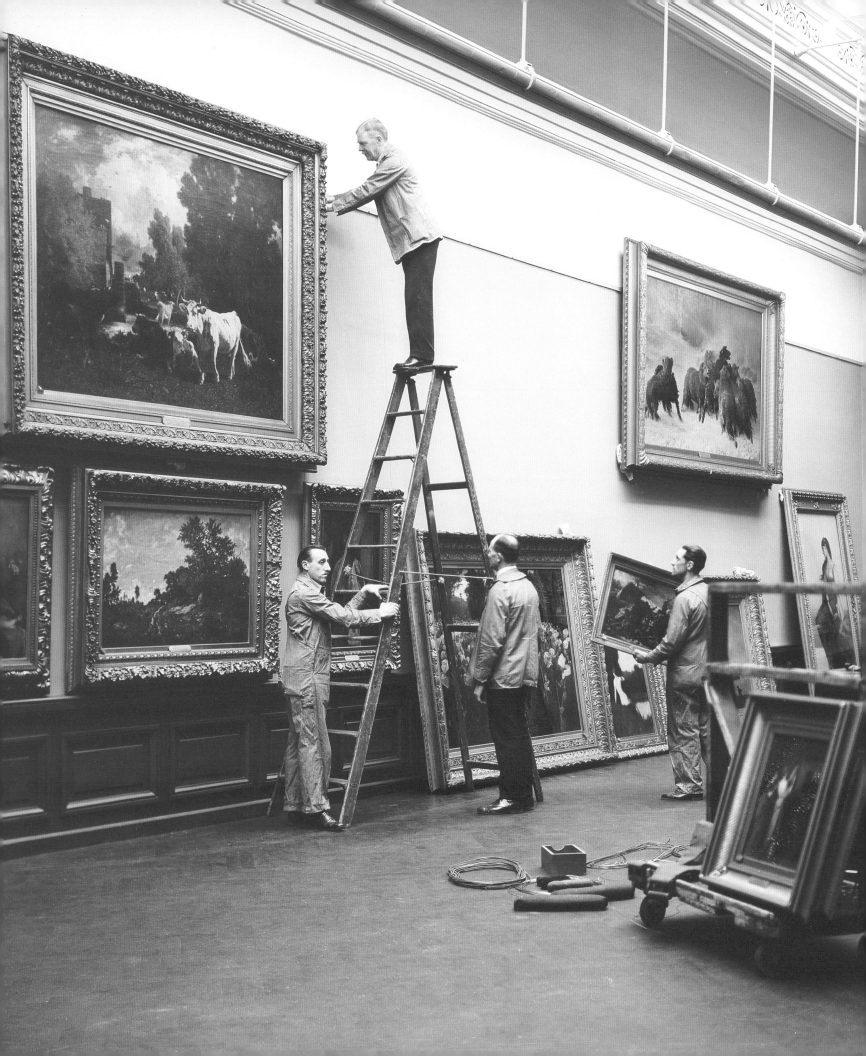

Edited by Andrea Bayer with Laura D. Corey

MAKING | 1870
THE MET | 2020

THE
MET

The Metropolitan Museum of Art, New York

Distributed by Yale University Press, New Haven and London

Contents

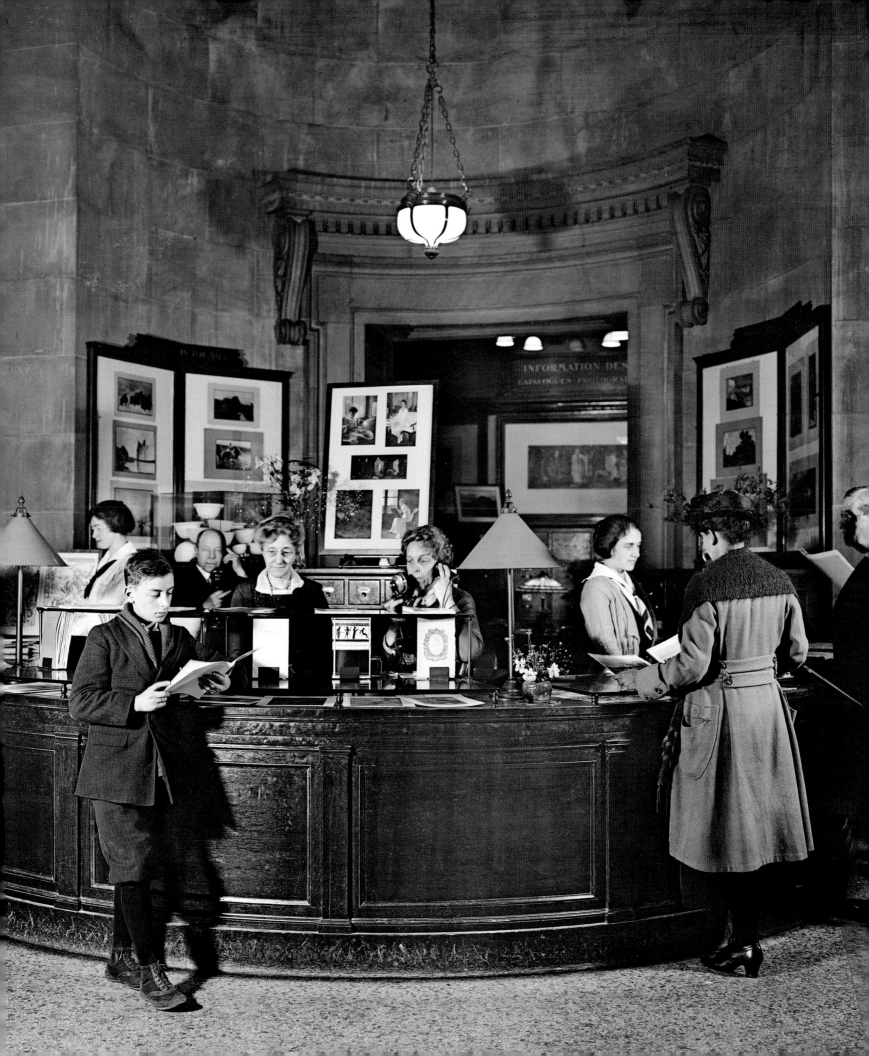

Director's Foreword

When I ponder the long history of The Metropolitan Museum of Art, from its earliest incarnation to the magnificent institution that stands on Fifth Avenue today, I am profoundly moved. Of course, it is wonderful to celebrate an anniversary, especially one as momentous as our 150th year as a consummate art museum. But this occasion is also a time to reflect on our history and to think about the role of The Met.

Remarkably, we started with a few people and the aspiration of becoming a world-class museum, but no art or building. In 2020, The Met is a renowned landmark stretching across several city blocks—with a second building, the beloved Cloisters, in Fort Tryon Park—beckoning a global audience to New York and reaching out across the world through our online presence and our many international activities. While the Museum's history and growth reflect the brash ambition of its hometown, we are always mindful of its serene presence in Central Park, which summons quiet reflection in the midst of a bustling metropolis.

With The Met's enormous reach comes great responsibility. In an era in which we see a potent combination of rising nationalism and political polarization, museums are becoming increasingly important venues for facilitating crucial cross-cultural, global conversations about history, representation, and expression. The Met is one of the few places where one can learn and appreciate what is unique about one's own culture even as art itself suggests the many things that we all have in common.

So on the occasion of this anniversary, we are thinking deeply about our role as stewards of The Met's extraordinary collection, and about how we can generate and contribute to conversations that will cultivate the understanding and appreciation of creativity and beauty, value underrepresented perspectives, and illuminate the interconnectedness of cultural histories.

Making The Met, 1870–2020 is the perfect vehicle for such ideals. It examines key moments since our founding in 1870, reckoning with triumphs and innovations and, yes, missed opportunities. It also celebrates our donors, whose generosity affirms the role of philanthropy in sustaining an encyclopedic institution that benefits countless people. As you read this book, I hope you enjoy looking at artworks that have meant so much to generations of visitors, and I also hope you come to a new understanding of the role of cultural institutions in the past, present, and future.

Many colleagues made vital contributions to *Making The Met*. I would like to thank Andrea Bayer, Deputy Director for Collections and Administration, for her outstanding work and curatorial leadership in spearheading this project and ensuring its success. She was adeptly assisted by Laura D. Corey, Senior Research Associate in the Director's Office and the Department of European Paintings, who was involved in every aspect of the exhibition and this catalogue. An advisory committee also played an essential role and I salute its exemplary spirit of collaboration. This project touched nearly every department in the Museum, and mounting it would have been impossible without the expertise and assistance of many individuals, working in unison.

We are tremendously grateful to the Iris & B. Gerald Cantor Foundation and Bank of America, both longtime donors whose generosity made *Making The Met* possible. We also wish to thank the Diane W. and James E. Burke Fund, The Peter Jay Sharp Foundation, and the Doris Duke Fund for Publications for their long-standing commitment to The Met and their support of this exceptional catalogue.

This book and exhibition tell the story of The Met, which is also a story of the development of New York and of museums over the past 150 years. We look forward to the continual evolution of this remarkable cultural institution.

Max Hollein
Director
The Metropolitan Museum of Art

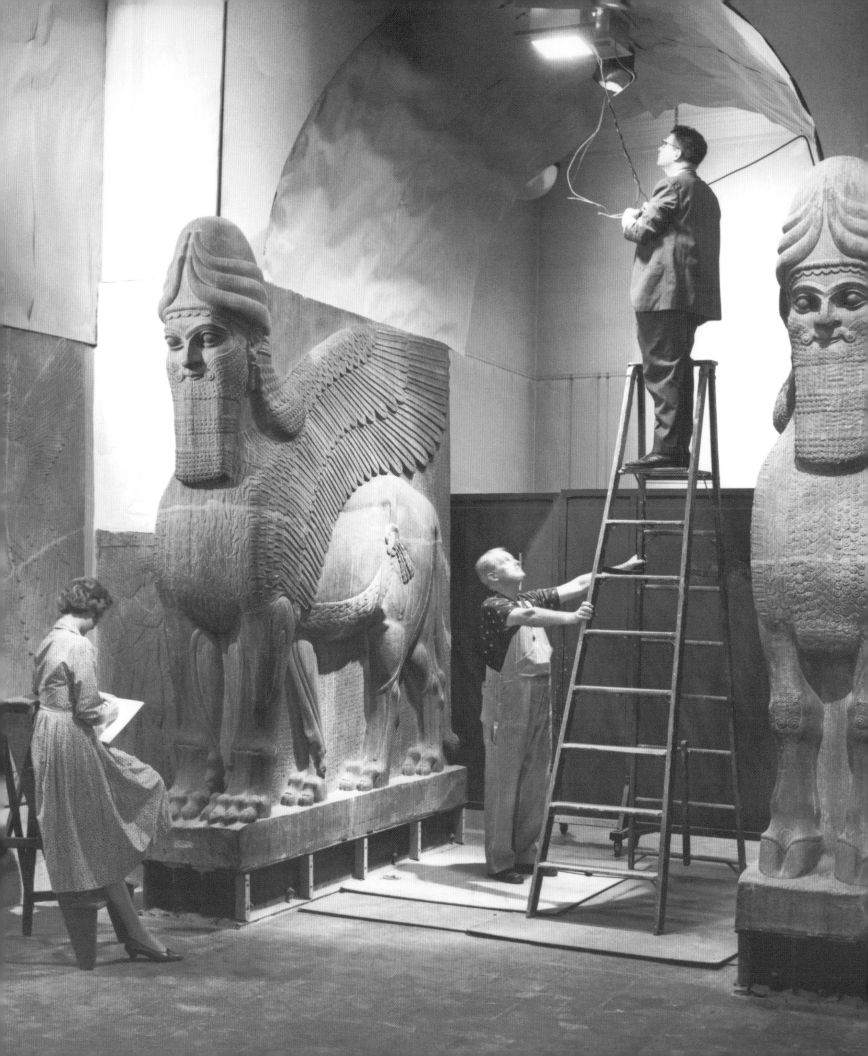

Sponsors' Statements

Iris & B. Gerald Cantor Foundation

A century and a half is surely cause for celebration! The Iris & B. Gerald Cantor Foundation proudly honors the landmark 150th anniversary of The Metropolitan Museum of Art with our sponsorship of *Making The Met, 1870–2020*.

An extraordinary milestone in the life of this venerable cultural institution, The Met's 150th holds special significance for the Cantor Foundation. Indeed, this is where our story began. It was at The Met in 1945 that a young Bernie Cantor first encountered a work by Auguste Rodin, the sculptor's marble rendering of *The Hand of God*. This experience inspired my late husband's "magnificent obsession" with Rodin, a lifelong passion that encompassed collecting, scholarship, and an abiding commitment—which I immediately shared when we met—to make Rodin's art accessible to the public.

Over the years Bernie and I personally, as well as our Foundation, took pleasure in enabling the creation or reopening of indoor and outdoor exhibition spaces at The Met; nourishing its Rodin collections by giving a number of major works; and sponsoring exhibitions that highlighted the prodigious contributions of Rodin and other artists. Today, the art of Rodin continues to be one of the Cantor Foundation's cornerstones, and The Met remains a treasured partner. Bernie would be proud.

Congratulations to The Metropolitan Museum of Art—to the visionaries who guided it to cultural preeminence over the past 150 years; to its brilliant staff and volunteers; and to all those who contributed to this outstanding, comprehensive exhibition and catalogue. We are delighted to play a role in sharing The Met's great legacy with the people of New York City and beyond.

Iris Cantor
President and Chairman
Iris & B. Gerald Cantor Foundation

BANK OF AMERICA

At Bank of America, we believe in the power of the arts to help economies thrive, educate and enrich societies, and create greater cultural understanding. That's why we are a leader in helping the arts flourish across the globe, supporting more than 2,000 not-for-profit cultural institutions each year. The Bank of America Art Program is part of the company's commitment to grow responsibly while bringing value to economies, society, and the communities we serve.

We are pleased to support The Metropolitan Museum of Art with *Making The Met, 1870–2020*, a major exhibition that will lead visitors on an immersive journey through the history of one of the world's preeminent cultural institutions.

The Met has been a longtime partner of Bank of America, and we value the integral role that it plays in our economy and the impact it has on the global cultural landscape.

Brian Moynihan
Chief Executive Officer
Bank of America

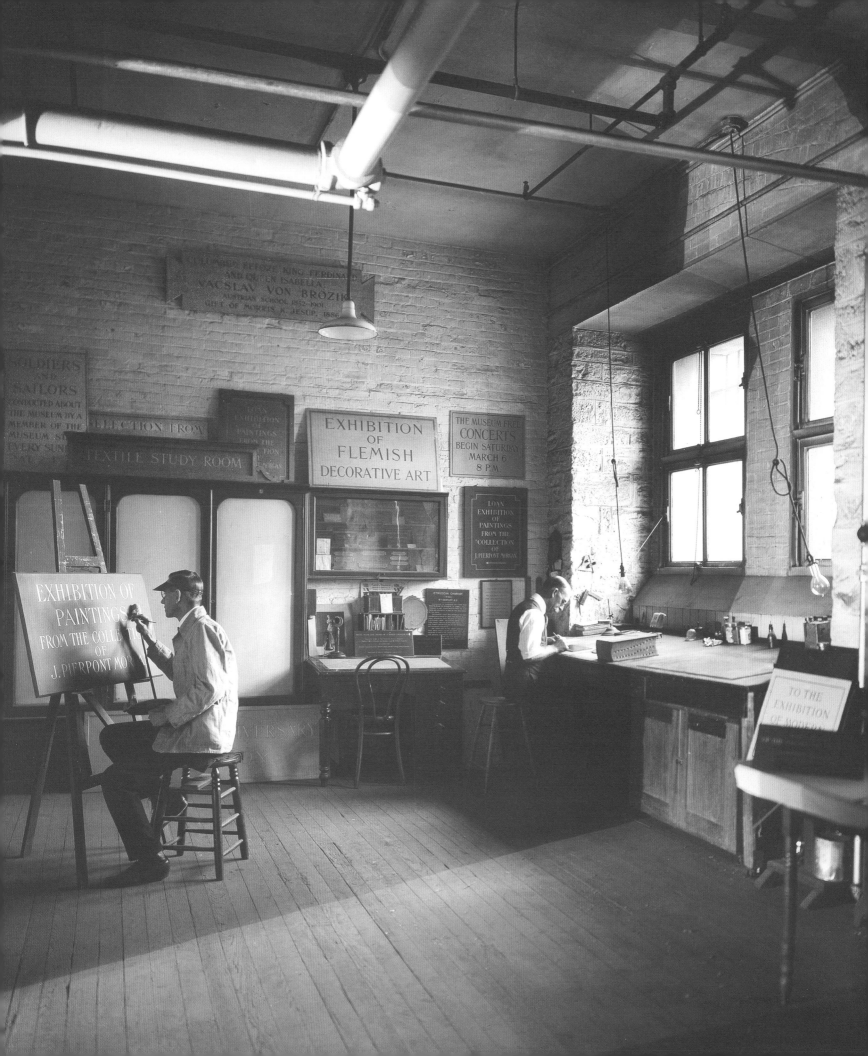

Preface

Andrea Bayer

When it comes to assessing The Metropolitan Museum of Art, it is easy to be seduced by the numbers. There are over 2 million square feet of buildings at its Fifth Avenue location and more than 1.5 million objects in the permanent collection. Last year the institution welcomed over 7 million visitors from some two hundred countries and territories and reached more than 30 million people through its website. These figures provide justifiable points of pride that suggest The Met's impact in the world and the rich experience that it offers its visitors in New York and those who encounter its collections and programs digitally across the globe. But they are equally impersonal.

This catalogue and the corresponding exhibition shift the emphasis away from statistics to a deeper understanding of the people and events that shaped the Metropolitan Museum and its collections. Throughout the years, social movements in New York and beyond helped to transform the Museum and influenced evolving ideas about the kind of art that warranted a place within its walls. The story presented here is celebratory, in honor of our 150th anniversary, but at the same time it recognizes the limitations and missteps of the past and acknowledges that our choices too will be subject to the judgment of future generations.

Instead of tracing a steady chronological narrative through a century and a half, this catalogue opens with an account of the Museum's history as seen through the complex development of its buildings. The next ten chapters each explore a transformative moment or initiative that fundamentally altered the course of the Museum along a syncopated yet compelling trajectory that illustrates changing tastes, priorities, and ambitions. From its founding decades after 1870—when a group of civic leaders and artists determined that New York needed a major art museum—to its anniversary

in 2020, the institution, and its growth, has been as dynamic, and sometimes as disorderly, as the city around it.

It is not surprising that momentum for a new museum in New York increased so rapidly in the optimism of the immediate post–Civil War era. The Museum of Fine Arts in Boston was likewise founded in 1870, a decade that also saw the establishment of both the Philadelphia Museum of Art and the Art Institute of Chicago. After residing in temporary quarters for ten years, the Metropolitan Museum opened its first permanent building in Central Park in 1880. At that time, Luigi Palma di Cesnola was its complicated and headstrong first director, who, joined by a group of dedicated trustees and staff members, began to build collections that reflected their own idiosyncratic sensibilities. The institution's development gained speed in 1904 after J. Pierpont Morgan became the Museum's president, adding his immense energy to the enterprise.

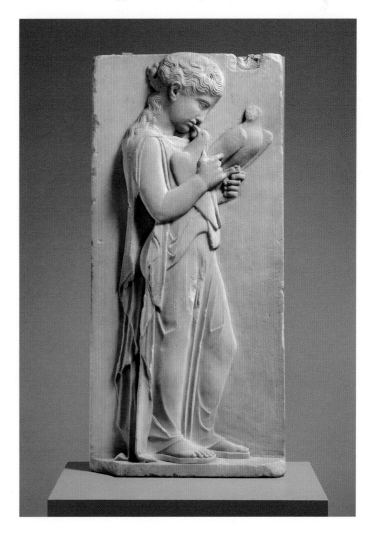

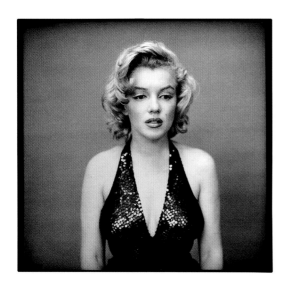

From the beginning, the Museum's staff has given thought to what we now consider the "visitor experience" and issues of accessibility. Such discussions have led to early innovations, including the 1880 introduction of turnstiles to count the number of visitors and the installation of telephones and electric lights in the same decade. In the early 1890s the Museum opened its doors on Sundays, and soon after his appointment as director in 1905, Sir Caspar Purdon Clarke allowed visitors to sketch in the galleries. Education was of fundamental importance to the Museum's founders and never ceased to be a priority for the institution. Pivotal dates include the 1880 opening of an art school focused on industrial practice, with classes ranging from metalworking to plumbing, and the creation of the Department of Education and Museum Extension in 1941.

When reconsidering the Museum's first fifty years, we have traced three of the often-overlapping directions that defined the institution. As discussed in the following pages, the staff and supporters of the Museum remained dedicated to education, especially in relation to The Met's role in providing sources of inspiration for artists and craftspeople and in nurturing American citizens. The greatest demonstration of this desire to democratize the experience of the Museum and enhance its purpose for the visitor resided in the establishment of collections focused on musical instruments, textiles, and works on paper. The breadth of these collections—from those selected as representations of technical variety to those of outstanding quality—and the exceptional global holdings of textiles and instruments were of indelible importance to the encyclopedic ambitions of the Museum.

Beyond acquiring and exhibiting these objects, the Museum welcomed visitors to engage with its textiles and works on paper in its dedicated study rooms, where anyone could (and can) book an appointment. We remember the curators who spearheaded these efforts, Frances Morris and William M. Ivins Jr., for championing the study, display, and acquisition of these spectacular objects.

At the same time, Morgan and his peers, such as Henry G. Marquand, wished to bring treasures to the Metropolitan Museum. In this pursuit, they carefully studied the royal and aristocratic collections of Europe and sought objects and paintings that were prized for their rarity and beauty. Morgan's 1907 purchase and subsequent gift of nearly three thousand pieces of furniture and decorative arts from the collection of Parisian dealer Georges Hoentschel represented the synthesis of the Museum's parallel approaches to collecting during this period, for the objects were appreciated at once for their potential to inspire American craftspeople and for their (often) princely provenance. Gifts of this magnitude required new spaces and curators with the background necessary to present full histories of the period. Morgan was also a major proponent of the Museum's excavations in Egypt, beginning in 1906 and continuing in full force in the following decades as the program expanded to other sites in the Middle East. Due to the policies at the time for the division of finds, highly significant artifacts came to New York—from exquisite sculpture to quotidian objects—providing a revelatory

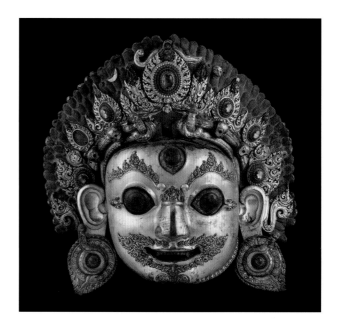

window into ancient societies. Today while we no longer collect from excavations, we continue archaeological fieldwork for research and preservation, working alongside colleagues from around the world to deepen the understanding of our own collection and to share resources and knowledge.

The 1920s were important years of reassessment for the Museum, marked by complex reactions to changes in American society and to ideas about modern art. The founding of the American Wing in 1924 was the culmination of decades of collecting by trustees, artists, and donors who brought forward works that they believed to be the finest paintings, sculpture, and decorative arts created in this country. The resulting displays were meant to foster an ideal of good taste for the local public, an aspirational goal for even the most recent arrivals to the United States in an era dramatically shaped by industrialization, urbanization, and immigration. Likewise, the 1929 bequest of Henry Osborne and Louisine Havemeyer brought to the Museum a visionary collection carefully crafted over decades. Longtime supporters of the institution, the Havemeyers contributed loans and gifts that increased awareness of American decorative

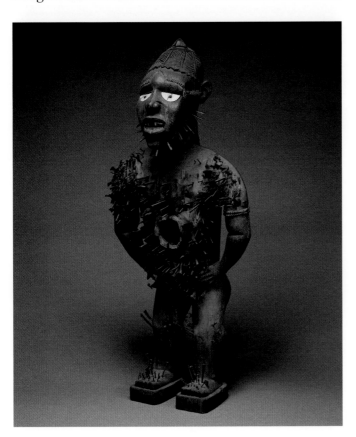

arts, especially the work of Louis C. Tiffany, Japanese prints and ceramics, Islamic art, Spanish painting, and much more. Above all, the over two hundred works of nineteenth-century French art in the bequest created an environment in which New York audiences could appreciate Gustave Courbet, Edouard Manet, Edgar Degas, and others.

A more general look at the Museum's practices in collecting contemporary art in the 1920s and 1930s reveals determination in some areas and avoidance in others. On the one hand, the institution was on the forefront of collecting photographs and exhibiting modern decorative arts and design. On the other, Museum officials remained ambivalent about avant-garde paintings and sculpture and grappled with the question of whether acquiring such works was part of the institution's larger mission, most notably by declining the offer of Gertrude Vanderbilt Whitney's collection of modern American art in 1929 (a second attempt at a merger failed in 1948). Throughout its history, artists have been important advocates for the Museum to meaningfully engage with the art of its time, both from inside and outside the institution. Daniel Chester French, Louis C. Tiffany, Mary Cassatt, Alfred Stieglitz, and Georgia O'Keeffe are among the champions featured in these chapters.

The Metropolitan Museum's seventy-fifth anniversary coincided with the end of World War II, and two stories from that period demonstrate the complex movement of works of art during times of international conflict. One story follows the path of four Neo-Hittite reliefs from Syria to New York via Berlin; excavated by German national Baron Max von Oppenheim, they escaped Allied bombing in 1943 but were seized by the United States government under the First War Powers Act and acquired by the Museum at auction. In contrast, the second story reveals the valor of the institution's staff who contributed to the efforts of the so-called monuments men and women to safeguard the cultural treasures of Europe. Their wartime activities influenced the development of The Met's collection, particularly the acquisition of exquisite medieval objects and manuscripts by James J. Rorimer, curator and later director of the Museum. These works enhanced the holdings of the Cloisters, which had opened to the public in 1938 and remains a treasured place of respite and study in Fort Tryon Park in northern Manhattan.

In the years after World War II, as New York became the center of the international art world and the Cold War

recast the sociopolitical landscape at home and abroad, the Museum too adapted to a changing world. Plans launched by Director Thomas P. F. Hoving just before 1970 and completed under the direction of Philippe de Montebello in the 1980s transformed the Fifth Avenue building and the character of the collection. By our centennial in 1970, construction was underway all around as the institution expanded its physical footprint to accommodate its ever-increasing activities. This was the moment of the arrival of the Temple of Dendur, of the building of the Robert Lehman Wing, of glittering exhibitions in the Costume Institute, and of new connections with artists and performers. Four impressive spaces brought the Museum's claim to be truly encyclopedic closer to reality: some fifty galleries were dedicated to the growing collection of Asian art; a comprehensive installation was

unveiled for Islamic art; the Michael C. Rockefeller Wing provided a home for the recently created Department of the Arts of Africa, Oceania, and the Americas; and the Lila Acheson Wallace Wing was built to hold modern and contemporary art. Seen in an aerial view (see fig. 20), these galleries seemed to encircle the existing building, and signaled the introduction of thoughtful presentations of our own and global cultures that have never ceased to evolve in the subsequent decades. Yet not all was rosy, as a number of the Museum's ventures drew criticism and protest from the art world and local audiences. In retrospect, we also now realize that some of our community outreach was unsuccessful, and certain collecting strategies were limited and limiting. It is only by listening to our critics and advocates that we can continually reassess our role as a cultural institution.

Acquisitions since the 1990s reflect new avenues of collecting, both close to home and globally. We have recognized historically underrepresented areas and broadened our sights to include regions and traditions new to our collection, ranging from eighteenth-century Venetian Judaica to an extraordinary Guatemalan devotional sculpture and

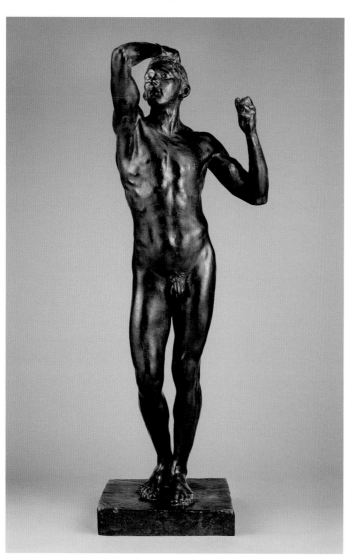

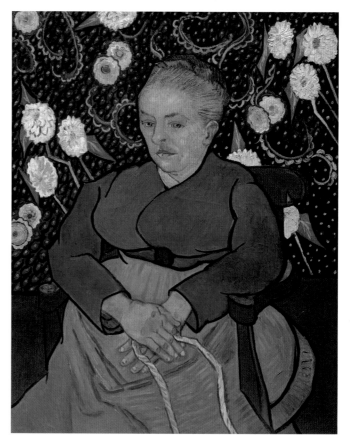

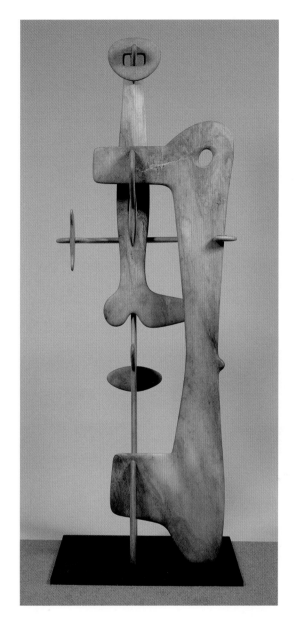

7. Isamu Noguchi (American). *Kouros*, 1945. Marble. Fletcher Fund, 1953

Indonesian headdresses designed to be worn before and after a pilgrimage to Mecca. In contemporary art, our collecting has also taken on a deeply international character, seeking to break the mold of earlier canons. In addition, as Max Hollein states in his chapter on the subject, we have committed ourselves in an expansive way to the exhibition and commissioning of contemporary art in unexpected places. A period of experimentation at The Met Breuer (2016–20), Marcel Breuer's iconic landmark on Madison Avenue, originally built to house the Whitney Museum of American Art, has led to a series of extraordinary monographic and thematic exhibitions, quite unlike most exhibitions in our main building. Encouraged by Breuer's monumental, distinctive Brutalist space, curators found a freedom to take on an adventurous program of shows and even acquisitions. These activities will continue at the Fifth Avenue building, where we have inaugurated annual site-specific commissions for the Iris and B. Gerald Cantor Roof Garden (2013), the once-empty niches on the grand Beaux Arts facade (2019), and the Great Hall (2019). In every case, the display of contemporary art is situated in the context of thousands of years of artistry, only possible in a place with as deep and rich a collection as the Metropolitan Museum.

This study examines the history of remarkable objects made accessible to an ever-growing public, not only through display in our galleries but also interpreted through publications and programs, and researched through conservation and intensive scholarly study. People and objects are deeply intertwined, with the passion for works of art transmitted by all those who worked for the Museum, became its supporters, or spent time with objects in our galleries or online. It is with this interconnectedness in mind that we open the catalogue (as we opened the exhibition) with seven extraordinary works of art inspired by the human figure, ranging from a Greek marble stele of a young girl tenderly holding her pet doves (fig. 1), carved around 450 B.C., through to a gripping photographic portrait of Marilyn Monroe taken by Richard Avedon in 1957 (fig. 2). In between, we encounter an intricately sumptuous yet fearsome mask representing Bhairava, a form of the Hindu deity Shiva, made in the Kathmandu Valley in the sixteenth century (fig. 3); an arresting nineteenth-century Power Figure identified with Mangaaka, a force of jurisprudence carved by a great sculptor of the Kongo peoples (fig. 4); Auguste Rodin's breakout sculpture *The Age of Bronze* that poignantly captures a moment of

human awakening (fig. 5); Vincent van Gogh's vibrant *La Berceuse*, or *Woman Rocking a Cradle*, painted in 1889 and originally owned by the sitter, Augustine-Alix Pellicot Roulin (fig. 6); and Isamu Noguchi's commanding *Kouros* (fig. 7), a biomorphic reinterpretation of the famous ancient Greek statues in our collection. With these masterpieces, we move around the globe and through time, at each step struck by a different kind of expressivity and beauty. The artworks arrived at the Museum as purchases, as gifts from artists, and as gifts from remarkable collectors, and as such, they also encapsulate one hundred and fifty years of dedication to the ambitions and ideals of a unique institution.

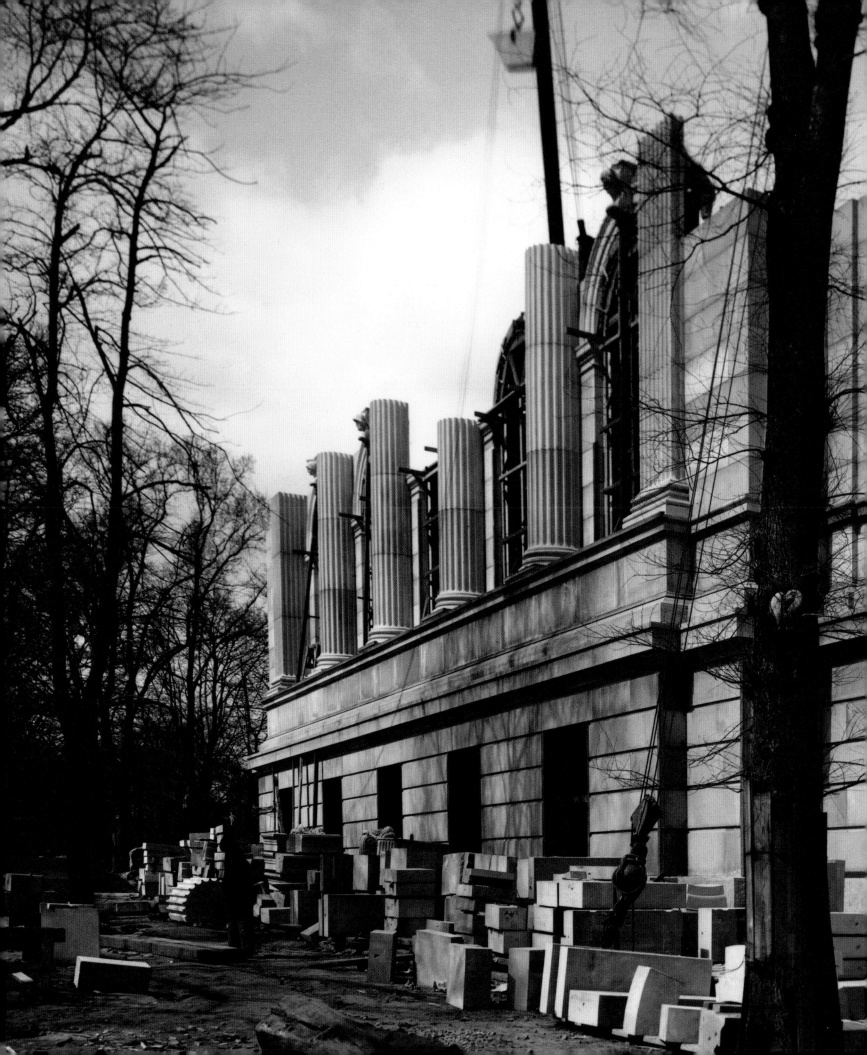

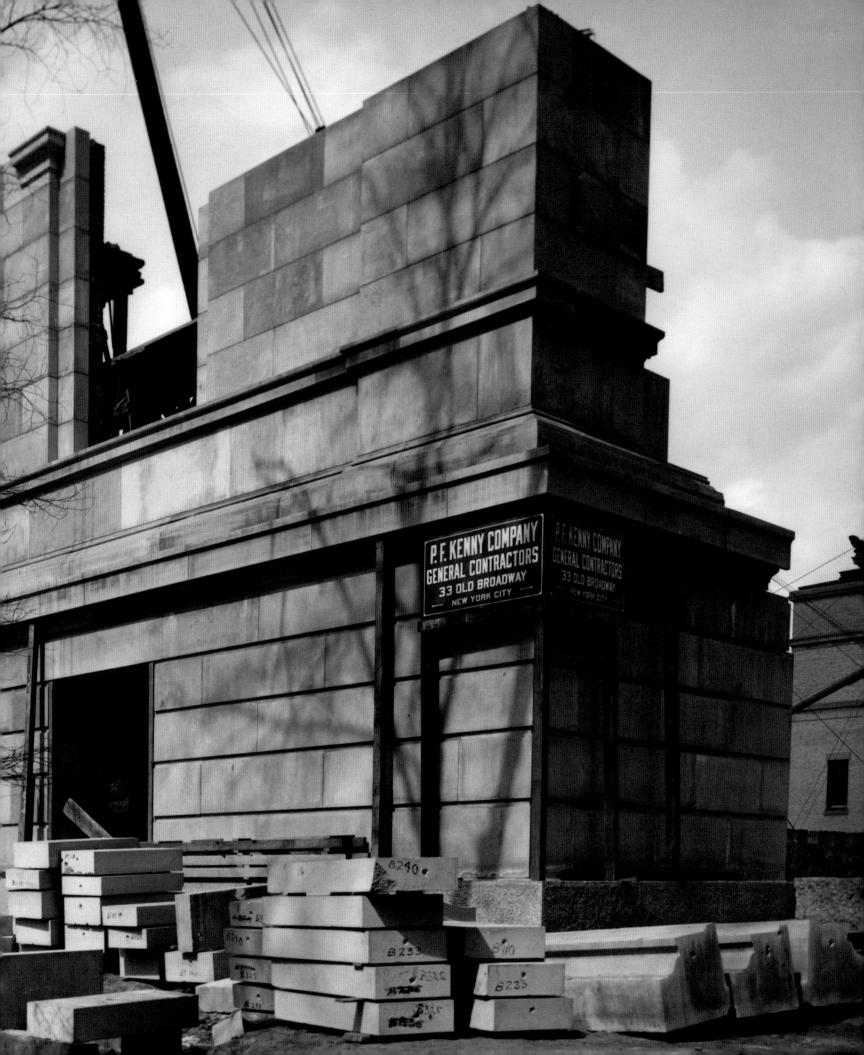

An Edifice for Art

Morrison H. Heckscher

The Metropolitan Museum of Art's edifice in Central Park is a microcosm of 150 years of American architectural history. Its classical Fifth Avenue facade masks a Victorian Gothic core and modernist twentieth-century extremities, the residue of five master plans and the ministrations of more than a dozen architects. It tells a story about the challenges faced by successive architects and their clients (be they museum trustees, directors, or curators) as they fashioned a public place to display the arts of all time and all places.

Building-wise, the Museum's first quarter century can be summarized as one of trustee indecision and architectural ineptitude. Much of this had to do with the Museum's fraught relationship with park officials and its ambivalence about locating in Central Park. The park's designers were opposed to large buildings in their naturalistic landscape, and a majority of Museum trustees would have preferred the more central Reservoir Square site on Forty-Second Street, where the New York Public Library later opened. But Andrew Haswell Green, who oversaw the park's creation as its all-powerful comptroller, ultimately insisted upon a park location for the Museum.

In fact, the program for the 1858 Central Park design competition had called for a museum; in their winning plan Calvert Vaux and Frederick Law Olmsted recommended using the existing New York State Arsenal at Sixty-Fourth Street and Fifth Avenue for that purpose. In 1860 the New-York Historical Society, recent recipient of important collections of European paintings and Egyptian art, inquired after the arsenal site; in 1862 the New York State Legislature set it aside for that institution, which three years later engaged Richard Morris Hunt, the first American to study architecture at the Ecole des Beaux-Arts in Paris, for designs. But what began as a remodeling of the arsenal morphed into plans for a palatial, mansard-roofed confection that was too big for the location. In 1868, at the parks commissioners' insistence, Vaux and Olmsted selected a new site centered on Fifth Avenue at Eighty-Second Street for the historical society. "A large range of buildings at this point," they later opined, "would be seen from no other point of the Park, the locality being bounded on two sides by the reservoir walls, on a third by a rocky ridge, and on the fourth by exterior buildings, while the whole of the territory

thus enclosed was too small for the formation of spacious pastoral grounds."[1]

The historical society now had the land it needed but not the money to build on it. The state legislature resolved this dilemma by preemption: on May 5, 1869, it authorized the board of commissioners of Central Park "to erect, establish, conduct, and maintain on the Central Park . . . a Museum of Natural History and a Gallery of Art." This was shortly after the chartering of the American Museum of Natural History (on April 6, 1869) and in anticipation of that of the Metropolitan Museum (on April 13, 1870). The natural history museum got the Manhattan Square site (then legally part of Central Park) on Central Park West, while the Metropolitan Museum was allocated what would have been the historical society's new site on Fifth Avenue. The following April the city appropriated one million dollars for construction, half for each institution. The land and buildings would belong to the city, the contents to the museums. Until its park building was ready, the Metropolitan Museum occupied temporary quarters, at 681 Fifth Avenue in 1872 (see fig. 25) and at 128 West Fourteenth Street from 1873 until its move in 1879 (see fig. 30).

For the design of these new buildings the commissioners naturally turned to the architects of previous park structures—Calvert Vaux, consulting architect to the Department of Parks, and his assistant Jacob Wrey Mould. Both had come to New York from London in the 1850s and were steeped in the High Victorian Gothic Revival style inspired by the writings of John Ruskin—*The Seven Lamps of Architecture* (1849) and *The Stones of Venice* (1851–53). In 1870 they conceived a master plan for the Metropolitan Museum, with six large, open quadrangles framed by narrow two-story wings, the latter with side-lit alcoves for objects on the first floor and skylit picture galleries on the second (fig. 8). But, in 1872, the trustees of the fledgling institution, balking at such an ambitious, long-term commitment, selected elements of the master plan as a first phase. "It is obviously of great importance," they declared, "that the building to be erected at once, with the half million already appropriated, should be made to include something of each part of the building: some picture gallery, some glass-roofed court, and some of the cloister or side-lighted gallery surrounding the court."[2] That precisely describes the structure that, after many missteps and change orders over eight years, finally

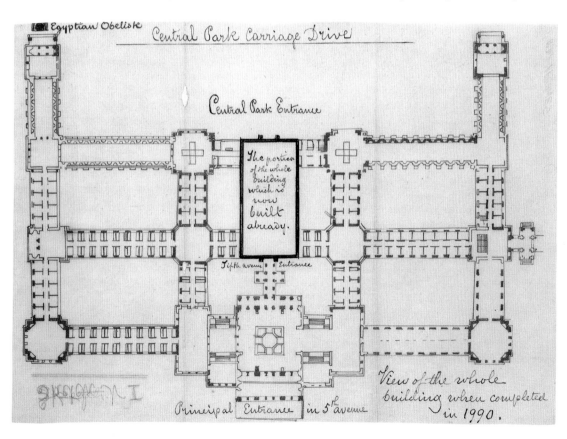

got built (fig. 9). Vaux had accommodated the board of trustees' wishes, incorporating an all-purpose starter structure within the innermost of his six planned courtyards. But the result pleased nobody. Art critic James Jackson Jarves called it "a forcible example of architectural ugliness,"[3] and Museum president John Taylor Johnston later wrote, "Our first building was a mistake, there must be none about the second."[4]

The trustees, reasoning that they needed a different architect, and one in their direct employ, renegotiated their modus operandi with the commissioners so that thenceforth, according to the enabling legislation of May 26, 1881,

the plans would be prepared by the trustees and approved by the parks commissioners. Of the two architects on the board, they passed over Hunt, a rising star in the architectural firmament and the obvious choice, in favor of Theodore Weston, a civil engineer with negligible experience in architectural design. Their decision may have been influenced by Hunt's prior association with the historical society or by the personal preference of the Museum's director, Luigi Palma di Cesnola.

Weston scaled Vaux's plan back to its central quadrangle, which he proposed to complete by clamping enclosing wings onto the south and north sides of the existing building, thereby creating a self-contained block of interconnected galleries with no provision for future expansion. Employing a similar brick and granite, he sought to blend his classicizing design with Vaux's Gothic one. In November 1884 the trustees decided to move the Museum's main entrance from Vaux's Fifth Avenue facade to the center of Weston's new, park-facing, south wing. He completed this south wing in 1888, only to resign in 1890. To Hunt's intense irritation, his fellow trustees again passed him by, giving responsibility for the north wing to Weston's youthful

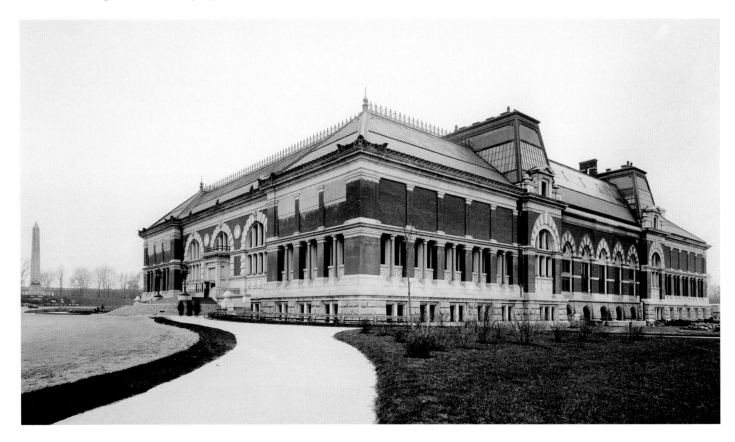

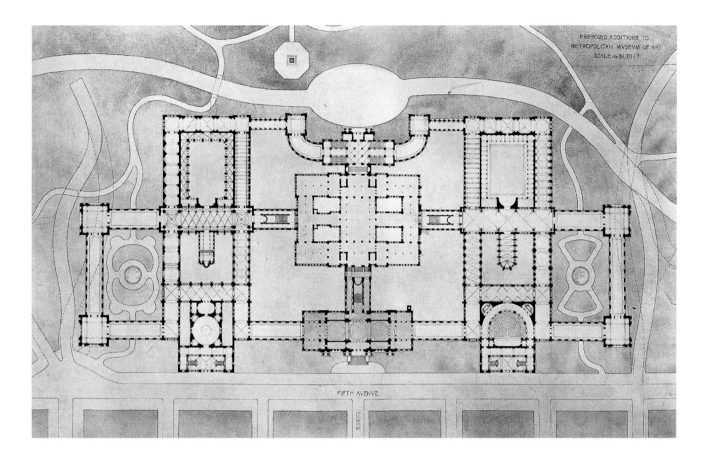

PROPOSED ADDITIONS TO
METROPOLITAN MVSEVM OF ART
SCALE 16 IN TO FT

FIFTH AVENVE

partner, Arthur Lyman Tuckerman. When finally finished, in 1894, the result, an unprepossessing oblong block, was occupied by the Museum's three curatorial departments, with sculpture and plaster casts on the first floor and European paintings on the second (fig. 10).

Only then was Henry G. Marquand, who had succeeded Johnston as president in 1889, finally able to hand the architectural reins to Hunt (who had designed houses for Marquand in New York and Newport, Rhode Island). The times were propitious, with unprecedented wealth being dedicated to art and architecture. Hunt was sixty-seven years old and at the height of his career—recent president of the board of architects of the World's Columbian Exposition in Chicago, architect of choice for the Vanderbilts, and revered as the dean of American architecture. He was in many ways the antithesis of Vaux, his long-time nemesis. The two men, almost exact contemporaries, held opposing views of art and nature: Gothic versus classic, naturalistic landscape versus formal garden, Anglo-American tradition versus French. In matters of design, Vaux represented the past and Hunt the future.

At a meeting in his office with Marquand and Cesnola on April 5, 1895, Hunt presented a set of plans he had spent months preparing, which showed "the entire architectural style of a building which, in his opinion, should be erected on the whole area which the City set aside for the Metropolitan Museum of Art."[5] This expansive scheme was a splendid example of Beaux Arts architectural composition (fig. 11). Hunt accommodated the existing building, floating it in an immense interior court. He returned the main entrance to Fifth Avenue, with a comparable entrance on the park drive to the west; additional entrances on Fifth Avenue led to an auditorium and a library. North and south, narrow wings formed open courtyards or quadrangles. Hunt made detailed studies of the east entrance wing, the building to be erected first: a massive central block, its three great arches with Roman thermal windows flanked by boldly projecting paired columns, elevated on a horizontally rusticated plinth and ornamented with sculptured figures and reliefs (fig. 12).

Eleven days after that meeting the legislature appropriated the funds for the new entrance wing. But Hunt had

12. Richard Morris Hunt's presentation
rendering of the new east wing's Fifth
Avenue facade, 1895

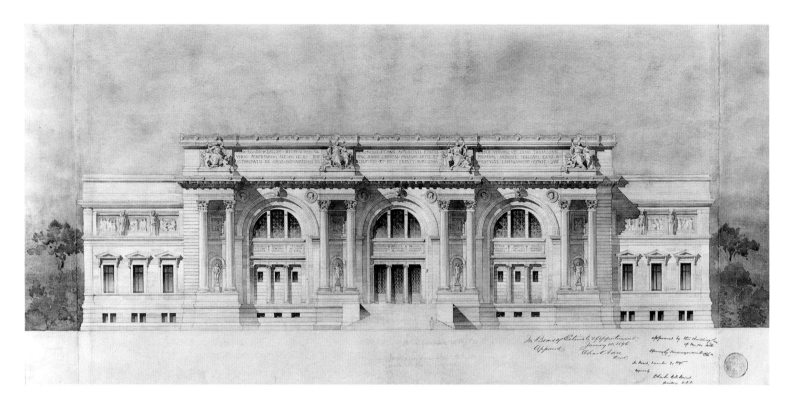

just three short months to savor his triumph. Worn out by
overwork, he fell sick and died in July 1895. Marquand
immediately took command, writing Cesnola: "I expect to
carry out the Hunt design—He went all over the work with
Richard his son and had given much thought on the subject
for a year—there will be no chance for any body else to
come in and snatch his monument."[6] The plans were
approved by the parks commissioners on November 7, 1895,
but only over Vaux's objections. Told that Vaux was "dead
against the general plan of the Museum," Cesnola replied:
"This the Trustees can well understand because the plans
which Vaux made in 1878 for the whole Museum build-
ing . . . have been ignored, and will be superseded by these
new plans of Mr Hunt."[7]

Hunt's entrance wing was erected between 1897 and
1902 by his son, Richard Howland Hunt. The only changes
to it, made for budgetary reasons (a problem Hunt's
Vanderbilt clients never had), were the switch from white
marble to Indiana limestone and the dramatic reduction
in the amount of sculptural carving, most noticeably includ-
ing the blocks above the facade's monumental paired col-
umns, unfinished to this day. Inside, directly behind and
echoing the arches of the facade, is the monumental Great
Hall, with its three saucer-shaped domes supported on

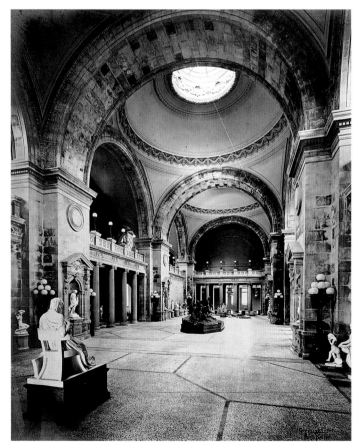

arches springing from immense masonry piers (fig. 13). Straight ahead, to the west, is the grand staircase leading up to Vaux's galleries in the original building, where the European old master paintings were, and still are, displayed beautifully in natural daylight. The interior views from the surrounding second-floor balcony are suggestive of Giovanni Battista Piranesi's eighteenth-century etchings of ancient Rome. After opening day, December 22, 1902, the *New York Evening Post* called the new wing "the most noteworthy building of its kind in the city, one of the finest in the world, and the only public building of recent years which approaches in dignity and grandeur the museums of the old world." The noted architectural critic Montgomery Schuyler, rarely one for effusive praise, had to admit that "[Hunt's] success, as we can all now see, has been really brilliant."[8]

Hunt's wing introduced a golden age of classical architecture for the Museum. The watershed moment was the election as president, upon Cesnola's death in 1904, of J. Pierpont Morgan, financier and collector extraordinaire. Morgan's influence would be pervasive. He initiated the transition to professional management with the hiring away of the directors of the Museum of Fine Arts, Boston, and the South Kensington Museum in London (now the Victoria and Albert Museum), and he saw to the creation and partial completion of a new master architectural plan to accommodate the collections he would acquire and the curatorial departments he would establish (see "Princely Aspirations").

For the latter task Morgan looked to Charles Follen McKim. The partnership of McKim, Mead and White was then the largest and most prestigious architectural firm in the nation, capable of complex planning and design on a large scale, as evidenced by New York's Pennsylvania Station, then rising on a two-block site in the West Thirties. McKim's eminence within the profession was unsurpassed. In 1902, the year he was elected president of the American Institute of Architects, he was remodeling the White House for Theodore Roosevelt and designing a private library on Thirty-Sixth Street for Morgan.

McKim was respectful of Hunt's splendid Fifth Avenue entrance pavilion. For the extensions on either side—each consisting of a low and narrow wing connecting to a higher and wider end pavilion—he employed the same limestone, the same classical architectural vocabulary. But there was a difference: Hunt's treatment was bold and complex, McKim's restrained and chaste. McKim totally reworked Hunt's master plan, consolidating its six subsidiary quadrangles, at north and south, into two massive skylit blocks (fig. 14). Dismissive of any need to preserve Weston's facade, he

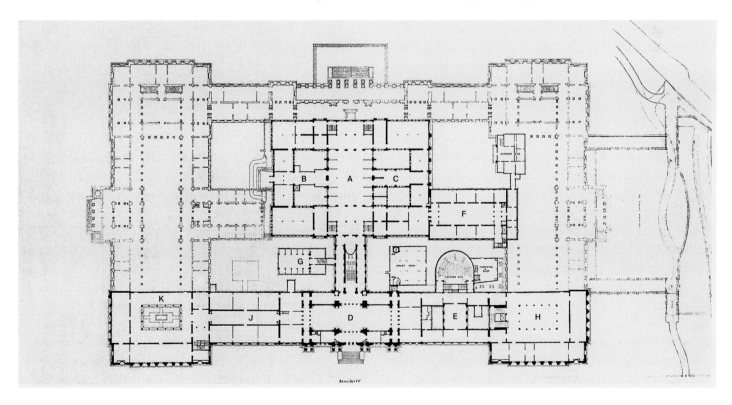

moved the Museum's north-south axis eastward from its center. He did away with the secondary Fifth Avenue entrances in favor of major openings on the building's three park sides. And he employed the latest thinking by European museums about gallery size and proportions and lighting. His ambitions for the master plan were not only to provide ample space and light, ease of circulation, and the utmost flexibility for future development; he also "sought to establish a scale which would give a proper sense of proportion and dignity to the building which was intended to house the greatest museum of fine arts in America, and which from its purpose, its setting, and its very dimensions was destined to be the most important public edifice in New York."[9]

Funding this massive undertaking required an unprecedented commitment by New York City. The priority was to guarantee that the entire Fifth Avenue facade, the Museum's public face, be completed in one building campaign. The extraordinary legislation of 1907—authorizing annual appropriations of $750,000 for ten years—ensured it would be, underscoring the power and prestige of Morgan's Metropolitan Museum and marking the high point of local government support of the arts.

It was at this time that the Museum's wings were designated by letter to distinguish among concurrent construction projects. The first building, by Vaux, became "Wing A" (see fig. 14). The six (out of a projected thirteen) wings that were erected by McKim, Mead and White between 1909 and 1917 were G (the library) and wings housing four new curatorial departments: E (Egyptian), F (decorative arts), H (arms and armor), and J and K (classical). Wing H had been intended as a second gallery for Egyptian art, but Morgan's last-minute switch, made to secure the princely armor collection of his old schoolmate William H. Riggs, meant that goal would have to wait.

One of McKim's first challenges was to address the notorious gloom within Hunt's Great Hall, a result of the decision to use limestone rather than more luminescent marble. "For God's Sake," Augustus Saint-Gaudens pleaded with him in 1905, "remember that proper lighting is an important consideration."[10] McKim enlarged the circular skylights in the domes and proposed big light wells within the wings that were to flank the hall. When the first wing to the north (E) was finished in 1909, it became clear that the light so gained came at the cost of a beckoning northern vista. (Today, upon entering the Egyptian galleries here, one

is immediately confronted by the Tomb of Perneb,[11] which fills part of a light well.) The matching south wing (J), designed in 1912, demanded a different approach (see pp. 16–17). Here William Rutherford Mead (the partner who had assumed responsibility for the project before McKim's death in 1909) proposed a splendid two-story, barrel-vaulted and skylit central corridor for classical sculpture, offering a breathtaking view south to where the monumental Ionic column from the Temple of Artemis at Sardis[12] now stands.

Light was also at issue in the long-standing debate between Mead and assistant director (later director) Edward Robinson over the great skylit center courts in the end pavilions (H and K) along Fifth Avenue. Mead, who favored two-story spaces topped with skylights to create grand architectural effects, had his way in H; Robinson, who preferred skylights at the second-floor level to better illuminate the adjacent galleries, had his way in K. Today all is reversed: a second floor, now housing the Astor Court, was added in H, and the skylight in K was raised to the attic in 2007.

By the time McKim stepped down in 1908, his original 1904 plan—extending fourteen hundred feet along Fifth Avenue, covering eighteen acres of parkland, and subject to questions of fiscal practicality and of park encroachment—had been trimmed back to the thousand-foot-long structure we have today. But the most dramatic of architect-client conflicts had yet to be resolved. The first of the new wings, E, was well under construction when debate erupted over the stairs that would need to be built at the second floor between the new and old wings, different levels being the result of Wing E's larger windows and higher ceilings. The director favored a costly change of plans to align the floors. The architects defended the new galleries' greater height as essential to the scale of their overall plan. In the end, the board sided with the architects; today, from the second floor of the main hall there are steps up to the Asian galleries and to the Ancient Near East and Islamic galleries, and a ramp to the galleries of nineteenth-century European paintings and sculpture.

A further challenge to the orderly completion of the Fifth Avenue wings was Morgan's decision to give precedence to housing Georges Hoentschel's collection of European decorative arts, which he had purchased in Paris in 1906 (see "Princely Aspirations"). McKim chose for it the north-central wing (F), an appendage of Wing C. He conceived

15. Charles Follen McKim's central hall of Wing F, 1910

16. Aerial view of the Museum from the southeast, ca. 1920

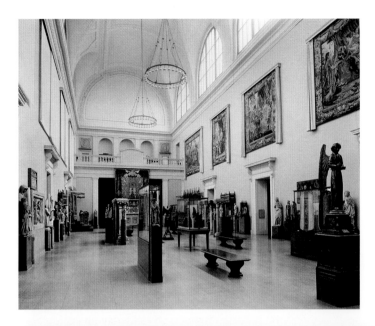

an immense central hall, sixty-seven feet high, rising far above the surrounding two floors of smaller galleries to provide for ten large clerestory windows (fig. 15). When the building was finished in 1910, Robinson described their effect: "These give to the hall a high side light which is beautifully diffused by the cream-white, vaulted ceiling, and falls most becomingly upon the sculptures and other objects on the floor and walls below. The shadows cast by it are never too sharp, and it is equally good in all parts of the hall."[13] The use of a neutral, unpolished Tennessee marble for the floor prevented reflections and inversed shadows. Here, where the arms and armor collections have been displayed to glorious effect since 1956, one experiences the majesty of the spaces McKim had envisaged for the Museum as a whole.

In 1913 Robert W. de Forest succeeded Morgan as president. He worked closely with Robinson to carry out the

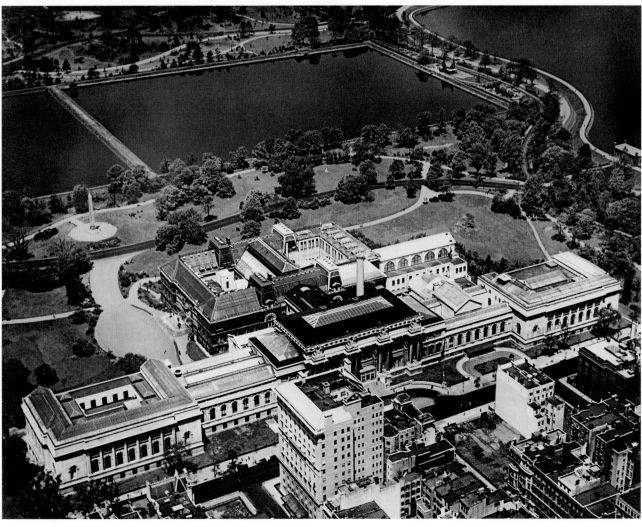

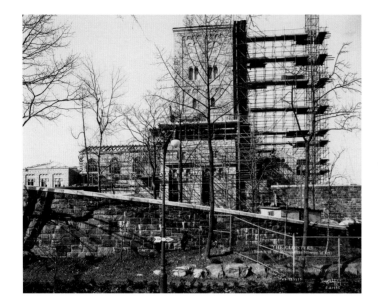

Morgan agenda, completing the exterior of the south end of the Fifth Avenue facade (Wing K) in 1917, just as World War I brought all construction to a halt (fig. 16). (The interiors were finished in 1922.) While the rest of McKim's master plan would remain on paper, never to be realized, his stately Fifth Avenue facade would forever be the Museum's public face.

The postwar years were economically lean, but in 1924 de Forest fulfilled a long-held dream of creating a wing to house early American domestic interiors and decorative arts (see "Creating a National Narrative"). With this goal in mind in 1915, he salvaged the marble facade of the Second Branch Bank of the United States (1824), which was being demolished on Wall Street, to be incorporated into the eventual American Wing (see fig. 129). Designed by Grosvenor Atterbury as a freestanding structure with a link to Wing F and its collection of European decorative arts, it was an architectural outlier until its incorporation within the greatly expanded new American Wing in 1980. The gift of Robert and Emily Johnston de Forest, the original American Wing was the first of the Museum's buildings erected with private funds.

In the spring of 1925 de Forest orchestrated the purchase, with funds from John D. Rockefeller Jr., of George Grey Barnard's Cloisters, a private museum of medieval sculpture in upper Manhattan. In 1930 Rockefeller offered to pay for a new building to house the Museum's collection of medieval art on a nearby site overlooking the Hudson River. The following year Rockefeller selected architect Charles

Collens to prepare a design broadly inspired by the modest church of Saint-Géraud in Monsempron, France. The building, its details painstakingly refined by curator Joseph Breck, was finally completed in 1938 (fig. 17). Rockefeller, like de Forest before him, had relished the freedom to select his own architect and "boss the job" himself.[14] The result is the magical Met Cloisters—a perfect integration of art, architecture, and nature.

Back on Fifth Avenue, the question of how to free up Wing H for Egyptian art had remained unresolved since the temporary installation of arms and armor there in 1913. An accomplished design in the McKim manner by John Russell Pope, last of America's great Beaux Arts architects, for a new decorative arts wing with a grand Arms and Armor Court was a victim of the financial crisis of 1929. Sometime after his appointment as director in 1932, Egyptologist Herbert E. Winlock devised an imaginative and affordable solution. As nothing was now more out of fashion than Victorian architecture and plaster casts, he emptied Wing A of its architectural casts and demolished Vaux's fifty-year-old "grand Centre Hall" to provide a central location for a purpose-built Armor Court. He engaged Otto R. Eggers from Pope's office to design a chaste Romanesque nave, completed in 1939, with a double-height barrel-vaulted ceiling and round-arched clerestory windows through which filtered daylight streams. One of the Museum's grandest historicizing galleries, it was home to armor-clad equestrians until their relocation to Wing F in 1956; the medieval sculptures that supplanted them have serenely inhabited the space ever since.

With Winlock's retirement in 1939, the trustees looked for a new kind of director, someone to anticipate a radically different postwar world. Their choice was Francis Henry Taylor, the articulate and opinionated young head of the Worcester Art Museum in Massachusetts, who, with a modernist's disdain for the past, would later write of the Metropolitan Museum's building: "The public have had their bellyful of prestige and pink Tennessee marble."[15] In 1940 Taylor hired architect Robert B. O'Connor, whose new exhibition galleries at the Wadsworth Athenaeum in Hartford, Connecticut, were considered the most advanced in America, to rethink the Museum's architectural plan. His first report proposed a massive rearrangement of the collections, including moving European paintings to the second floor in Wings J and K, and enlarging the galleries' footprint there by flooring over J's majestic vaulted corridor. His

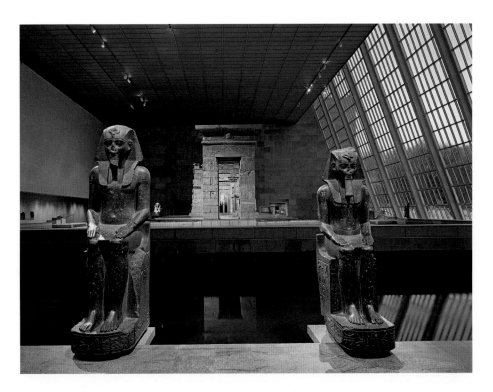

second, prepared upon the premise of a merger with the
Whitney Museum of American Art (see "Reckoning with
Modernism"), proposed that the three-story American Wing
given by the de Forests twenty years earlier be jacked up on
skids, lowered onto rails, and pulled to the south side of the
Museum to join a new Whitney building. But when the parks
commissioner, Robert Moses, announced that the days of
the city footing the bill were over, Taylor had to make do
with modernizing the nineteenth-century wings, sprucing
up their interiors with terrazzo floors and sleek travertine
door surrounds.

Both Taylor and James J. Rorimer, the curator of medie-
val art at the Cloisters who succeeded him in 1955, found
their architectural ambitions crimped by the economic con-
straints of the times. But each obtained private funding
to deal with antiquated facilities that McKim had designed
almost fifty years earlier. Taylor replaced a steep-seated,
semicircular lecture theater (part of Wing E), notorious for
its inaudibility, with the elegant and acoustically exquisite
Grace Rainey Rogers Auditorium, a seven-hundred-seat con-
cert and lecture hall by Voorhees, Walker, Foley, and Smith
(1954). Ten years later Rorimer replaced the Renaissance-
style library (Wing G, off the main stairs) with the much
larger Thomas J. Watson Library, an essay in the fashionable
International Style by Brown, Lawford, and Forbes (1964).

The sixteenth-century Spanish Renaissance marble patio
from the castle of Vélez Blanco,[16] installed at the same time
and through which the library is approached, offers a foil
to the latter's modern severity. It also provides an authentic
example of Renaissance architecture to replace McKim's
twentieth-century replica.

Rorimer's sudden death in 1966 precipitated the eleva-
tion to the directorship of another medievalist, Thomas P. F.
Hoving, the charismatic New York City parks commissioner.
As with Taylor twenty-five years before, the trustees gambled
on a young, untested candidate. But this time the stars were
in alignment: at the beginning of an era of prosperity that
would prove to be of unprecedented duration, there was a
sense of possibility, of optimism, that was altogether new.

Overall, the Museum was little changed since World
War I: a mishmash of disparate structures lay behind that
perfect Fifth Avenue facade. Hoving, backed by board presi-
dent C. Douglas Dillon, was the first person in fifty years
to have the audacity to contemplate a comprehensive mas-
ter plan, one that would complete the rectangular footprint
McKim had envisaged (see "The Centennial Era"). He com-
bined imagination and foresight with ambition and chutz-
pah. Like Morgan, he recognized the transformative power
of acquiring whole collections and erecting new buildings
to house them, and he seized upon the Temple of Dendur[17]

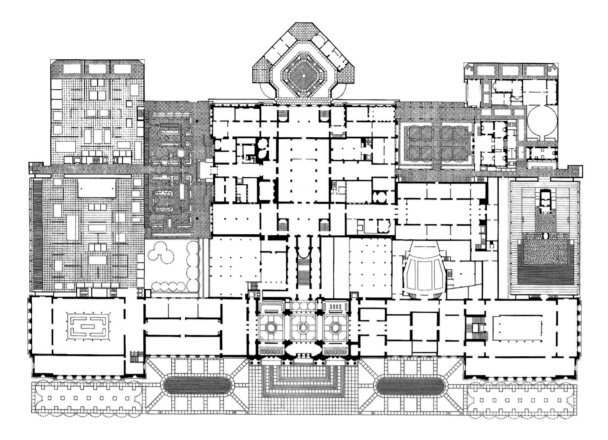

to launch his campaign. Egypt had presented the temple to the United States in 1965, and various institutions were vying for it. Hoving's winning bid to install it in a glass pavilion on the north side of the building, adjacent to the Egyptian collections in Wing H, committed the Museum to expanding its footprint westward into Central Park (fig. 18). Hoving went on to offer a matching glass pavilion on the south side and a pavilion projecting from the center of the west side for the collections of Nelson Aldrich Rockefeller and Robert Lehman, respectively. His grand plan to complete the Museum also encompassed the expansion of the American Wing in the northwest corner and the construction of what became the Lila Acheson Wallace Wing for modern and contemporary art at the southwest corner. In total, the scheme would add one million square feet, nearly doubling the size of the Museum. It was like a return to the glory days of Morgan.

To realize his dream Hoving turned to Kevin Roche John Dinkeloo and Associates (fig. 19). Roche, formerly principal design associate in the office of Eero Saarinen, had been idolized in the press for his 1968 Ford Foundation headquarters with its great glass atrium on Forty-Second Street. He

was a pragmatic modernist but had a classical architectural education that enabled him to appreciate the Museum building's historic components—a rare perspective in the wake of the recent demolition of McKim's Pennsylvania Station. Roche's first task was to redesign the plaza on Fifth Avenue in time for the Museum's centennial in 1970. Hunt's front steps, treacherously steep and lacking any room to congregate at top or bottom, had inspired proposals from every subsequent architect: McKim would have extended them eastward; O'Connor would have replaced them with a vehicular ramp; Brown, Lawford, and Forbes would have substituted an interior escalator. Roche, recognizing that most visitors arrived on foot from north or south, designed today's stately but welcoming three-sided ascent.

Inside, circulation was the great challenge. Roche correctly saw the Metropolitan as a collection of individual museums, and his goal was to create a series of "self-contained but properly related museums accessible from a common circulation space."[18] For a new north-south corridor, Roche returned to Hunt's idea of centering it in Weston's historic facade. But how to "go west" from the Great Hall and reach each wing directly? The obvious

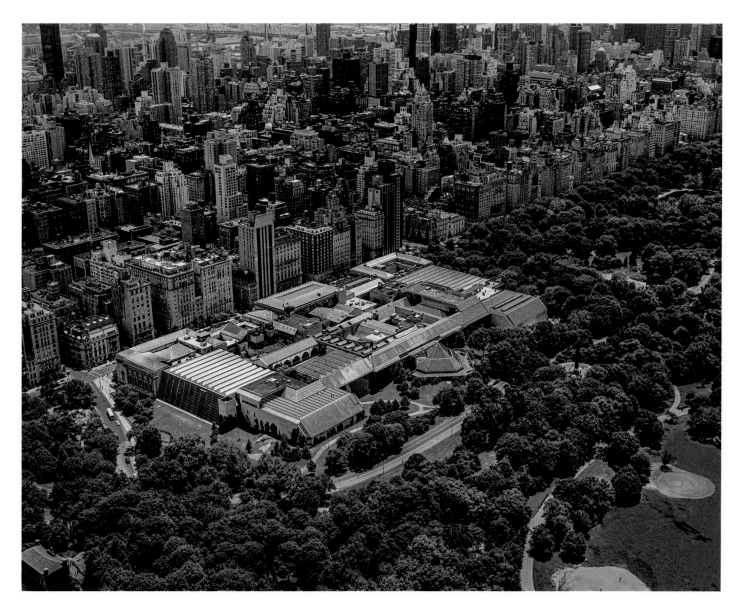

answer was to remove Hunt's grand staircase, an option that was neither politically possible—the very idea was the subject of protest—nor architecturally acceptable—it would unquestionably compromise Hunt's masterpiece. Thus, over the ensuing years, new routes have been opened between departments around the periphery, for example between the American Wing and the Temple of Dendur in the Sackler Wing.

In response to sometimes fierce public opposition to the Museum's expansion plans, Roche ultimately built out to a smaller footprint in the park than McKim, Mead and White had proposed. And in contrast to McKim's stately Fifth Avenue elevations, he made his facades low-slung and self-effacing, minimizing the building's apparent size (fig. 20). His method was twofold: physically, to blur the rooflines with slanting glass skylights, canted corners, and setbacks; and visually, with walls of ivy-covered limestone alternating with sheer walls of glass that reflected nature. Indeed, from the park his building is almost invisible.

Roche flanked the Museum's Victorian core with glass-roofed garden courts whose glass curtain walls front on the park, and he met the fraught issue of access from the park by providing doorways there. (The far grander park entrances proposed by Hunt and McKim had been predicated upon people arriving in vehicles on the park's carriage drive.) To the north the Charles Engelhard Court (1980), the grand

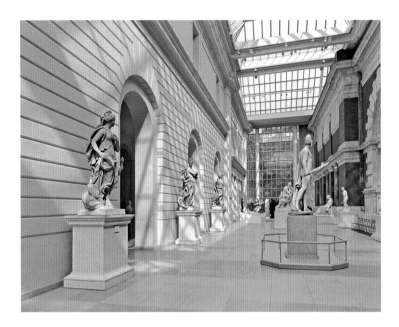

entrance to the American Wing, is anchored by the Second Branch Bank facade of 1824; to the south, the Carroll and Milton Petrie European Sculpture Court (1990) abuts Weston's facade of 1888 (fig. 21). These Roche intended as places of rest and refreshment; today they also display sculpture. A third skylit court, facing Vaux's facade of 1880, is the central gallery of the Robert Lehman Wing (1975), which houses the collector's bequest in galleries that replicate his residence. These light-filled spaces, together with the glass pavilions on the building's north and south sides, are Roche's principal design statement. In some cases, however—notably the southern pavilion housing the Michael C. Rockefeller Wing for the arts of Africa, Oceania, and the Americas (1982)—they make manifest the innate conflict between modern architecture's love affair with glass and the need to protect light-sensitive works of art.

Roche's master plan was carried to completion in 1990 by Philippe de Montebello, who succeeded Hoving as director in 1978 and oversaw construction of many of its key elements. Recognizing that the original Roche plan did not adequately anticipate the massive increases in the number of visitors, special exhibitions, and corporate events, much less the continued growth of the collections, de Montebello called for adjustments. Most notable was the addition of the Henry R. Kravis Wing for European sculpture and decorative arts (1991), which Roche inserted between the Petrie Court and the Lila Acheson Wallace Wing (1987).

Remarkably, working with a single architectural firm and in a little less than a quarter of a century, the Museum succeeded in building out its Central Park structure. The interior, however, remained a work in progress, and Roche would oversee two more big projects before his fifty-year association with the institution ended. With de Montebello he restored and gave new life to the great suite of galleries for classical art by McKim, Mead and White in Wings J and K (1996–2007). Continuing the renovation of Wing K, Roche reconstructed and expanded the galleries for Islamic art on its second floor (2011). Finally, working with the American Wing curators he transformed his own building of 1980 into a far finer showcase for the art displayed therein (2007–12).

Another priority was the Museum's front plaza, which had deteriorated in the forty years since Roche completed it. In 2011 Thomas P. Campbell, who had begun his tenure as director two years earlier, hired the Olin Partnership to redo it as a pedestrian zone with a greener, altogether more welcoming design (fig. 22). Today people move freely beneath its aerial hedges (silver linden trees) and pollarded bosques (London plane trees), which echo the wings of the building's facade. Max Hollein, director since 2018, will oversee the two major foreseeable architectural initiatives: an overhaul of the Rockefeller Wing for the arts of Africa, Oceania, and the Americas designed by Kulapat Yantrasast of wHY; and a remodeling of the southwest wing for modern and contemporary art by David Chipperfield and Associates.

An engagingly naive annotation on a rendering of Vaux's nineteenth-century master plan (see fig. 8) estimated that the Museum's construction would be completed in 1990—not that far off, as it turned out. But neither Vaux nor that prescient seer could have envisioned the Museum that was ultimately built. The Hunt, McKim, and Roche master plans, as well as the smaller intervening additions that were superimposed upon Vaux's original footprint, resulted in a palimpsest of staggering complexity. And yet underlying it all is a simple embrace of past and future: the Museum's majestic Fifth Avenue facade symbolizes its commitment to the eternal verities, while its diverse interiors and extensions invite experimentation and change.

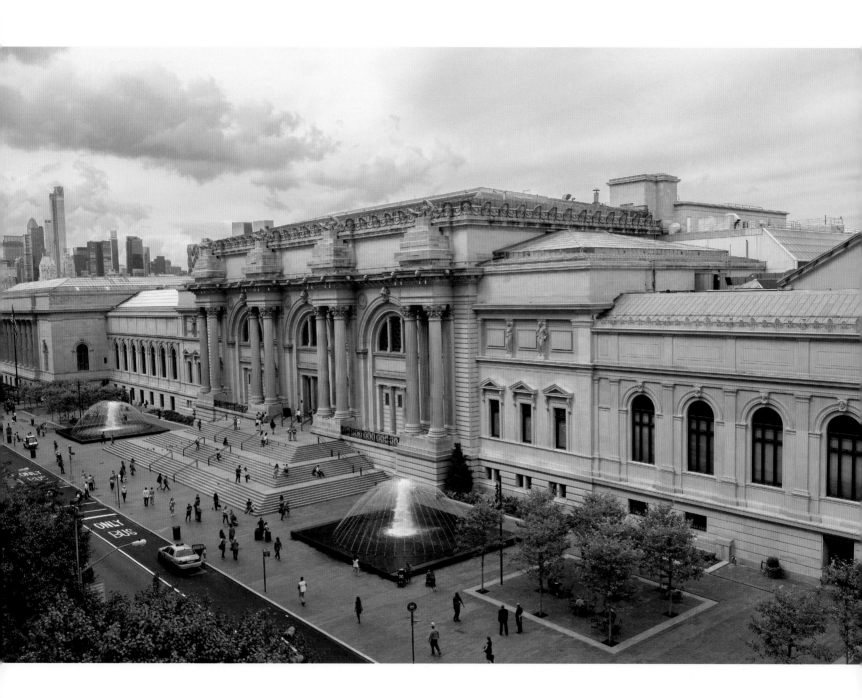

The Founding Decades

Katharine Baetjer and Joan R. Mertens

On July 4, 1866, fifteen months after General Robert E. Lee's surrender at Appomattox signaled the end of the Civil War, Americans in Paris celebrated the rewards of peace and the ninetieth anniversary of the signing of the Declaration of Independence.[1] Tents were set up in the Bois de Boulogne at a popular outdoor place of entertainment, the Pré Catelan, with refreshments and provision for dancing. It was during these festivities that The Metropolitan Museum of Art was first envisioned. In a speech to the notables in attendance, New York attorney John Jay remarked (as he later recalled) that it was "time for the American people to lay the foundation of a National Institution and Gallery of Art."[2] His proposal was eventually referred to the art committee of the Union League Club of New York: George P. Putnam, founder of the publishing house; art dealer and collector Samuel P. Avery; sculptor John Quincy Adams Ward; and four painters, including Eastman Johnson and John Frederick Kensett (fig. 23). In their report of October 14, 1869, the group drew attention to New York's increasingly rich cultural offerings, including its splendid Central Park (opened to the public in 1858), the New-York Historical Society (founded in 1804), the

Astor Library (opened in 1854), and the plans under way for a museum of natural history. Suggesting the opportunity for further rapid growth, they pointed out that London's South Kensington Museum (now the Victoria and Albert Museum) had made enormous strides in a quarter century. However, they also concluded that neither the municipal nor the national government was suited to the task of opening such an art museum in New York.

On November 23 the question was brought to the attention of some three hundred individuals of standing in New York who attended a more public meeting. Professor George Fiske Comfort of Princeton University gave an address in which he pointed out that every small city in Europe had its own art museum.[3] Those present sought to establish what William Cullen Bryant, editor of the *New York Evening Post*, fulsomely described as a new art museum "worthy of this great metropolis and of the wide empire of which New York is the commercial center."[4] On January 31, 1870, trustees and executive committee members were voted into office, together with the president of the board, John Taylor Johnston, and the chairman of the executive

committee and vice president of the board, William Tilden
Blodgett. The Metropolitan Museum of Art was incorpo-
rated on April 13, 1870. Seven months later, on November 21,
the executive committee accepted the first acquisition, a
Roman sarcophagus given by Abdo Debbas, the American
vice consul at Tarsus, in present-day Turkey.[5]

Johnston and Blodgett were typical, in their different
ways, of the prominent, enormously wealthy New Yorkers
of the mid-nineteenth century. Johnston graduated from
what is now New York University and studied law at Yale.
After several years at a prestigious law firm, he resigned
to travel in Europe, where he began to collect paintings;
upon his return, he bought into a small New Jersey railway
company.[6] Johnston's railroad ran from the Pennsylvania
coalfields to the banks of the Hudson River, where he built
a terminal to serve Manhattan, and these ventures were
the source of his fortune. Although Johnston's taste in

nineteenth-century painting was conventional, he owned
two works of exceptional importance, J. M. W. Turner's
The Slave Ship of 1840 (Museum of Fine Arts, Boston) and
Winslow Homer's 1866 *Prisoners from the Front*.[7] Several
years after the financial crisis of 1873, his railroad went into
receivership, and he closed his private gallery and was
obliged to sell those works, among many others. He served
as president of the Museum until 1889.

Blodgett, who would prove pivotal to the Museum's
earliest acquisitions (fig. 24), was born in western New
York State and moved to the city in 1838. In his twenties he
turned a local varnish factory established by his uncle into
a thriving international business. From the Civil War years
onward, Blodgett was widely known for his philanthropic
activities. He too had a significant collection of European
and American works, including Frederic Edwin Church's
1859 *Heart of the Andes*.[8] Blodgett chaired the first executive

24. Eastman Johnson (American).
Christmas-Time, The Blodgett Family,
1864. Oil on canvas. Gift of Mr. and Mrs.
Stephen Whitney Blodgett, 1983

25. 681 Fifth Avenue, the Metropolitan
Museum's home in 1872–73, as it looked
in ca. 1900

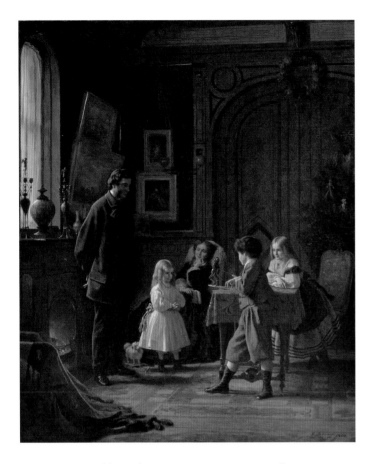

committee and board meetings, on May 27 and June 15, 1870. A primary focus was to raise urgently needed funds for the new Museum; the founders were concerned that, should a major collection come on the market in Europe or an artist or collector in New York wish to make an important gift or bequest, no art museum in the city would be prepared to receive such a purchase or donation. The largest contributions at the outset were from Johnston, Blodgett, and trustee and department store owner Alexander T. Stewart.

Not long after the June board meeting, Blodgett departed for Europe, probably settling in Paris shortly before the outbreak of the Franco-Prussian War on July 19, 1870.[9] On August 23, less than a month after Prussia invaded France, the dealer Léon Gauchez sold him fifty-seven pictures referred to as "the Paris collection." As far as Blodgett (and later his fellow trustees) understood, he had acquired the holdings of a private individual in that city who wished to dispose of his entire collection owing to the difficult political and financial conditions then prevailing. On September 22, while Paris was under siege, Blodgett made a second purchase, one hundred paintings offered by the expert and

dealer Etienne Le Roy. This collection was thought to have belonged to a Belgian aristocrat, Count Cornet de Ways Ruart. The scenarios were similar, and similarly inaccurate: each dealer had in fact bought the greater portion of the works at various public auctions. Gauchez completed a third and final sale of seventeen works to Blodgett in early November 1870. Le Roy, who was also a restorer, took charge of the repairs and reframing of Blodgett's acquisitions, while Gauchez managed the onward shipments through the port of Liverpool. In December Blodgett offered his fellow trustees the 174 European old master paintings he had assembled abroad for the purchase price plus costs. They resolved unanimously to accept his offer on March 31, 1871, and payment was completed in December. The purchase formed the nucleus of the new museum's collection.

The Metropolitan Museum of Art opened to the public on February 22, 1872, in the Dodworth Building, a town house the trustees leased at 681 Fifth Avenue, between Fifty-Third and Fifty-Fourth Streets; it was previously the site of a dancing academy (fig. 25). To improve the quality of the illumination, they underwrote the installation of a skylight in

the main room, where twenty-four of the most important of Blodgett's pictures were exhibited. In view of the city's Dutch heritage, it is not surprising that the arrangement demonstrated a marked preference for the seventeenth-century Northern schools. Paintings by Anthony van Dyck (fig. 26), David Teniers the Younger, Jacob Jordaens, and Salomon van Ruysdael were cornerstones of the installation. The eighteenth century was represented by French master Jean-Baptiste Greuze and German painter Christian

Wilhelm Ernst Dietrich. Pictures ascribed to Paris Bordone, Sassoferrato, and Peter Paul Rubens were later discovered to have been misattributed and have left the collection. There was little interest in eighteenth-century Venice: fine works by Giovanni Battista Tiepolo, Giovanni Domenico Tiepolo, and Francesco Guardi (fig. 27) were consigned to secondary spaces. According to the young Henry James (writing anonymously in the *Atlantic Monthly*'s June 1872 issue), it was not "a brilliant collection, for it contains no first-rate example

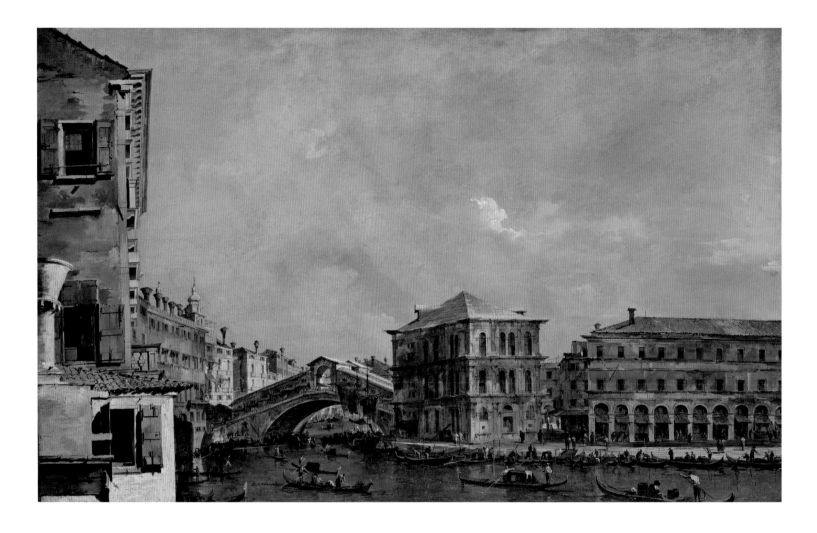

of a first-rate genius; but it may claim within its limits a unity and continuity which cannot fail to make it a source of profit to students debarred from European opportunities."[10] The strenuous efforts of the hanging committee—Frederic Edwin Church, Daniel Huntington, John Frederick Kensett, and Samuel Avery—had assured a successful opening. George Putnam offered to serve for a year as superintendent, provided he had an assistant or clerk. Such a person was soon engaged, becoming the first member of staff.[11]

The first significant acquisition of European sculpture was a marble portrait bust of Benjamin Franklin by Jean Antoine Houdon (fig. 28). It was presented in 1872 by John Bard, founder of Bard College (whose wife, Margaret, was John Taylor Johnston's sister), and had descended to him through his mother, born Catherine Cruger. The practice of the time was to associate works of art with their

former owners, lending reassurance to buyers, luster to acquisitions, and flattery to patrons; both the Bards and the Crugers had connections to the founders of the nation.

During the last days of that first year of operation, Johnston and Blodgett, in consultation with financier Junius Spencer Morgan (father of the Museum's future president, J. Pierpont Morgan), committed themselves to the purchase of a very large collection of antiquities from Cyprus (fig. 29).[12] It was assembled by Luigi Palma di Cesnola, an Italian military officer who had emigrated to America in the late 1850s, fought with the Union forces during the Civil War, endured nine months of Confederate captivity in Richmond, Virginia, and at the end of the war wangled the position of American consul in Cyprus, where he served, with interruptions, from 1865 to 1876. As was the case with other diplomatic representatives on the island, he excavated

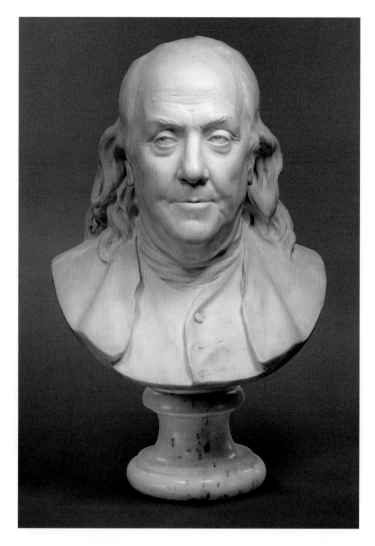

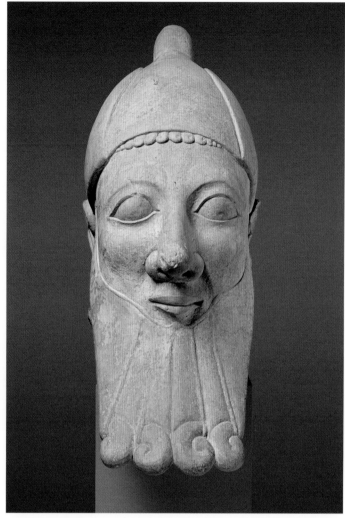

antiquities, in large part for financial gain. When the Otto-man authorities sought to curb his activities, he left for London in January 1872 with a collection of 5,756 pieces he was intent on selling. After seeking to interest museums in London, Berlin, and Saint Petersburg, he reached an agreement with the Metropolitan Museum and arrived in New York at the beginning of 1873 with 275 crates. The rationale for the acquisition included the trustees' desire to build the collection in all areas as well as a strong contemporary interest in cultures mentioned in the Bible. As with the purchase of Blodgett's collection in 1871, the necessary funds were raised by subscription.

Since the space in the Dodworth Building was wholly inadequate for the latest acquisition, the trustees arranged to relocate to larger premises, the Douglas Mansion, at Fourteenth Street between Sixth and Seventh Avenues,

where the Museum remained from March 1873 until February 1879 (fig. 30). A painting by Frank Waller (fig. 31) depicts two of its second-floor galleries as they appeared in 1879. Van Dyck's *Saint Rosalie* (see fig. 26) is to the left of the doorway; the display case beyond contains the reproduction of a salver.[13] To further Cesnola's work, the trustees voted to provide him with a salary and expenses to unpack, display, and catalogue the plethora of vases, terracottas, bronzes, glass, and especially sculptures; his chance discovery in 1870 of the site of Golgoi had yielded the most significant concentration of limestone sculpture on Cyprus. By late September 1873 Cesnola returned to Cyprus because he was officially still serving as American consul. However, he had signed an agreement with the Museum that any further finds he made would belong to the institution, under specific financial conditions. He returned to New York

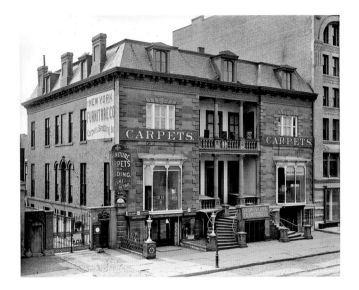

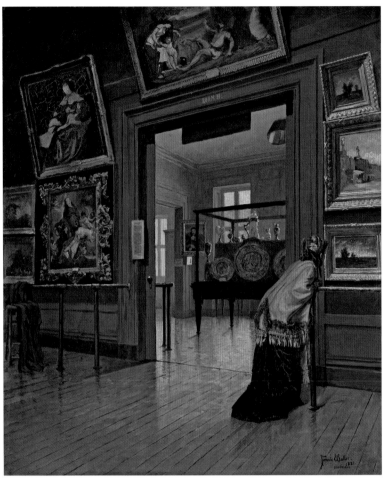

definitively in 1876, became secretary of the Museum in 1877, and on May 15, 1879, was named the first director.[14]

The following year the Museum finally moved into its permanent home in Central Park, which had been designed and developed during the 1850s and 1860s, the achievement of Calvert Vaux and Frederick Law Olmsted (see "An Edifice for Art").[15] The only buildings included in their plans were amenities to the park such as a music hall, pavilions for restaurants, and a children's playhouse. When public pressure intensified for structures to accommodate the New-York Historical Society, a natural history museum, and an art museum, Olmsted, Vaux, and the parks commissioners designated "along the [park's] boundary, several small spaces of ground, buildings within which, if properly designed, will not affect the park landscapes, and which, regarding the Park as a work of art . . . may be considered extraneous."[16] On a park plan of January 1, 1870, an area between Eighty-First and Eighty-Fourth Streets had already been set aside for

a "Proposed Art Museum and Hall," and on a plan of May 1, 1870, less than a month after the Metropolitan Museum was incorporated, it was formally assigned this site.

Architectural designs by Vaux and Jacob Wrey Mould for a building at this location began in 1870,[17] and construction got under way in 1874. In 1876, when Cesnola returned to New York from Cyprus, the structure was enclosed and contracts were being signed for the completion of the interior. On February 14, 1879, the Douglas Mansion was closed to allow for the transfer of the collection to the new building, which opened on March 30, 1880. According to an account of the move in the *New York Evening Post* of March 19, 1880, much of the labor was personally undertaken by the trustees: "The removal of the vast collection of Cypriote potteries, statuary, glass, bronzes, and other objects and paintings and marble statues from the Fourteenth Street Museum to the Park was not only superintended during six weeks by trustees but every separate fragile object was

packed at one place and unpacked at the other by the gentlemen themselves. . . . [It] is almost a miracle in this age of work for pay."[18]

Until 1882 the administration of the institution consisted of Cesnola supported by some assistants and employees, hired on a monthly basis. That year, a curator, Professor William Henry Goodyear, and a librarian were appointed, and an organizational plan providing for a staff of twenty-two, including the director, was drafted. After a study of various European museums, two curatorial departments were established in 1886. The Paintings Department was responsible for all paintings, textiles, and works on paper, including photographs. The Department of Sculpture, under Professor Isaac H. Hall, basically covered all three-dimensional objects, including antiquities, jewelry, ceramics, "and such other objects of art as commonly are termed Bric-à-Brac."[19] In 1889 the Department of Casts, led by Professor John A. Paine, was added. It dealt with copies and reproductions in all forms as well as with the art school, which lasted only until 1894. This was the Museum's basic structure during Cesnola's tenure.[20] The gradual growth in

specialized staff was accompanied by the introduction of technological innovations, such as turnstiles to count visitors in 1880, telephones in 1883, and electric lights in 1889.

With the Museum firmly established, the late 1880s and early 1890s saw increasing activity and the significant development of the collection. Notable to these efforts were three donors of European paintings: Catharine Lorillard Wolfe, Erwin Davis, and Henry G. Marquand. Born to a life of philanthropy, Wolfe had been the only woman to contribute to the first campaign to raise funds for the Metropolitan Museum.[21] Her father was a successful investor in New York real estate, and her mother was a beneficiary of the Lorillard tobacco fortune. Their sole surviving child, Wolfe inherited a fortune at age forty-four; she lived unobtrusively in New York but traveled abroad widely and constantly in pursuit of works of art. She bought paintings and watercolors, mostly French, Spanish, and German and dating from the 1860s through the mid-1880s; she also commissioned several works, probably more than are now identified. She favored narrative and genre subjects and bequeathed fine paintings by Jules Breton, Camille Corot (fig. 32),

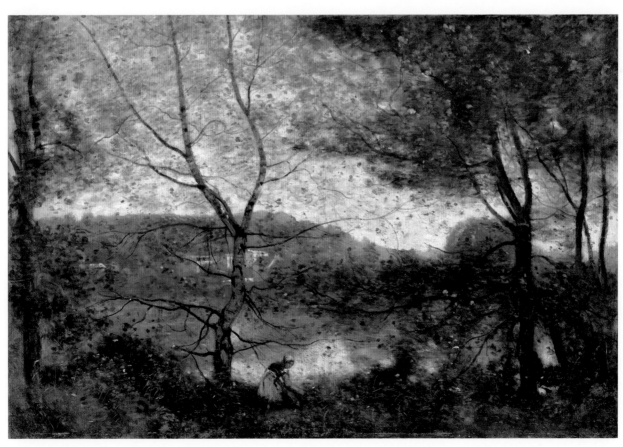

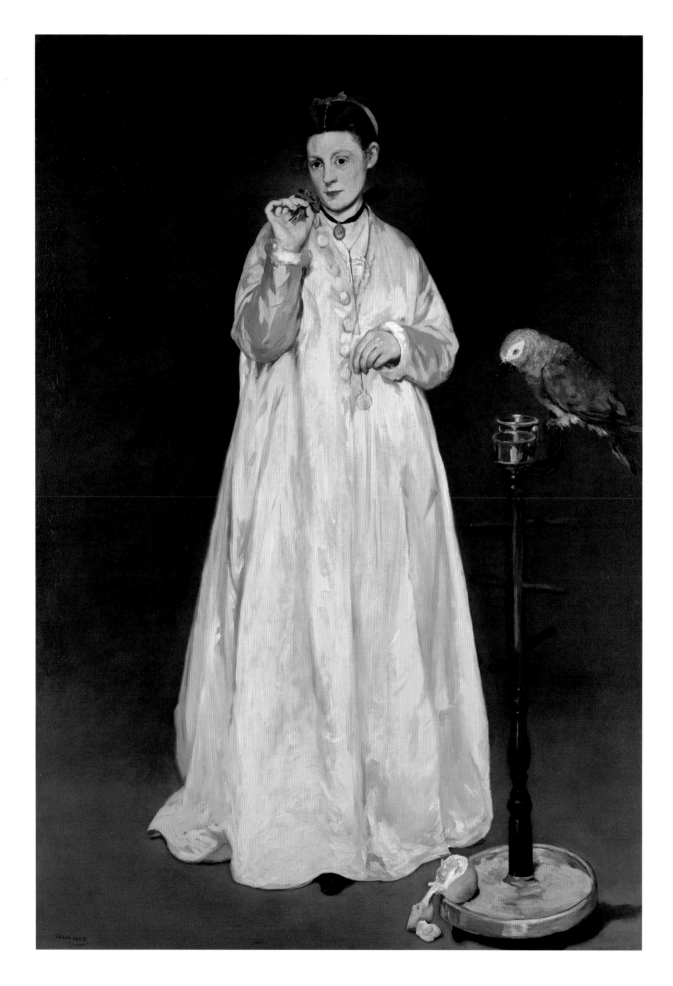

The Founding Decades

Pierre-Auguste Cot, and Jean-Léon Gérôme, among others, that were popular with the Museum's visitors. But for the fact that she was little interested in Barbizon landscapes, her holdings of European art were typical of her time. While many such collections were broken up for reasons of inheritance or because their owners developed other interests, Wolfe bequeathed hers in 1887 as formed. She also endowed a fund for the maintenance of her collection and for purchases of the art of her time. With the Wolfe Fund the Museum acquired Jacques Louis David's *The Death of Socrates*[22] and *Madame Georges Charpentier and Her Children* by Pierre-Auguste Renoir.[23]

The second important early donor, Erwin Davis, was a speculator in mining and railroads. He gave only a few works, but they were of great significance. Davis made his introduction to the Museum on March 21, 1889, calling on Samuel Avery to present a letter in which he offered to give three modern paintings: Edouard Manet's *Young Lady in 1866* (fig. 33) and *Boy with a Sword*[24] as well as *Joan of Arc* by Jules Bastien-Lepage.[25] Avery, a board member, was a well-informed connoisseur and dealer; he was listed as an advisor in the catalogue of 145 paintings that Davis had offered at public auction the two previous days. He knew that the proposed gifts had been bought in by Davis at inflated prices under a blind name, a practice that while not illegal was widely deplored. Nevertheless, he accepted them immediately, rather than awaiting approval, because, as he wrote to Cesnola later that day, he was certain of the agreement of the trustees. He saw no reason why the Bastien-Lepage "may not be at once put in place."[26] Davis had paid $23,400 to buy the painting in, whereas he gave $6,700 for *Boy with a Sword* and only $1,350 for *Young Lady in 1866*, a compelling indicator of the taste of the moment. The nature of the benefit to Davis (other than the improvement of his reputation in the New York art market) remains uncertain. The Museum was fortunate: the Manet paintings were the first of his works to enter any public collection.

Davis began with conventional nineteenth-century art but developed an interest in the new painting, owning, in the 1880s and later, works by Edgar Degas, Manet, Claude Monet, and Alfred Sisley. The American painter Julian Alden Weir had been Davis's agent in Paris for the purchase of the three pictures that came to the Museum. Weir had bought the Bastien-Lepage in 1881 from the artist and had secured the Manets in 1882 from the Paris dealer Durand-Ruel.

Thereafter Davis bought, sold, and traded pictures with impunity, but the Metropolitan Museum never heard from him again.

The third of the triumvirate of essential early donors of European paintings was Henry G. Marquand, a member of the Museum's original organizing committee, who committed a significant portion of both his wealth and his knowledge to the Museum (see "Princely Aspirations").[27] Typically for a striving New Yorker, he had started out in business young, working on Wall Street and in real estate. Richard Morris Hunt completed the exterior of his mansion on Madison Avenue and Sixty-Eighth Street in 1874. Marquand furnished the house with nineteenth-century British and American paintings, including a picture he commissioned from Sir Lawrence Alma-Tadema, *A Reading from Homer* of 1885 (Philadelphia Museum of Art). He fixed on the idea of forming a collection of the best available European old masters that he would in due course present to the Museum. His project came to fruition with major gifts totaling fifty pictures in 1889 and 1890, by which time he had succeeded Johnston as president of the board. As with the Wolfe bequest, the works were housed in a space designated in Marquand's honor.

Marquand acquired the vast majority of his intended gifts at speed, paying high prices on the London art market between 1886 and 1889—a time when the land-poor British aristocracy was retrenching. He bought what he believed to be a Jan van Eyck (now ascribed to Petrus Christus)[28] and a Leonardo da Vinci (*Girl with Cherries*, now attributed to Marco d'Oggiono),[29] not as a matter of personal taste but as an expression of his ambitions for the Metropolitan Museum. Notably, Marquand brought the first Rembrandt as well as the first Vermeer to America, and he was the donor of *James Stuart, Duke of Richmond and Lennox* by Anthony van Dyck[30] and a swashbuckling portrait by Frans Hals.[31]

The Museum also made acquisitions in important areas that lay beyond European boundaries, and the variety of objects was impressive even in the early decades. A pioneer in this regard was Mary Elizabeth Adams Brown, a benefactor who collected passionately in decidedly unconventional terrain: musical instruments, primarily of non-Western cultures.[32] Her initial gift in 1889 of 276 instruments laid the foundation for the Museum's Department of Musical Instruments; it was only the beginning of her systematic acquisition and donation of more than 3,600 pieces (see "Art

for All"). Cesnola, the director between 1879 and 1904, is not remembered for a broad and deep knowledge of art but must in a significant way have supported and encouraged all the collections' growth—except of "our American artists in general, and those of New York in particular . . . because they are humbugs."[33] It is worth noting the inclusion during his tenure of women artists, the American painters Caroline Cranch and Sarah Goodridge as well as the British sculptor Mary Grant.[34]

Interest in the arts of the Americas was manifested in Marquand's 1882 gift of a large group of Precolumbian and ancestral Native American textiles, ceramics, and objects of

bronze and silver.[35] Similarly, the American landscape painter Frederic Edwin Church offered two early Toltec reliefs he had acquired in Mexico in the winter of 1892–93 (fig. 34). Writing to Cesnola, Church referred to them as Aztec tiles and stated that they had been uncovered by a plow in a field near Tampico, on the east coast of Mexico. He wished to "add [them] to the meagre collection of American Art of the New World in our Museum."[36]

The extensive and varied collection Edward C. Moore bequeathed in 1891 contributed significantly to the diversity of the Museum's holdings. Moore was an early collector of Islamic art, notably glass, ceramics, and metalwork; his

acquisitions also focused on Greek and Roman glass and vases and Asian, particularly Japanese, pieces.[37] For Moore, a leading silversmith of the second half of the nineteenth century and the artistic director of Tiffany and Company's silver division, collecting was a professional endeavor: he sought out works that would provide artistic inspiration and technical information for his designers as well as for himself. In that way his aims dovetailed with principles underlying the founding of the Museum: "encouraging and developing the study of the fine arts, and the application of arts to manufacture and practical life."[38] Toward that end, selections from his bequest were exhibited in a designated space until 1942.

Holdings of Asian art were substantial even before the Moore bequest. In 1879 Samuel Avery sold the Museum more than thirteen hundred ceramics, primarily Chinese (fig. 35).[39] Consistent with a contemporary pattern of collecting to strength in a specialized area, Heber R. Bishop, a longtime trustee, bequeathed 1,028 jades of the eighteenth and nineteenth centuries in 1902 (fig. 36).[40] The arms and armor brought together by Maurice de Talleyrand-Périgord, duc de Dino, which the Museum purchased in 1904, established the basis of another of its signal departments. While the collection's strengths lay in European works, it included important Islamic and Japanese pieces (figs. 37, 38).[41]

Serious effort and considerable money were also devoted to the acquisition of plaster casts and reproductions in other media. The impetus behind extraordinary activity in this area was twofold: first, the belief that, despite its ambitions and successes, the Museum would not be able to assemble a collection of originals equal to those in Europe; second, the prevailing estimation of casts as valuable replicas of the great works of world art and thus also significant objects of study. Even before the Department of Casts was established in 1889, the Museum devoted itself to the creation of scale models: funds bequeathed by Levi Hale Willard at his death in 1883 led to the formation of a commission affiliated with the American Institute of Architects, which engaged Adolfe Jolly in Paris to make reductions to scale of outstanding monuments. Jolly's subjects included the Hypostyle Hall in Karnak, Egypt, the Pantheon in Rome, the Cathedral of Notre-Dame in Paris, and the Parthenon in Athens; the latter is the only one to survive. In 1886 Henry Marquand provided funds for the purchase of plaster casts of sculpture from all periods of Western art. The group

designated to select the objects included Robert W. de Forest, F. W. Rhinelander, Augustus Saint-Gaudens, Louis C. Tiffany, John Quincy Adams Ward, and Stanford White; they were active from 1891 until 1895. Edward Robinson, later the third director of the Museum, was the purchasing agent. The *Catalogue of the Collection of Casts*

called on the director for financial and administrative information concerning the institution. The very first purchase with the Rogers Fund was Thomas Cole's *A View near Tivoli (Morning)*,[42] and Cesnola quickly took advantage of the opportunity to secure a group of Roman wall paintings from a villa at Boscoreale near Naples[43] and an Etruscan bronze chariot from Monteleone with related grave goods.[44] The fund continues to be a major source of acquisitions for all departments.

The extraordinary ingathering of works of art and the Museum's declared mission to inform and educate led to an ambitious program of publications and lectures. Provision for a library was part of the institution's charter, and a space for books was set aside when the Fifth Avenue building opened.[45] Between 1872 and 1904 the Museum published more than one hundred catalogues, many of them devoted to the permanent and loan collections of European and American paintings. The first two collection catalogues were issued for the Dodworth Building and the Douglas Mansion; the first exhibition catalogue was published in 1874. Among the many subjects of other early publications are Oriental porcelain and jades, engraved gems, and musical instruments. Cesnola oversaw the production of his folio *Atlas* on the Cypriot collection between 1885 and 1903. By 1905 the decision was taken to issue the quarterly *Bulletin*. The first number, of November 1905, expressed its aim: "to be a ready means of communication between the officers and staff of the Metropolitan Museum of Art and its members, using that term in its largest sense to include . . . all the citizens of New York, who . . . are interested in art."[46]

The Museum would soon expand its constituency well beyond New York as it built on the solid foundation established by the men and women who had brought it into existence. With the ardor and personal commitment exemplified by Frederic Church hanging paintings and Luigi Palma di Cesnola wrapping Cypriot pottery, those early leaders had collected broadly and creatively, developed a well-run organization, and provided the ancillary resources of a library, publications, and educational programs. The cumulative energy, dedication, knowledge, and sense of purpose that marked these early years set the direction for the Museum's remarkable future development.

published in 1908 lists more than fifteen hundred pieces. Between 1906 and 1936, Robinson—a classicist—and Gisela M. A. Richter, who would guide the future Department of Greek and Roman Art to its position of eminence, also bought hundreds of two-dimensional renderings and three-dimensional copies of recent finds in Greece from the enterprise of Emile Gilliéron and Son. Nonetheless, by the end of World War I, originals were rapidly replacing copies in the galleries.

In 1901 the Museum received an unprecedented and entirely unexpected bequest of over $5 million that made possible purchases that no longer needed to be funded by subscription or advances by trustees that were later reimbursed. The donor was Jacob S. Rogers, a locomotive manufacturer in Paterson, New Jersey, who had been a Museum member since 1883 and, between 1891 and 1899, regularly

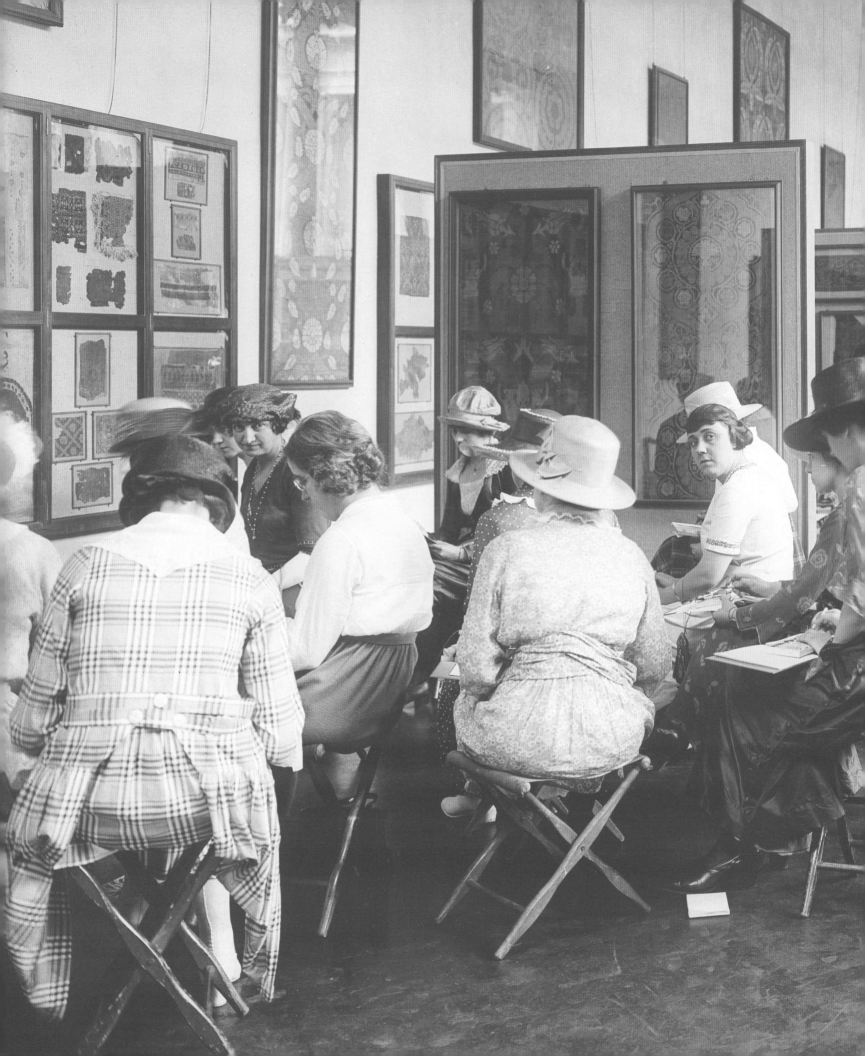

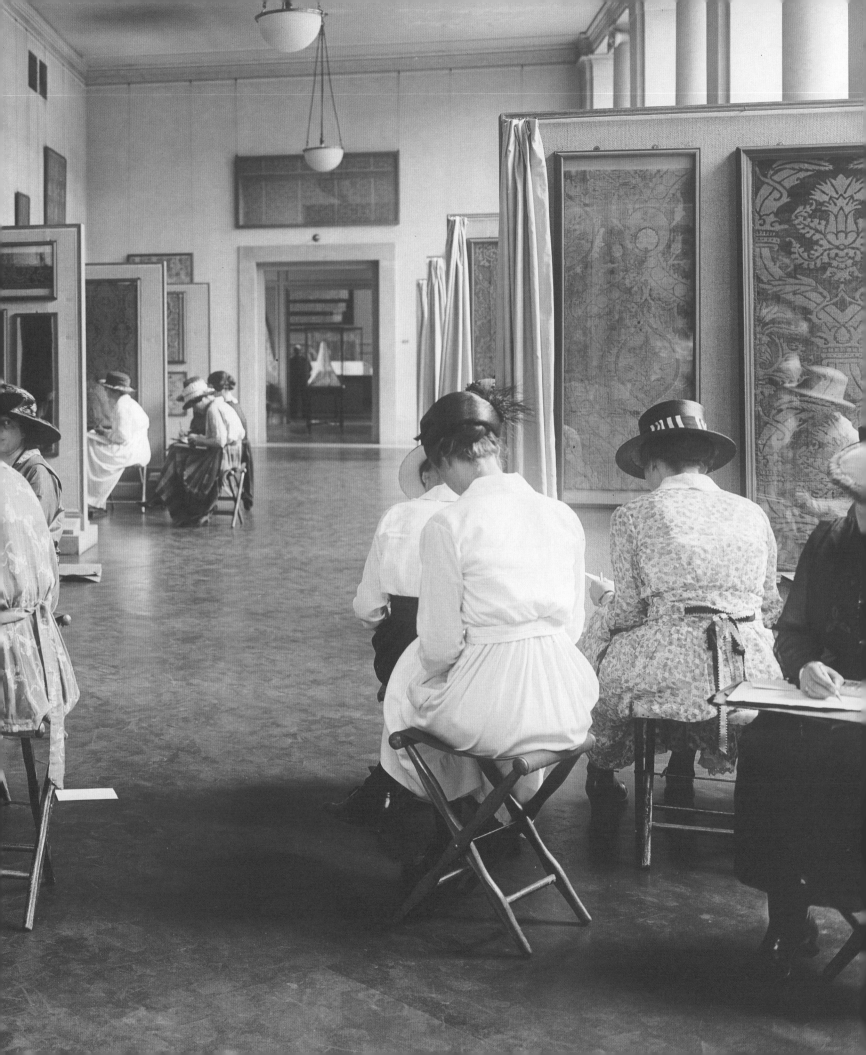

Art for All

Amelia Peck and Freyda Spira

The year 1905 opened an entirely new era at the Metropolitan Museum. After the unexpected death of first director Luigi Palma di Cesnola in November 1904, it became obvious that the institution needed to change and stop functioning like a private club. Under the guidance of their recently elected president J. Pierpont Morgan and secretary Robert W. de Forest, the board moved quickly to find another director. Their choice was Sir Caspar Purdon Clarke, formerly director of the South Kensington Museum in London (now the Victoria and Albert Museum), which was a clear model for the young New York institution. Clarke, an experienced museum professional with expertise in Indian art and design and training as an architect, strongly believed that museums could positively influence industrial design. Soon after Clarke's arrival, trustee and well-known sculptor Daniel Chester French wrote to his brother William M. R. French, director of the Art Institute of Chicago, noting in praise, "Sir Purdon is taking hold in the right way and I am sure is going to be a popular, as well as practical, success. He has recently arranged so that any one shall be permitted, at any time, to take notes or make sketches from any object owned by the museum."[1] This move to provide greater access was clearly something new; while there was an agreement in 1877 with Tiffany and Company to work directly with the Museum's objects in order to copy and sell reproductions of jewelry in the collection (figs. 39, 40), the idea of opening

the collection for all to work with, and be inspired by, was a product of the new administration.

Morgan and de Forest outlined a fresh agenda for the Museum in an annual report published in 1905.[2] After announcing the new director, the authors recommended the creation of several additional departments, each headed by "a curator thoroughly equipped by knowledge and experience for his specialty and capable of leadership not only in arranging and cataloguing his department, but in enlarging it and utilizing its educational possibilities."[3] They then bemoaned the state of the collections, which had "not been systematically developed under any comprehensive plan. In some departments it is lamentably deficient; in others perhaps abnormally extended; in many inadequately represented."[4] While acknowledging that this imbalance was caused by the Museum's primary reliance upon gifts to build its collection in its early years, they noted that the resources provided by the 1901 bequest of the Jacob S. Rogers Fund (of more than $5 million with which to "purchase rare and desirable art objects and books for the library") would allow for the implementation of a considered plan for acquisitions "according to a comprehensive scientific plan." Morgan and de Forest then clarified that "it will be the aim of the Trustees not merely to assemble beautiful objects and display them harmoniously, still less to amass a collection of unrelated curios, but to group together the masterpieces of

different countries and times in such relation and sequence as to illustrate the history of art in the broadest sense, to make plain its teaching and to inspire and direct its national development." Having set out the ideal of building a truly encyclopedic museum, the authors reiterated that the institution's original educational mission "was not merely that of 'establishing' a great collection of art objects but 'of encouraging and developing the study of [the] fine arts, and the application of arts to manufacture and practical life.'"[5]

The trustees swiftly took steps to achieve the goals of displaying objects for the public's delight and creating study collections to inspire designers, craftspeople, and students.

By the end of 1906 three additional departments—Egyptian Art, Arms and Armor, and Metalwork—had been established and the curatorial staff had grown substantially. Notably, two women are listed as "assistants": Frances Morris and Gisela M. A. Richter.[6] These two women would change the face of the Museum. Richter rose to become the head of the Department of Greek and Roman Art, while "Miss Morris," as she was always known, would curate both the musical instruments and textile collections. As the institution continued to expand, the contributions of pioneering curators, such as Morris, and later William M. Ivins Jr., who built the prints, drawings, and photographs collection, would play a fundamental role in upholding the dual goals set out in 1905.

Frances Morris, First Curator of Musical Instruments and Textiles

By 1906, when she was given the professional designation of "assistant," Frances Morris had already been cataloguing and arranging the displays of the Museum's musical instruments collection for the previous ten years. That she came to museum work at all seems to be a matter of chance at the start, rather than passion. Details about her early life and education are limited, though it is unlikely that she received a college education. While her parents, Abraham Caulkins Morris and Catherine Ann Salisbury Morris, were both from upstate New York, by 1860 they were living in New York City, where Abraham worked as a clerk. He died in 1879 when Frances was only thirteen years old. Before coming to the Museum (and indeed for a time afterward), she worked as a secretary for Rev. Dr. Charles Parkhurst, a crusading Presbyterian minister who is credited with bringing down New York City's politically corrupt Tammany Hall.[7] Through her connection to Parkhurst, she met Mary Elizabeth Adams Brown, an insatiable collector of musical instruments from around the world, and the daughter and mother of Presbyterian ministers herself. Brown came to collecting musical instruments later in life when what started as a project in 1884–85 to decorate her music room became a lifelong passion.[8] She began to collect in earnest in 1885, after visiting the installation of European musical instruments put together specifically for the Museum by banker and philanthropist Joseph W. Drexel.[9] Three years later she and her son William Adams Brown wrote an

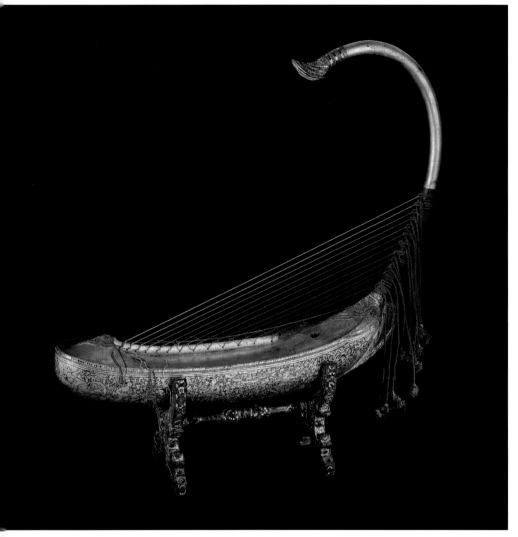

41. *Saùng-gauk.* Burmese (Myanmar),
19th century. Wood, deerskin, paint,
cotton cord, metal, glass. The Crosby
Brown Collection of Musical Instruments,
1889

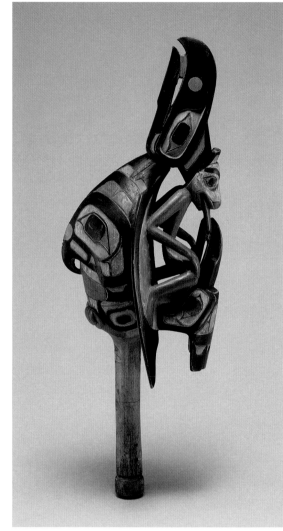

42. Raven rattle. Native American,
Tsimshian, Skidegate, British Columbia,
Canada, 19th century. Cedar, pebbles,
paint. The Crosby Brown Collection of
Musical Instruments, 1889

illustrated catalogue of her 276 instruments. Mrs. Brown took a holistic worldwide approach to collecting, and her collection was particularly rich in non-Western instruments, many of which she acquired through a far-flung network of missionaries, business associates of her husband, explorers, and dealers. The cover of the 1888 catalogue was adorned with a *saùng-gauk*, a type of Burmese harp like the one illustrated above (fig. 41).[10] In 1889 she sent the Metropolitan Museum a copy of the book and offered to donate her collection. But there was a highly unusual caveat: she stipulated that she and her son reserved the right over her lifetime to remain in control of the collection, adding or withdrawing instruments as they saw fit. The trustees accepted the gift and her conditions; by the time of her death in 1918, the collection had grown to about 3,600 objects.

In 1896 Morris began working at the Museum one day a week cataloguing the Crosby Brown Collection (named in honor of Brown's husband, John Crosby Brown), being paid on an hourly basis for her services. By 1898 two galleries had been set aside for the collection, which had already swelled to 1,200 objects, and Morris now was working two days a week to catalogue them and create their displays.[11] There is no evidence that she worked at the museum full-time (Monday through Saturday) until 1905, when she was offered her own office (in the attic) and a fixed yearly salary.[12]

While it is unknown whether she had any formal training in music, from her first day at the Museum, Morris was responsible for curatorial functions related to the collection of musical instruments except for acquiring new objects, which was Brown's role. Thanks to the family's financial

support, a set of "preliminary" catalogues was published between 1901 and 1907. The Browns actively participated in the research for and proofreading of these books. Though uncredited, Morris also clearly provided research and was certainly responsible for compiling and writing all the text. It was not until 1914 that Morris published a catalogue of part of the collection under her own name. Her scholarly *Catalogue of the Musical Instruments of Oceanica [sic] and America*, which included such stars as the Native American raven rattle (fig. 42), was presented as volume two in what she hoped would eventually be a series of four catalogues; unfortunately, Morris never found the time to write the other three volumes.[13]

Brown's intentions in collecting were clear, as relayed in the introduction of the 1901 catalogue: "In the choice of individual specimens the educational purpose has been paramount. Though containing many examples of rare artistic merit, no instrument has been chosen for its beauty alone, nor has historical association been a determining consideration. In each case the specimen has won its right to a place because illustrating some step in the development of music."[14] Following the nineteenth-century mania for taxonomy and the precise ordering of all things, Morris created displays planned with exacting scientific methodology, arranging the "specimens" according to their geographic origin, in order "to trace the development of the several distinct types of musical instrument from the first rude beginnings to the finished forms now in use, and . . . to illustrate the varying forms assumed by these types under the influence of the different civilizations" (fig. 43).[15]

Brown actively collected for the Museum until about 1905; after this, her involvement slowed. On June 4, 1906, she sent a letter to the Museum's assistant director Edward Robinson, in which she stated that most of the cataloguing work on the musical instruments collection had been completed and proposed an additional job for Morris in the care of the Museum's growing lace collection: "Under the circumstances, I venture to suggest that Miss Morris should continue to have the care of the laces, as she is so familiar with it."[16] Yet, why would a curator who had worked on musical instruments for ten years suddenly take over the collection of lace? Again, it's not known if Morris had any previous expertise with lace, but she made it another of her specialties (fig. 44).[17] She went on to become a founding member of the Needle and Bobbin Club (extant 1916–89), a group of ladies who originally focused primarily on lace study, and with Marian Hague, she wrote one of the most important early books on lace, *Antique Laces of the American Collectors* (1920–26). In that work, her essay "The Development of Lace Collecting in America" is invaluable to our understanding of how lace once held pride of place among wealthy women collectors, since it is now a somewhat overlooked textile subject. Morris noted that at around the time of the 1876 Philadelphia Centennial Exposition, where a plethora of machine-made textiles were viewed as a sign of American progress and prosperity, some people began to seek out "works of art and rich fabrics woven by the patient craftsmen of earlier days that could not be produced by mechanical means."[18]

The Metropolitan Museum soon benefited from this trend; in 1877 the MacCallum Collection of lace, a group of about three hundred pieces, was exhibited at the Museum's premises at the Douglas Mansion at Fourteenth Street. Two years later Anna Clinch Cook, the daughter of a wealthy businessman and an active participant with her husband in the New York art scene, anonymously purchased that collection for the Museum.[19] This set off a rash of lace collecting and donating; indeed, if one reviews the textile acquisitions between 1879 and 1906, the vast majority are gifts of lace, donated by important female members of New York society, such as Mrs. John Jacob Astor in 1886. In 1906 Morris worked with a hired consultant, Stephanie Kubasek, a renowned lace

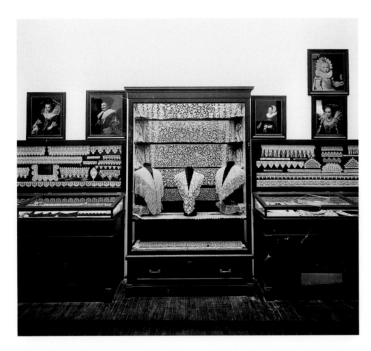

45. "The Lace Room," March 29, 1907

46. Voided velvet. Italian (possibly Genoa), second half 17th century. Silk and metal-wrapped thread. Rogers Fund, 1909

expert from Vienna, to create a display of this popular collection of then more than one thousand pieces in just six short weeks (fig. 45). True to form, the lace was arranged to facilitate easy study, a fact highlighted in a review: "An examination of the many hundred valuable pieces of lace will not only furnish delight to the casual visitor, but stimulate and gratify an interest in lace history in the student. The laces are arranged in chronological order, showing the development and growth of lace manufacture."[20]

From the mid-nineteenth through most of the twentieth century, the United States was one of the largest textile producers in the world. By the early part of the twentieth century more than forty percent of ready-to-wear clothing was made in New York. The garment business was the city's largest industry by far; at one time, nearly a third of the adult workforce, most of whom were recent immigrants, toiled in the garment trade. But for all the capital that was invested and reaped from that industry, American textile and fashion designers and producers traditionally looked abroad for their ideas, and often simply copied what was fashionable in Europe, especially France. Even if someone

in the trade in the United States was interested in researching textile design, there simply was no one place to see a multitude of examples.

From laces, it was a short leap for Morris to be put in charge of all the textiles in the Museum by the end of 1906.[21] While the collection was rich in lace, it needed to be enlarged to be truly useful as a resource for research.[22] In 1909 money from the Rogers Fund was used to acquire the collection of Friedrich Fischbach, a German textile historian and design professor who had gathered 3,797 textiles of "Peruvian, Coptic, European, and Oriental" origin, ranging in date from the sixth to the nineteenth century, specifically for study purposes (fig. 46).[23] The purchase was announced in the February 1909 *Bulletin*: "With this accession, our collection of textiles has attained a development quite equal to that of our laces; and it is hoped that it will prove of great value to students of the arts and crafts."[24]

A memo dated May 11, 1910, headed "Department of Textiles," and undoubtedly written by Morris, outlined her plans for storage, a study room, and three adjoining galleries to house all the 8,700 objects now under her care:

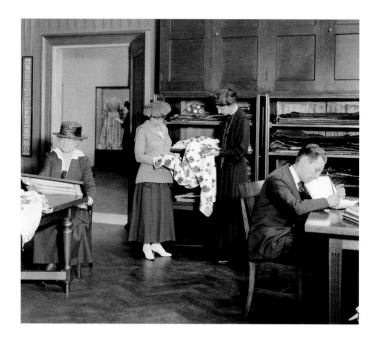

approximately 5,200 textiles, 3,000 pieces of lace, and 500 embroideries.[25] The Textile Study Room opened in October 1910 in the basement of the new Decorative Arts Wing (fig. 47). Its usefulness was lauded in a newspaper article: "The textile collection at the Metropolitan Museum of Art, newly arranged, has in the last few days been visited by many designers seeking inspiration from fabrics to be seen there, old and new. . . . The museum has at the service of manufacturers and artisans a special study room, where duplicate specimens of textiles and small pieces may be handled."[26]

Morris was finally promoted to assistant curator after the opening of the Textile Study Room and newly designed and installed textile galleries (fig. 48; see also pp. 48–49). Ever tireless, she continued to catalogue and arrange the collection of musical instruments, which had swelled to fill five galleries by 1903, while at the same time acquiring a wide variety of textiles, always seeking to enlarge the scope of objects available for display and study. Decades before the Costume Institute was established in 1946, the Museum received the Maria P. James bequest in 1910, which included dresses, accessories, toys, furniture, and porcelain that had been owned by one of New York's founding families, the Ludlows. The 244 costumes and dress accessories ranged in date from the mid-eighteenth to the early nineteenth century. A *Bulletin* article on this collection of "fashion and textile fabrics as applied to dress" stated that it was hoped that

"[s]uch a collection would prove a boon not only to artists but to artisans as well."[27] Other landmark acquisitions of dress made during Morris's time overseeing the textile collection include an exquisite Japanese Noh costume (fig. 49), an extraordinary medieval English embroidered velvet chasuble (fig. 50),[28] and an ancient Peruvian tunic presented as a gift from collector and trustee George D. Pratt (fig. 51).

During her thirty-three-year tenure, Morris worked on several exhibitions and published numerous articles, including fifty-five for the *Bulletin* alone, and at least five catalogues. One of the most charming objects in the Museum's textile collection, an Indian painted and resist-dyed chair seat for the European market (fig. 52), was originally owned by Morris herself, acquired undoubtedly for inclusion in her landmark 1927 exhibition *Painted and Printed Fabrics* that featured textiles from all around the world.[29] In this show, under the heading of "Contemporary Prints," Morris included works by such design luminaries as William Morris (fig. 53) and Raoul Dufy. She also published an important book on the subject of the exhibition, cowritten with French textile expert Henri Clouzot; her section was entitled "Notes on the History of Cotton Printing, Especially in England and America."[30]

After the success of her 1927 exhibition, Morris may have felt that a change in title was overdue (she had been promoted to associate curator only in 1922), and in April 1929, after receiving an attractive job offer at a gallery, she

49. Noh costume (*Karaori*) with cherry
blossoms and fretwork. Japanese, Edo
period (1615–1868), first half 18th century.
Silk, brocaded twill. Rogers Fund, 1919

57

50. Chasuble (*Opus Anglicanum*). English,
ca. 1330–50. Silk velvet embroidered with
silver, silver-gilt, and colored silk threads, with
pearls. Fletcher Fund, 1927

51. Tunic with confronting catfish. Nasca-Wari (Peru), 800–850. Camelid hair, tapestry-weave. Gift of George D. Pratt, 1929

52. Chair-seat cover. Indian for the European market, 1725–50. Cotton, painted resist and mordant, dyed, with overpainting. Rogers Fund, 1927

53. William Morris (British). *Strawberry Thief*, design registered 1883, printed 1917–23. Cotton, indigo discharged and block-printed. Purchase, Edward C. Moore Jr. Gift, 1923

asked to be promoted to full curator.[31] Although her colleague Gisela Richter had been given the title of curator in 1925, Morris's request was denied.[32] In an impassioned letter of a month later, she presented her case for at least receiving a salary increase: "For thirty-three years I have served the Museum in two widely divergent fields: textile fabrics and musical instruments; subjects in which the public is increasingly interested. During this period I have spared no efforts in developing the collections placed in my care, and have endeavored in every way to carry forward the desired educational policy of the Museum." She also requested help with routine office work and occasional leaves of absences for study abroad. If the Museum wouldn't grant these conditions, she asked that "some arrangement be made whereby I might be allowed to devote my entire time to the necessary reorganization of the Crosby Brown Collection and the completion of its catalogue." She ended the letter by threatening to "sever a connection of so many years standing" if her conditions were not met.[33] On June 6, Joseph Breck, Morris's boss as curator of decorative arts and at that moment acting director, reported to the executive committee of the board of trustees that director Edward Robinson had decided that Morris's salary could be increased to the maximum compensation for an associate curator, but that she was not to be given a promotion, extra office help, or sabbaticals.[34] Morris was understandably unhappy with these terms, and when her friend Anna Barnes Bliss invited her on "an extended trip through the Far East" two months later, Morris resigned her position.[35]

That Morris actually followed through on her resignation seemed to shock the men in power and was certainly a source of distress to Breck, with whom she was quite friendly.[36] Even the Museum's president Robert de Forest was concerned. He wrote to Breck that he would receive her resignation, but that after she returned from her trip, he did not "want to foreclose the opportunity of her returning in some capacity. . . . She has been faithful to the Museum for many years. She has close relations with people whose interest in the Museum it is desirable to retain and increase."[37] However, despite her talent and her useful connections, Morris never returned to work at the Museum.

Morris left the textile collection in the capable hands of Frances Little, who oversaw it from 1929 to 1942, and other women curators followed after her. Textiles remain a treasured part of the decorative arts collection, and today number about 33,000 examples. The functions of the original study room are now overseen by the Museum's Antonio Ratti Textile Center, where objects are still available for study by members of the public.

The musical instruments collection did not originally share such a happy fate; soon after Morris's departure, Breck wrote to de Forest, "For the ninety-ninth time I have been studying the Crosby Brown Collection, in the hope of finding some way of bringing this collection into line with modern methods of exhibition and with the scope of our collections as now defined. Frankly, the problem seems to me hopeless."[38] Breck thought the collection was more scientific than artistic, and suggested that it be given back to William Adams Brown (both his parents were deceased by this point) in order for him to donate the collection to a science museum. With the Brown family's permission, throughout the 1930s the trustees pursued giving the collection jointly to the Juilliard School of Music and the New York Public Library, but no plan to deaccession it was successful due to lack of funds on the part of the proposed recipients. By 1933 the galleries had been closed to the public as the Museum looked for ways to dispose of the collection, and they were essentially used as storerooms for the instruments until the arrival in 1941 of curator Emanuel Winternitz, a professionally trained expert in musical instruments who led the department for more than thirty years and returned the collection to the prominence it holds today.

Even after her resignation, Morris remained active in the textile field, holding leadership positions in the Needle and Bobbin Club until her death in 1955. She served as an "advisor of textiles and needlework" to the Brooklyn Museum in the early 1930s. In 1938 she was contacted by Anna Bliss's daughter Mildred, who with her husband (who was also her step-brother) Robert Woods Bliss owned Dumbarton Oaks in Washington, D.C., which they were in the process of transferring over to Harvard University as a research center. Morris was hired to catalogue their textile collection and advise on potential textile purchases, a project she worked on until 1941, when she finally retired.[39] She had moved several years earlier from New York to Ridgefield, Connecticut, where after a fruitful and pioneering career, she died at the age of eighty-eight.

William M. Ivins Jr., Founding Curator of Prints

As early as 1882, fourteen years before Morris arrived at the Metropolitan Museum, the trustees, including Samuel P. Avery, began agitating for the creation of a print department.[40] In the next year they accepted ninety-two nineteenth-century etchings by the likes of Joseph Pennell and James McNeill Whistler given by the Museum's librarian William Loring Andrews.[41] Nevertheless, the trustees refused to establish a new department, citing financial concerns, and continued to haphazardly acquire works on paper, with many of the prints going into the library and drawings into the paintings department. It was not until 1916, following the acquisition of more than thirty-five hundred prints from the paper manufacturer Harris Brisbane Dick, who also gave a large fund for purchases, that the trustees brought in William M. Ivins Jr. to build a collection that rivaled its other departments.

Ivins was thirty-five years old when he abandoned his law career to head the newly formed department. He came from a well-established New York family; his father, William M. Ivins Sr., was a lawyer, politician, and avowed bibliophile who traveled extensively in Europe and Latin America. Ivins's mother, Emma Yard Ivins, an amateur photographer and associate of Susan B. Anthony, was herself involved in social and political causes, most notably the women's suffrage movement. Ivins studied economics and political philosophy at Harvard University, and at the behest of his father, he went on to law school at Columbia University. Like his father, Ivins had always been devoted to early printed books, but it was at Harvard, where he took courses in art history and, alongside his friend Paul J. Sachs, began collecting prints, that he developed a profound connection to works on paper, ignited by his introduction to the oeuvre of Albrecht Dürer (fig. 54).[42]

Ivins would continue to acquire works by Dürer and to ponder the artist's accomplishments and failures throughout his career. Although Ivins's collecting policy for the Museum was to "[spread] the butter thin on as much bread as possible," seeking to show variety among techniques and schools, in Dürer's case he set out to acquire a comprehensive collection of the artist's engravings and woodcuts.[43] In 1919 Ivins successfully negotiated Junius Spencer Morgan's gift of his remarkable and nearly comprehensive Dürer woodcut collection and the purchase of his Dürer engravings.[44]

Ivins believed that prints "throw open to their student with the most complete abandon the whole gamut of human life and endeavor, from the most ephemeral of courtesies to the loftiest pictorial presentations of man's spiritual aspirations."[45] Mindful of the central role of works on paper in the history of humankind, Ivins sought to create a collection, an exhibition program, and a department that upheld the educational mission of the Museum. In order to achieve this goal, he especially promoted the importance of the study room. In the first short essay he wrote for the *Bulletin*, he noted:

> other departments of the Museum have constantly on exhibition a very large portion of the objects under their care. In the print department this cannot be so . . . In order that the collection may serve its purpose, therefore, the departmental study room will be the place to

which most persons not merely casually looking at prints will have to come. It is my intention and very earnest hope that many people shall come to that study room, where it will be my very great pleasure and constant endeavor to serve them in their aesthetic diversion and to aid and cheer them in their researches.[46]

He also understood that the department's curatorial role was "to emphasize the human aspect of the material with which it dealt and the various uses and purposes not only to which it has been put in the past, but to which they may be applied to the present moment."[47]

In 1917 the so-called Department of Prints (which also included other works on paper) opened its doors to the public in three galleries on the second floor; its basement quarters included a small office for Ivins and his staff, a study room (fig. 55), and a room to hold its ever-growing collection.[48] Ivins's tremendous success was recognized in 1931 by the *New York Times* journalist Elisabeth Luther Cary, who

wrote that to see the best modern art in the city, one should head to the Metropolitan Museum, not upstairs in the galleries, but "[d]ownstairs is where you want to go. They are in cases in the Print Department. There is no red tape. Ask for what you want, and when you are through with it you may compare [the modern work] with some of its forerunners, if you like. And you will like! Believe it."[49] One could request to see John Sloan's contemporary etchings of New York's tenements and contrast them with the colorful lithographs of Edouard Vuillard's Parisian interiors (fig. 56), or dig into the hypnotic eighteenth-century spaces of Giovanni Battista Piranesi.

Prints and drawings are, as noted by Ivins, "the only form of original pictorial art with which the greater public ever comes into intimate contact."[50] The type of close and sustained looking that was possible with works that one could hold in one's hands was essential to Ivins. His oft repeated philosophy, "What can be shown cannot be said," is taken from Ludwig Wittgenstein's 1921 *Tractatus*

Logico-Philosophicus.[51] However much he read and wrote, Ivins spent even more time looking intently—experiencing the work of art. The importance of the act of looking is reflected in the organization of his department around a study room and goes to the heart of what Ivins envisioned as the principal educational mission of museums—showing and not telling.

With the department's opening, the trustees published their own vision for its collection in the *Bulletin*. It was to encompass works by both old masters and nineteenth-century artists and to exclude the kinds of objects that were being actively collected by libraries, athenaeums, and archives: in short, anything that appeared to be of historical rather than aesthetic interest.[52] Ivins, however, largely ignored these instructions and set out to assemble a collection suitable for a public museum "whose outstanding virtue is variety, and for a city that pursues every interest in the world."[53] He amassed many hundreds of thousands of European, American, and Mexican prints, drawings,

photographs, and illustrated books, seeking richness of content as well as of form (fig. 57). As Ivins asserted at the beginning of his tenure: "the print collection of a museum cannot be formed solely upon Yes and No answers to the question: Is it a work of art? Rather must it be, like the library of a professor of literature, composed of a corpus of prints in themselves distinctly works of art, filled out and illustrated by many prints which have only a technical

historical importance."[54] To that end, the collection he assembled includes the most beautiful, rare, and exceptional examples, lauded for their aesthetic appeal, such as Martin Schongauer's monumental *Christ Carrying the Cross* (fig. 58), as well as popular prints, posters, and trade cards that were printed in large numbers, widely circulated, and never intended to last. Collecting ephemera and popular prints was unprecedented in American museums, but Ivins recognized that these more common, more ephemeral works are storehouses of information about their time and place. The intellectual framework for his collecting practice transformed the field of prints and drawings by broadening its scope beyond the aesthetic, formal, and technical aspects and asking new questions about the function of works of art, their historical and cultural context, and their active role as both containers and purveyors of knowledge (figs. 59, 60).

Nevertheless, the taste of the day—in the form of Harris Brisbane Dick's fashionable yet predictable collection of mainly French, British, and American nineteenth-century etchings—unquestionably shaped the Museum's early collection. Ivins sought to build on Dick's gift by accumulating works by other artists and from other periods that were in vogue with American collectors; for example, he amassed a collection of the celebrated etchings of Rembrandt van Rijn, most skillfully acquired through gifts. Many of these gifts came from associates connected to his law career and his active participation in the Grolier Club, the New York society of bibliophiles. His old school friend Paul Sachs, now a businessperson and associate director of the Fogg Museum at Harvard, gave the department some of its first Mary Cassatt etchings and aquatints. Years of friendship and close collaboration led to the astounding gift of banker Felix Warburg's collection of over 230 old master prints, including his beloved Rembrandts. Another notable transformative gift was James Clark McGuire's bequest of over seven hundred fifteenth-century woodcuts. According

to Ivins, McGuire, a director at New York's Port Authority, collected these mostly anonymous works because he wanted to figure out how prints circulated in the market outside of books. During Ivins's tenure Georgiana Sargent also presented works by Honoré Daumier and Paul Gavarni, and sculptor Bessie Potter Vonnoh gave American and French posters.

In his first months at the Museum, Ivins petitioned the director for a specially designated fund and an abbreviated acquisitions process that he could exploit in addition to presenting works to the Purchasing Department, which met only six times a year.[55] Ivins recognized that he would have to act quickly and decisively to build the collection that he hoped would rival those at the British Museum, London, the Bibliothèque Nationale de France, Paris, and the Albertina Museum, Vienna, which he had carefully scrutinized. In his first year, he acquired five albums from the Sotheby's sale of the Earl of Pembroke's collection at Wilton House; the nearly 2,200 prints taken from these albums form the nucleus of the Museum's collection of Italian prints. As Ivins's protégé A. Hyatt Mayor pointed out, by acquiring

such collections Ivins "like a good lawyer, depended upon the criterion of precedent, consulting past judges of prints whose opinions had stood the test of time. . . . So, if a print had been good enough for Pierre Jean Mariette, Adam Bartsch, or the Goncourts, it was good enough for the Metropolitan Museum."[56] But Ivins also challenged conventions by negotiating early on with living artists, such as Edward Hopper and Martin Lewis. The acquisition of contemporary art was revolutionary for the Museum and demonstrated Ivins's confidence as a collector and authority as a tastemaker.

Ivins's convictions also led him to acquire and ultimately make markets for then-underappreciated artists such as Goya, whose work the American public derided as too personal and definitively not beautiful. Ivins had been exposed to Goya's works during his student days traveling in Paris and was deeply affected by the artist's visual expression of mankind's cruelty.[57] For Ivins, Goya was a fine technician, but his power came from skillfully communicating emotions, ideas, and a sense of his own time and place. In his first five years as curator, he acquired fifty-seven Goya prints in addition to an entire set of eighty Caprichos. Based on Ivins's efforts, the department has close to three hundred works on paper by Goya, making its collection one of the richest in the world.

Today the collection includes over one million three hundred thousand prints and drawings and represents the full scope of printmaking and draftsmanship in Europe and the Americas from approximately 1400 to 2020.[58] During Ivins's tenure, works usually came not in ones and twos but in the hundreds and sometimes thousands. These prints and drawings were available to be seen in the study room, on the walls of the Museum, and in the publications that flowed from the department. In all Ivins mounted nearly sixty exhibitions, touching on his favorite topics, like ornament and early woodcuts, grappling with fundamental issues concerning taste, and celebrating generous patrons. Ivins's publications were extensive and encompass influential texts such as *How Prints Look* (1943) and *Prints and Visual Communication* (1953), as well as nearly two hundred short, witty, and generously illustrated articles for the *Bulletin* on topics as disparate as the esoteric Baillie Collection of Bookplates and prints after Pieter Bruegel.[59] In these articles, which he discussed with the Museum's secretary and editor of the *Bulletin* Henry Watson Kent, Ivins concluded that "it

would be better to have only a short highly condensed paragraph or two and reproductions of as many of the things as possible. After all why not let the artists speak for themselves? Rather than have me palaver about them? I've come to the point of thinking that anything else is perilously close on the borders of impertinence."[60]

The Department of Drawings and Prints (as it is now known) preserves Ivins's methodology for collecting. Because of this, the Museum houses not only Michelangelo's magnificent preparatory drawing *Studies for the Libyan Sibyl* (fig. 61), which is a close study from life of a male figure seen from behind as well as an exploration of the positioning of his hands and feet, but also Domenico del Barbiere's engraving *Two Flayed Men and Their Skeletons* (fig. 62). This print likely reproduces a lost composition from a printed book on anatomy, but it demonstrates, just as the Michelangelo drawing does, that both artists were incredibly knowledgeable about the skeletal and muscular complexities of the body. Ivins built the collection and set up the department with the foresight to satisfy any conceivable interest, answer innumerable questions, foster debate, and submit to interdisciplinary inquiries. In celebrating Ivins's legacy, Mayor wrote that he created "one of the most universally useful of print collections."[61] In the print room, one could, and still can, examine Antoine Watteau's *Seated Woman Holding a Fan* (fig. 63) and be led to ask questions about the accoutrements that signify the gender and place of this woman in society. From there one can explore the over one hundred eighteenth- and nineteenth-century designs for fans acquired by Ivins in 1938, including an

63. Antoine Watteau (French). *Seated Woman Holding a Fan*, ca. 1717. Red, black, and white chalk. Gift of Ann Payne Blumenthal, 1943

anonymous French design decorated with an illusionistic collage of French Republican monetary notes, or assignats (fig. 64).[62]

Ivins wanted the museum visitor to experience works of art in the same intimate and absorbing way he experienced Goya's works as a student in Paris. As he recalled (albeit in the third person): "The lad began to live, it having for the first time been brought home to him that his eyes were there to see with."[63] This adolescent sensation of being completely transported by a work of art informed Ivins's notion of the function of the museum, which is, as he said, "distinctly and inevitably educational."[64] As assistant director from 1933 to 1939, Ivins penned an article titled "On Education in a Museum" that encapsulated his ideas about the fundamental purpose of such institutions.[65] As he described it, the Metropolitan Museum's collection is made up of works that are both art and important and vital documents in the history of thought, religion, economics,

politics, and social life. Thus, the role of the museum is not only to make the collection available to the public—in galleries and study rooms—but also to help people use the collection. For Ivins this meant providing a space in which people could open themselves up, rid themselves of preconceived notions or borrowed opinions, and see the works for themselves. He wanted visitors to understand that art resonates across generations because of our common humanity. The huge and dizzyingly diverse collection of works on paper that Ivins built was meant to be available and meaningful to all who sought it out.

Although Ivins worked against the expectations of those trustees who set out the parameters for the print department, his clear collecting methodology and his belief, shared by Frances Morris, that the collection must be available and utilized for educational purposes by the public follow closely the desires that Morgan and de Forest published in the 1905 annual report.

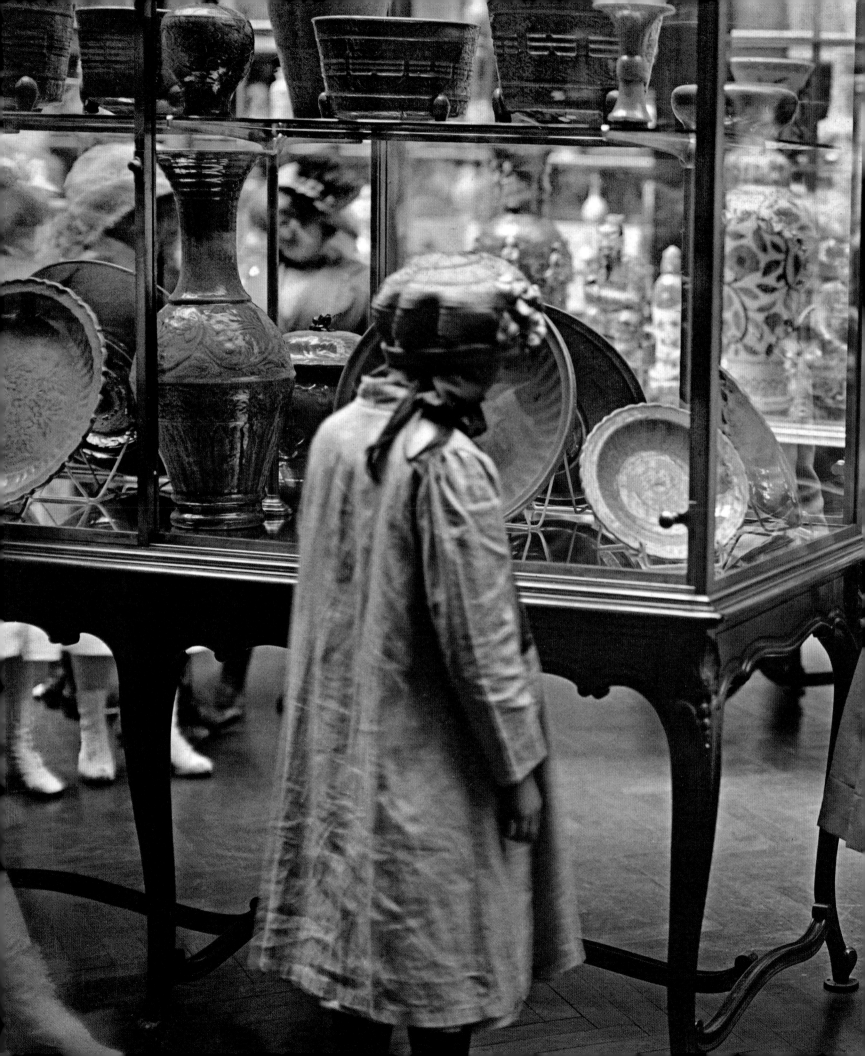

Princely Aspirations

Andrea Bayer, Barbara Drake Boehm, and Daniëlle O. Kisluk-Grosheide

When J. Pierpont Morgan died in 1913 and the contents of his will became known, New Yorkers were startled to learn that the noted financier had left the disposition of his vast art collection to his son, rather than having donated it to public institutions, especially the Metropolitan Museum, which he had served as president since 1904. As the situation evolved, newspaper articles expressed grave concern that Morgan's masterpieces would be sold to industrialist and collector Henry Clay Frick and others, and that their loss to the general public would hinder the studies of local crafts-people and artists.[1] Speculation about the state of affairs ranged widely, with the Museum receiving a fair share of blame. Some immediate consolation, however, was to be found in a temporary exhibition of a selection of the Morgan collection that opened at the Metropolitan Museum in February 1914, filling thirteen galleries with hundreds of works,[2] "ranging in size from miniatures to large tapestries" and featuring enamels, bronzes, jewelry, clocks, maiolica, porcelain, glass, furniture, ivories, sculptures, and more (fig. 65).[3] The impact was staggering. As one reviewer noted, "In spite of all that has been said and written of Mr. Morgan

as an art collector, the public will find itself unprepared for the revelation of his activities afforded by the rooms now dedicated to his possessions at the Metropolitan Museum."[4] While many works did go to other private collectors and art institutions permanently (including Jean-Honoré Fragonard's famous *Progress of Love* series now at the Frick Collection), ultimately close to seven thousand exceptional objects were transferred to the Metropolitan Museum as a bequest from the family in 1917.[5] Such a gift would have been inconceivable a few short decades earlier.

At the dawn of the twentieth century, wealthy New Yorkers, Morgan chief among them, developed a passion for acquiring works of art that rivaled the example that had been set for centuries by European collectors, primarily royal and titled families. These American industrialists benefited from an economic boom, the rise of corporate trusts, and the absence of income tax (until 1913) on this side of the Atlantic. At the same time in Europe, a decline in the fortunes of nobility and an increase in inheritance taxes brought works that had long been held in private estates to the art market. The so-called Gilded Age saw the

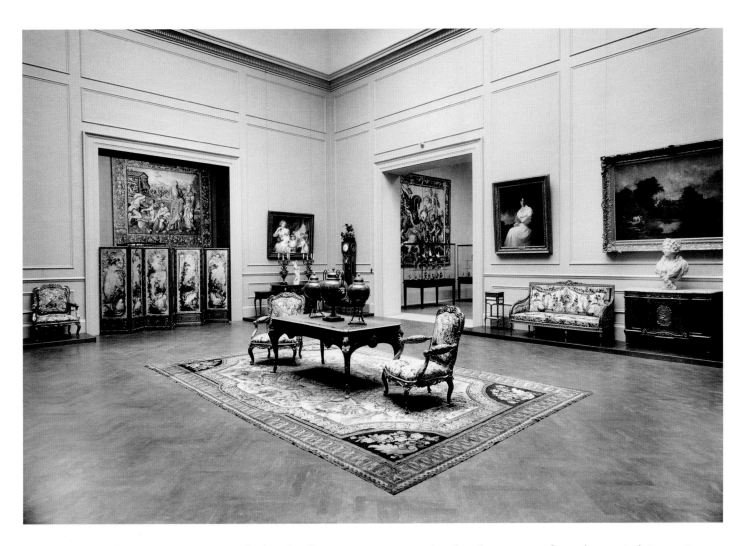

concentration of great prosperity into the hands of a privileged few. The commercial success that enabled their art-purchasing power often depended on the grueling labor of a large body of workers, many of them recent immigrants to the United States, who operated under conditions that have since been rebuked. While a legacy of cultural beneficence cannot overturn widespread social injustice, by giving large portions of their collections to public institutions, Morgan and his fellow collectors turned private passion to public good, placing great art at the center of civic life. Undeniably this explosive period of collecting in New York—and the personalities and motivations behind it—had an enduring impact on the Metropolitan Museum.

The remarkable transformation that the Museum underwent between the year of its founding and the date of the Morgan exhibition elicited considerable response, not only in the press but also in literary circles, and can be encapsulated in three quotes from that period. Surveying the recently opened institution in 1872, Henry James remarked with a degree of condescension that "it contains no first-rate example of a first-rate genius."[6] Little wonder, therefore, that James imbued his fictional character Rowland Mallet with the conviction that it was his duty as a citizen to purchase Dutch and Italian paintings and to give them to a museum.[7] When James again assessed the city's art scene in the 1880s, he observed ambivalently, "There was money in the air, ever so much money. . . . And the money was to be for all the most exquisite things—for *all* the most exquisite except creation, which was to be off the scene altogether."[8] Finally, when merchant Benjamin Altman, owner of the eponymous New York department store, died in 1913[9] and the trustees heard of the bequest of his collection—containing such masterpieces of European painting as Rembrandt van Rijn's *The Toilet of Bathsheba*

66. Rembrandt van Rijn (Dutch). *The Toilet of Bathsheba*, 1643. Oil on wood. Bequest of Benjamin Altman, 1913

(fig. 66) and equally prized *objets d'art* from fine carpets[10] to Chinese snuff bottles[11]—one effused that the bequest placed the Museum at "the forefront of the world's treasure houses, with the Louvre and Madrid."[12] Almost overnight the Metropolitan Museum was mentioned in the same breath as European national collections founded on royal holdings that had developed over centuries. For a nascent art institution, both the speed of this metamorphosis and the emphatic shift in direction were stunning, as a somewhat random accumulation of objects evolved into a collection shaped by deeper knowledge, deeper pockets, and the increasingly cosmopolitan lifestyles and cultural ambitions of its patrons.

During his tenure as president of the Museum, Morgan was the driving force behind much of this change, as he was with almost everything he touched. With zeal and gusto, he professionalized the staff, courted donors, fostered building projects, funded excavations, and personally contributed to an exponential increase in the collections.[13] On his many voyages between New York, London, Paris, Rome, and later Egypt—especially after 1901, the year of his semiofficial retirement—Morgan undertook vast art-buying campaigns, voraciously acquiring works not only for himself but also for the Museum, on whose board he had served since 1888. Morgan's first significant move for the institution involved securing a fully developed collection of Chinese porcelains, demonstrating that he understood, from the very beginning, that Asian art was an essential component of a great museum. The Chinese porcelains had belonged to James A. Garland, vice president of the First National Bank of New

67. Vase with immortals offering the peaches of longevity. Chinese, Qing dynasty (1644–1911), Kangxi period (1662–1722). Porcelain, overglaze enamels. Bequest of Benjamin Altman, 1913

68. Peter Peck (German) and Ambrosius Gemlich (German). Double-barreled wheellock pistol made for Emperor Charles V, ca. 1540–45. Steel, gold, cherrywood, staghorn. Gift of William H. Riggs, 1913

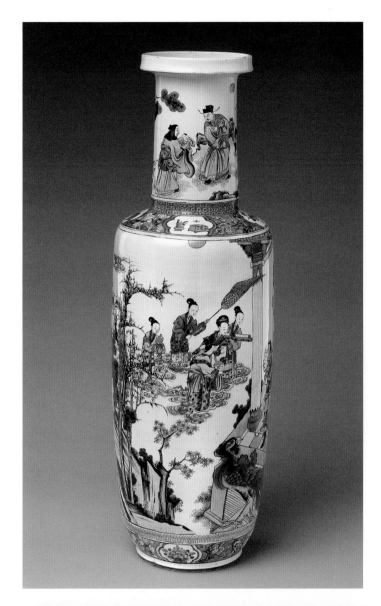

York and an investor in railroads, and were on loan to the Museum in 1900. When Garland died that year, his family sold the objects en bloc to dealer Henry Duveen, but Morgan promptly bought them all back with his own money and added to them before presenting them to the Museum.[14] In this action, Morgan followed established taste, for Asian works of art had been treasured by European aristocratic collectors since at least the Middle Ages and were already much appreciated in the United States (see "The Founding Decades"). Notably, Altman's 1914 bequest also featured a remarkable collection of over four hundred highly sought-after Chinese porcelains, mostly dating to the eighteenth and nineteenth centuries and also acquired from Duveen (fig. 67).[15]

In 1904 Morgan organized the purchase of an important armor collection from French aristocrat Maurice de Talleyrand-Périgord, duc de Dino, then set his sights on another, that of American expatriate William H. Riggs, who had assembled the finest and largest private arms and armor collection of his generation at his home in Paris. Together with Bashford Dean, a vertebrate zoologist with a passionate interest in armor, whom he appointed as a cataloguer and then curator, Morgan worked for almost a decade to convince Riggs to give his collection—which he was known occasionally to don himself—to the Museum. Finally, in 1913, on his first visit back to the United States since 1870, Riggs agreed to present the majority of his beloved collection as a gift (fig. 68), with the rest coming as a bequest in 1925.[16] Thanks to Morgan's efforts, by 1913 the Museum had exceptional pieces, ranging from prestigious European firearms to unusual Japanese (see fig. 38) and Islamic examples (see

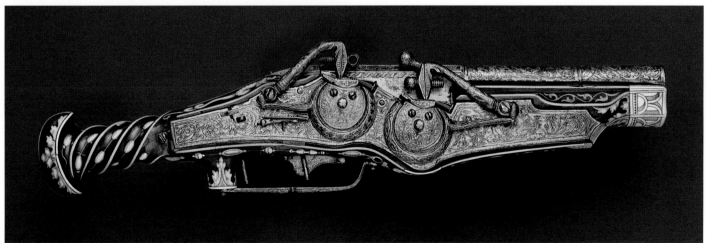

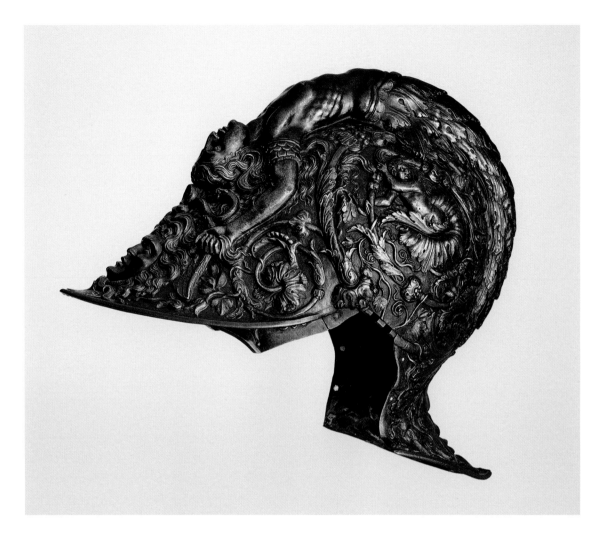

fig. 37), making the arms and armor collection one of the first to be truly global in scope. In addition, the Morgan bequest included an exquisite burgonet, or helmet, crafted by Milanese armorer Filippo Negroli in 1543 (fig. 69). The signature masterwork of one of the most celebrated armorers of all time, the helmet was forged from a single piece of steel and ornamented with *all'antica* imagery, culminating in an elegant siren arched over the comb who clasps the serpentine tendrils of Medusa's hair at the peak.[17]

Whether hunting for pieces for his own personal enjoyment or for the Museum, Morgan sought to build collections marked equally by their breadth and depth. One of his most notable acquisitions, celebrated in a *Bulletin* article of 1907, was the collection of Parisian decorator Georges Hoentschel.[18] Hoentschel had designed the international exhibitions hosted in Paris in 1900 and St. Louis in 1904 to great acclaim, and he counted the king of Greece and the emperor of Japan among his clients. Given Hoentschel's celebrity, it is hardly surprising that Morgan visited his private gallery in Paris in 1906. There Morgan found medieval art and sculpture installed on the lower level, and seventeenth- and eighteenth-century French paneling, architectural fragments, decorative paintings, and other objects arranged on the main floor in a symmetrical museum-like manner (fig. 70). The furniture included an armchair, part of a large set, commissioned in 1787 for Louis XVI's *salon des jeux* (gaming room) at the Château de Saint Cloud (fig. 71).[19] Among the elements of woodwork was a door panel thought to originate from the Tuileries Palace but now identified as coming from the Hôtel de Belle-Isle, the Paris residence of César-Gabriel de Choiseul Praslin, a military officer, ambassador, and minister of foreign affairs for Louis XV (fig. 72).[20] There were also panels for a decorative frieze from the *cabinet intérieur* at Chanteloup, the

70. Léopold Stevens (French). *Interior View of the Hoentschel Collection at 58 Boulevard Flandrin, Paris*, ca. 1903–6. Oil on canvas. Purchase, The James Parker Charitable Foundation Gift, 2019

71. Georges Jacob (French). Gilded by Louis-François Chatard (French). Armchair (*fauteuil*), 1788. Walnut, carved and gilded; gold brocaded silk (not original). Gift of J. Pierpont Morgan, 1906

72. Door from the *grand cabinet* of Hôtel de Belle-Isle, Paris. French, 18th century. Oak, carved, painted, and gilded. Gift of J. Pierpont Morgan, 1906

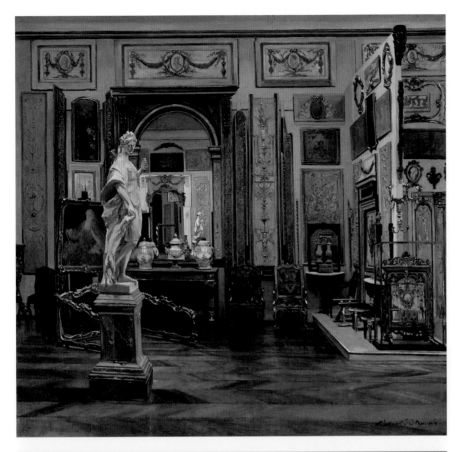

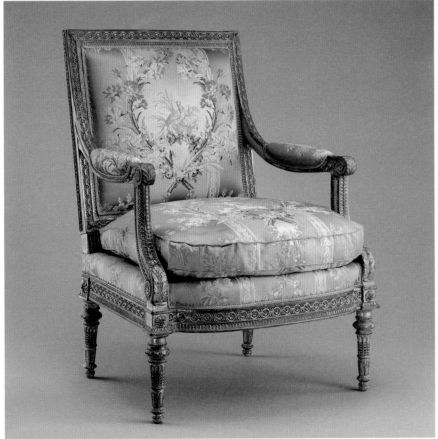

château in the Loire Valley dismantled in 1823 that had
belonged to Etienne-François, duc de Choiseul, and likewise
a foreign minister of France under Louis XV. The frieze
incorporates medallions representing esteemed sixteenth-
and seventeenth-century Italian architects and artists, such
as Andrea Palladio (fig. 73).[21] These elegant panels, distin-
guished in provenance and didactic in intent, surely impressed
Morgan, who decided on the spot to acquire nearly the
entire Hoentschel collection, with the intention of present-
ing the objects as either gifts or loans to the Museum.[22]

The scale of this endeavor was astonishing. It quickly
became clear that Morgan's combined gift and loan of
nearly three thousand artworks—packed in 364 crates and
shipped to America in twelve installments—would not fit in
the Museum's existing building even with the north exten-
sion on Fifth Avenue (Wing E) that was then under con-
struction by the architectural firm McKim, Mead and White
(see "An Edifice for Art"). Charles Follen McKim, who

famously designed Morgan's own library in New York, vis-
ited Hoentschel in Paris and returned with sketches for an
additional future wing. Constructed in record time, the new
building, subsequently known as Wing F or the Morgan
Wing, opened to the public in March 1910.

The arrival of the Hoentschel works also led to the
establishment of a decorative arts department, the first of
its kind in an American museum. At the donor's request,
the Hoentschel treasures were not to be segregated in their
own galleries but should form the nucleus of a great collec-
tion of decorative arts and be exhibited alongside compara-
ble pieces. Wilhelm R. Valentiner, previously assistant to
Wilhelm von Bode, director of Berlin's Kaiser-Friedrich-
Museum (now the Bode Museum), was named curator of
the new department in 1907.[23] He displayed the decorative
arts with sculpture in what he described as "period rooms"
that evoked the spaces for which the artworks had been
conceived, stating that his goal was to educate the American

public not familiar with "the art and culture of an extraordinarily rich past," and to offer it "an acquaintance with the outstanding examples of artistic achievement."[24] Students and copyists were also invited to work in the Morgan Wing, thus realizing the founders' mission of encouraging visitors to study the objects in the collection and apply their learning to industrial design.[25] The two principles of the Museum's collecting thus far, the search for transformative objects and the pursuit of education, coalesced with the acquisition of the Hoentschel objects, the opening of a new wing, and the appointment of Valentiner as curator.

Yet admiration for Morgan's extravagant success as a collector could be tinged with irony, as when art historian Bernard Berenson quipped that Morgan's Prince's Gate residence in London looked "like a pawnbroker's shop for Croesuses" (fig. 74). McKim even gave Morgan the sobriquet "Lorenzo the Magnificent," after the Florentine Renaissance ruler and collector whose power and self-styled image derived from the family's control of European banking.[26] In a cartoon published in American humor magazine *Puck* on June 21, 1911, Morgan deploys a magnet in the form of a huge dollar sign to attract European works of art across the Atlantic. In the clear-sighted eye of the cartoonist,

Morgan's purchasing power, combined with his rapacious acquisitiveness, constituted a veritable force of nature (fig. 75).[27] While the scope of his collecting could boggle the mind of visitors to his English houses (he had 350 figural groups of Meissen porcelain at one of his residences), Morgan felt his expansiveness was justified because he ultimately intended to bring together all of his holdings in the United States as a way for the American public to see "the best of historic European culture."[28] Even though Morgan relied on numerous dealers and experts for guidance, he was always very decisive about a purchase. He loved precious materials; to collect "runs" of certain kinds of objects (and when satisfied, to stop); rarity; and illustrious earlier patrons and collectors. Of this last quality, Germain Seligman, a prominent dealer in *objets d'art*, remarked, "to him, pedigree is also of importance, if for no other reason than the historical continuity which is so much a part of the aura surrounding works of art."[29] Morgan wished to bring that "aura" to the United States as well.

All the qualities that Morgan valued are found in objects that came to the Museum as part of the family's bequest. The antiquities extend from early Greek through Roman art and include consummate masterpieces. The Etruscan bronze

statuette of a young woman is representative of the excep-
tional works of Greek and Etruscan art of the eighth to
sixth century B.C. in bronze, ivory, and amber (fig. 76). Glass
was a medium developed by the Romans to a hitherto
unparalleled level of refinement, with Ennion as the most
accomplished master of mold-blown glass in the first cen-
tury. The jug, one of two signed examples bequeathed by
Morgan, is a paradigm of this art in the Museum's collection
(fig. 77). Such attributes are equally apparent in Morgan's
1906 purchases from a dealer in Paris of objects from the
Cyprus Treasure, excavated at Karavas in 1902, notably its
spectacular group of silver plates. With expert carving and
working of the precious metal surface, the artist transformed

the silver into bas-relief sculpture. The result, manifest in
the Battle of David and Goliath, is majesty worthy of the
Byzantine emperor Herakleios, during whose reign the
plates were made (fig. 78). Utterly opposite in tone are two
hooded *Mourners* created to meet princely taste of an entirely
different era. Carved from pearly alabaster about 1453, they
once stood alongside the tomb effigy of Jean, duc de Berry,
as reminders of the quiet and lonely pain of grief (fig. 79).

Morgan's love of medieval sacred art is evident in a pair
of precious book covers, in which the Crucifixion of Jesus
is twice realized in ivory—once by a Byzantine carver,[30]
once by a Spanish one (fig. 80). In each case the figures are
embedded in a golden and bejeweled frame. Purchased by

78. Plate with the Battle of David and Goliath. Byzantine, 629–30. Silver. Gift of J. Pierpont Morgan, 1917

79. Etienne Bobillet (Franco-Netherlandish) and Paul Mosselman (Franco-Netherlandish). *Mourners*, ca. 1453. Alabaster. Gift of J. Pierpont Morgan, 1917

80. Book cover(?) with ivory figures. Spanish, before 1085. Gilded silver with pseudo-filigree, glass and stone cabochons, cloisonné enamel, ivory with traces of gilding on pine support. Gift of J. Pierpont Morgan, 1917

81. Medici Porcelain Factory (Italian).
Ewer (*brocca*), ca. 1575–87. Soft-paste
porcelain. Gift of J. Pierpont Morgan, 1917

Morgan in Paris in 1906, these exceptional works also attest to medieval princely patronage, in this case that of a female ruler. The name of Queen Felicia, wife of the king of Aragon and Navarre, who jointly endowed the nunnery of Santa Cruz de la Serós in Jaca in the eleventh century, appears on the gilded-silver sheet that supports the ivory figures on the version illustrated here. Later precious European objects from Morgan include the first securely identifiable porcelain created in Europe, produced at the court of Francesco I de' Medici in Florence (fig. 81), and a celestial globe with clockwork, made by Gerhard Emmoser in 1579 (fig. 82). Supported by the figure of Pegasus, the silver globe rotated to chart the constellations, a feat of both mechanical technology and aesthetic achievement. Holy Roman Emperor Rudolf II displayed the clock in his celebrated curiosity cabinet in Prague, from whence the armies of Christina, queen of Sweden, forcibly appropriated it during the Thirty Years War.[31]

Because of the dispersal of parts of his holdings, Morgan had less impact than he might have had on the development of the Museum's paintings collections. There are several major exceptions, above all Raphael's grand early altarpiece *Madonna and Child Enthroned with Saints*,[32] which made such a sensation when Morgan purchased it in 1901.[33] But the strategies of various other New York collectors active in the same years more than filled the gap. Henry G. Marquand, one of the Museum's early trustees and its second president, gave a group of fifty European paintings between 1889 and 1891 (his gifts of decorative arts and funds were also of enormous importance to the fledgling institution; see "The Founding Decades"). The *New York Times* wrote that Marquand "felt an absorbing personal pride in the result of his art researches," and stated in no uncertain terms that "the collection represents the outlay of a princely fortune and contains many gems."[34] Marquand, who in 1880 shifted his focus from his banking and railroad interests to the acquisition of art, was sent to Corsham Court in Wiltshire, England, in 1886 to see the collection of the Methuen family in order to assess the appropriateness of a group of their paintings for the Museum. Marquand particularly desired to see their famous Anthony van Dyck portrait of James Stuart,[35] which he bought and later gave to the Museum in 1889, along with a Renaissance portrait that was then attributed to the Florentine artist Masaccio. Study soon revealed that Fra Filippo Lippi had painted the panel, now titled *Portrait of a Woman with a Man at a Casement*,[36] and it is recognized as one of the most innovative portraits of the fifteenth century. In 1887 Marquand made his most unexpected and noteworthy purchase (for a very low price, and perhaps without even knowing anything about the artist), Vermeer's *Young Woman with a Water Pitcher*;[37] it was the first work by that painter to arrive in the United States.[38]

The quality of those works, which Wilhelm von Bode said "would be a treasure to every gallery on the continent," set the scene for other gifts of the same order.[39] Was it because of the city's early Dutch heritage that New York collectors shared a love of Dutch paintings of the seventeenth century? Notably, half of the groundbreaking 1909 *Hudson-Fulton Exhibition* was given over to Dutch paintings, with the other half dedicated to American decorative arts (see fig. 126). Benjamin Altman, who at the last moment allowed six of his paintings to be part of the exhibition, bought thirteen paintings he considered to be by Rembrandt over

the course of his lifetime, including the haunting *Toilet of Bathsheba* (see fig. 66).[40] That unique painting has always stood out among the many portraits and single figure studies by the artist that otherwise dominate the Museum's collection. Another painting that appeared in the 1909 exhibition was Vermeer's *Young Woman with a Lute* (fig. 83), which had been purchased by railroad magnate Collis P. Huntington and was lent by his widow, Arabella; it eventually came to the Museum as part of Huntington's bequest, as finalized by his son, Archer Milton Huntington, in 1925. A contemporary review of the *Hudson-Fulton Exhibition* by

critic Kenyon Cox offers a sense of the excitement experienced by the public, hitherto unaccustomed to seeing such works in New York and reacting to Vermeer's new place in the hierarchy of collecting: "It is this picture, without provenance and without history, until now uncatalogued and undescribed, which is that pearl of price, a perfect work in perfect condition of the most perfect painter that ever lived."[41]

In the early twentieth century, American collectors were drawn as well to British portraiture of the eighteenth century, perhaps because as art historian Cynthia Saltzman argued, "English portraits furnished Americans with

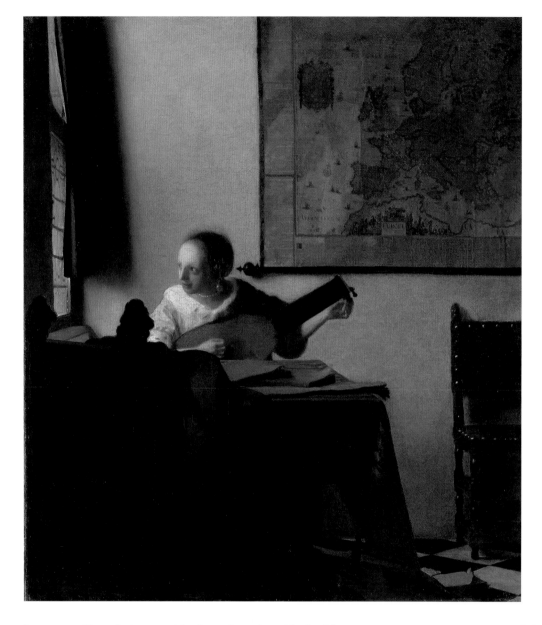

'ancestors,' but their appeal had much to do with the life they portrayed and the virtuosity and bravura with which they were painted. . . . Although it may seem ironic that Americans were drawn to images of England in the era of George III—the king from whom they had won independence in the Revolution a century before, by taking possession of the portraits, Americans marked a financial and cultural conquest."⁴² Among the exceptional examples that made their way to the Museum are Sir Thomas Lawrence's portrait of Elizabeth Farren (fig. 84). The painting arrived as part of the bequest of Edward S. Harkness in 1940, but it had earlier been an important fixture in Morgan's collection.

In it, Lawrence portrayed the renowned comic actress at a high point of her London career, and just before she met Edward Smith Stanley, the Earl of Derby, who became her husband in 1797. Morgan was well aware of the fame of both work and sitter, and the enticing full-length portrait is the subject of one of the most legendary anecdotes about the collector. It was reported by his son-in-law, Herbert L. Satterlee, and suggests the American's sublime confidence on the international stage, as well as his decisive, laconic personality. King Edward VII visited Morgan in 1906 at his London home at Prince's Gate, and they sat in the library where the Lawrence hung. Satterlee noted that as the king

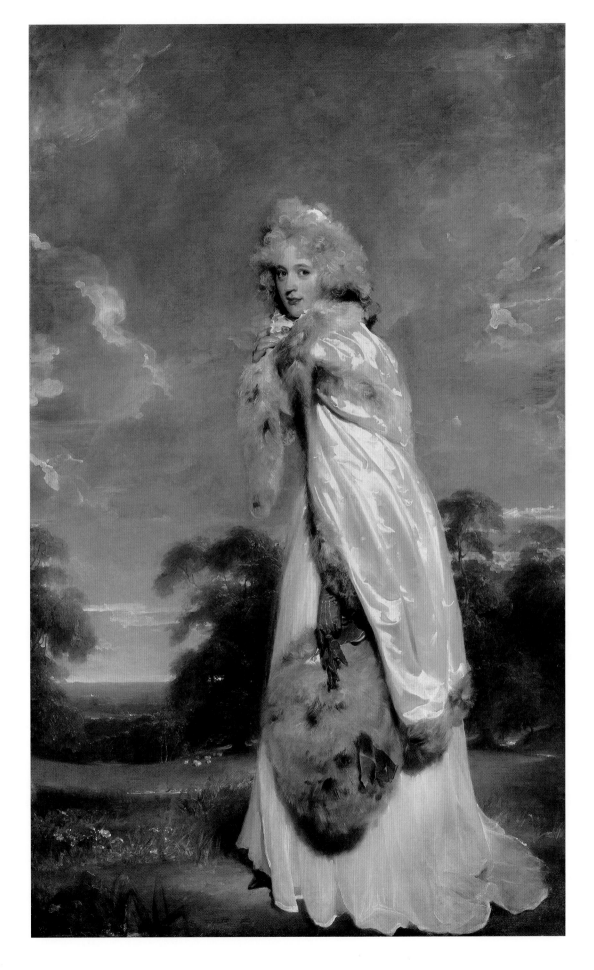

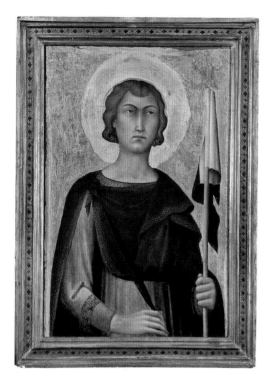

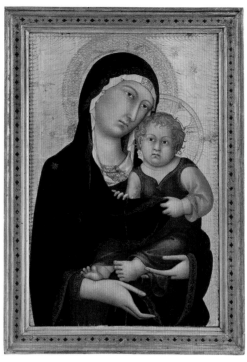

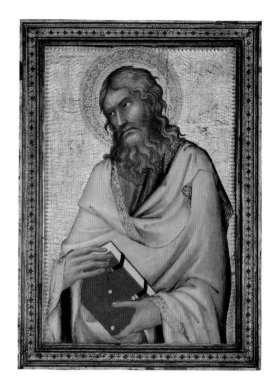

85. Simone Martini (Italian). *Saint Ansanus*, ca. 1326. Tempera on wood, gold ground. Robert Lehman Collection, 1975

86. Simone Martini (Italian). *Madonna and Child*, ca. 1326. Tempera on wood, gold ground. Robert Lehman Collection, 1975

87. Simone Martini (Italian). *Saint Andrew*, ca. 1326. Tempera on wood, gold ground. Gift of George Blumenthal, 1941

looked at the painting he observed, "'The ceiling is too low in this room for that picture. Why do you hang it there?' Mr. Morgan looked at the portrait steadily for quite a long time and then said, 'Because I like it there, sir.'"[43]

Most of the early Italian paintings from Florence, Siena, and elsewhere that make the Metropolitan Museum's collection so distinctive are associated with later gifts, but it is important to recognize the passionate collecting that brought them to New York at the start of the twentieth century. German-born banker and Museum president George Blumenthal, whose gift came to the institution in 1941, and Robert Lehman, head of the financial services firm Lehman Brothers, were actively seeking gold-ground paintings as early as 1910–15, a taste inspired in the United States largely by Bernard Berenson.[44] They traveled through Italy with American scholar-dealers, such as Frederick Mason Perkins, and sometimes competed for the same works.[45] This was the case in 1915 when several panels of a portable altarpiece by the seminal fourteenth-century Sienese artist Simone Martini emerged for sale, and after complex—and possibly not very transparent—negotiations, two were sold to Lehman (figs. 85, 86) and one to Blumenthal (fig. 87).[46] The rich patterning in the fabrics and halos, delicate rendering of the gestures, and poignant expressions of the figures

exemplify the qualities for which Martini was admired in his time and beyond. Both Blumenthal and Lehman were looking for "really first-class" examples of Sienese art, and they devoted significant time and effort to acquiring them. From these beginnings, as New York collectors joined in the hunt for works Perkins described as distinctive and rare Italian "primitives," their collections grew in size and importance.[47]

Lehman bequeathed the Metropolitan Museum some 112 Italian paintings, most of them from the fourteenth and fifteenth centuries. In total, his momentous gift contained more than 2,600 works of art, some of which had been acquired by Robert's father, Philip, one of the founders of Lehman Brothers and a notable collector in his own right. The marvelous variety in their collection—from European paintings and drawings to maiolica, glassware, frames, and illuminations—recalls that of Morgan's holdings.[48] When the bequest was announced at the Centennial Benefactors' Dinner in 1969, Arthur A. Houghton Jr., chairman of the board of trustees, expressed gratitude to the Lehman family and foundation for adding "a crown of glittering jewels to our collections."[49] A wing was built to accommodate the bequest, which opened in 1975 with a suite of rooms designed to re-create the family's sumptuous residences, inviting museumgoers to experience the art as they had.

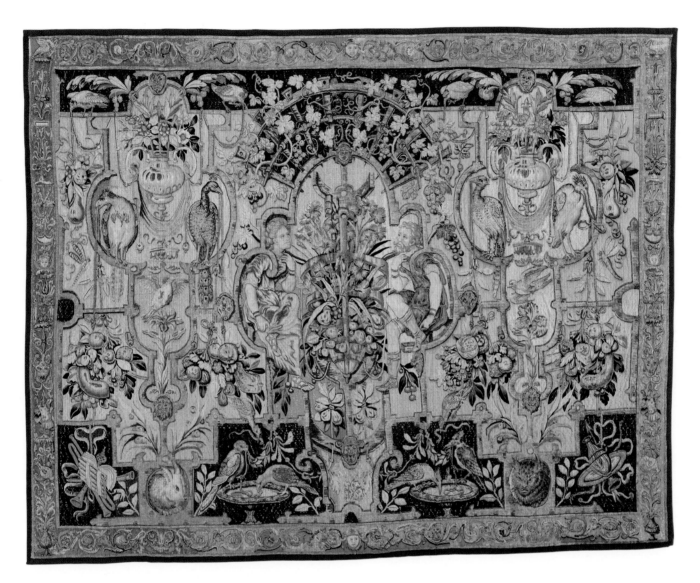

American collectors, like Morgan, Blumenthal, Philip and Robert Lehman, and others, shared a taste for what they viewed as the most elevated European art. They also all sought great objects, from tapestries (fig. 88) to more intimate pieces of glassware and ceramics (although, of course, they each had their own particular interests). These collectors and generous benefactors form a bridge to some of the Museum's most notable recent donors, who have striven to collect in the same areas and at the same high levels of quality, and whose contributions are re-making entire galleries even now (figs. 89, 90).

Standing out among their shared taste is the appreciation for portraits of distinguished figures. Just as Henry Marquand brought home and eventually presented to the Museum a great Van Dyck portrait from Corsham Court,

more than a century later, in 2019, philanthropist and trustee Jayne Wrightsman bequeathed the artist's image of Henrietta Maria, queen of England, painted for Cardinal Francesco Barberini in Rome in 1636 (fig. 91). Indeed, Jayne, along with her husband Charles, had a penchant for great portraits: over time, they donated such outstanding examples as *Antoine Laurent Lavoisier and His Wife (Marie Anne Pierrette Paulze)* by Jacques-Louis David,[50] and an exceptional self-portrait by Peter Paul Rubens with his wife Helena Fourment and their son of about 1635.[51] In 2014 Wrightsman support made possible the acquisition of Charles Le Brun's portrait of German-born banker Everhard Jabach and his family.[52] These last three are defining works of group portraiture in Europe. A gem of the Lehman Collection, Jean Auguste Dominique Ingres's portrait of Princess Pauline de Broglie

89. Mounted vase. Chinese with French mounts. Hard-paste porcelain: early 18th century; gilded-bronze mounts: ca. 1750. Gift of Mr. and Mrs. Charles Wrightsman, 1971

90. Martin Gizl (Austrian). Ewer and stand (*présentoir*), 1758. Alpine ibex horn, gold, gilded copper. Purchase, Anna-Maria and Stephen Kellen Foundation Gift, 2013

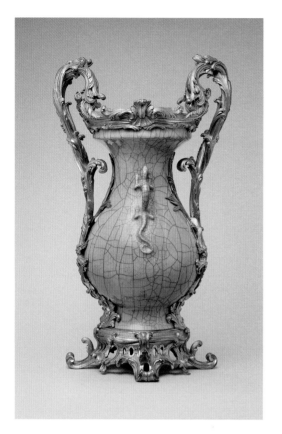

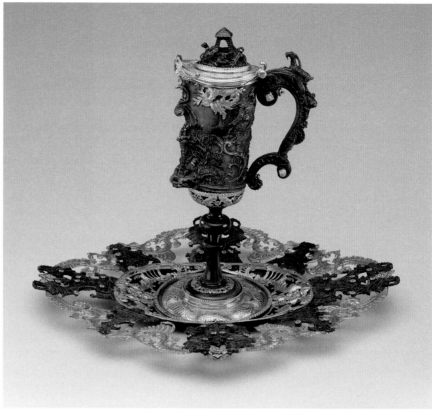

is a "delicious incarnation of nobility": painted in Paris in 1851–53, it passed through successive generations of the sitter's family until acquired, through Wildenstein & Co., by Robert Lehman in 1958 (fig. 92).[53] With its shimmering blue silk and diaphanous lace, and the princess's porcelain skin and delicate hands, the work casts a spell in the Lehman Wing. It is an unforgettable example of a sensibility attuned to the beauty of French culture, another mutual interest of these collectors.

The refined art of France's *ancien régime* was Jayne Wrightsman's real passion, evident in the Wrightsman Galleries of the Metropolitan Museum. She and her husband amassed furniture, decorative *bronzes d'ameublement* (wall lights, chandeliers, firedogs, and clocks), mounted porcelains, carpets, and snuffboxes of exceptional workmanship. Among the treasures that they initially lent and later presented to the Museum are artworks with a royal provenance, including Louis XV's red-lacquered *bureau plat*, or writing table, by Gilles Joubert (fig. 93). Those works and other exquisite gifts were intended to furnish the period rooms that the Wrightsmans helped to create and that justly bear their name.[54] Installed at the Museum, the rooms allow the

furniture and decorative arts to be seen in a fittingly evocative context and thus regain their scale and sense of purpose.

Few have expressed the enduring affinity for French art and objects more compellingly than banker Michel David-Weill: "If I am so sensitive to French taste, this is because it displays a true desire for beauty and elegance, balance, a lack of excess and respect for the painting's subject."[55] The importance of French heritage suffuses the patronage of the David-Weill family, French-American bankers whose renowned collections were plundered by the Nazis during World War II (see "Fragmented Histories"). A desk created by Emile-Jacques Ruhlmann about 1918–19 (fig. 94) for David David-Weill was designed to harmonize with the furnishing of the family's *hotel particulier* in Paris, notably a Louis XVI armchair that had belonged to David's father, an equally passionate and discerning collector.[56]

What does it mean to sit in a chair and at a desk that are not merely utilitarian, but works of art, created centuries apart and yet possessed of a complementary aesthetic? To do so is to assert, as artists and patrons have done since time immemorial, that art is central to daily existence, an integral component of the most mundane matters of business and

91. Anthony van Dyck (Flemish). *Queen Henrietta Maria*, 1636. Oil on canvas. Bequest of Mrs. Charles Wrightsman, in honor of Annette de la Renta, 2019

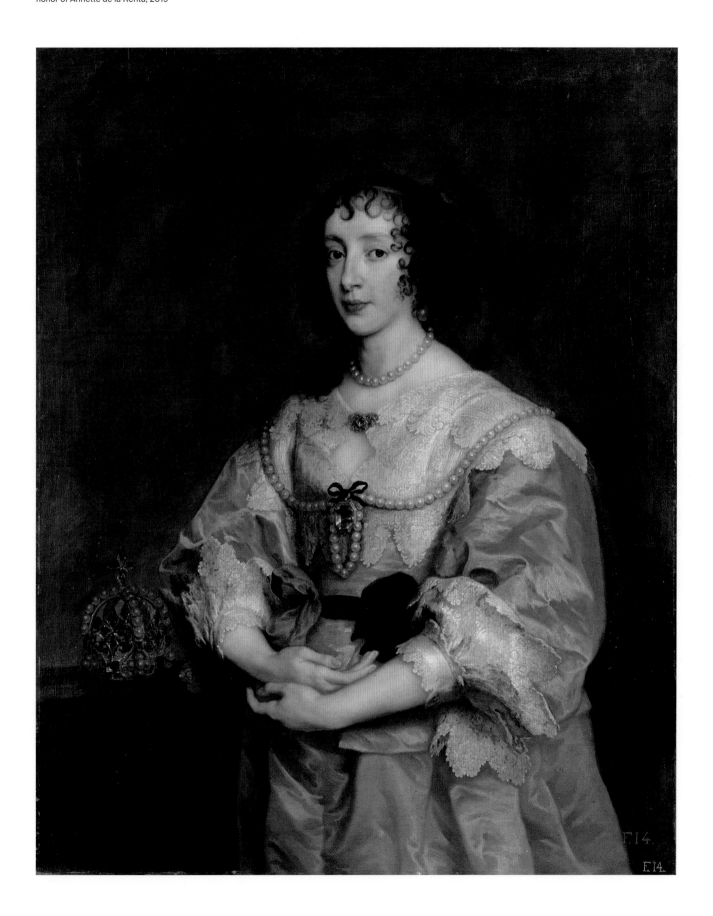

92. Jean Auguste Dominique Ingres (French).
*Joséphine-Éléonore-Marie-Pauline de Galard
de Brassac de Béarn, Princesse de Broglie,*
1851–53. Oil on canvas. Robert Lehman
Collection, 1975

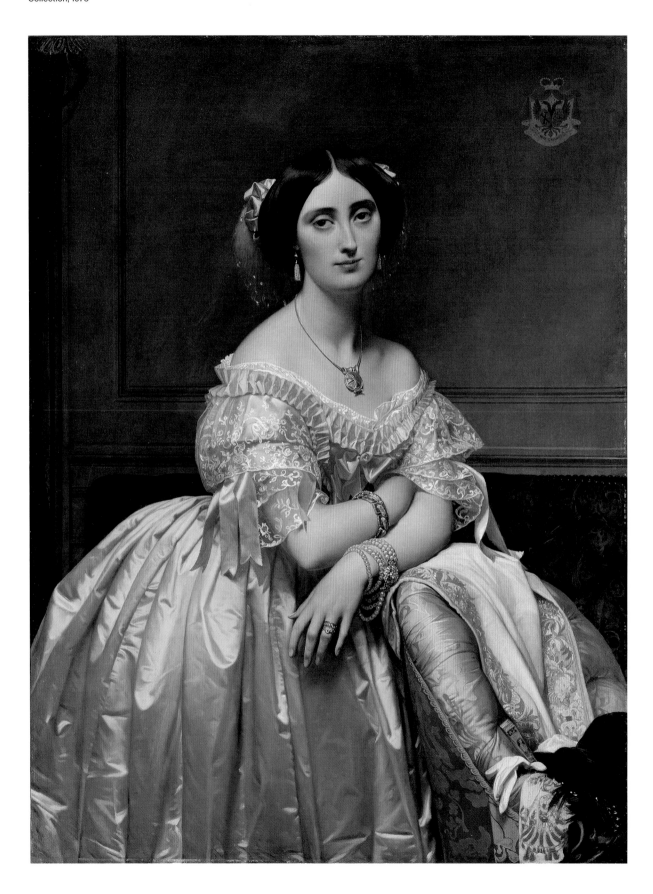

Princely Aspirations

93. Boiserie from the Hôtel de Varengeville, Paris, including Gilles Joubert's writing table, in the Wrightsman Galleries, as it looked in 2008

94. Emile-Jacques Ruhlmann (French). "David-Weill" desk, ca. 1918–19. Amboyna, ivory, sharkskin, silk, metal, oak, lumber-core plywood, poplar, walnut, birch, macassar ebony. Purchase, Edgar Kaufmann Jr. Gift, 1973

the most exalted undertakings alike. At the opening of the Metropolitan Museum's building on Fifth Avenue, trustee Joseph Hodges Choate rather crassly appealed to the "millionaires of many markets" to find personal glory in converting "pork into porcelain" and stock into "the glorified canvas of the world's masters."[57] But Choate failed to read the defining hallmarks of the collector. Whatever their desire for an enduring legacy, whatever their background, whatever their individual characters, the men and women of this story fervently believed that art was essential to their lives and, ultimately, to all of ours. In the defining moment of their giving, their collections became far more than "a story of cabinets and chairs and tables," as Henry James would have it.[58] At that moment, their princely passions and possessions, representing "the splendid accumulations of the happier few," became, instead, the collective heritage of the greater public.

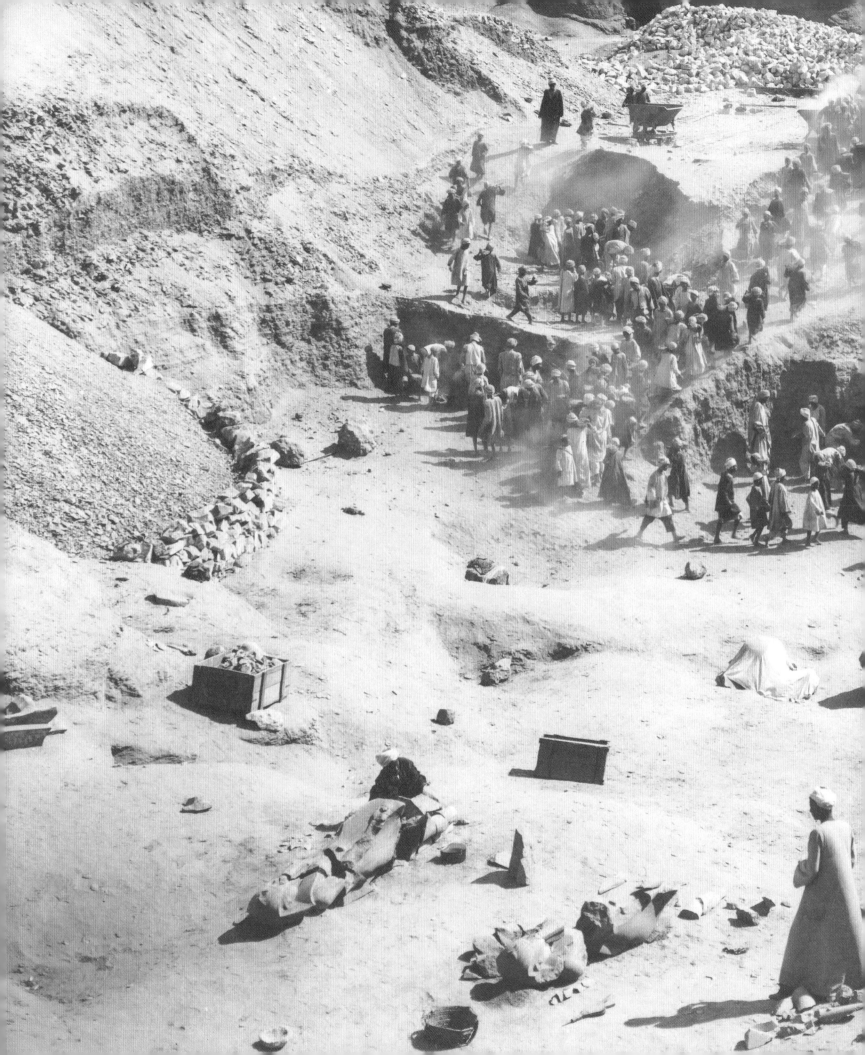

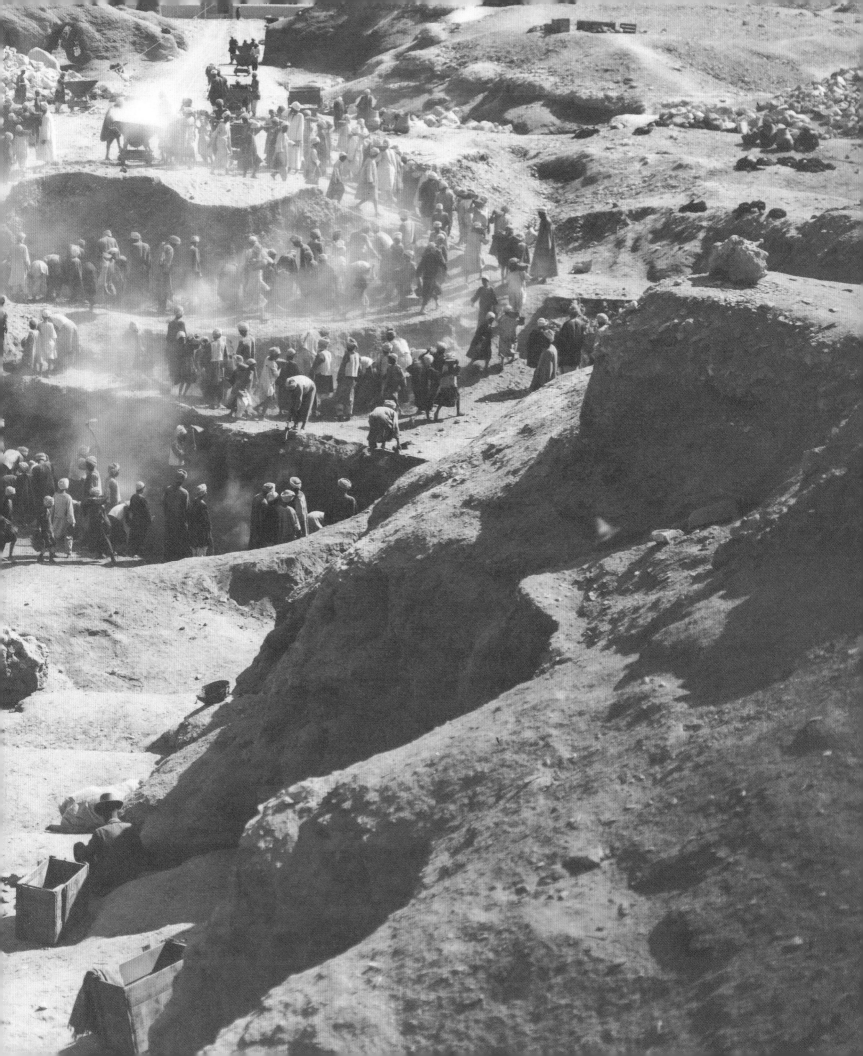

Collecting through Excavation

Catharine H. Roehrig

Since 1870, when the founders of the Metropolitan Museum accepted a Roman sarcophagus as its first acquisition,[1] works of ancient art have occupied a prominent place within the collections. But in its early decades, the Museum did not acquire antiquities by actively engaging in archaeological fieldwork. That would change in 1906, when the board approved the Museum's first excavation, to be funded "by private generosity."[2] An intensive program of excavations soon followed, initially in Egypt and later in the Middle East.[3] The excavations continued for nearly half a century and eventually added to the collections of five curatorial departments: Ancient Near Eastern Art, Arms and Armor, Egyptian Art, Islamic Art, and Medieval Art and The Cloisters.[4]

Before 1906 the Museum had collected ancient art primarily through gifts from private collectors and purchases, an approach subject to the vagaries of donors and the marketplace. What's more, such acquisitions usually lacked the historical and cultural context attached to pieces that came from carefully documented archaeological excavations. Nevertheless, the Museum significantly added to its small Egyptian collection in 1886 by purchasing a group of artworks that recently had been excavated by the Egyptian Antiquities Service.[5] At the time the Egyptian government partially funded its own excavations by selling pieces that were similar to objects already in the Boulaq Museum (now the Egyptian Museum, Cairo). The group that came to the Metropolitan Museum included coffin sets belonging to Iineferty and Khonsu, the wife and son of Sennedjem, one of the artists who decorated the royal tombs in the Valley of the Kings (about 1250 B.C.).[6] His tomb was the final resting place of three generations of family members. Not only are the coffins fine works of art, but their archaeological

95. Helmet (excavated Ōtsuka-yama
Kofun, Sakume-chō, Matsuzaka City,
Mie Prefecture, Japan), 5th century. Iron,
copper, gold. Fletcher Fund, 1928

provenance provides a historical context that allows the
Museum to tell the story of their owners and the time in
which they lived.[7]

In addition to conducting its own excavations, the Egyp-
tian Antiquities Service issued contracts to foreign excava-
tors and had a generous policy of dividing the finds ("part-
age"), nearly half of which went to the excavation sponsor.
Beginning in 1895 the Museum benefited from this policy, as
private funds were donated on the Museum's behalf to the
Egypt Exploration Fund (EEF), a British organization that
supported excavations in Egypt and donated its share of the
finds to the Metropolitan Museum and other art institutions
designated by its sponsors. Excavated works of classical art
came to the Museum in a similar fashion. As a result of pri-
vate donations to the American Society for the Excavation
of Sardis, the capital of ancient Lydia in Asia Minor, the
Museum was given excavated material from this site, includ-
ing a magnificent Ionic capital and part of a column from
the Temple of Artemis (mid-fourth century B.C.).[8]

In 1905–6 Bashford Dean, then honorary curator of the
collection of arms and armor, arranged an extraordinary
acquisition of excavated material.[9] By training a vertebrate
zoologist, Dean was a professor at Columbia University and
worked for the American Museum of Natural History. He
had been interested in arms and armor since childhood and
had acquired a vast knowledge of historical European and
Asian armor and weapons. One of his goals was to acquire
early examples of arms and armor from Japan. The weap-
ons of the Kofun period (third through sixth century) are
based on Chinese prototypes and represent a stage in the
development of forms that are distinctly Japanese. The only
examples of this material were in Japanese collections. In
1905 Dean visited the Imperial Museum in Tokyo (now the
Tokyo National Museum), where he negotiated an agree-
ment by which duplicate examples of excavated Japanese
material would come to New York. Some of the objects
chosen were from the Eda Funayama *kofun*, a famous early
burial mound on Kyūshū Island; they included a *ken*, a rare
double-edged sword.[10] The Metropolitan Museum was
fortunate to acquire such pieces, whose counterparts in
Japan have since been designated national treasures. In
exchange, the Japanese curators wanted ancient Egyptian
artworks for a core collection in the Imperial Museum.
After leaving Japan Dean arranged for the purchase of
nearly two hundred Egyptian artifacts. He donated these

to the Metropolitan Museum for use in the exchange,
which proceeded to the satisfaction of both museums.[11]
Two decades later, after becoming the full-time curator of
the Department of Arms and Armor, Dean arranged the
acquisition of additional Kofun-period armor, from the col-
lection of Professor Seki Yasunosuke.[12] The objects
included a rare ceremonial helmet made of iron wrapped
with gilded copper (fig. 95).

Establishing the Excavation Program

The Metropolitan Museum might not have begun sponsor-
ing its own excavations but for events that unfolded during
the fall of 1905 at the Museum of Fine Arts, Boston (MFA).
A bitter dispute had developed between a committee of
trustees and Edward Robinson, who had been the MFA's
director since 1902 and curator of classical art since 1885.[13]
Robinson was highly respected in academic circles in both
the United States and Europe, and the majority of the trust-
ees wanted him to stay in Boston. However, in December,
after four months of negotiations, they regretfully accepted
his resignation. Boston's loss was a resounding gain for the
Metropolitan Museum, which immediately hired him as
assistant director and curator of classical art.

Robinson's move to New York would have further rami-
fications for both museums, as he was soon joined by Albert

M. Lythgoe, a former student he had hired in 1902 as the MFA's first curator of Egyptian art. Lythgoe had begun to expand the MFA's collection through purchases from dealers in Egypt and from the Egyptian government, but he was convinced that excavation was the best way to build a collection that covered the vast span of ancient Egyptian civilization. Excavation could target sites of specific time periods, whereas purchases depended on availability. Lythgoe had worked at a variety of sites in Egypt since 1899 and knew that great discoveries were not assured. He also knew that a carefully chosen, excavated, and recorded site could produce significant works of art and a wealth of cultural material that provided a better understanding of the artwork's historical context and purpose. In January 1906, while overseeing the MFA's first excavation in Egypt, Lythgoe realized that the trustees did not fully support his collection strategy and decided to resign at the end of the season—a decision he shared with Robinson.[14]

Hoping to take advantage of Lythgoe's impending availability, Robinson decided to gauge the interest of the trustees in expanding the Museum's small collection of ancient Egyptian art. He advised Lythgoe to expect a visit at his excavation site from William M. Laffan, a publishing magnate and trustee who had a broad knowledge of art and an interest in the ancient world: "I have put the matter into his hands by asking him to investigate and report upon the possibilities in Egypt. . . . If he writes or reports on his return that we ought to start an Egyptian department with a man in Egypt collecting for the Museum, and that you are the man, the rest is simple."[15] Impressed by both the excavations and Lythgoe's ideas for creating a comprehensive collection of Egyptian art, Laffan asked Lythgoe to write a proposal for the board.

Lythgoe's proposal explained that the Egyptian Antiquities Service was opening sites to foreign expeditions that had been reserved for its own excavators. At the current rate of excavation (both legal and illicit), Egyptologists believed that nothing would be left to find within fifteen years. During that time Lythgoe intended to excavate sites that covered the full scope of ancient Egyptian history, from the Predynastic through the Byzantine period (fourth millennium B.C.–A.D. mid-seventh century). State-of-the-art excavation methods would ensure a complete record of the archaeological context of the finds, photographs would enhance the Museum's displays, and scholarly publications would present the results to a wide audience. When possible, Lythgoe would also purchase artworks to fill gaps in the collection.[16] With this plan, Lythgoe believed he could create the most comprehensive and best-documented collection of ancient Egyptian art in America.

Lythgoe's proposal had the hearty support of Laffan, who urged the board not to hesitate: "As for the Museum, it is now or never, and I unequivocally favor Now."[17] The executive committee resolved that the board should establish a department of Egyptian art, appoint Lythgoe as curator, and make a generous appropriation of funds for purchases. It did not, however, sanction the use of Museum resources for excavations, as there was no guarantee of a return on the money.[18] The board's president, J. Pierpont Morgan, endorsed the committee's resolution—and also offered to fund the excavations for two years himself, anonymously. If nothing were found, the entire cost would be his. Otherwise, the Museum would reimburse him for up to sixty percent of the cost based on the declared value of artworks acquired in the division of finds.

The Egyptian Expedition, 1906–36

The Museum's Egyptian Expedition began excavations in December 1906 at the royal cemeteries of Lisht, about thirty miles south of Cairo. It was the perfect place to study monuments of the Middle Kingdom (about 2030–1640 B.C.): the ruined pyramids of the first two kings of Dynasty 12 dominate the site and are surrounded by tombs of contemporary officials. With funding secured for only two years, Lythgoe needed to show the value of excavation quickly. In the July *Bulletin* he reported on important finds at the funerary temple of Amenemhat I—including a huge granite offering table and several blocks of fine painted relief[19]—that made "a distinct contribution to the history of Egyptian architecture and art."[20] These were awarded to the Museum in the division of finds.

An even more important discovery soon followed: the nearly intact burial of a noblewoman named Senebtisi.[21] Her funerary equipment included a variety of ceremonial staves hitherto found only in the burials of male officials, and her mummy was adorned with ritual jewelry usually associated with royalty.[22] An unparalleled find at the time, it alone would have proved the merits of excavation and was the subject of the first volume of publications by the Egyptian

Expedition.[23] At the end of the season, the trustees voted to reimburse Morgan out of the Rogers Fund, which supported the Egyptian excavations for the next thirty years and funded later excavations in the Middle East as well.

After the success of the first season, Lythgoe was able to expand the excavations to Kharga Oasis, a remote site in the desert some four hundred miles southwest of Cairo. Reachable only by camel until 1908, when a train line opened, Kharga's inaccessibility had protected the ancient monuments, which date from the Late Period into early Christian/Coptic times (seventh century B.C.–A.D. fifth century). As Lythgoe explained, "The site contains the most important Early-Christian cemetery preserved, and being undisturbed in modern times would yield the full results on that side which we would want."[24]

That cemetery, Bagawat, and the nearby settlement of Ain et-Turba date to the fourth and fifth centuries and span the transition from Roman to Byzantine rule, when ancient Egyptian, Ptolemaic Greek, and Roman influences blended in the local art and architecture. The elite tombs in Bagawat include mud-brick chapels that mix ancient Egyptian and classical architectural features (fig. 96).[25] The burials contained pottery and personal ornaments, and one chapel had glass vessels incorporated into the dome.[26] Archaeological evidence the expedition uncovered in Kharga documents a vibrant Christian community but also reveals a spiritually transformative period, as some wholeheartedly adopted the new religion, some adhered to the ancient gods, and some embraced both. At Ain et-Turba the team unearthed houses with well-preserved walls and distinct floor plans; they contained household items, including beautiful examples of millefiori glass,[27] altars for burnt offerings, and small bronze figures of ancient Egyptian deities—holdovers from the ancient religion.[28]

97. Copy of an epistle of Severos, bishop of Antioch (excavated Hermitage of Epiphanius, Egypt), ca. 509–640. Limestone, ink. Rogers Fund, 1912

98. Censer with a lioness hunting a boar (excavated Hermitage of Epiphanius, Egypt), 6th–7th century. Bronze. Rogers Fund, 1944

The Coptic Church traces its roots to the early first century, when Saint Mark brought Christianity to Egypt, and the earliest evidence for Christian monasticism comes from the Nile Valley. A primary location for studying Egypt's monastic tradition is the Theban necropolis, on the west bank of the Nile opposite modern Luxor (ancient Thebes). One of the richest archaeological sites in Egypt, western Thebes has remains from prehistoric through early Christian times (pre-3100 B.C.–A.D. seventh century) and preserves numerous hermit's cells and monasteries. In February 1912 the Egyptian Expedition began excavating mud-brick structures associated with a religious recluse named Epiphanius. One or more anchorites, Epiphanius being the most revered, inhabited the hermitage for much of the seventh century, a turbulent time when Byzantine rule over Egypt was repeatedly challenged and finally, between 639 and 641, overthrown by Muslim forces.

Two seasons of excavations showed that the anchorites had been self-sufficient, weaving linen and making baskets, mats, rope, and leatherwork. There were hundreds of texts written in Greek and, later, in Coptic, the latest form of ancient Egyptian.[29] Many record biblical passages;[30] some are letters sent from a nearby town; others are copies of contemporary church documents, such as an epistle written by the bishop of Antioch (fig. 97), that demonstrate the connection of this isolated hermitage to distant cities of the Byzantine Empire. The finest work of art from the hermitage is a censer with the depiction of a lioness attacking a

boar (fig. 98), which was found in a crevice above the west courtyard. Morgan was visiting the excavations when the censer was discovered and was allowed to lift it out of its find spot. As funder of the excavations, Morgan owned the artworks from the division of finds until the Museum reimbursed him. He was taken with the little censer, and it was one of the few pieces from the excavations that he kept for his own collection. (The Museum later purchased it.) The censer is a curious piece. Its decoration includes no

99. Funerary mask of Wah (excavated Tomb of Wah, Thebes, Egypt), ca. 1981–1975 B.C. Cartonnage, wood, paint, gold foil. Rogers Fund and Edward S. Harkness Gift, 1940

Christian iconography, and its place of manufacture is unknown. If purchased on the art market, absent archaeological documentation, even its date would have been hard to determine, and no one would have guessed that it ever belonged to a small hermitage in western Thebes. In 2000 the Department of Egyptian Art transferred the censer, along with other artworks and records from its excavations of early Christian sites, to the medieval art collection, and many of the artworks are now on display in the Byzantine Egyptian galleries beneath the grand staircase.

The excavations in the Theban necropolis continued for more than two decades. One of the most important discoveries occurred in March 1920, when excavators were clearing the ruined tomb of an important official of the early Middle Kingdom (about 1980 B.C.). The intact burial of a man named Wah was among the finds, but its significance was not immediately recognized.[31] Herbert E. Winlock, who had joined the expedition in 1906, was now field director. Although Winlock had fourteen years of excavation experience, the contemporary art historical view of high and low art seems to have influenced his assessment of the find. Wah's tomb was a crudely carved, undecorated corridor that contained only a coffin and some food offerings. Winlock regarded Wah's mummy mask (fig. 99), with its "pinched little face," "thin moustache," and "scant whiskers," as "a barbarous-looking affair . . . bought from one of the more old-fashioned of the local artisans."[32] His distaste led him to identify Wah as a man of no great importance, all evidence to the contrary. As a longtime excavator, Winlock should have been persuaded by the facts: the pinched face was gilded, the coffin was made of imported coniferous wood, the body was exquisitely wrapped, and the food offerings included an entire foreleg of beef—a gift suitable for the gods. In 1939 Wah's mummy was X-rayed, revealing his elite status. His funerary and personal jewelry included a broad collar of Egyptian faience (fig. 100); a scarab of lapis lazuli, a stone that had traveled along the ancient trade routes from Afghanistan;[33] and a solid-cast silver scarab with the names and titles of Wah and his employer inlaid in gold on the wing cases (fig. 101).

Until 1920 Winlock's primary interest was the Middle Kingdom, but his focus shifted over the following decade as fragments of deliberately destroyed statues began to emerge from the area he was excavating in front of two royal funerary temples built against the cliffs at Deir el-Bahri,

100. Broad collar of Wah (excavated Tomb of Wah, Thebes, Egypt), ca. 1981–1975 B.C. Faience, linen thread. Rogers Fund and Edward S. Harkness Gift, 1940

101. Scarab (excavated Tomb of Wah, Thebes, Egypt), ca. 1981–1975 B.C. Silver, electrum, glazed steatite, linen cord. Rogers Fund and Edward S. Harkness Gift, 1940

in western Thebes. One temple was constructed about 2000 B.C. by Mentuhotep II, founder of the Middle Kingdom. The other was built about 1475 B.C. by Hatshepsut, the female pharaoh who ruled Egypt for two decades in Dynasty 18, at the beginning of the New Kingdom. It soon became clear that the limestone fragments belonged to statues that once were attached to the facade of Hatshepsut's temple; the granite pieces belonged to freestanding colossal statues that probably lined the procession route to the shrine of the god Amun on the temple's upper terrace. Between 1923 and 1932 thousands of fragments emerged (see pp. 92–93). In some cases, pieces of the same statue turned up in different areas and at different levels of the excavation. Beginning in 1928 Winlock's young assistant, William C. Hayes, was tasked with reassembling individual statues from the fragments. At the end of this process, the Egyptian

Collecting through Excavation

When Hatshepsut's statues arrived in New York in the 1920s and early 1930s, they were restored to appear as though they had never been damaged. Over the years attitudes about restoration changed, and in the 1970s and early 1980s an effort was made to distinguish between the original stone fragments and the modern restoration by cutting back the plaster fill. That gave visitors a better understanding of the historical context in which Hatshepsut's co-ruler and nephew, Thutmose III, had destroyed her statues after her death, in an attempt to obliterate memory of her reign from Egyptian history. This second round of restoration left a gap in the face of Hatshepsut, whose left eye was missing. The statue was displayed this way until 1993, when curators of Egyptian art decided that the damage inhibited the viewer's appreciation of one of the finest pieces of sculpture in their collection (fig. 103). To restore the face, they worked with the Department of Objects Conservation and the Museum's model maker, who created a mirror image of the preserved right eye to fill the gap.

Excavations in British Mandatory Palestine, 1926

Although the Museum began and for many years continued its excavation program in Egypt, it also supported expeditions elsewhere in the eastern Mediterranean. In September 1923 Bashford Dean consulted Edward Robinson about a possible archaeological expedition to obtain arms and armor from the time of the Crusades. Knowledge of European arms and weapons from this period (twelfth–thirteenth century) was "pitifully meager," and Dean thought that exploring the ruined crusader castles of Palestine might unearth valuable evidence.[35] Following World War I, British and French mandates controlled much of the Middle East. As in Egypt, the antiquities authorities in these areas divided archaeological finds with excavators; Dean had already made inquiries in Jerusalem and had chosen Montfort Castle. Montfort was one of the administrative seats of the Teutonic knights from 1220, when they acquired the surrounding land and started fortifying the castle, until 1271, when it was besieged, taken, and demolished by the Mamluks. Robinson found the project intriguing, "in addition to which it has the fascination of the gambler's chance."[36] However, after enumerating the many projects the trustees had recently undertaken, he advised Dean to delay submitting his proposal. Two years later, after Dean raised the

Antiquities Service kept the most complete example of each statue type for the Egyptian Museum. It gave the rest to the Metropolitan Museum along with fragments that could be joined with pieces that had been found and sent to Europe in the mid-nineteenth century.

The most extraordinary fragments belonged to a lifesize head carved in a distinctive hard white limestone (fig. 102). Winlock reported the find to Lythgoe with great excitement: "[W]e turned up a delightful face of Hatshepsut in that hard limestone which is almost marble. I remembered a battered head of the same material which we found last year. . . . The face fitted to it, and personally I think that it is one of the best things which we have ever found."[34] The unusual material identified the face as part of a headless statue in Berlin's Ägyptisches Museum, which also owned the head of a granite sphinx whose body fragments had been excavated by the Egyptian Expedition. At the end of the 1928–29 season, Winlock negotiated an exchange that would provide each museum with a nearly complete statue: Berlin acquired the granite body of its sphinx head and the Metropolitan received the limestone body of the newly reassembled head of Hatshepsut.

103. (opposite) Seated statue of Hatshepsut (excavated Deir el-Bahri, Egypt), ca. 1479–1458 B.C. Indurated limestone, paint. Rogers Fund, 1929

104. Catapult projectiles, each approximately 150 pounds, excavated Montfort Castle, Palestine (near present-day 'Akko, Israel), before 1271. Photograph 1926

105. Keystone with carved plant motifs (excavated Montfort Castle, Palestine [near present-day 'Akko, Israel]), ca. 1220–30. Limestone. Gift of Clarence H. Mackay, Archer M. Huntington, Stephen H. P. Pell, and Bashford Dean, 1928

funds from private donors, including himself, his plan was approved.[37]

Dean chose as the Museum's field representative William L. Calver, who had directed excavations for the New-York Historical Society and whose finding skills he greatly admired. Though Dean had hoped the expedition would discover complete examples of armor and weapons, only small clumps of rusted mail,[38] fragments of crossbows, and various types of arrow, spear, javelin, and bolt heads were found during the monthlong season, in March 1926. There were also dozens of stone catapult projectiles (fig. 104), evidence of the final siege.[39]

Although a "dismal failure" with regard to its primary purpose, the exploration of Montfort provided valuable information on the lifestyle of crusaders in the Holy Land.[40] The knights had lived as comfortably as they would have in western Europe, not under conditions of stress or hardship.[41] The castle was decorated with grisaille and stained glass made in the French tradition,[42] and the rooms were enhanced with

architectural sculpture carved from local limestone by skilled craftspeople trained in the traditions of late Romanesque and Gothic art (fig. 105).[43] The presence in the castle of working artists is suggested by a stone with matrices that may have been used to emboss ornamentation on objects made of hardened leather or on paintings (fig. 106).[44] Some domestic items were clearly obtained locally, such as oil lamps,[45] including one inscribed in Arabic (fig. 107).[46]

Montfort also produced masses of shattered window glass and tableware, which many excavators would have discarded at the site. Fortunately one of Dean's many interests was glass, so hundreds of pieces came to New York. Decades later Museum conservators and research scientists collaborating with the Corning Museum of Glass studied selected fragments to determine whether the Montfort glass was imported from Europe, as some scholars believed. Results showed that, like the architectural sculpture, much of the glass was produced with local materials by craftspeople familiar with European forms and painting styles.[47]

Excavations in Iraq and Iran, 1932–47

With its excavation program well established, in 1931 the board debated expanding to other sites in the Middle East. Maurice S. Dimand, who was in charge of the Near Eastern

106. Stone with matrices (excavated Montfort Castle, Palestine [near present-day 'Akko, Israel]), ca. 1220–30. Limestone. Gift of Clarence H. Mackay, Archer M. Huntington, Stephen H. P. Pell, and Bashford Dean, 1928

107. Lamp with Arabic inscription (excavated Montfort Castle, Palestine [near present-day 'Akko, Israel]), before 1271. Earthenware. Gift of Clarence H. Mackay, Archer M. Huntington, Stephen H. P. Pell, and Bashford Dean, 1928

108. Wall decoration with floral patterns in four panels (excavated Ctesiphon, Iraq), ca. 6th century. Stucco. Rogers Fund, 1932

collections in the Department of Decorative Arts, was proposing a joint expedition in Iraq with the Staatliche Museen zu Berlin at the ancient city of Ctesiphon, on the Tigris River southeast of Baghdad.[48] Ctesiphon was the capital of the Sasanians, a Persian dynasty that ruled much of the Near East for four centuries, from 224 to 651. It had also been a commercial center with an ethnically diverse population.[49] Dimand and Joseph Breck, the curator in charge of decorative arts, were interested in acquiring Sasanian and early Islamic pottery, which was not widely available or well known at the time. They also hoped to find molded stucco reliefs like ones their German colleagues had already discovered at the site.[50] The floral and geometric patterns of Sasanian stuccos had developed from earlier Near Eastern and Hellenistic traditions, and they became an inspiration for later decorative arts in the Islamic world, the eastern Mediterranean, and medieval Europe.[51]

After approval of the proposal, Dimand's young assistant, Joseph M. Upton, went to Iraq for the 1931–32 excavation season, which ran from mid-November to mid-February. While working there Upton learned that the trustees had established an independent department of Near Eastern art, with Dimand as head and himself as assistant curator, and he responded with excitement: "It is such an enormous field that we will have to work night and day to become really competent and keep up with the new

developments."[52] The next summer the new department received the Museum's share of the finds under a system of partage that newly independent Iraq had inherited from its time under British mandate. These objects include representative groups of ceramics and glass and an extraordinary range of decorative stucco motifs from palaces and elite dwellings found in the cultural center of the Sasanian Empire (fig. 108).[53]

The Museum decided to end its participation in the joint expedition in Iraq after one season, and Upton went in search of a new site. Antiquities laws in Iran had recently broadened opportunities for foreign excavation, and the Metropolitan Museum obtained a concession to excavate at Qasr-i abu Nasr, a site near modern Shiraz that had important Sasanian remains as well as material from the Parthian and Islamic periods (247 B.C.–A.D. fourteenth century).[54] In the meantime, Herbert Winlock, who had been named director in January 1932, was trying to preserve funding for the excavation program. Although the Great Depression affected the Museum less severely than some institutions, cuts were required. As a solution, Winlock combined the budgets of the Middle Eastern and Egyptian excavations and transferred staff members from Egypt to Iran. One of them was Charles K. Wilkinson, a British artist who had worked in Luxor since 1920 copying tomb paintings.

109. Bowl with inscription: "He who talks a lot, spills a lot" (excavated Nishapur, Iran), 10th century. Earthenware, white slip with incised black slip decoration under transparent glaze. Rogers Fund, 1940

110. Mural fragment with a dog (excavated Nishapur, Iran), 12th century. Lime plaster, paint. Rogers Fund, 1948

Although Wilkinson was not a trained archaeologist, Winlock was confident he could easily pick up excavation skills.[55]

Winlock's support of the Middle Eastern excavations was rooted in his nearly thirty-year experience excavating in Egypt. Like his mentor Albert Lythgoe, he understood that excavation effectively built a collection of ancient art in a way that added significantly to the understanding of the culture that had produced it. Shortly before he became director the Museum had acquired a group of Neo-Assyrian reliefs and two winged, human-headed figures, protective deities known as lamassu (see p. 8),[56] all excavated at Nimrud in the nineteenth century. Presenting these to the public in the *Bulletin*, Winlock proclaimed "a new chapter in the Museum's history of art," explaining that the civilization of Mesopotamia "has been neglected by us out of all proportion to its importance in our history."[57]

In June 1934 the Iranian Expedition moved to Nishapur, an important commercial center in northeastern Iran on the Silk Road, the fabled network of caravan routes extending from China to the Mediterranean. Between the ninth and twelfth centuries, under Samanid and Seljuq rulers, Nishapur had been one of the great cultural centers of the Islamic world. The Nishapur excavations uncovered several residential areas, which yielded domestic goods from as far away as China. Locally made items indicated that the city and its

region supported master craftspeople who created glassware[58] and ceramics decorated in a variety of styles; finds included a buff-ware bowl with figurative decoration[59] and a calligraphic bowl (fig. 109). A bronze ewer engraved with hunting scenes and inscriptions expressing wishes for happiness, blessings, and peace is a fine example of the metalwork created at the time.[60] The walls of some of the excavated buildings were decorated with carved and painted stucco panels reminiscent of those from Ctesiphon; others had painted murals. Many fragmentary paintings, some with successive layers of decoration, came to New York in the division of finds (fig. 110). The pigments in those paintings, which date from the ninth to the twelfth century, were the subject of a revealing 2015–16 study. Staff from the Departments of Objects Conservation, Islamic Art, and Scientific Research, in collaboration with an Iranian scholar working at the Museum on a fellowship, found that the earlier paintings used pigments that probably were imported, whereas pigments used in the later paintings were obtained locally or were artificially made. The research demonstrated a shift toward the more systematized and standardized palette that was achieved in the twelfth century.[61]

The Depression eventually took its toll on the Museum's excavation program. Egyptian excavations ended in 1936, owing partly to financial constraints and partly to the

111. Female head (excavated Nimrud, Iraq), ca. 9th–8th century B.C. Ivory, gold. Rogers Fund, 1954

fact that, over thirty years, Lythgoe and his successors had largely achieved his goals for collecting ancient Egyptian art. Excavations at Nishapur were suspended in 1940, following the outbreak of World War II, and a final season was conducted in 1947–48. After that, the strategy for collecting ancient Near Eastern art shifted. Charles Wilkinson was appointed assistant curator of Near Eastern archaeology, and the Museum started to contribute funds and send staff to expeditions organized by other institutions, receiving a portion of the division of finds in return. The careful choice of sites by Wilkinson and later curators provided the Museum with significant excavated material that covers the history of ancient Near Eastern art and culture from the sixth millennium B.C. through the seventh century A.D.

During Wilkinson's tenure the Museum participated in British excavations in Iraq at Nimrud, one of the capitals of the Assyrian Empire (ninth–seventh centuries B.C.).[62] The Museum already owned the fine set of Neo-Assyrian reliefs excavated at this site in the 1840s, and the twentieth-century excavations brought a very different group of objects: ivory sculptures carved in a variety of styles, some acquired as booty or tribute from Phoenicia and Syria, others created in Assyria. Two unique pieces from this group are the face from a composite statue of a woman or goddess (fig. 111) and an extraordinary tribute bearer leading an oryx and carrying a monkey and a leopard skin (fig. 112).

The Museum also funded American excavations at Nippur (also in Iraq), where the Sumerian goddess Innana was worshiped continuously for more than three thousand years in successive temples built on the same site.[63] Votive statues apparently had been placed in the temple to worship the cult images of deities on behalf of their donors and never left the sacred precinct. During periodic renovations of the temple, earlier votives were ritually broken, and the fragments, like a pair of feet and an inlaid eye in the Museum's collection,[64] were incorporated into later temple structures. A well-preserved statue of a female worshiper that came to the Museum was found sealed in the plaster of a mud-brick bench in the temple cella (fig. 113).

Excavation after Partage

Seventy years of organizing and sponsoring excavations during the era of partage significantly enriched the institution's holdings, yielding more than half of the collection of Egyptian art alone. Current fieldwork, conducted in collaboration with host countries in the Americas, central Asia, the eastern Mediterranean, and the Middle East, no longer delivers a share of the finds but continues to deepen the understanding of ancient cultures and of the Museum's collections. Participants include curators from six departments, as well as Museum conservators and photographers. The departmental roster, somewhat changed over the years, now includes the Arts of Africa, Oceania, and the Americas, Greek and Roman Art, Medieval Art and The Cloisters, Ancient Near Eastern Art, Egyptian Art, and Islamic Art.

The ongoing commitment to excavation would have astonished the Museum's 1906 board of trustees, who were so uncertain that Lythgoe's first Egyptian Expedition would succeed that they insisted on outside funding. Of course, Lythgoe quickly proved that excavation was, in fact, a viable collection strategy—one that by 1936 had garnered the Museum the most comprehensive and best-documented collection of ancient Egyptian art in the country and one of

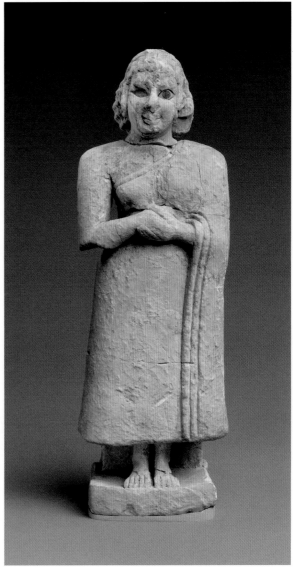

the finest in the world. Other excavations made similarly meaningful contributions to the Museum's holdings and body of research. Although the excavation in Palestine did not produce well-preserved examples of arms and armor, it did provide valuable information about the lives of the crusaders in the Holy Land, as well as architectural fragments, artisanal tools, and domestic furnishings now in the collections of arms and armor and medieval art. The expeditions in Iraq and Iran provided significant excavated works for the collections of ancient Near Eastern and Islamic art. These objects are all accompanied by important archival records that set them in their historical context and help document the cultures that created them. And, much as the Montfort

glass and Nishapur painting fragments did, these centuries-old works of art continue to generate fascinating new insights about their manufacture and origins years after their excavation, as scientific methods evolve.

Albert Lythgoe understood in 1906 that excavation had a value far beyond the acquisition of objects for the Museum's collection and that dissemination of knowledge acquired from the excavations was part of the Museum's mission. Today the Museum participates in archaeological projects in order to gain information that can lead to better understanding of the collections and as part of its broader engagement and collaboration with scholars and researchers around the world.

Creating a National Narrative

Amelia Peck and Thayer Tolles

Since 1872 and the gift of Hiram Powers's marble statue *California*,[1] the first work by an American artist to enter the Metropolitan Museum, American art has been bedrock to the institution. By 2020 its American Wing's holdings, dating from the late seventeenth to the mid-twentieth century, numbered some eighteen thousand objects. This collection has been influenced by formidable personalities—curators, trustees, donors, and artists—who collectively shaped the conventional canon of American art, one that continues to evolve to reflect more diverse and expansive representation. In establishing and responding to ever-shifting aesthetic trends, the American collection has had broad sociocultural resonance. The years surrounding the 1924 founding of the American Wing for the display of decorative arts particularly reflect how the American art holdings have been pressed into service to promote patriotism, to educate, and to instill social and global aspirations.

In 1905 the Museum was at a collecting crossroads. Its longtime first director, Luigi Palma di Cesnola, who regarded living American artists warily, had died in 1904, as had founding trustee Samuel P. Avery, a prominent art dealer and seminal early shaper of the American collections. The artists with long institutional associations had either died (Frederic Edwin Church in 1900) or stepped off the board (John Quincy Adams Ward in 1901 and Daniel Huntington in 1903). Through their diplomacy and counsel the Museum had gradually but not systematically acquired American paintings and sculpture through gift, bequest, and subscription in its first three decades, with pockets of strength in paintings of the late eighteenth and early nineteenth centuries and neoclassical

marble sculpture of the mid-nineteenth century. While the Museum acquired contemporary decorative objects in the late nineteenth century—Tiffany and Company's Bryant Vase,[2] glass by Louis C. Tiffany (see fig. 135), and a few pieces of furniture, such as a pair of chairs made by Pottier and Stymus[3]—there was little American-made material beyond paintings and sculpture.[4] Significantly, no funds were available for the purchase of works by living American artists.

The Museum's annual report of 1905 acknowledged that a new generation of leadership, under board president J. Pierpont Morgan and secretary Robert W. de Forest, enjoyed "present opportunities" to shape and build collections methodically, noting that theretofore the holdings had not been "developed under any comprehensive plan" but rather through the necessity of collecting by gift.[5] The annual report affirmed a new goal of expanding the holdings of American art, "which has peculiar claims upon our interest and patriotism. . . . Foreigners coming to America naturally expect to find in the chief museum of our country the evidence of what America has done and indeed the material for full appreciation of the development of American art. Our own countrymen should expect nothing less."[6] Implicit in this manifesto was the Museum's power to shape public taste through a prescribed breed of nationalism reflected in the collections. Indeed, the report, urging quality rather than quantity, included desiderata lists of American painters and sculptors, ranging from colonial portraitists to more recent landscape artists, in hopes of inspiring gifts.[7]

The trustees were greatly aided by the 1901 bequest of Jacob S. Rogers. While the Rogers Fund was impactful across all collecting areas,[8] for American art it was transformative, generally used to purchase historical paintings and decorative arts, as well as contemporary sculpture. Indeed, the first purchase made from the fund, in January 1903, was an American painting: Thomas Cole's 1832 landscape *A View near Tivoli (Morning)*.[9] With resources at hand, the campaign to acquire American paintings and sculpture began immediately, soon followed by a focus on decorative arts.

The Museum's collections of American paintings, sculpture, and decorative arts developed along distinct, albeit complementary tracks and were managed by separate departments in the early twentieth century. It was not until 1933 that the American Wing was established as its own curatorial department, apart from the Department of Decorative Arts. In 1949 the Department of American Art was founded, uniting the collections administratively, although their installations remained separate until 1980.

Paintings

By about 1905 the Museum's American paintings collection was under scrutiny, especially by living artists. Cesnola had prioritized the acquisition of American "old master" paintings, such as those by Charles Willson Peale, Gilbert Stuart, and John Trumbull, Revolutionary War–era artists renowned for their portraits of prominent Americans and historical scenes, an initiative that had had patriotic overtones in the years immediately following the country's centennial in 1876. Contemporary American paintings had also entered the collection—by gift, rather than by strategic purchase—in the 1880s and 1890s. For instance, in 1881 the Philadelphia realist painter Thomas Eakins presented his *Chess Players* (fig. 114), the first work given to the Museum by an artist. Other contemporary paintings were donated through coordinated efforts, some presented as the "Gift of Several Gentlemen." But the collection thus assembled was far from comprehensive. By 1904 artists, individually and through petitions from New York art clubs such as the Salmagundi and the Lotos, were appealing to the Museum to devote funds "to the purchase of a historical collection of easel pictures by American artists."[10] In response, Cesnola tasked the curator of paintings, George H. Story, himself an artist, with analyzing the entire collection. Story tallied 888 paintings, 265 by Americans—more than any other national school—of which 168 were on view. De Forest reported these statistics to the petitioners, observing, "It has always been the intention of the Trustees to continue to obtain desirable works by American Artists and they will do so and exhibit them together as far as may be expedient."[11]

Story's inventory led to a more deliberate institutional approach to acquisitions by gift and purchase; as detailed in the 1905 annual report, it was meant to ensure representation of the best work by the best American artists. The Museum's strategic new direction for collecting American paintings also reflected personnel transitions, with a new generation of trustees and an increasingly professional staff. Story, who had served as acting director after Cesnola's death, was succeeded by Roger Fry, whose tenure lasted just two years. He was succeeded by Bryson Burroughs, who in

1907 was named acting curator and in 1909 curator of paintings, a title he held until his death in 1934.

Burroughs was responsible for holdings of vast geographic and chronological range, as European and American paintings were then a single department. His discernment in shaping the breadth of the paintings collection resulted in part from his background as a Paris-trained artist and his ongoing work as a painter; indeed, throughout his tenure he spent his mornings painting and his afternoons at the Museum.[12] As the *New York Times* observed, "while he never lost sight of the importance of old masters and the modernists of Europe, Mr. Burroughs had a never-failing enthusiasm for the paintings of Americans."[13] Nevertheless, Burroughs was beholden to powerful trustees and donors who promoted their own, often Eurocentric interests or defied his recommendations for or against acquisitions. Fellow artists also proffered opinion at close range: the president of the National Academy of Design had been an ex officio Museum board member since 1870.

Burroughs's early years coincided with a remarkable commitment to living American painters by George A. Hearn, a dry goods mogul who had acquired a vast and far-ranging collection. He served as a trustee from 1903 until his death in 1913, when he was eulogized for gifts to the Museum that served as a "stately monument both to the donor and to American art."[14] In 1906 Hearn established an endowment for the purchase of contemporary American paintings, stipulating that the artists must be American citizens and alive in or born after 1906. At that time he also presented a gift of twenty-four British and twenty-seven American paintings, among them two oils by Winslow Homer,[15] and requested that they be hung together in a single gallery, to "show that good American pictures can hold their own against the foreigners."[16] That gift was followed by annual contributions, including works by Mary Cassatt, Childe Hassam, and four more oils by Homer (fig. 115). In 1911 Hearn gave additional funds for acquisitions in memory of his son Arthur Hoppock Hearn. In addition to the acquisition endowments, Hearn's "princely munificence" resulted in some 130 American paintings entering the collection between 1894 and 1913 (fig. 116).[17]

Hearn, who sat on the trustees' committee on paintings, orchestrated the purchases from the Hearn Fund himself. He selected paintings, buying works from galleries and out of exhibitions, even before approval by his trustee colleagues, and received repayment from the Hearn Fund for those the committee accepted. This unusual arrangement was regarded as a mixed blessing by Burroughs and the trustees, who did not always hew to Hearn's aesthetic preferences. In 1906 Burroughs pointedly observed, "If these paintings, offered in this way, be accepted, and if the precedent be followed, the formation of the Hearn Fund Collection is taken entirely out of the Museum's hands."[18] At a moment when modernist and progressive aesthetics were emergent, Hearn, and by extension the Museum, favored relatively conservative and academic paintings by established living artists. In the years after Hearn's death, his endowment, now more firmly under Burroughs's discretion, was used to purchase John Singer Sargent's *Madame X (Madame Pierre Gautreau)* (fig. 117) and works by Ashcan School artists, including William James Glackens, Everett Shinn, and John Sloan.

In addition to Burroughs's forays into contemporary American art, under his guidance the trustees remained firmly committed to the acquisition of historical American paintings as part of a larger mission to educate about American history and values. As the holdings of decorative arts of the eighteenth and early nineteenth centuries expanded rapidly in the years leading up to the founding of the American Wing in 1924, so too did the historical paintings collection.[19] The Rogers Fund was often used to buy colonial and early Federal portraits, including six by Gilbert Stuart between 1905 and 1908. In 1915 the Museum purchased its first oil painting by John Singleton Copley, *Mrs. Jerathmael Bowers* (fig. 118), from descendants of the sitter. Copley's likenesses of the social and political elite dovetailed with the Anglo-American cultural ideals that early American decorative arts symbolized to the trustees and staff most closely involved in forming the collection.

Although Hudson River School landscapes were less favored on the commercial market at the turn of the twentieth century than previously, the Museum steadily acquired them through gift and purchase, in part due to its close association with its practitioners and the trustees who collected them. In 1914 the bequest of Maria DeWitt Jesup brought in such distinctive works as Frederic Edwin Church's *The Parthenon* (fig. 119)—a familiar Greek subject representing

117. John Singer Sargent (American).
Madame X (Madame Pierre Gautreau),
1883–84. Oil on canvas. Arthur Hoppock
Hearn Fund, 1916

democratic ideals, which her husband had commissioned—Sanford Robinson Gifford's *A Gorge in the Mountains (Kauterskill Clove)* (fig. 120), and paintings by Thomas Cole, Asher Brown Durand, and John Frederick Kensett. With America's emergence as a global power, these landscapes remained prized throughout World War I and the postwar isolationist 1920s for their overt nationalism. As Burroughs asserted in a text accompanying an October 1917 exhibition of Hudson River School paintings from the collection, such landscapes represented "the nearest approach to a native school of art which America has yet produced."[20]

Notwithstanding the strength in Hudson River School paintings the Museum developed under his auspices, Burroughs was above all an advocate for American modern masters, writing insightful articles on acquisitions for the Museum's *Bulletin*, vividly describing paintings and their merits. He organized an impactful string of memorial exhibitions, including shows dedicated to James McNeill Whistler (1910), Winslow Homer (1911), William Merritt Chase (1917), and Albert Pinkham Ryder (1918). Each was intended to canonize the featured artist as well as to enhance the institution's

reputation and holdings. The Museum steadily acquired Whistler's work between 1906 and 1916, including in 1912 the ethereal nocturne *Cremorne Gardens, No. 2* (fig. 121). The Homer exhibition featured twelve late watercolors that Burroughs purchased for the Museum from the artist's estate, after conferring with Homer himself on the selections shortly before his death.

Burroughs's greatest crusade was reserved for Thomas Eakins, an artist who, unlike Homer or Whistler, enjoyed little critical or public favor during his lifetime.[21] Through the platform of the Museum, Burroughs posthumously elevated Eakins, an American realist painter in whose work

he saw "manliness and single-minded sincerity."[22] In 1917, with the cooperation of Eakins's widow, Susan Macdowell Eakins, Burroughs mounted a monthlong exhibition and subsequently built core holdings of his oils and works on paper. His enthusiasm was such that, when proposing separate galleries for Eakins, Homer, and Sargent in 1927, he wrote de Forest: "I believe Thomas Eakins will be considered the foremost American artist of his time."[23]

By contrast, John Singer Sargent benefited from a relationship with the Museum through much of his career, bolstered by trustees and staff who were clients and friends.[24] The Museum's third director, Edward Robinson, enjoyed a

particularly close association with the artist and was instru-
mental in organizing a steady acquisition of his oils, water-
colors, and drawings. In 1915, through Robinson's negotia-
tions and Burroughs's recommendation, the Museum
bought ten watercolors at a reduced price directly from
Sargent, forming the nucleus of now-extensive holdings of
his graphic work. Most notable was the 1916 acquisition—
also from the artist and at a moderate price—of the iconic
full-length portrait *Madame X*, which, Sargent posited, was
"the best thing I have done."[25] The appetite for Sargent's art
and the respect accorded him were such that more than
eight thousand people attended the opening of his memo-
rial exhibition in January 1926, and more than sixty thou-
sand visited during the show's run.[26]

During the late 1920s and early 1930s, acquisitions of
American paintings remained largely conservative, focused on
the same range, from colonial portraits to American Impres-
sionist landscapes, favored during the previous two decades.
Few works by American women were acquired beyond those
by revival miniature painters and Mary Cassatt, leaving subse-
quent generations of curators to address this lacuna (see
"Visions of Collecting"). Yet Burroughs himself was clearly
catholic in his taste—occasionally, as with Eakins, even trail-
blazing. While constrained by long-serving trustees who had

not embraced the shift toward modernist aesthetics, over
nearly three decades the even-keeled and quietly confident
curator put his lasting imprint on the American paintings col-
lection. He was remembered at his death in 1934 as "a curator
equally knowing, experienced, industrious, sincere, and
understanding,"[27] and was accorded a memorial exhibition at
the Museum the following year.

Sculpture

The sculptor Daniel Chester French joined the board of
trustees in 1903 and tirelessly served the Museum, "one of
the greatest interests of his life," until his death in 1931.[28] He
was a leading sculptor celebrated in his time for such public
works as *The Minute Man* (1871–75; Concord, Mass.) and the
enormous seated Abraham Lincoln for the Lincoln Memo-
rial (1911–22; Washington, D.C.).[29] With the resignation of
sculptor trustee John Quincy Adams Ward in 1901, French, a
well-liked consensus builder and a consummate insider in
artistic circles, was the ideal successor. French served as
chair of the trustees' committee on sculpture, recommend-
ing acquisitions to the board while negotiating with fellow
sculptors and their representatives. His arrival coincided
with the elimination of the Department of Sculpture in

1905, and so he was also the de facto curator of modern American and European sculpture, which at that time fell under the purview of the Department of Decorative Arts. His judgment was so respected that one journalist quipped: "[W]hen the Museum wants to go a-shopping for sculpture, it returns without sculpture until such a time as Mr. French has passed on it."[30] His popularity with the staff and board, not to mention his esteem as an artist, was such that in 1907 the trustees attempted to buy his portrait bust of Ralph Waldo Emerson (fig. 122). French, uncomfortable with permitting the purchase, responded by donating the bronze.[31] His fellow trustees later orchestrated the accession of three major marbles to ensure that French's work was adequately represented.

French's early years at the Museum corresponded to a pivotal moment for contemporary American sculptors. The establishment of an American bronze-casting industry in the mid-nineteenth century had fostered the popularity of the statuette—collectible, affordable, and, in its subject matter and material, promoted as reflecting democratic American values. Savvy to the benefit of the Museum's imprimatur on his field, he assembled a collection of contemporary American and European bronze sculptures to "illustrate the

modern development of this art"; he rarely acquired neoclassical marbles by artists he termed "the by-gone generation."[32] French visited galleries, exhibitions, and artists' studios, building the collection in statuettes, reliefs, and full-scale sculptures across themes, from figurative subjects—nudes, portraits, and genre groups—to animals, allegories, and works related to significant public monuments. He assembled a stellar collection of bronzes with American western subjects. As he made his acquisitions, French routinely asked the sculptors whether his choices "would fairly represent you."[33] He was particularly attentive to procuring works by talented women who enjoyed enormous professional success after the turn of the twentieth century. In 1906 four bronze statuettes by Bessie Potter Vonnoh were acquired by the Museum, among them her best known, *A Young Mother* (fig. 123). They were the first works by an American woman sculptor to enter the collection. As he did with Vonnoh, French often worked with the artists and their preferred foundries to advise on casting and finishing, ensuring quality control. The press was soon championing such sculptures in the growing collection as three-dimensional symbols of the American spirit. One writer reflected "how deeply [the] work is rooted in our national character, how

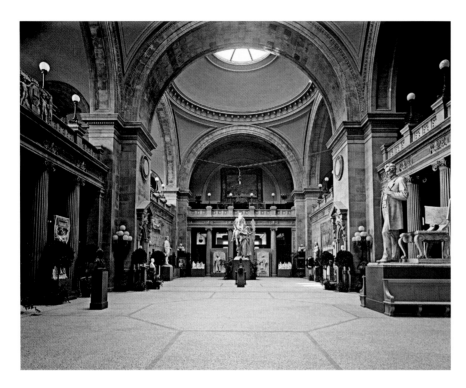

124. *Memorial Exhibition of the Works of Augustus Saint-Gaudens*, Hall of Sculpture (Great Hall), March–May 1908

vital is its connection with our national life, how expressive it is of varied phases of our feeling as a people."[34]

No artist received greater attention from French than Augustus Saint-Gaudens, who rose from Lower East Side immigrant roots to international fame.[35] When French arrived, the artist was represented in the Museum's collections only by two examples of his *George Washington Inaugural Centennial Medal*, donated by Henry G. Marquand in 1890.[36] French swiftly redressed this gap, in 1905 commissioning three marble bas-relief portraits of children selected by Saint-Gaudens.[37] After the sculptor's death in 1907, French organized the *Memorial Exhibition of the Works of Augustus Saint-Gaudens*, an installation in the Hall of Sculpture (now the Great Hall) that featured 154 works (fig. 124). It was the first special exhibition since the 1900 memorial show for Frederic Edwin Church and the first in a progression honoring distinguished American artists. Altogether, twenty-one works by Saint-Gaudens were acquired through gift and purchase during French's tenure, including, in 1917, the gilded statuette *Victory* (fig. 125), a reduction after the allegorical figure for the nearby William Tecumseh Sherman Monument (1892–1903; Grand Army Plaza, New York). French's last significant accession, in 1928, was the iconic *Diana*,[38] a familiar landmark in the American Wing's Charles Engelhard Court.

American sculpture had always had a strong presence in the Museum. It acquired even greater prominence after 1902, when the Hall of Sculpture opened, ultimately expanding to galleries flanking the Grand Staircase and to French's pet project, the *Exhibition of American Sculpture*. The latter was a long-term installation of contemporary large-scale works that opened in 1918. The display initially included many loans French intended to convert to acquisitions and plaster casts he hoped to commission in bronze; he was successful in both arenas. Beginning in 1926 he collaborated with assistant curator of decorative arts Preston Remington to install two galleries in the new southwest Wing K, a testament to French's efforts to acquire modern sculpture and to "open the eyes of the public to the fact that there is an American school of sculpture of great importance,"[39] a school he had been central in establishing, both as an artist and as a trustee.

In the late 1920s and early 1930s, economic depression and international political upheaval—as well as institutional decisions—brought further change to the status of American paintings and sculpture at the Museum. Acknowledging evolving taste, the Museum undertook its first large deaccessioning campaign in 1929—and at the same time turned down Gertrude Vanderbilt Whitney's offer of her modern collection and an endowment to pay for a new wing to

house it (see "Reckoning with Modernism").[40] And another
generational pivot in Museum personnel inevitably led
to change: in 1931 Robert de Forest, Daniel Chester French,
and Edward Robinson died, followed in 1934 by Bryson
Burroughs. The Museum upheld its commitment to histor-
ical American art during the 1930s with the purchase of
masterworks such as George Caleb Bingham's *Fur Traders
Descending the Missouri*[41] and Eakins's *The Champion Single
Sculls (Max Schmitt in a Single Scull)*,[42] as well as with mono-
graphic exhibitions—among them for Copley, Homer,
and John La Farge. But calls to diversify the collections aes-
thetically—a charge led once again by a new generation of
painters and sculptors—resounded up to the trustee level.
Writing in the *Bulletin* in 1940, curator Harry B. Wehle
acknowledged: "A review of the painters who were honored
at the beginning of this century reveals many whose works
are still found enjoyable to the museum visitor but very few
indeed who have any vital significance for progressive Amer-
ican artists."[43] The late 1930s and 1940s would usher in
bolder purchases of modernist and social realist art, a proac-
tive campaign urged by living painters and sculptors, just as
they had done a generation earlier.

Decorative Arts

Well into the first decade of the twentieth century, the
Museum's collection of Americana was sparse. The first
important piece of historical American decorative arts to
enter the collection was a silver tankard made in New York
in about 1763 that was donated in 1898.[44] The first piece of
antique American furniture, a Philadelphia rococo side
chair from the second half of the eighteenth century,[45] was
thought to be English when it entered the collection in
1908.[46] Objects like these were housed within the general
Department of Decorative Arts that was founded in 1907
under the care of Wilhelm R. Valentiner, who came to the
Metropolitan Museum from Berlin's Kaiser-Friedrich-
Museum (now the Bode Museum) (see "Princely Aspira-
tions"). His areas of expertise included ceramics and the
paintings of Rembrandt, but not American decorative arts.

All this changed in 1909, when the Metropolitan Museum
held an exhibition in conjunction with the Hudson-Fulton
Celebration, a statewide commemoration of the three
hundredth anniversary of Henry Hudson's exploration of the
river eventually named after him and of the hundredth

anniversary of Robert Fulton's first successful run up the
Hudson of his steam-powered boat, the *Clermont*. In contrast
to the commercial focus of the recent World's Fairs, which
promoted products and progress in manufacturing, the
emphasis of the two-week-long Hudson-Fulton Celebration
was educational, aiming to create "an historical awakening
throughout the State."[47] Notably, it sought to glorify New
York's colonial and early nineteenth-century history to pro-
mote assimilation following the huge wave of European
immigration that had begun in 1880 and would continue until
highly restrictive laws were passed in 1924. As the celebration
commission stated in its annual report: "Knowledge of the
history of a city, or a state, or a nation conduces to love of
country, civic pride and loyalty to established institutions. It
serves to bind a people together, make it more homogeneous
and give it stability. And it makes the inhabitants better

citizens by holding up to their eyes lofty traditions to enlist their affections and inspire their imitation."[48]

Various committees were appointed to manage the event, including one on art and historical exhibits to which the Museum lent considerable support. J. Pierpont Morgan, the Museum's president, served as chairman, while the subcommittee on art exhibits was chaired by its secretary, Robert de Forest, and included three other Museum officials. Inevitably, the group devised a major exhibition for the Museum, which in the fall of 1909 mounted the *Hudson-Fulton Exhibition*, a loan show in two parts. The first featured Dutch paintings of the seventeenth century, a reference to the fact that Henry Hudson, an Englishman, had been funded by the Dutch East India Company on his 1609 voyage in search of a Northwest Passage to Asia. Instead he landed in North America and explored the New York region and the Hudson River, laying the foundation for Dutch colonization. The second part of the exhibition was dedicated to decorative arts, showing the evolution of American domestic design from the time of the earliest settlers up to Robert Fulton's era. It was conceived by Henry Watson Kent, the Museum's assistant secretary and an expert on colonial American furniture with close ties to the day's few important collectors of Americana. His interests led him to advise his boss, de Forest, that "a museum which showed Greek,

Roman, Egyptian, Chinese, and other Eastern things surely ought to show its public the things America had accomplished." De Forest agreed, and Kent assembled an exhibition of more than six hundred examples of furniture, paintings, silver, ceramics, and other decorative objects. "This was the first time American 'antiques' were ever shown in New York," he wrote, "and they made a great hit, with public and dealer alike."[49]

The *Hudson-Fulton Exhibition* was a trial run for the development, fifteen years later, of the American Wing. Its display foreshadowed the American Wing's eventual organizing principle and design: various kinds of objects—furniture, paintings, silver, ceramics, glass, textiles—from each period were displayed together chronologically, and some platforms included architectural elements that simulated rooms (fig. 126). The show was drawn in large part from the holdings of three major collectors. The earliest furniture (forty-three pieces) was from the collection of H. Eugene Bolles of Boston; much of the later eighteenth-century furniture was owned by Bolles's cousin George S. Palmer of New London, Connecticut; and R. T. Haines Halsey of New York lent his early nineteenth-century Duncan Phyfe furniture and his extensive collection of silver. (In 1914, Halsey, a stockbroker, would become a trustee and be named chairman of the committee on American

decorative arts, making him the de facto curator responsible for the creation of the American Wing.[50])

The entire *Hudson-Fulton Exhibition* was a resounding success. It ran from September 20 through November and drew more than 300,000 visitors to the Museum while it was on view. The strong reception of the American section made clear that the Museum needed to continue to represent American decorative arts in its galleries. Even before the exhibition closed, de Forest convinced Margaret Olivia Slocum Sage, widow of a financier, to purchase Bolles's entire collection of furniture and other decorative arts for the Museum, more than seven hundred pieces in total (fig. 127).[51] De Forest was Sage's lawyer and had helped her set up the Russell Sage Foundation in 1907 in memory of her late husband. The foundation's charter simply stated that it was committed to "the improvement of social and living conditions in the United States of America." To de Forest's way of thinking, access to good art, particularly American art, was clearly a way to improve the social conditions of Americans.

Suddenly the Metropolitan Museum owned hundreds of pieces of American decorative arts but had no place to display them. A selection of objects was placed in four galleries in the wing for Western decorative arts, which opened in early 1910, but plans to establish an entire wing for the American collections were already afoot. For display in such

a wing, the first architectural room setting, from the eighteenth-century Hewlett House of Woodbury, Long Island, was purchased for the Museum in 1910 by Emily Johnston de Forest, wife of Robert, daughter of John Taylor Johnston (the Museum's first president), and the true collector in the family.[52] Robert, a dyed-in-the-wool progressive who was involved with innumerable charitable and social betterment causes throughout the city, was primarily interested in Americana's educational role; it could both teach history and help to elevate the taste of American consumers, since simple Colonial furniture could be inexpensively reproduced by modern factory methods.[53] Emily, an amateur historian who published several books about her forebears, was fascinated by the history and the aesthetics of objects, and enjoyed the collector's thrill of the chase. Her taste was far-ranging and ahead of its time.[54] In 1904 she and Robert traveled to Mexico, where she became intrigued by the tin-glazed earthenware ceramics of Puebla. Eventually she collected 169 pieces, a selection of which was exhibited in 1908 at the Hispanic Society of America, which showed the entire collection in 1911. That year Emily offered the collection to the Metropolitan Museum, writing to the trustees: "The collection is important, in my opinion, not only as representing an artistic ceramic development, but, more particularly, as representing such a development in America. It seems to me to form a part of a collection representing the arts of Mexico which I hope will at some time be represented in the Museum, as an American Museum."[55] Eventually most of the group entered the Museum, including the masterpiece of her Mexican collection, a seventeenth-century basin for washing altar linens (fig. 128).[56]

At about the same time that Emily donated the Hewlett room and the Mexican pottery, the de Forests decided to fund the building of an American wing. As Emily de Forest recalled, "My Rob, who had gradually become very sympathetic to my hobby, said to me: 'You and I are becoming more and more interested in early Americana, and the more we think about it the more we wish that such pieces of early American furniture, silver, brass, glass and china as are now scattered in the Metropolitan Museum could all be collected and shown together. . . . How would you like it if we gave to the Museum an American Wing in which some or all of these interesting things could be shown together?'"[57] The idea "thrilled" Emily, and with the help of their personal architect, Grosvenor P. Atterbury, plans for the American

128. Master Potter A. Basin. Puebla (Mexico) ca. 1650. Earthenware, tin-glazed. Gift of Mrs. Robert W. de Forest, 1912

Wing commenced. The first concrete step toward the wing's realization was the acquisition of its facade, a neo-classical marble front that had graced the Second Branch Bank of the United States (1824), which stood at 15½ Wall Street until its demolition in 1915. At Robert de Forest's request, the bank's facade was saved and stored on a vacant lot owned by the Museum until it could be repurposed for the American Wing (fig. 129).

By 1922 the fifteen historic interiors or "period rooms" that would make up the American Wing had been acquired and building had commenced under the watchful eyes of Kent, Halsey, and de Forest. The idea to install the objects in appropriate room settings was inspired by Swiss, German, and Scandinavian museums that had embraced this new way of arranging their collections. They showed the decorative arts in a "sequence of rooms, taken from historic houses architecturally expressive of given periods," with "galleries introductory to these rooms, and harmonious architecturally with them, [that displayed] the bulk of the museum material of the periods."[58] That is exactly how the American Wing was set up, with central introductory galleries on each of the three floors ringed by period rooms.[59] The uppermost floor had two seventeenth-century reproduction rooms and four rooms that were at least partially authentic, furnished to represent the first half of the

eighteenth century. The central gallery was an interpretive reproduction of the Old Ship Meeting House (1681) from Hingham, Massachusetts. The second-floor rooms were furnished with high-style American rococo furniture from the second half of the eighteenth century. The largest room on this floor was the Alexandria Ballroom (1792), taken from Gadsby's Tavern in Virginia, where George Washington attended two birthnight balls held in his honor. Portraits of the great man were displayed there, and other objects in the wing further emphasized the country's founders (fig. 130). The first floor had five Federal-era rooms surrounding a gallery that included furniture highlighting the workshop of Duncan Phyfe.

The opening of the American Wing on November 10, 1924, was cause for great celebration. De Forest, Kent, and Halsey all gave addresses at the Museum that day. De Forest's talk was genial and modest, playing down the fact that he and his wife had funded its construction. He relayed their fifty-year history of collecting Americana and remarked how the *Hudson-Fulton Exhibition* proved that "American domestic art was worthy of a place in an art museum," ultimately leading to the new American Wing.[60] Halsey gave the most pointed speech, asserting that the American Wing was an essential corrective at a time of high immigration, an idea similar to the one that had underlain the 1909 Hudson-Fulton Celebration. "The tremendous changes in the character of our nation and the influx of foreign ideas utterly at variance with those held by the men who gave us the Republic threaten, and unless checked may shake, the foundations of our Republic," he said. He viewed the American Wing as "a setting for the traditions so dear to us and invaluable in the Americanization of many of our people to whom much of our history has been hidden in a fog of unenlightenment."[61] Halsey's xenophobia should be seen in the context of the social unrest and labor struggles of the time. His point of view would also have been informed by a devastating 1920 bombing on Wall Street that was linked to Italian anarchists, which Halsey, an officer of the stock exchange, may have experienced firsthand. Many of the era's problems were blamed on the immigration boom, and stringent anti-immigration laws were enacted in May 1924, six months before the opening of the wing. Its founders believed that the "Americanization" of immigrants was one of the American Wing's most important aims. The beautiful and serene rooms were meant to teach American history

129. The American Wing with façade of the Second Branch Bank of the United States (1824), as it looked in 1924

130. Mantel installed with fireboard. Mantel: Robert Wellford (American). Probably Pennsylvania, ca. 1800. Wood, composition ornament, paint. Gift of Mrs. Francis P. Garvan, 1966. Fireboard: American, ca. 1800. Pine, paint. Rogers Fund, 1952

as well as to be aspirational settings for newcomers to the country, combining de Forest's belief in the uplifting role of the visual arts, Kent's interest in the history of the objects and architecture, and Halsey's social concerns.

The American Wing's opening proclaimed the Museum's serious interest in Americana, and gifts and purchases

followed. Old-time New Yorkers were happy to have a museum where they could donate their family treasures. One such collection arrived just before the opening, the gift of Mr. and Mrs. William A. Moore, descendants of two major eighteenth-century New York merchant families. They gave family belongings in all media, dating from the early eighteenth through the mid-nineteenth century, including the first American quilt to enter the collection (fig. 131). A notable acquisition in 1928, courtesy of the Rogers Fund, was a 1788 engraved glass goblet by John Frederick Amelung (fig. 132). Other major gifts to the American Wing came in the 1930s. In 1933 more than five hundred pieces of American silver, most of which had been on loan to the Museum for years, entered the collection as the bequest of Alphonso T. Clearwater (fig. 133). Judge Clearwater had first lent pieces of silver to the Museum in 1909 for the *Hudson-Fulton Exhibition*.[62] Another loyal lender was Natalie K. Blair, who purchased only the finest of objects for the "museum rooms" she set up in the attic of her home in Tuxedo Park, New York.[63] She gave objects from her collection to the Museum throughout her lifetime, including a unique easy

125

chair (circa 1758) with original embroidered upholstery (fig. 134) that she first lent to the American Wing in 1927. The more than fifty objects still on loan in 1952, the year she died, were bequeathed to the Museum. In 1934 Emily de Forest contributed a collection of about two hundred Pennsylvania German artworks, including furniture, metalwork, textiles, and pottery. Much of this was displayed in two rooms of Pennsylvania German woodwork that were annexed to the wing, which in merely a decade had proven too small for the growing collections.

The building continued to expand, with galleries and period rooms added somewhat haphazardly, until the wing was completely redesigned under the Museum's comprehensive 1970 master plan. That year—the centennial of the Museum's founding—the ambitious exhibition *19th-Century America* brought about a renewed appreciation for American paintings, sculpture, and decorative arts. Just as the *Hudson-Fulton Exhibition* had served as a test run for the future American Wing, the 1970 show inspired the expansion of that building to include galleries for American art of all media up until about 1920. When the New American Wing opened in 1980, paintings, sculpture, and decorative arts were finally shown all together. Although the collecting strategy at the time remained focused on traditional Euro-American art, the chronological span expanded. Today new areas of strength include a broad range of nineteenth- and early twentieth-century decorative arts, such as Aesthetic Movement furniture and art pottery, and later nineteenth-century period rooms, culminating with the Frank Lloyd Wright Living Room (1913–15). In recent years the American

Wing has broadened its vision beyond the established canon of historical American art by including works from colonial Latin America (following Emily de Forest's lead) as well as by African American, Native American, and women artists (see "Broadening Perspectives").[64] While the American Wing remains a place for teaching both aesthetic appreciation and American cultural history, the goal of including more expansive American artistic traditions has supplanted the goal of creating homogeneity via the "Americanization" that was once deemed so important.

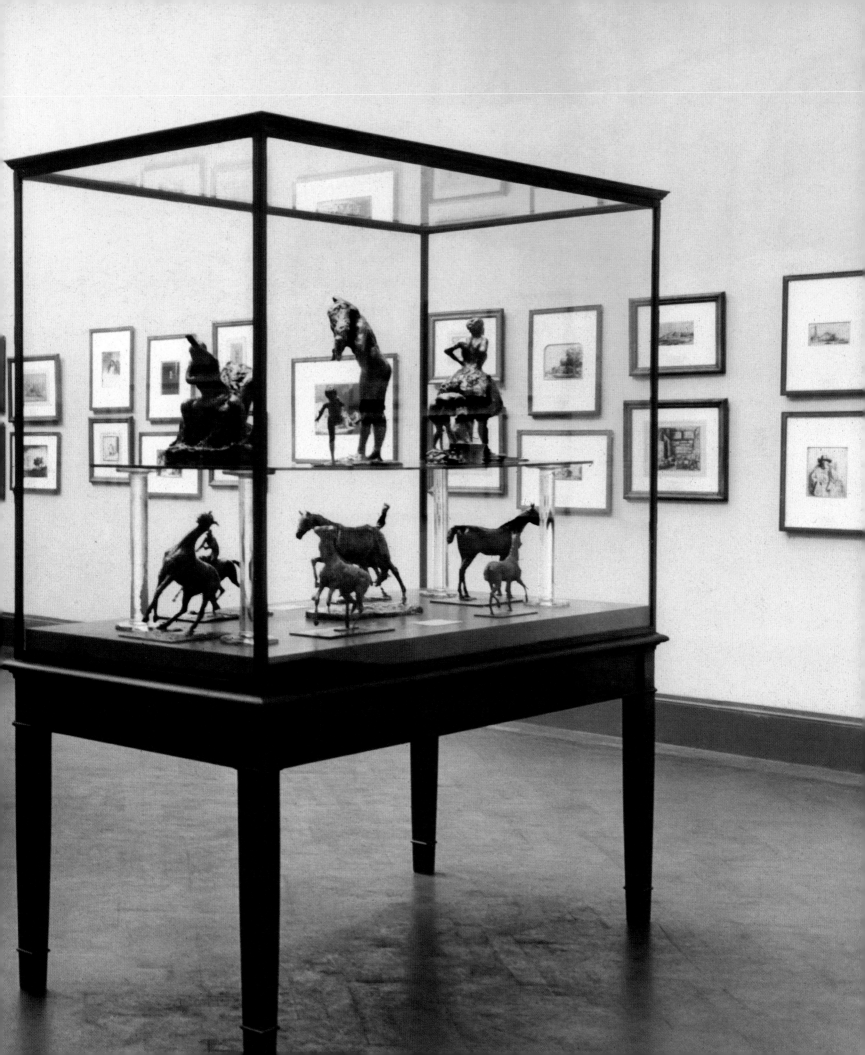

Visions of Collecting

Laura D. Corey and Alice Cooney Frelinghuysen

In December 1881 Henry Osborne Havemeyer wrote to the Metropolitan Museum's first director, Luigi Palma di Cesnola, acknowledging receipt of an exceptionally fortu-itous piece of misdirected mail. It seems the Museum had intended to court a different Henry Havemeyer, distin-guished by his middle initial and an address uptown. Never-theless, the present Havemeyer, known as H. O. or Harry, expressed pleasure in becoming a patron, sent a check for $1,000, and was promptly listed in the annual report among the institution's early supporters, marking the beginning of an outstanding philanthropic legacy.[1]

Nearly half a century later, after the death of Harry's widow, Louisine, in January 1929, the Museum became the beneficiary of 1,967 objects from the Havemeyers' renowned collection.[2] Director Edward Robinson hailed the bequest as "one of the most magnificent gifts of works of art ever made to a museum by a single individual, not only because of its richness in numbers but because everything in it is of the highest quality."[3] The bequest was remarkable for its range, from old master and Impressionist paintings to Roman glass, Islamic pottery, and Asian works in all media. It transformed the holdings of multiple departments and, in the assessment of critic Frank Jewett Mather, "[made] the Metropolitan the premier Museum for nineteenth century French art in America, and one of the two or three most distinguished . . . in the world."[4] The press seized on the news, not only in New York, where the *Times* alone pub-lished more than thirty related articles over the next year, but also across the country and abroad.[5] Unveiled in March 1930—a celebratory moment in the wake of the stock mar-ket crash—the bequest was seen by a staggering 266,765 visi-tors during its eight-month exhibition before the objects were dispersed throughout the Museum.[6]

The Havemeyers brought a new vision of collecting to the Metropolitan Museum, reflecting the distinctive tastes Harry and Louisine cultivated through friendships with American artists that trace back to their individual forays into the art market. Both were New Yorkers by birth and started buying art on their travels. It was on Harry's trip with painter Samuel Colman and presumably designer

Louis C. Tiffany to the nation's Centennial Exhibition in Philadelphia in 1876 that he launched his collection with the purchase of a large group of Japanese textiles, lacquerware, and inro.[7] Around the same time Louisine was introduced to Impressionism by Mary Cassatt, the only American member of that French avant-garde circle, on visits to exhibitions and galleries in Paris that laid the foundation for a lifelong collecting partnership. Louisine was immediately captivated: "I felt then that Miss Cassatt was the most intelligent woman I had ever met, and I cherished every word she uttered and remembered almost every remark she made. It seemed to me that no one could see art more understandingly, feel it more deeply or express themselves more clearly than she did."[8] With Cassatt's encouragement, Louisine bought an Edgar Degas ballet scene (which initially seemed "so new and strange" to her), followed by a Claude Monet river view, a Camille Pissarro fan, and a Cassatt self-portrait, making her one of the first American collectors of Impressionism.[9]

Following their marriage in 1883, Harry and Louisine became a trailblazing and prolific collecting duo, bolstered by a strong conviction in their personal tastes, artists who advised them to explore new fields, and a generous income from the profits of Harry's sugar-refining company, which became the second trust in America in 1887. Their collection was well known among art enthusiasts during their lifetimes. They opened their Tiffany-designed home at Fifth Avenue and Sixty-Sixth Street to invited guests on Tuesdays during the winter and on Sundays for musicales and art viewing, and they lent regularly to exhibitions.[10] The Havemeyers had a long-standing commitment to sharing their art with the public, stemming from a firsthand understanding of the value of museums. Louisine recalled in her memoirs the foundational experience of visiting a gallery in Naples when she was only fourteen, and later in life she was passionate about museum education for young people, concluding: "Yes, let them see the best pictures at the earliest possible age. Youthful impressions are very vivid, and . . . may have an important influence upon their lives."[11]

These beliefs informed their support of the Metropolitan Museum from the 1880s onward. In 1888 Harry bought Gilbert Stuart's *George Washington* for the institution because he felt an American museum should have an iconic portrait of the nation's founding father.[12] The same year, he purchased and lent pendant Rembrandt van Rijn portraits

to display in the paintings galleries.[13] Harry reportedly said "it was by no means improbable" that he would give his prized Rembrandts to the Museum one day, should New Yorkers judge them favorably.[14] In 1890, with their home under construction, they further supplemented the Museum's nascent collection with a loan of fourteen pictures by Rembrandt, Frans Hals, Pieter de Hooch, Camille Corot, Eugène Delacroix, Constant Troyon, and others.[15] The *New York Times* declared that "[t]he old complaint that American cities had no 'old masters' to educate the eyes of pupils in the fine arts is fast becoming pointless. The Marquand and Havemeyer collections contain a large number of priceless works by the masters of the past."[16] Their early contributions align with the dominant taste of the day for seventeenth-century Dutch painting, nineteenth-century French Salon and Barbizon painting, and portraits of historical figures and attest to the high standards of quality associated with their collection.[17] In support of public access to art, Harry donated $10,000 in 1892 to open the Museum on Sundays to accommodate working citizens. His gift accounted for nearly two-thirds of the necessary funds, a noteworthy gesture of support, especially considering he was never made a trustee.[18]

The first cornerstone gift from the Havemeyers, a harbinger of their ultimate impact on the institution, was a set of fifty-five extraordinary vessels by Louis C. Tiffany, which introduced American glass into the Museum in 1896. No doubt encouraged by the artist himself, Louisine and Harry were among the earliest collectors to seriously embrace Tiffany's hand-blown, iridescent, and colored Favrile glass (fig. 135). On December 8, 1896, Harry wrote the Museum's president Henry G. Marquand: "Mr. Louis Tiffany has set aside the finest pieces of their production, which I have acquired for what I consider to be their artistic value. Their number now is such that I am disposed to offer the collection, which is one of rare beauty."[19] Acclaimed for their novel colors and textures, these works are exemplars of the revolutionary direction Tiffany was taking in glass. The peacock vase, with its evocation of the eye and oily surface of that bird's feathers, is one of the most spectacular. Inspired by nature, others suggest plant motifs. At the time of the gift, Harry made an unusual request, specifying that the glass was to be arranged by Tiffany personally, with Colman's help. The two men had decorated and furnished the Havemeyers' house, which reflected the couple's taste

135. Louis C. Tiffany (American), Tiffany Glass and Decorating Company (American). Five vases, 1893–96. Favrile glass. Gift of H. O. Havemeyer, 1896

136. The second floor of the Havemeyers' Tiffany-designed two-story paintings gallery with "flying" staircase, 1 East Sixty-Sixth Street, New York, ca. 1890–92

with its inventive eclecticism, replete with glass-mosaic walls, Near Eastern–inspired lighting fixtures, elaborate filigree work in the balustrades and fireplace screens, and a dramatic suspended staircase in the picture gallery (fig. 136).[20] The Havemeyers' 1896 gift inspired Tiffany himself to lend to the Museum some twenty-seven examples from his personal collection (those vases were eventually given to the institution by his foundation in 1951).[21]

After Harry died in 1907, Louisine carried on expanding the collection and sharing it with the public. Ludwig Justi,

director of the Nationalgalerie in Berlin, praised her as "one of the real pioneers of the art life of your country," when reflecting on his tour of collections across the United States in 1909.[22] That year, Louisine took up Harry's legacy by contributing Dutch pictures to the landmark *Hudson-Fulton Exhibition* at the Metropolitan Museum,[23] and she began to make her own mark on the institution, discreetly at first, with anonymous loans of her nineteenth-century French paintings. She offered Edouard Manet's *The Dead Christ with Angels* (fig. 137) for long-term loan and agreed to

Robinson's request to borrow Gustave Courbet's *Woman with a Parrot* (fig. 138) to satisfy artists who had been asking for nudes to study in the galleries.[24] Manet and Courbet were safe choices, both dead for more than twenty-five years and already represented in the collection, yet these were bold compositions. Imposing in scale and provocative in the treatment of the nude figure—one sacred, one profane— the paintings had been purchased expressly to keep them in America for public benefit and never found a place in the Havemeyers' house. Louisine referred to the *Dead Christ* as a "museum Manet" that "crushed everything beside it and crushed [her] as well."[25] Similarly, she recalled that she had "begged" her husband to buy the Courbet, "not to hang it in our gallery lest the anti-nudists should declare a revolution . . . but just . . . that such a work should not be lost . . . to the students who might with its help, and that

of other pictures, some day give a national art to their own country."[26]

The staff and trustees of the Metropolitan Museum were not as quick as Louisine had been to recognize the significance of French modern art. It is worth remembering that Impressionism emerged as an avant-garde alternative to academic art in the 1870s, just as Louisine was beginning to collect and the founding trustees were organizing the Metropolitan Museum. As an upstart museum seeking to establish its authority, the institution adopted a collecting strategy that prioritized sanctioned art of the past and, selectively, its own national heritage. The question of whether or not to acquire "modern" art would prove to be an ongoing challenge. Early exceptions to the reluctance to display the avant-garde art of the founding era came about by gift or loan. Of particular note are the two Manets that

Erwin Davis gave to the Museum in 1889 (see fig. 33). In 1906, twenty years after the last Impressionist exhibition in Paris, William Church Osborn lent three Monets and a Pissarro, which curator Bryson Burroughs proclaimed was the first time Impressionist pictures were "exhibited at the Museum to any extent."[27] Still, in 1909, the year Louisine lent her Manet and Courbet, the *New York Times* ran an article with the sensationalized headline: "Sir Purdon Clarke on the 'Impressionists': The Director of the Metropolitan Museum Arraigns Them as Faddists Whose Art Is Meaningless, Insincere and of No Lasting Value."[28]

While Louisine remained relatively conservative with her loans, outside the museum she was an outspoken advocate for women's suffrage (fig. 139)[29] and deployed her Impressionist paintings for the cause. In 1915 she arranged a benefit exhibition at the New York gallery M. Knoedler and Co. with more than forty works by Degas and Cassatt, accompanied by a lecture and pamphlet in which she recounted her interactions with the artists.[30] The tides were turning at the Metropolitan Museum as well. Burroughs wrote about the development of nineteenth-century French painting in a *Bulletin* article in 1918, alluding to gaps in the Museum's holdings.[31] The following year, he was more direct: "The most conspicuous lack in the Museum collection of modern pictures is the absence of any paintings by Degas. His importance is no longer disputable; indeed, there are now but few who hesitate to place him in the company of the greatest French masters."[32] He would have

to wait another decade for the Havemeyer bequest to fully answer his plea. In the meantime Louisine increased the pace of her loans, such as by contributing eleven paintings to the Courbet retrospective she helped Burroughs organize in 1919 and the artist's *Madame de Brayer* to the 1921 *Loan Exhibition of Impressionist and Post-Impressionist Paintings*.[33] That exhibition sparked controversy among the press and public, yet it was not the Courbets or even the Manets and Monets that drew criticism but the works of the new avant-garde, especially those by Henri Matisse and Pablo Picasso.[34] Near the end of her life, between 1923 and 1927, Louisine finally lent from her Degas collection a group of sculptures for display in the gallery of modern French paintings. Curator Joseph Breck touted the occasion as the American debut of Degas's seminal *Little Fourteen-Year-Old Dancer* (fig. 140), a bronze cast of the one sculpture the artist exhibited during his lifetime.[35]

By the end of the 1920s, Impressionism had secured its place in the canon of art history. The French state transferred its collection from the Musée du Luxembourg to the revered galleries of the Louvre.[36] The Museum's American peers in Boston and Chicago had also surpassed the Metropolitan in their commitment to the Impressionists, with exhibitions and acquisitions.[37] Critics began to appeal to the public to address this deficiency in the popular press. Walter Pach dedicated an entire book in 1928 to castigating the Museum for ignoring modern French art as a pivotal period of art history and challenged artists to spearhead an

advancement in taste.[38] How fortunate, then, that for nearly fifty years, Cassatt had served as Louisine's "fairy godmother," helping her assemble a premier collection, which altered the course of the Museum upon Louisine's death in 1929.[39] The over two hundred works of nineteenth-century French art from the Havemeyer bequest laid the foundation of what has become one of the most celebrated areas of the Museum's collection.

Louisine's will originally designated 142 works of art, mostly pictures, for the Museum and allowed her children to consult with the curators to select any additional objects they deemed suitable. Virtually every department was enhanced. Curator William M. Ivins Jr. called the bequest the most significant gift made to the print room, highlighting the estimable group of thirty-four Rembrandt etchings and drypoints.[40] Masterpieces by Rembrandt, Lucas

Cranach, Paolo Veronese, Bronzino, and others were hung prominently among the Dutch, German, and Italian paintings, harking back to Harry's loans in the 1880s and 1890s. Yet, above all, the bequest stood out because Louisine and her husband had "flouted the taste of their time by going hot-headed for El Greco and the Impressionists," and the Museum at long last became the beneficiary of their visionary connoisseurship.[41]

The gift contained a near-complete representation of the work of Degas, with 112 objects in all media. The Museum had bought prints and drawings from the artist's estate sale in 1918 and acquired a milliner pastel in 1922 but did not have a single painting or sculpture by the artist until the 1929 bequest.[42] The paintings span his career from the 1860s to 1890 (fig. 141), with images of dancers, portraits, and various figure studies. Among the pastels are six remarkable bathers, a series that defied conventions of femininity when it debuted at the final Impressionist exhibition in 1886 and that Cassatt described as "for painters and connoisseurs," skeptical that the public could appreciate the nudes even more than twenty years later (fig. 142).[43] Like Manet's *Dead Christ* and Courbet's *Woman with a Parrot*, these pictures

142. Edgar Degas (French). *Woman Having Her Hair Combed*, ca. 1886–88. Pastel. H. O. Havemeyer Collection, Bequest of Mrs. H. O. Havemeyer, 1929

143. Edgar Degas (French). *Dancer Adjusting Her Slipper*, 1873. Graphite heightened with black and white chalk. H. O. Havemeyer Collection, Bequest of Mrs. H. O. Havemeyer, 1929

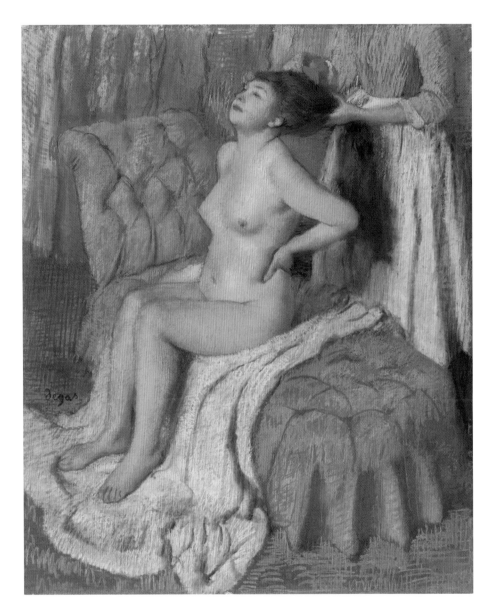

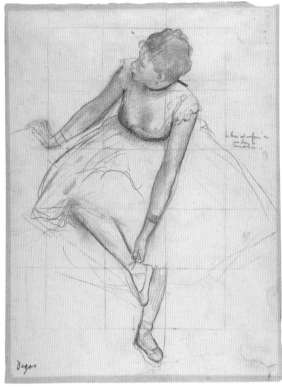

reveal the Havemeyers' openness to the more challenging subjects tackled by the "painters of modern life." Several works on paper illustrate the importance of their friendships with artists, including three drawings selected for them by Degas on a visit to his studio in the company of Cassatt (fig. 143).[44] The sixty-nine bronze sculptures in the bequest are another tribute to Louisine's patronage (see pp. 128–29), for she was given priority to secure the first cast of each due to her long-standing relationships with Degas and Cassatt.[45]

The Havemeyers were devoted supporters of Cassatt's work, and their bequest supplemented the Museum's budding holdings with two signature mother and child paintings (fig. 144), two late pastels, and twenty-three drypoints and aquatints. Among the Cassatts already in the collection in 1929, ten had ties to the Havemeyers, a reminder that their influence extended beyond their direct contributions. In 1922 the Museum acquired a group of nine paintings and pastels by Cassatt through Ernest Stillman from the estate of his father, James, former president of National City Bank of New York and a friend of the Havemeyers.[46] They had introduced James to Cassatt, and he went on to accumulate the largest body of her work outside of her family. Ernest made the unusual stipulation that the Metropolitan Museum could select from among the nineteen Cassatts in his father's collection and distribute the rest to American

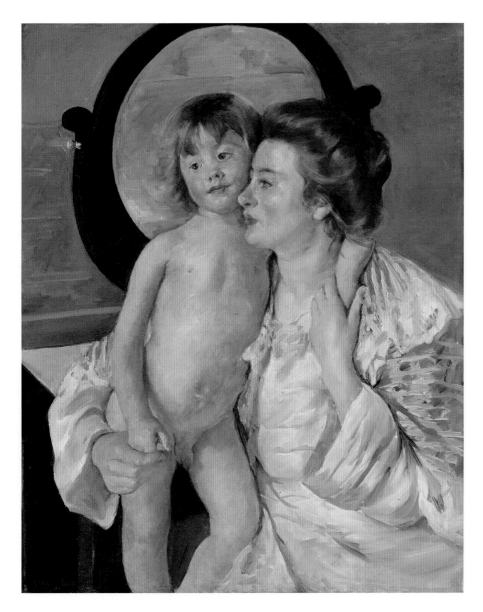

museums that did not yet own her work. Satisfied with the results, Cassatt agreed, through Louisine's intercession, to donate her masterful *Lady at the Tea Table* to the Museum in 1923 (fig. 145).[47]

Further amplifying the nineteenth-century collections, the Havemeyer bequest gave the Museum its first painting by Pissarro and its second by Pierre-Auguste Renoir.[48] The Monet collection blossomed from a sole landscape[49] to include two floral still lifes from the 1880s and four series paintings from the 1890s, exemplars of the style of Impressionism that had grown popular among American collectors in the last generation.[50] The Havemeyers had also inherited Cassatt's affinity for Monet's then less-fashionable early

output, represented by two paintings in the bequest. Cassatt's mother once described *The Green Wave* as "certainly one of those [images] which it would take an artist to appreciate."[51] The other, Monet's *La Grenouillère* (fig. 146)—painted less than a year before the Museum was founded—has since been regarded as an "icon in the history of Impressionism" and "the starting point from which Impressionism proper was to be developed during the 1870s."[52] The Havemeyers' regard for such works is a testament to their prescient taste.

Louisine and Harry were among the original American patrons of Paul Cézanne, the pivotal progenitor of modern painting and the only Post-Impressionist whose work they

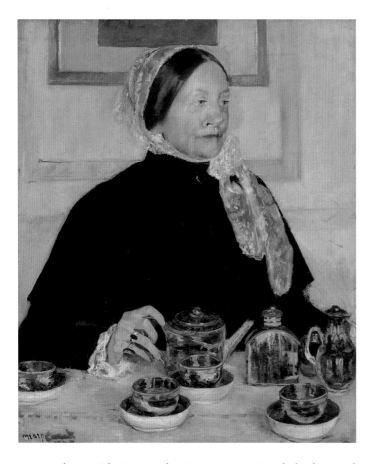

acquired. As with Monet, the Museum previously had owned only a single canvas by the artist, purchased at the Armory Show in 1913.[53] The five Havemeyer paintings by Cézanne brought his portraits, still lifes, and a key example of the Mont Sainte-Victoire series to the collection (fig. 147).[54] From the earlier part of the century, the twelve Corots and twenty-one Courbets in the bequest added an influx of largely figurative works, including the first nudes (see fig. 138), to the Museum's holdings, hitherto dominated by the landscapes most collectors of the era preferred. Of no less importance, the Havemeyers' nine Manets built on the two initial Davis gifts with three commanding Spanish toreador paintings, the first of his pastels in the collection, and such major works as *Boating* and the *Dead Christ* (see fig. 137) that have since presided over the nineteenth-century paintings galleries.[55]

Like Manet, Cassatt, and several of the other French artists whose work they collected, the Havemeyers became fascinated with Spanish painting.[56] They traveled off the beaten track for works by El Greco and Goya beginning on a trip through Spain with Cassatt in 1901,[57] and their acquisitions incited a new trend in American collecting. The

Museum subscribed to this genre more readily than Impressionism and made purchases with Rogers Fund monies of an El Greco in 1905 and a Goya in 1906.[58] It missed the opportunity, however, to buy El Greco's monumental *Assumption of the Virgin* that Harry and Louisine helped bring to America in 1904 and that took pride of place at the Art Institute of Chicago two years later, a symbol of the couple's broad reach as tastemakers.[59] Yet, neither the Havemeyers nor Cassatt were infallible in their quest for Spanish old masters. As they ventured into relatively uncharted territory, they encountered new obstacles, like the pitfalls of false attributions in an era before significant scholarship and documentation. Still, while all five of the so-called Goyas they gave to the Museum have since been questioned, the two El Grecos they discovered on that first trip—*Cardinal Fernando Niño de Guevara* (fig. 148) and the *View of Toledo*[60]—are considered masterpieces of the artist's oeuvre.

While the Havemeyer name may be associated most readily with European paintings, Asian works of art outnumbered any other category in the bequest.[61] During their lifetimes and as part of the bequest, the couple gave the Museum some two thousand Chinese, Japanese, and Korean objects in diverse media—from prints, screens, lacquerware, inro, tea wares, and sword furnishings to porcelains and bronzes. By 1896 Harry had already given the Textile Study Room an extensive collection of Japanese silk fragments, purchased from the Parisian dealer Siegfried Bing, a champion of Japanese art, and donated at the suggestion of either Tiffany or Colman.[62] Tiffany himself was an avid collector of Japanese swords and sword fittings, and the Havemeyers followed suit, no doubt also drawn to the highly decorative designs and meticulous craftsmanship of these objects. They amassed a large collection of sword guards (*tsuba*): one of the finest examples features a miniaturized folding screen with gold and silver inlay of chrysanthemums (fig. 149). Notably, such combinations of gold, brass, and copper on a dark ground with patterning of floral or animal motifs were among the inspirations for Edward C. Moore's designs for Tiffany and Company at the same moment.

The Havemeyers' varied collections of Asian art mostly conformed to the avant-garde Parisian tastes of the day, promulgated by Bing and others, rather than the conservative and highly decorative tastes of their American contemporaries.[63] Cassatt was probably the prevailing influence on their preferences in Japanese prints, which the Impressionists

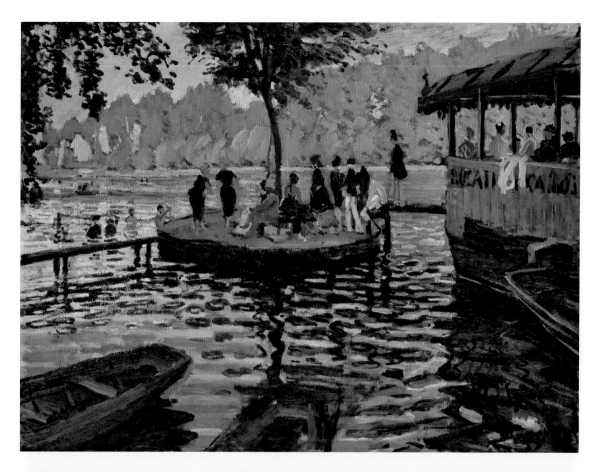

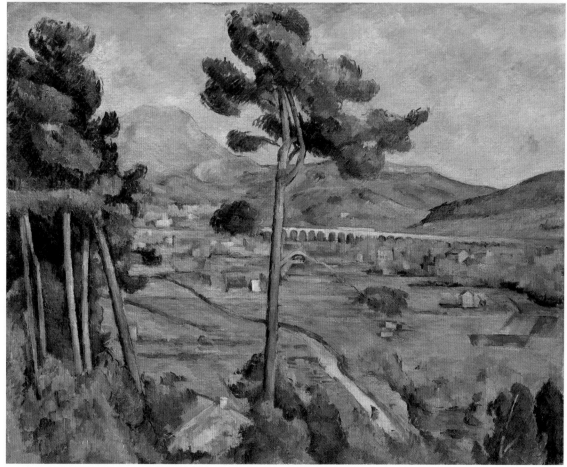

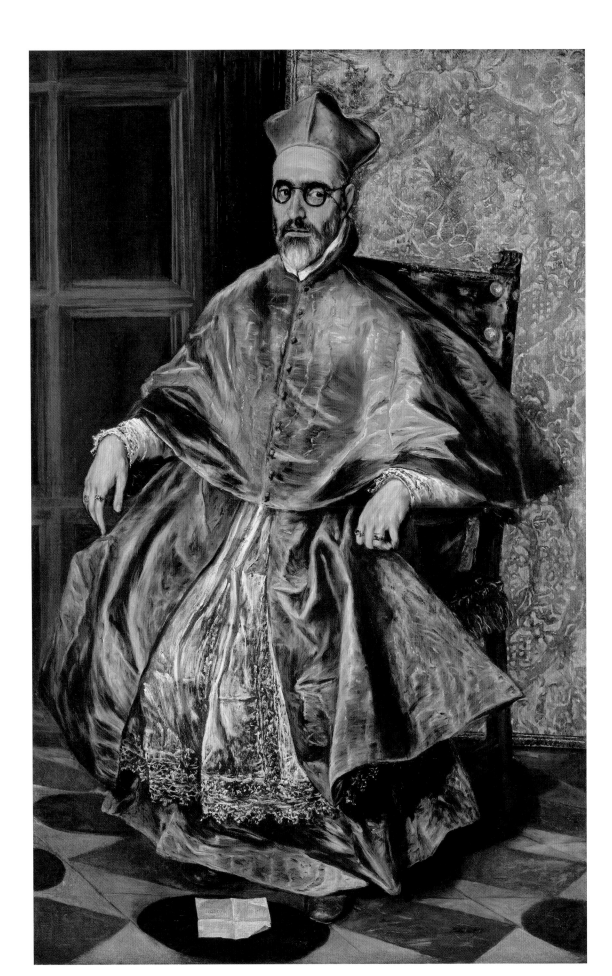

148. El Greco (Greek). *Cardinal Fernando Niño de Guevara*, ca. 1600. Oil on canvas. H. O. Havemeyer Collection, Bequest of Mrs. H. O. Havemeyer, 1929

studied for their flat surfaces, novel perspectives, and subject matter drawn from daily life. The 1929 bequest contained fine *surimono* albums, unique compilations of high-quality woodblock prints with pictorial motifs, poetry, and other texts that were privately published and usually issued as New Year's greetings. Their set of three albums assembled by Hayashi Tadamasa, the noted Parisian dealer of Japanese art, has over four hundred prints by numerous artists, including the best and largest selection in the world of works by Kubo Shunman, who made a specialty of these deluxe commissioned prints. There were more than three hundred *ukiyo-e* prints by such nineteenth-century Japanese masters as Katsushika Hokusai, Utagawa Hiroshige, and Kitagawa Utamaro. Among the highlights is a marvelous impression of Hokusai's famous *Great Wave* (fig. 150) and an impressive group of Utamaro's images of women (fig. 151) and women with children that resonate with works by Cassatt and Degas the Havemeyers prized.[64]

The couple's curiosity and willingness to learn about new cultures and styles shaped their patronage. In a particularly touching vignette, Harry recalled Louisine's reaction to the arrival of a case of tea caddies in 1884, shortly after their marriage. Though unfamiliar with these objects, she carefully opened the boxes and decorative silk bags that held the small, beautiful, brown-glazed jars (fig. 152) that were

"so soft you want to hold them in your hand, and so lovely in color you cannot but admire them."[65] Louisine took seriously her role as the de facto curator of the Havemeyers' collection and meticulously recorded and labeled the individual works, creating a special HOH Collection label that she affixed to the bottom of the vases, lacquerware, and bowls. Their philosophy of display—to present objects in an aesthetic way—went hand in hand with their desire to educate through their collection. For example, when Harry and Louisine visited the noted Boston scholar Edward Sylvester Morse to view his holdings of tea caddies, they were dismayed by how the objects were arranged by their classification, more in keeping with lining up work as if it were an ethnological exercise. She later recalled Harry's exclaiming: "Did you ever see such an arrangement? . . . He puts that magnificent vase beside those others not fit to cook in. Who is going to look at a lot of stuff like that just to see one fine thing? . . . Educate the people to know what is beautiful and they can do all the classifying they want to later."[66] Such was their interest in the aesthetics of their environment that when the Museum asked to borrow some Chinese bronzes for an exhibition, in a rare instance, Harry declined the loan, explaining that they "are so distributed through the house that it would be impossible for me to remove them without damage to the surroundings."[67]

One of their most cherished objects was a Chinese stoneware Song dynasty tea bowl (fig. 153). Remarkable for its simplicity and spare design of a leaf on the interior, it was considered at the time, perhaps a bit inflated by today's standards, to be a masterwork of Chinese ceramics, and the object of much admiration on the part of scholars and connoisseurs around the world for "the form, the size, the paste, the tooling, the edge or lip, the design, the simplicity, the style and above all the color."[68]

With regard to Japanese lacquerware, they favored the more unusual examples associated with Ritsuō, or Ogawa Haritsu, whom Bing very much admired. Ritsuō used novel techniques, materials, and motifs to achieve a new aesthetic in lacquer decoration.[69] Many of the Ritsuō examples in Western collections have not stood the test of time and are now considered to be late nineteenth-century forgeries. A genuine eighteenth-century writing box from the Havemeyer bequest, however, is exceptionally fine (fig. 154). Original in its use of ceramic inlay, it depicts three mice chewing on a fan that is inscribed with a haiku. Echoing the poem's meaning, the box illustrates the natural process of decay. Two mice are shown fully, while the third is depicted with its head emerging from the top as if it had just gnawed through it. Rather wonderous and humorous in its concept and execution, when opened, the underside of the cover shows the rest of the mouse's body.[70]

New scholarship has led to reattributions and reassessments, most notably for the hanging scroll *Kshitigarbha* (fig. 155). At the time of the bequest in 1929, it was accepted

as an important example of Japanese Buddhist painting of the fourteenth or fifteenth century. Several decades later, however, Museum scholars reattributed it as a Korean work of the Goryeo dynasty, dating to the first half of the fourteenth century; it is now recognized as one of the important Korean works to enter the Museum's collection in the early twentieth century.[71]

The Havemeyers' avant-garde aesthetic appreciation extended to Islamic works of art as well, an interest they shared with Moore, Tiffany, and Colman. The interiors of their house displayed distinctive Islamic references, and they were among the earliest American collectors of Islamic art, especially pottery made in Raqqa, Syria, and Kashan. As Cassatt became their critical advisor on paintings, and Tiffany and Colman on Asian art, the dealer Dikran Kelekian was the principal influence on their acquisitions of Persian pottery. After her husband's death, Louisine continued to collect Islamic art, particularly ceramics, a love she passed on to her son, Horace. Mother and son often visited dealers in each other's company, and Louisine periodically presented him with examples to mark birthdays or Christmases. Only two years after his mother's death, Horace lent some sixty-six items to the Museum's *Loan Exhibition of*

Ceramic Art of the Near East.[72] More importantly, from 1929 until his death in 1956, Horace was clearly carrying out his mother's wishes and philanthropic legacy when he donated two important carpets and numerous examples of Islamic pottery, including a large Iranian tile panel with ornate arabesques in metallic lusters (fig. 156).

Philanthropy was embedded in Louisine's DNA. When writing late in life to her children, she imparted these words of wisdom: "never forget how blessed you are and when an opportunity offers, try to equalize the sum of human happiness and share the sunshine that you have inherited."[73] They more than followed her instructions. The Havemeyers' commitment to the Museum and to sharing their works of art with the public extended through the generations,

first with Horace's gifts of Islamic works, and followed in 1962 with the donation of five Japanese folding screens by his elder sister, Adaline Havemeyer Frelinghuysen.[74] The next generation notably presented a Degas pastel of a ballet dancer at the barre, a Cassatt portrait of Adaline Havemeyer as a young woman, Japanese daggers, and a partial gift of Manet's powerful early seascape *The "Kearsarge" at Boulogne.*[75]

The Havemeyers' impact on the Museum would be greater than the sum of the works of art given during their lifetimes, by bequest, or even by their descendants. Harry and Louisine were potent tastemakers who influenced other American collectors, like James Stillman. The couple also inspired their friend Colonel Oliver Hazard Payne, a Civil

War brigadier general turned investor who lived in an apartment attached to the Havemeyers' home, to buy major paintings by Goya, Courbet, and Degas now at the Museum.[76] According to Louisine, in 1898 Harry "relinquished" *The Dance Class* (fig. 157), encouraging Payne to buy the coveted painting instead, "just to try to make his friend . . . appreciate Degas as he did."[77] They regretted not acquiring the picture themselves, but, by virtue of Payne's descendants, it assumed a permanent place alongside the Havemeyer works at the Museum in 1987, after having been lent each summer for decades.[78]

Subsequent generations of donors have taken stock of the Havemeyer collection when considering their gifts. Stephen C. Clark, of the Singer Sewing Company family,

carefully selected which of his works to distribute to the Museum and other institutions.[79] Among the paintings by Cézanne, Degas, Renoir, Seurat, and El Greco in his 1961 bequest is a superb still life (fig. 158) that the Havemeyers originally brought to America.[80] Thirty years later, the Honorable Walter H. Annenberg announced that he and his wife Leonore would leave their sought-after collection of more than fifty Impressionist and Post-Impressionist pictures to the Metropolitan Museum with the statement, "Much as I respect the other institutions that have lately shown our collection—the Philadelphia Museum of Art, the Los Angeles County Museum of Art and the National Gallery of Art in Washington—I happen to believe in strength going to strength, and I think that the Met is the proper repository

158. Paul Cézanne (French). *Still Life with a Ginger Jar and Eggplants*, 1893–94. Oil on canvas. Bequest of Stephen C. Clark, 1960

159. Claude Monet (French). *Camille Monet on a Garden Bench*, 1873. Oil on canvas. The Walter H. and Leonore Annenberg Collection, Gift of Walter H. and Leonore Annenberg, 2002, Bequest of Walter H. Annenberg, 2002

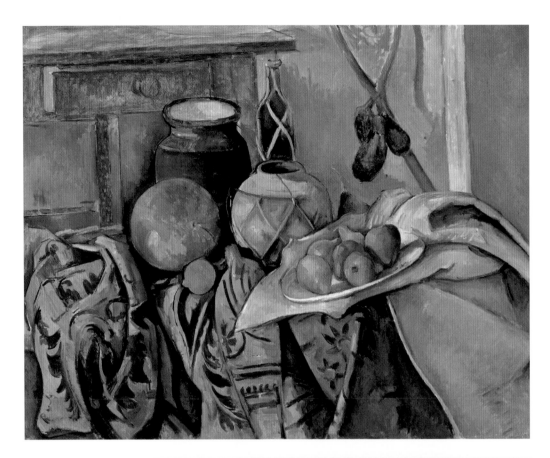

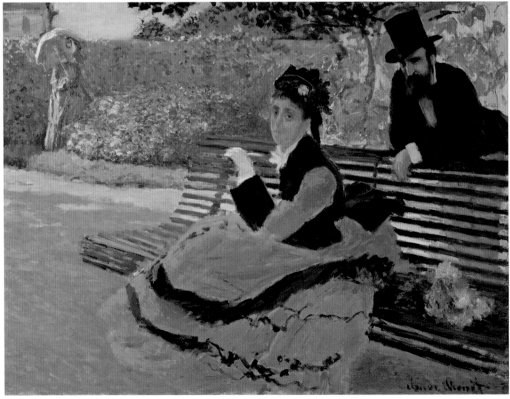

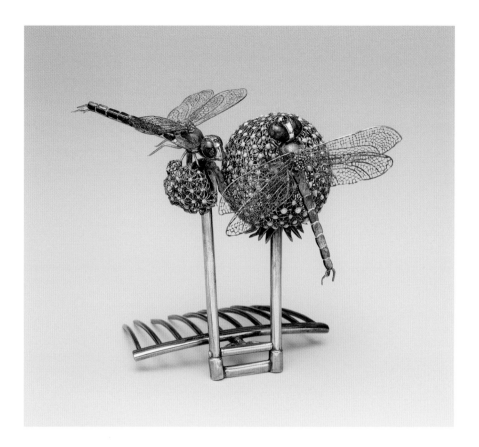

for them."[81] With their own discerning eyes, the Annenbergs augmented areas of strength anchored by the Havemeyer bequest, as with Monet (fig. 159) and Cézanne. And they had a transformative effect just beyond the Havemeyers' purview, most prominently with the addition of seven paintings by Van Gogh (fig. 6) to the existing eleven at the Metropolitan Museum, creating the largest holding of his work on this side of the Atlantic. While the Museum's eminent collection of nineteenth-century French art now reflects the vision of many donors and curators over more than a century of development, the major gifts of the Havemeyers and Annenbergs bookend the defining attributes of the collection, from Courbet to Van Gogh.

A fitting coda, attesting not only to the Havemeyers' taste but also to their philanthropic legacy, is the remarkable hair ornament designed by Louis Tiffany for Louisine and donated by their great-granddaughter Linden Havemeyer Wise in 2002 (fig. 160). Taking the form of two dandelion seed balls with two dragonflies, it was made about 1904, the year that Tiffany introduced his jewelry designs to the public at the Louisiana Purchase Exposition in St. Louis. The common field flower is seen in a fading state, and in a nod to the

ephemeral nature of living things, one of the puffs is portrayed as partially blown away. Two dragonflies set with opals and with delicate filigree wings alight on the dandelions. Wise, former legal counsel of the Museum, expressed her sentiments on donating this precious object in a letter accompanying the gift: "[H]ow fortunate I feel to have the opportunity to experience and share in the satisfaction my great-grandparents took in adding to the collections of the Metropolitan Museum. . . . It strikes me that this is the real reward in giving to this Museum—knowing the enjoyment and stimulation these works of art bring to the Museum's public."[82] From the exquisite creations of Tiffany to the vibrant canvases of the Impressionists, the Museum owes a great deal of its color to works of art, now much beloved, that the Havemeyers helped bring to light. Bold and perspicacious, with eyes trained by artists, they played a decisive role in expanding the scope of the collection during a period of significant change for the maturing institution. A testament to the avant-garde taste of the era in which it was formed, the Havemeyer collection still serves as a touchstone for the Museum's commitment to the evolving ideals of modernity and diversity, quality and beauty.

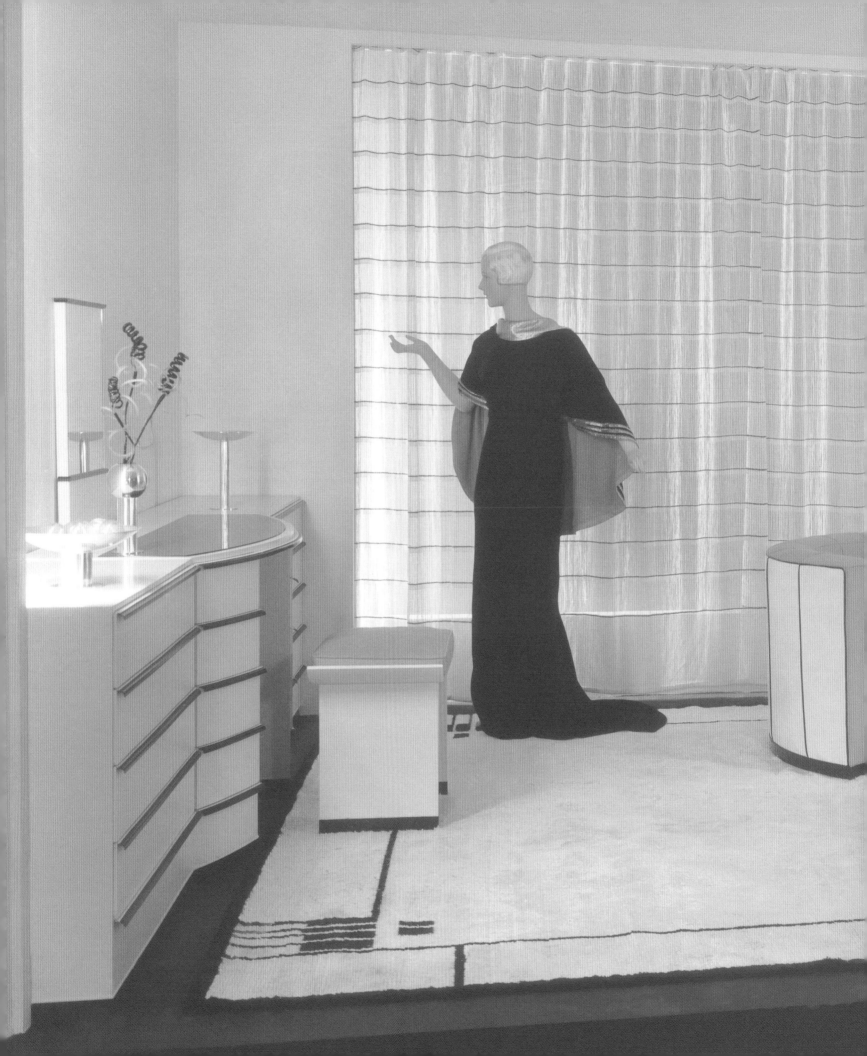

Reckoning with Modernism

Douglas Eklund, Marilyn F. Friedman, and Randall R. Griffey

The Metropolitan Museum confronted modern art warily in the early twentieth century. While the term "modern" encompassed, as it does even today, a wide range of definitions, by the interwar period it carried distinctly stylistic connotations—especially regarding abstraction and experimentation in painting and sculpture, about which the Museum remained skittish. A hint of its trepidation can be gleaned from a comment by Henry Watson Kent, the Museum's secretary, who cautioned: "To buy the modern in haste is to repent at leisure."[1] Yet even as it hesitated to embrace modernism in painting and sculpture, the Museum forged new and ambitious paths of collecting and exhibition programming that ranked it among the country's leading art institutions in the area of pioneering industrial design. At the same time, its early forays into modern photography can be attributed not to institutional aspirations but to strategic donations by Alfred Stieglitz, a tireless champion of photography who helped cement its status as art worthy of inclusion at museums like the Metropolitan.

Photography

"The Metropolitan Museum has opened its sacred halls to Photography," wrote Stieglitz to a friend in December 1928, boasting, "My photographs have performed the miracle!"[2] The Museum's board of trustees had just accepted his gift of twenty-two photographs—the first to enter the collection as art. Stieglitz was not only a master photographer (fig. 161) but also a powerful tastemaker. He introduced the American public to the best of modern art and photography through his influential and luxuriously printed journal *Camera Work* (1902–17) and his Little Galleries of the Photo-Secession (1905–17), known to insiders simply as "291," its address on Fifth Avenue. Stieglitz was also his gallery's best client, supporting the artists he most admired by purchasing

161. Alfred Stieglitz (American). *Georgia O'Keeffe—Hands and Thimble*, 1919. Palladium print. Gift of Mrs. Rebecca S. Strand, 1928

162. Paul Strand (American). *Blind Woman, New York*, 1916. Platinum print. Alfred Stieglitz Collection, 1933

163. Charles Sheeler (American). *Doylestown House—The Stove*, 1917. Gelatin silver print. Alfred Stieglitz Collection, 1933

their work and, as a result, building an impressive collection of early twentieth-century art, including photographs.

Placing photography side by side with the other arts at the nation's preeminent museum had been a dream of Stieglitz's since the century began. In 1902 the Museum's first director, Luigi Palma di Cesnola, summoned the photographer with a request from Prince Luigi Amedeo, duke of Abruzzi. Cesnola had been charged by the duke with gathering American works of art for the Esposizione Internazionale di Arte Decorativa Moderna, opening that May in Turin, and the duke—himself an amateur photographer—wanted Stieglitz to provide works from his unparalleled collection. Never one to miss an opportunity, Stieglitz agreed to Cesnola's request—on the condition that the prints he chose would be accepted into the Museum's collection and exhibited after the show in Turin. Cesnola's astonished reply—"Why, Mr. Stieglitz, you won't insist that a photograph can possibly be a work of art . . . you are a

fanatic"—is one of the most famously shortsighted statements in the history of photography. Stieglitz's response—that he is a fanatic who will be proven right by time—captures both his missionary zeal and his moxie, which over a half century of exhaustive effort secured photography's status as contemporary art.[3]

Cesnola's death in 1904 voided the gentleman's agreement he had with Stieglitz to accept his selection for the Turin exposition into the Museum's collection, but Stieglitz continued to push for photography's institutional recognition. His efforts paid off at the end of the decade in a landmark 1910 exhibition he organized at the Albright-Knox Art Gallery in Buffalo, New York; it featured six hundred photographs by sixty-five artists of the Photo-Secession, the loose-knit group of photographers in his circle, Pictorialists whose gauzy images suggested the brushy aesthetic of paintings and works on paper. The following year the Albright-Knox became the first American museum to

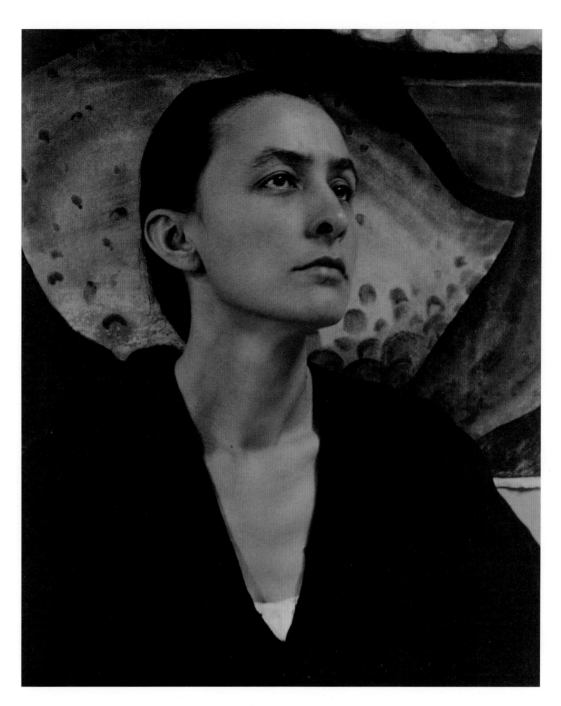

acquire photographs as works of art, bringing into its collection a dozen of the exhibited works. That milestone prompted Stieglitz to write to German collector Ernst Juhl: "The dream that I had in 1885 in Berlin has been realized—the full recognition of photography by an important art museum!"[4] He remained determined that his collection would wind up at the Metropolitan Museum, but it would take more than two decades for that to happen.

After closing his 291 gallery in 1917, Stieglitz threw himself anew into his own photography, seizing upon the possibilities suggested by the artists with whom he surrounded himself. Newcomer Paul Strand fused old strands of Pictorialism into a capacious and innovative vision that

encompassed nearly abstract Cubist-inspired still lifes, volumetric machine studies, and a brawny but formally elegant form of lyrical urban documentary that would be his longest-lasting contribution (fig. 162). Likewise, the painter-photographer Charles Sheeler fulfilled Stieglitz's call for an authentic American modernism by finding abstract style in the folk vernacular of Shaker furniture (fig. 163).

By this point Stieglitz's own photographs were reflecting what Sarah Greenough described as the "dense patterning and compression of pictorial space" pioneered by the American painters he championed.[5] In other words, the photographer was grafting the language of advanced painting onto a medium that, in its broadest non-art manifestations, was

seen by Cesnola and the rest of the art establishment as largely illustrative in function. But it was likely Stieglitz's 1916 encounter with the young painter Georgia O'Keeffe that unlocked what was original in his art, a sensuous, haptic intimacy that Maria Morris Hambourg, founding curator of the Museum's Department of Photographs, described as a "rigorously framed, lushly aesthetic, and transcendent naturalism removed from the din and grit of the city."[6] In the best of his portraits of O'Keeffe, Stieglitz achieved an emotional equipoise between artist and subject that was natural and unforced, and in which feeling is a form of knowledge (figs. 164, 165).[7]

Stieglitz's presentation in 1928 of twenty-two of his own photographs for accession to the Museum was shepherded by William M. Ivins Jr., the curator of prints, who had known Stieglitz for years (see "Art for All"). They cannily maneuvered the acquisition as a gift that would not require any cash outlay by the trustees; the photographs came in as donations by well-heeled supporters of both Stieglitz and the Museum such as Alma Morgenthau Wertheim. Offering gifts had eased Stieglitz's way into institutional collections

four years earlier, when he donated sixteen of his photographs to the Museum of Fine Arts, Boston—the second museum after the Albright-Knox to acquire photographs as works of art.

If Stieglitz's 1928 gift pried the Museum's doors slightly ajar, he threw them wide open in 1933 with a gift of 419 Pictorialist works that provided the nucleus around which the entire photography collection would be built.[8] Among the many indisputable masterworks in the gift are Gertrude Käsebier's *Blessed Art Thou Among Women* (fig. 166) and Edward J. Steichen's three monumental prints of the Flat-iron Building, each in different hues, representing different aspects of twilight in the city (figs. 167–69). These were supplemented by the bequest of 199 photographs following Stieglitz's death in 1946. Many of the works have what Stieglitz called "royal blood," being the very prints he exhibited in his galleries, sent to exhibitions around the world, and reproduced in *Camera Work*. All together, Stieglitz's gifts propelled the Metropolitan to the forefront of museums collecting artistic photography. The collection is the richest anywhere of works by the Photo-Secession.

166. Gertrude Käsebier (American).
Blessed Art Thou Among Women, 1899.
Platinum print. Alfred Stieglitz Collection,
1933

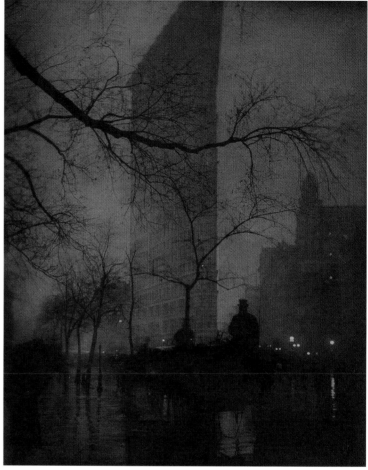

Photography was actively and in many cases daringly collected at the Metropolitan Museum over the succeeding decades by curators in the Department of Prints, including Ivins, A. Hyatt Mayor, and John J. McKendry. Notable additions in the 1930s include 591 views of the American Civil War,[9] a unique album of 36 works by William Henry Fox Talbot, the British inventor of photography,[10] and 61 portraits by the nation's premier daguerreotypists, Albert Sands Southworth and Josiah Johnson Hawes.[11] The following decade 55 photographs by Thomas Eakins and his students at the Pennsylvania Academy of the Fine Arts entered the collection by gift and purchase.[12] Also noteworthy were the acquisitions in 1969 and 1974, respectively, of two photographs by Diane Arbus[13] and 229 color photographs from Stephen Shore's American Surfaces series, made the previous year.[14]

The medium garnered heightened attention from the late 1960s through the 1970s, a pivotal time when only a handful of cognoscenti recognized the important works that were coming to auction.[15] Savvy private collectors such as Samuel J. Wagstaff Jr., Pierre Apraxine (for Howard Gilman), and John C. Waddell were quick to seize the opportunity; they were able to buy with a speed and in amounts that the slow-moving museum world never could. The private collectors thus led the way in the connoisseurship and the formation of a photographic canon that the medium's institutional and academic acceptance relied on.[16] Their collections were, however, destined for encyclopedic museums, and they worked closely with curators to develop them. With photography's rising stature and in anticipation of its collection's growth, the Museum established an independent Department of Photographs in 1992.

Design

By contrast to the comparatively new field of photography, which the Museum initially embraced reluctantly, design

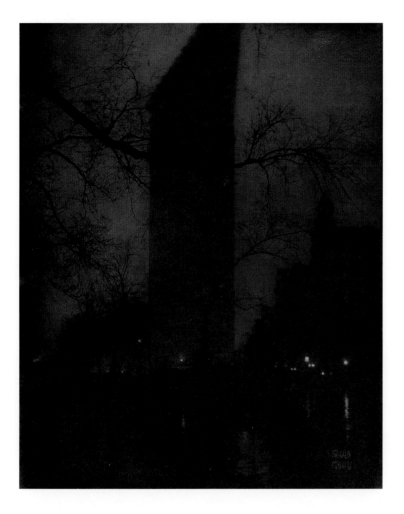

objects and decorative arts had been acquired for the collection from the outset, a history that led it naturally to add contemporary works. Indeed, with an ambitious program of acquisitions, exhibitions, and outreach, the Museum was instrumental between the wars in introducing European modern design to the American public and in nurturing the development of American modern design. The effort was spearheaded by Robert W. de Forest, the Museum's president, Henry Watson Kent, secretary of the board of trustees, and two key museum employees: Joseph Breck, who acquired and exhibited some of the best examples of European modern decorative arts, and Richard F. Bach, who mounted exhibitions of industrial arts to inspire American designers and manufacturers to experiment with new styles. (The term "decorative arts" was generally understood to denote hand-wrought materials, while "industrial arts" denoted machine production, though the line between them was and is unclear. Here, the two are subsumed in

the term "modern design.") In furtherance of its goal to encourage and develop "the application of arts to manufacture and practical life,"[17] the Museum in 1914 inaugurated a series of lectures for buyers and salespeople at department stores, which was intended to improve design standards. That was followed in 1917 by *The Designer and the Museum*, an exhibition meant to demonstrate and promote designers' use of the collections as a resource.

Bach was hired in 1918 to augment the Museum's efforts in this sphere by coordinating with manufacturers, designers, artisans, and craftspeople; making the collections available to them; and exhibiting their work. With an anticipated increase in consumer-related manufacturing and purchasing after World War I, the Museum saw this as an essential endeavor.[18] Initially, objects in Bach's exhibitions were required to have been inspired by objects in the collections. At that point Bach seems not to have been interested in a particular style or mode of production; his goal was

159

170. Jean E. Puiforcat (French). Tea and coffee service, ca. 1922. Silver, lapis lazuli, ivory, gold. Purchase, Edward C. Moore Jr. Gift, 1923 and 1925

to "assist the trades . . . in formulating a better concept of taste in industrial art" and to see to it that the Museum would "take the leadership, to become the patron of American industrial art, to make itself the workbench of a national taste."[19]

Breck, curator in the Department of Decorative Arts, focused on modern design in the early 1920s. His ambitious program of acquisitions was supported by a 1922 pledge by Edward C. Moore Jr. to give funds to the Museum each year for five years for the purchase of "examples (of only the very finest quality) of the modern decorative arts of America and Europe."[20] In 1923 the Museum opened a new gallery of modern decorative arts and mounted an exhibition of objects Breck purchased with Moore funds. Of the pieces shown, perhaps the most emblematic of Breck's taste was a silver coffee and tea set embellished with lapis lazuli, ivory, and gold, by French master silversmith Jean E. Puiforcat (fig. 170). Puiforcat employed traditional forms and materials but signaled his embrace of modernity by substituting for traditional applied ornament or repoussé an exaggerated form of fluting, which presaged an emphasis on geometric forms in modern design. Two candelabra in bronze and marble by American sculptor Paul Manship similarly look both forward and backward, with stylized images of biblical and mythological figures.[21] Recommending the acquisition of the candelabra, Breck hoped that "the purchase by the Museum would induce other sculptors to take an interest in making objects of utilitarian value."[22] Also exhibited in 1923 were a silver and coral box in the form of a fantastical bird by Austrian designer Dagobert Peche (fig. 171) and a textile with stylized flowers by French designer Paul Poiret (fig. 172).

In 1923 France announced plans for an International Exposition of Modern Decorative and Industrial Arts, to be held in Paris two years later. The invitation to prospective participants specified that every object in the exposition had to be an original design. Following the French lead, the Metropolitan Museum in 1924 eliminated the requirement that objects in what were then titled "Industrial Arts" exhibitions be based on its collections. Bach thereafter sought to create via the annual exhibitions a record of American design. In particular, he was interested in designs that could be

171. Dagobert Peche (Austrian). Bird-shaped box, 1920. Silver, coral. Purchase, Edward C. Moore Jr. Gift, 1922

172. Paul Poiret (French). Textile, ca. 1920. Printed linen. Purchase, Edward C. Moore Jr. Gift, 1923

171. Dagobert Peche (Austrian). Bird-shaped box, 1920. Silver, coral. Purchase, Edward C. Moore Jr. Gift, 1922

produced in quantity from a mold or model, which he viewed as "a democratic expedient for meeting the requirements of the mass."[23]

Both Bach and Breck visited the exposition in Paris in 1925, Bach to report on it as a member of a delegation appointed by Herbert Hoover, then the secretary of commerce. Breck, whose purpose was to view and acquire objects for the Museum, found the exhibits to be of great interest. In a letter to de Forest, he expressed his hopes for the next generation of designers and craftspeople, who were "being emancipated from the 'dead hand' of the historic styles."[24] He purchased many objects shown and commissioned a cabinet by Emile-Jacques Ruhlmann after seeing one that had been purchased by the French government (fig. 173). The *"Etat"* cabinet embodies what we now term "Art Deco," a style characterized by expensive materials, inlaid stylized floral or geometric designs, and clarity of

form.[25] Breck did not, however, favor the European designers who embraced the machine and new materials, asserting that "if a new style is to live, it must attach itself to the main stem of tradition."[26] In his correspondence from the Paris exposition, he made no mention of Le Corbusier's L'esprit nouveau pavilion, a model home, or other exhibits by the more avant-garde French designers.

In 1926 the Museum mounted two modern design shows. An exhibition of objects from the Paris exposition introduced Americans to Art Deco, and the tenth American industrial arts exhibition presented contemporary American design. Yet Bach was convinced that the Museum had to do more to mobilize manufacturers and dealers to encourage the public to buy design that was truly modern. In support of Bach's efforts, de Forest chaired the advisory committee for exhibitions of modern design at the department store R. H. Macy and Company in 1927 and 1928. De Forest

believed that art should permeate every object in the home, and that good art need not cost more than bad art.[27] In 1927 the Museum received from Stehli Silks Corporation a gift of textiles from its Americana Prints collection, many of which had been exhibited at Macy's (fig. 174).

Also in 1927 the Museum mounted an exhibition of Swedish contemporary decorative arts, inspired in part by Breck's visit to the Paris exposition's Swedish Pavilion, whose exhibits he praised for "freshness of expression—without violent departure from tradition."[28] Among the numerous pieces the Museum purchased from its own exhibition was a vase of hand-engraved crystal that depicted

women dressed in fashionable modern garb (fig. 175), precisely the kind of modern design Breck admired.

With three more major exhibitions of industrial arts, in 1929, 1934 (see pp. 150–51), and 1940, the Museum sought to give credibility to the modern movement; all three were heavily promoted, widely covered in the periodicals of the day,[29] and extremely well attended, especially the 1929 exhibition, which attracted some 186,000 visitors.[30] In the show's catalogue, Bach posited that as "neutral ground" the Museum was well positioned to mount a "sincere effort in favor of contemporary design."[31] Indeed, one critic noted that "in penetrating into the Metropolitan the official stamp

of approval has been placed upon [modern art] as a true and worthy expression of our day."[32] In 1934 the emphasis was again on designs that could be produced in quantity, in response to criticism that many of the objects and installations shown in 1929 were not affordable to the general public. Bach was determined to demonstrate with the 1940 exhibition that the "sharp line of distinction" between "the industry of the machine and the industry of the hand" was difficult to place, and that both hand and machine were integral to modern design.[33]

Following the death of Joseph Breck in 1933, efforts to collect modern decorative arts diminished. The Department of Decorative Arts was dissolved and its objects distributed among other departments. In the 1970s and 1980s the

Museum acquired a number of significant decorative art objects, including a chair designed by Eliel Saarinen that was shown at the 1929 industrial arts exhibition (fig. 176) and additional examples of Art Deco. But the Museum would not resume an aggressive program to collect modern design until the late 1990s.

Painting and Sculpture

Despite the Museum's groundbreaking engagement with modern photography and design in the early twentieth century, its relationship with other aspects of modernism was ambivalent, especially with regard to the new painting and sculpture that challenged conventional definitions of beauty

177. Diagram showing the proposed
Whitney Wing at the Metropolitan
Museum, 1946

and quality. Even so, the Museum boasts a few notable firsts in modern art, including being the first American museum to acquire works by Henri Matisse and Paul Cézanne. Three Matisse drawings joined the collection in 1910 thanks to a gift from Florence Blumenthal, who purchased them from an exhibition at Stieglitz's 291 gallery.[34] The Museum acquired Cézanne's *View of the Domaine Saint-Joseph*[35] from the 1913 Armory Show, which, as the country's largest showcase of European and American modern art to that date, was as controversial as it would prove to be influential.[36] To a degree the Museum was obliged to engage with contemporary American painting by virtue of conditions of the George A. Hearn Fund, which provided for acquisitions of works by artists alive in or born after 1906 (see "Creating a National Narrative").[37] The Museum was generally more amenable to American modernism than to avant-garde European art for two reasons: the former tended to be less stylistically experimental than the latter and it also supported the institution's long-standing priority to educate immigrant communities about their adopted homeland through art.

However notable as firsts, the Matisse and Cézanne acquisitions did not initiate a substantial, sustained commitment to collecting and showing modern painting, in part because the Museum questioned the value of work untested by the passage of time. Another reason was that the public remained largely unfamiliar with many aspects of modern art (particularly more recent experimental developments in Europe, such as Dada and Surrealism) and was unaccustomed to seeing it in the context of institutions like the Metropolitan Museum. Indeed, a public protest erupted in response to its 1921 exhibition of Impressionist and Post-Impressionist painting (see "Visions of Collecting").[38]

But the most significant factor shaping the Museum's uncomfortable relationship with modernism in the 1930s and 1940s was the emergence of the Whitney Museum of American Art and the Museum of Modern Art (MoMA). The Metropolitan Museum famously played a key role in the Whitney's founding in 1929, when it declined Gertrude Vanderbilt Whitney's offer of her collection of contemporary American art; it subsequently became the nucleus of her namesake museum. In the *Bulletin* the following year, curator Bryson Burroughs simultaneously lauded the opening of the Whitney and justified his own institution's lack of commitment to modern art: "Our present-day productions can be readily seen [at the Whitney] and . . . judged for what they are in themselves without the unfair competition of the well-winnowed art of the past ages which they would be subjected to in a museum of wider scope."[39] MoMA's launch in 1929 only highlighted the need to clarify, even formalize, the museums' distinct boundaries and respective missions. The two institutions sought to develop an alliance modeled on that of Paris's Musée du Luxembourg and Musée du Louvre, which coordinated activities and chronological "territories" to complement each other. A formal agreement, announced in November 1934, provided for older works from MoMA's collection to transfer over time to the Metropolitan Museum, and for MoMA to exhibit modern and contemporary American art the Metropolitan Museum had acquired through its Hearn Fund, gifts, and other purchases.

The landscape of New York's museum culture was poised to shift yet again following Gertrude Vanderbilt Whitney's death in 1942, when the Metropolitan Museum and the Whitney entered into discussions to join forces. In

178. Pablo Picasso (Spanish). *Gertrude Stein*, 1905–6. Oil on canvas. Bequest of Gertrude Stein, 1946

the thirteen years since the Metropolitan Museum had declined Whitney's offer, new considerations and possibilities had emerged. The Whitney's collection had grown substantially in stature with the addition of such masterworks as Edward Hopper's *Early Sunday Morning*, and the patriotic milieu attending wartime enhanced the cultural currency of American art generally. Negotiations culminated in a plan in which the Whitney collection would transfer to the Metropolitan Museum and eventually be featured in a new wing built and named in honor of the collector (fig. 177).[40] The war forestalled planning for the Whitney Wing, however; in hindsight that was a harbinger (among others) of the plan's fate ultimately to fail.

Well-intentioned but intensely complicated institutional efforts to parse and to coordinate missions extended into the 1940s. One outcome was the reification of the Museum's identity as a repository of historical art, notwithstanding the ongoing activity of the Hearn Fund. In 1947 the three museums announced an alliance that

clarified their primary fields: the Whitney's in American art, MoMA's in American and foreign art "of the present and recent past," and the Metropolitan Museum's in "visual arts of the past, both American and foreign."[41] Following this logic, the Metropolitan Museum and MoMA agreed to long-term loans of works that seemed more appropriate for the other institution. (One notable result was that Pablo Picasso's portrait of Gertrude Stein [fig. 178], an icon of the Metropolitan Museum's modern holdings, went on view briefly at MoMA, until Alice B. Toklas intervened in defense of Stein's expressed desire that the painting be seen at the Metropolitan Museum.) In addition, MoMA agreed to serve as a collection pipeline for the Metropolitan Museum, as "modern" art would become "classic" with the passage of time.

As the three-museum agreement came into focus, Georgia O'Keeffe informed the Metropolitan Museum that it was among six institutions that would receive a significant part of the collection amassed by Stieglitz, who had died

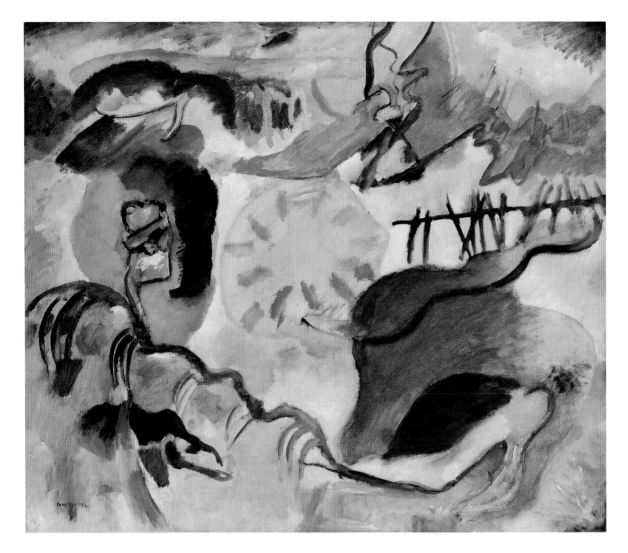

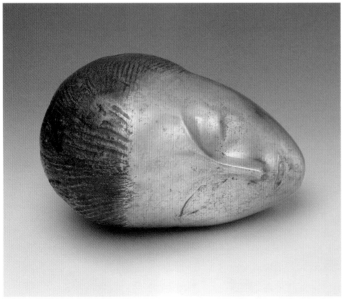

in 1946.[42] Ensuring that her husband's impact at the institution extended beyond photography, O'Keeffe's deposition included major works of European and American art that are now considered cornerstones of its modern collection. This trove includes Vasily Kandinsky's *Improvisation 27 (Garden of Love II)* (fig. 179), which Stieglitz acquired from the Armory Show; Constantin Brancusi's *Sleeping Muse* (fig. 180); Charles Demuth's *I Saw the Figure 5 in Gold* (fig. 181); Marsden Hartley's *Portrait of a German Officer*;[43] and O'Keeffe's *Cow's Skull: Red, White, and Blue* (fig. 182).

Under the terms of the museums' agreement, many of the works in the Stieglitz bequest would have been redirected to MoMA; indeed, Alfred H. Barr Jr., MoMA's director, inquired about the status of the bequest in a letter to the Metropolitan Museum's Francis Henry Taylor on September 20, 1948. However, this prospect was rendered moot

181. Charles Demuth (American). *I Saw the Figure 5 in Gold*, 1928. Oil, graphite, ink, and gold leaf on paperboard (Upson board). Alfred Stieglitz Collection, 1949

182. Georgia O'Keeffe (American). *Cow's Skull: Red, White, and Blue*, 1931. Oil on canvas. Alfred Stieglitz Collection, 1952

as the agreement began quickly to unravel. Contributing to its disintegration was Juliana R. Force's decision in February 1948 to withdraw from her position as the Metropolitan Museum's advisor for contemporary American art purchases over differences of opinion with Taylor. Force had worked closely with the Whitney and served as the integral link between the two institutions; after her departure, the Whitney withdrew from the agreement. That precipitated the Metropolitan Museum's reengagement with contemporary American art, and in a more concerted way; in January 1949 it appointed Robert Beverly Hale as associate curator responsible for contemporary art in the newly formed Department of American Painting and Sculpture. The Metropolitan Museum and MoMA remained in the agreement a few years longer, but the complexities of the deal beleaguered both institutions. In 1953 the *New York Times* announced the discontinuation of the formal arrangement, quoting John Hay Whitney, chairman of MoMA's board: "The museum has come to believe that its former policy, by which all the works of art in its possession would eventually be transferred to other institutions, did not work out to the benefit of the public."[44] The Metropolitan Museum would finally establish its own department dedicated to twentieth-century art in 1967 (see "The Centennial Era").

Filling Gaps

The Museum's uneven track record on modernism produced numerous collection lacunae, but beneficence from generous donors and collectors and commitment from later curators, particularly in the 1980s and 1990s, allowed it to fill several critical gaps. The Metropolitan Museum's 1984 acquisition of Heinz Berggruen's great Paul Klee collection made the Museum an important center for the study and appreciation of the artist's work.[45] A significant group of works by Italian Futurist Umberto Boccioni, including a cast of his iconic sculpture *Unique Forms of Continuity in Space*,[46] entered the collection by bequest in 1989. The bequest of Florene M. Schoenborn in 1995 contributed major paintings by Giorgio de Chirico, Fernand Léger, Joan Miró, Picasso, and other eminent European modernists. An even more chronologically expansive and stylistically eclectic cross section of twentieth-century art arrived in 1998 with the Jacques and Natasha Gelman Collection,[47] whose masterworks include Balthus's provocative painting *Thérèse*

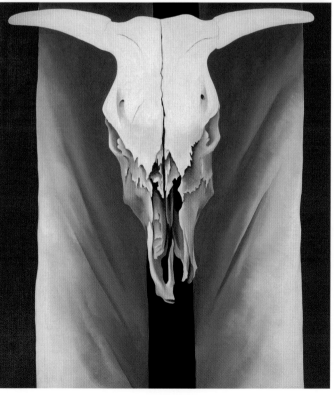

Dreaming[48] and Alberto Giacometti's haunting bronze *Woman of Venice II*.[49] The acquisition of the Mr. and Mrs. Klaus G. Perls Collection in 1997 strengthened considerably the Museum's representation of the School of Paris, boasting key examples by Amedeo Modigliani, Chaim Soutine, Picasso, and others.

Similarly, the collection of modern design filled out as the twentieth century came to a close. An imbalance between handcrafted design, which had formed the bulk of the Museum's modern design collection, and machine-made design, which Bach had exhibited but not acquired, was finally corrected in 1998 with a gift of American products of industry from the 1920s and 1930s from John C. Waddell. His gift brought to the Museum artifacts of its own exhibition history: a variant of the tea service designed by Eliel Saarinen (fig. 183) that was displayed at the 1934 industrial arts exhibition and Walter von Nessen's "Continental" coffee set,[50] also shown in 1934. Also presented by Waddell were objects that had been contemporaneously exhibited at other New York venues, including a lamp designed by Donald Deskey that epitomized the zig-zag Art Moderne of the late 1920s (fig. 184) and a bowl of electroplated nickel silver designed by Ilonka Karasz that relied solely on geometric forms for interest.[51] And while Bach's exhibitions had focused on domestic needs, the Waddell gift brought into the Museum such industrial objects as a commercial meat slicer[52] and an outboard motor.[53] Works like those proclaimed the importance of

thoughtful modern design in every object, no matter its purpose or price point.

Waddell was also responsible for the second great collection (after the Stieglitz gifts) that helped form the core of the new Department of Photographs. Working with curator Maria Morris Hambourg, Waddell assembled five hundred supreme examples of European and American modernist photography that he intended, just as Stieglitz had, for the Metropolitan Museum. It joined the Museum in 1987 as the Ford Motor Company Collection and includes major works by Berenice Abbott, Brassaï, Walker Evans, André Kertész, El Lissitzky, László Moholy-Nagy, and Man Ray (figs. 185–87).[54]

Acquisitions of major collections continue to enhance the Museum's holdings of modern art in the twenty-first century. Arriving in 2002, the Pierre and Maria-Gaetana Matisse Collection of paintings, sculpture, and drawings— one of the largest donations made to the Department of Modern and Contemporary Art—strengthened particularly

185. El Lissitzky (Russian). *Runner in the City*, ca. 1926. Gelatin silver print. Ford Motor Company Collection, Gift of Ford Motor Company and John C. Waddell, 1987

186. László Moholy-Nagy (American, born Hungary). *Fotogramm*, 1926. Gelatin silver print. Ford Motor Company Collection, Gift of Ford Motor Company and John C. Waddell, 1987

187. Man Ray (American). *Compass*, 1920. Gelatin silver print. Ford Motor Company Collection, Gift of Ford Motor Company and John C. Waddell, 1987

169

the Museum's holdings of Surrealism, with significant paintings by Leonora Carrington, René Magritte, Miró, and many more.[55] In 2005 the Gilman Paper Company Collection of more than 8,500 photographs came to the Museum, which had exhibited many of its highlights since 1993.[56] Rich in early British, French, and American photography as well as works from the turn-of-the-century and modernist periods, the Gilman Collection catapulted the Museum's photography holdings to world-class status. A 2014 gift by Dr. David Landau and Marie-Rose Kahane of forty-four works in glass created by Italian architect Carlo Scarpa in 1932–47 added dimension to the Museum's important collections of Swedish and American glass of the period. The current and promised gifts of the Leonard A. Lauder Cubist Collection,

a remarkable trove of oil paintings, works on paper, collages, and sculpture by Georges Braque, Juan Gris, Fernand Léger (fig. 188), and Pablo Picasso, will distinguish the Metropolitan Museum's holdings of this period as one of the finest of any public institution. The significance of this transformational act of cultural philanthropy was heralded in the press, and the story made front-page news for the *New York Times*, on April 9, 2013, with Picasso's extraordinary *Woman in a Chemise in an Armchair* (fig. 189) featured as one of the many collection highlights.[57] Alongside his gift, Leonard Lauder also provided significant support for the creation of the Leonard A. Lauder Research Center for Modern Art at the Metropolitan Museum, a scholarly resource that promotes intensive intellectual engagement with twentieth-century art.

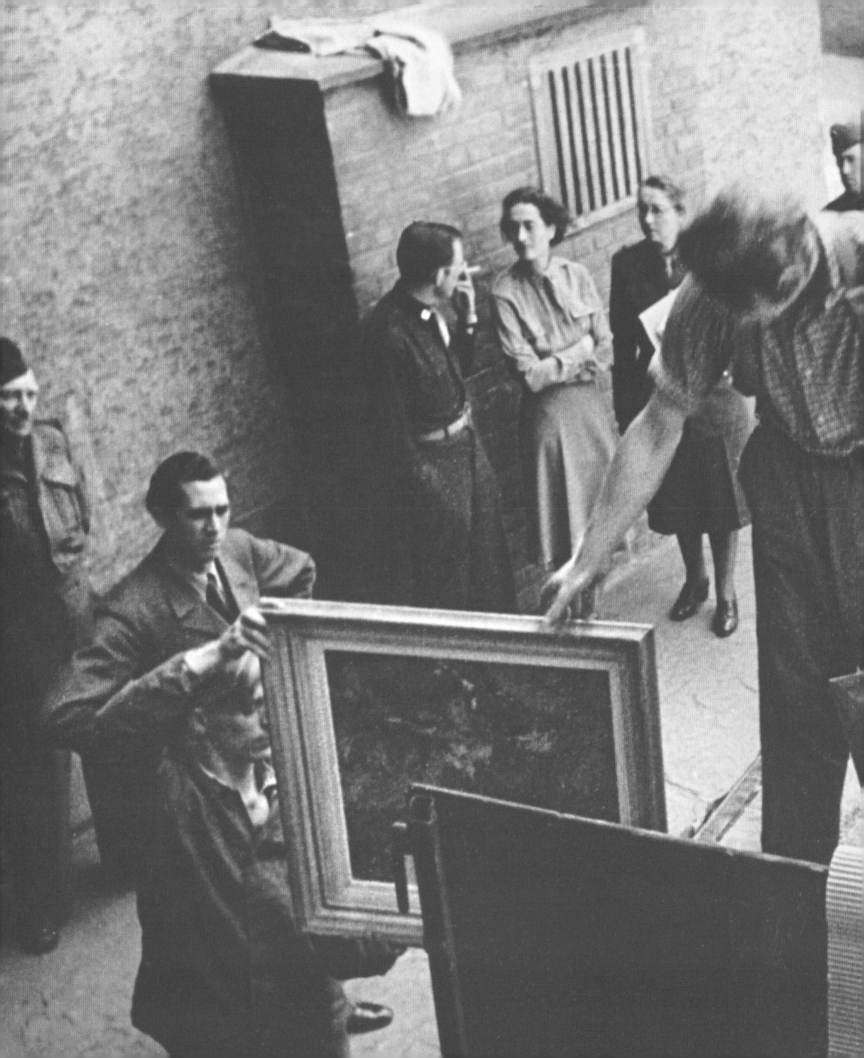

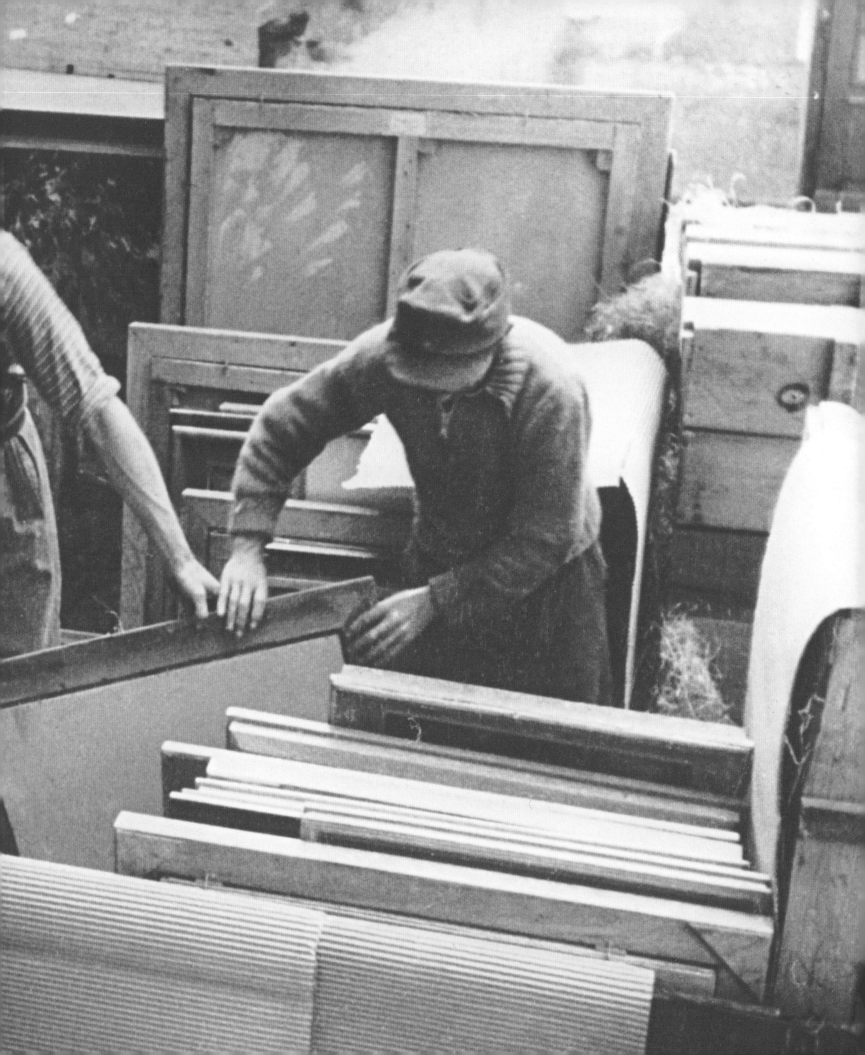

Fragmented Histories

Christine E. Brennan and Yelena Rakic

World War II had a greater impact on the Metropolitan Museum than any other conflict in the twentieth century. Months before the United States' formal entry into the war in 1941, the staff had already begun to consider the role of museums during wartime.[1] Director Francis Henry Taylor oversaw efforts to safeguard the collection, even sending eighteen thousand works to Pennsylvania.[2] At the suggestion of the trustees, an exhibition on the art of warfare was mounted in the summer of 1943 as a public gesture in support of the war effort.[3] Between 1940 and 1945, members of the Department of Arms and Armor, including Stephen V. Grancsay, curator, and Leonard Heinrich, armorer, assisted the United States Military with the development of lighter, safer helmets and body armor (fig. 190).[4]

Since its founding the Museum has been dedicated to protecting cultural heritage, and recent world events serve as a reminder of the ongoing need to respond to global threats to art and culture.[5] From 1943 Metropolitan Museum staff aided Allied efforts to safeguard works from further destruction and to recover looted treasures. Yet, that same year, the institution acquired impressive architectural reliefs

from the ancient site of Tell Halaf in present-day Syria, property that had been seized by the United States government from German national Baron Max von Oppenheim, who had left the reliefs in New York in 1932. These two stories reveal the diverse fate of art during World War II and the unexpected role the Museum played in this history.

The Monuments Men

Francis Henry Taylor was a founding member of the American Commission for the Protection and Salvage of Artistic and Historic Monuments in War Areas, formed in June 1943. Also known as the Second Roberts Commission after Supreme Court Justice Owen J. Roberts, the group selected specialists to aid in the protection and recovery of cultural works affected by the war. For the first time in history, the preservation of cultural heritage during wartime was identified as an essential moral imperative to be addressed at the same moment that military victories were sought. The Monuments, Fine Arts, and Archives Division (MFAA), which emerged out of the Second Roberts

Commission, was a joint operation between the United States and Great Britain, run by the Civil Affairs branch of the Allied Military Government for Occupied Territories. The men and women who served in this division, commonly known as monuments men, participated in an extraordinary endeavor. At its height, about 350 monuments officers worked to safeguard monuments and prevent further destruction, interrogated Nazi looters to locate hidden art troves, and returned tens of thousands of artworks to their rightful owners.[6] While a number of Metropolitan Museum staff served in the MFAA, the herculean contributions made by Theodore Rousseau Jr., James J. Rorimer, and Edith A. Standen had the most lasting impact on the institution and its collections.[7]

Based on his knowledge of European languages, his international education, and his contacts, Theodore Rousseau Jr. played a critical role in the activities of the Art Looting Investigation Unit of the Office for Strategic Services (OSS).[8] Officers in this unit uncovered information about art stolen from Jewish collectors and other perceived enemies of the Third Reich. Considered the intelligence component of the MFAA, the unit assisted the monuments men who served in the field with the armed forces to locate caches of looted art stored in monasteries, castles, and salt mines. Rousseau himself interrogated numerous Nazis, including Hermann Göring, Reichsmarschall of Germany, and many of his associates. These interrogations resulted in seminal reports outlining the Nazis' comprehensive looting operations, the largest recorded systematic despoiling of cultural property.[9] Göring had stated his intention to "plunder and to do it thoroughly," and he was bested in this endeavor only by the actions set into motion by Adolf Hitler to create the Führermuseum in Linz, Austria.[10]

The Metropolitan Museum has two previously restituted works of art that were once in Göring's personal collection: the sixteenth-century marble sculpture *Virgin and Child with*

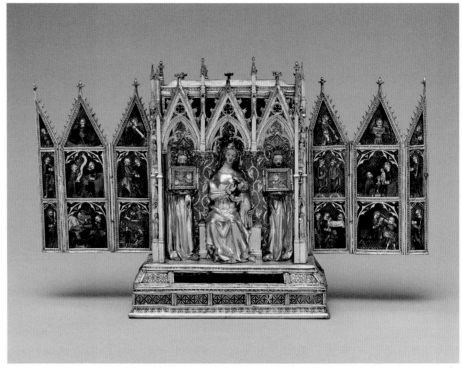

the Young Saint John the Baptist (fig. 191), acquired in 1959, and a rare fourteenth-century enameled reliquary shrine purchased in 1962 that once belonged to the convent of the Poor Clares of the Order of Saint Francis at Buda, founded by Queen Elizabeth of Hungary in 1334 (fig. 192).[11] Göring's art dealer Walter Bornheim bought the sculpture in 1943 and apparently gave it to the Reischsmarschall.[12] Göring may have personally selected the reliquary from Edmond de Rothschild's collection in 1940 either on one of his visits to the Jeu de Paume in Paris, where the Nazis had brought the artworks they had looted from many French collections, or from Edmond's residence on the rue du Faubourg-Saint-Honoré, which was requisitioned by the Reichsmarschall and his staff.[13] This reliquary is perhaps the same work that was temporarily taken by economically desperate members of the local population from Göring's personal railcars, which German troops had filled with his art collection and other possessions, and later abandoned in the Bavarian town of Berchtesgaden in the final days of the war.[14]

After his discharge from the navy in 1946, Rousseau was appointed associate curator of paintings at the Metropolitan Museum, eventually serving as chairman of European paintings and later as vice director and curator in chief of the Museum.[15] Rousseau's wartime experiences, however,

continued to play a vital role in his career: he preserved newspaper clippings and letters concerning the individuals he had interrogated and lectured about stolen art, discussing Hitler's and Göring's rationales for art collecting.[16] Within three years of his appointment, Rousseau notably acquired *Soap Bubbles*, by celebrated eighteenth-century French painter Jean Siméon Chardin (fig. 193). The painting had belonged to German Jewish banker Fritz Mannheimer, who had assembled an important collection using his company's assets. Upon Mannheimer's death in 1939, the title for this work and many others in his collection were transferred to his wife, Jane; the painting remained in Paris until its seizure by the Nazis and "sale" for 800,000 francs in 1944.[17] It was restituted to Jane in 1948, and she sold it to the Metropolitan Museum one year later. Rousseau immediately published an article on the acquisition, remarking that it had been destined for Hitler's museum in Linz and that, when acquired, its stretcher (later replaced) still bore the labels of the Einsatzstab Reichsleiter Rosenberg (ERR), the organization responsible for appropriating artworks in areas under Nazi control.[18]

James J. Rorimer began work at the Metropolitan Museum as a curator in 1929 and would later be appointed director of the Cloisters before becoming director of the

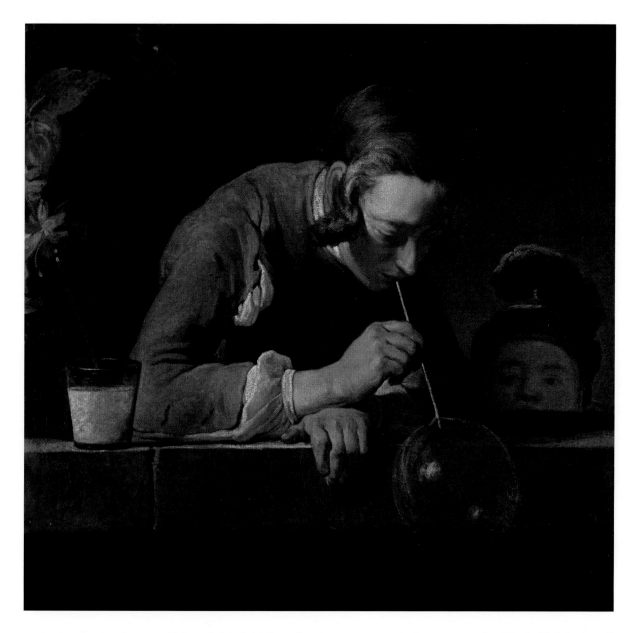

entire institution in 1955. Although his initial application to serve in World War II was rejected because he failed his physical, Rorimer was able to enlist in the army in 1943 and was transferred to the MFAA in April 1944.[19] Arriving in Normandy on August 3, just two months after the D-Day invasion, Rorimer safeguarded monuments throughout the region as he traveled toward the French capital. Once there, he participated in the liberation of Paris and worked tirelessly to protect buildings and movable works he deemed at risk due to previous German depredations or poor Allied military decisions. Through this work, Rorimer met Rose Valland, a volunteer curator at the Jeu de Paume who,

unbeknownst to the Nazi officials, was fluent in German.[20] During the Occupation, Valland secretly recorded the details of looting operations, including the location of art repositories throughout Nazi-occupied territories.[21] Based on crucial information from Valland, Rorimer traveled with the United States Seventh Army to uncover artworks hidden by the Nazis in mines at Heilbronn and Kochendorf, southeast of Frankfurt, and he later tracked Göring's personal collection to Berchtesgaden.

On May 4, 1945, Rorimer arrived at Neuschwanstein Castle in Bavaria, where he discovered twenty thousand artworks taken from the finest Jewish collections in France,

194. First Lieutenant James J. Rorimer
and Sergeant Anthony Valim examine
recovered objects from the Rothschild
Collection at Neuschwanstein Castle,
Germany, May 1945

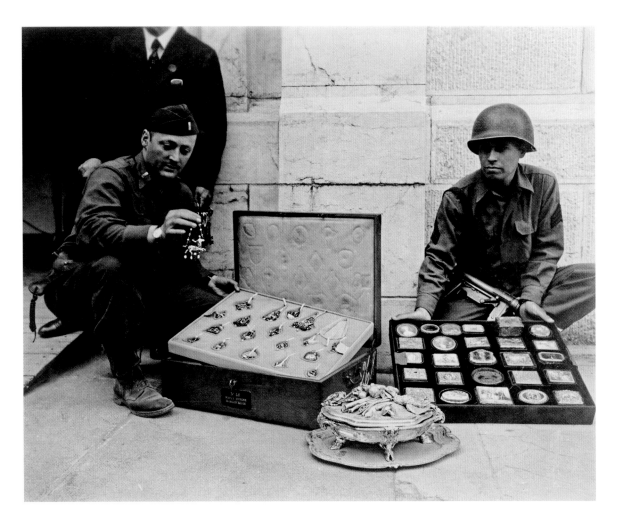

including jewels and silver from the Rothschild and David-Weill families (fig. 194).[22] In a published memoir of his wartime service, Rorimer provided a vivid description of his first visit:

> The verticality of the surrounding mountains was repeated in the structure of the castle, so that in going from one series of rooms to another one had the feeling of climbing up the mountainside. . . . We were guided to a hidden, thick steel door; this one locked with two keys. Inside there were two large chests of world-famous Rothschild jewels and box upon box of jewel-encrusted metalwork. There were also rare manuscripts and more than a thousand pieces of silver from the David-Weill and other collections.[23]

As the first monuments official to reach the castle, Rorimer also discovered the meticulously kept ERR records documenting Nazi looting activities. He was, in fact, so concerned about safeguarding these records that he affixed an antique seal with wax and cord to the doors to ensure that no one entered the room until his return.[24]

Among the works of art found at the castle were renowned medieval manuscripts, including the fourteenth-century *Hours of Jeanne d'Evreux, Queen of France* (fig. 195).[25] It belonged to Maurice de Rothschild, head of the French branch of the family and one of the wealthiest men in France prior to the war.[26] This prayer book, one of nearly four thousand works taken from the Rothschilds, had been sent from Paris to the Bavarian castle before March 1941.[27] The Nazis penciled an inventory number (R 1052) on the folio inside the front cover.[28] In June 1948 the book was restituted to Maurice, and by 1952 it was housed in his library at the Château de Prégny near Geneva. Two years later he offered it for sale along with another celebrated French manuscript in his collection, *The Belles Heures of Jean de France, duc de Berry*.[29]

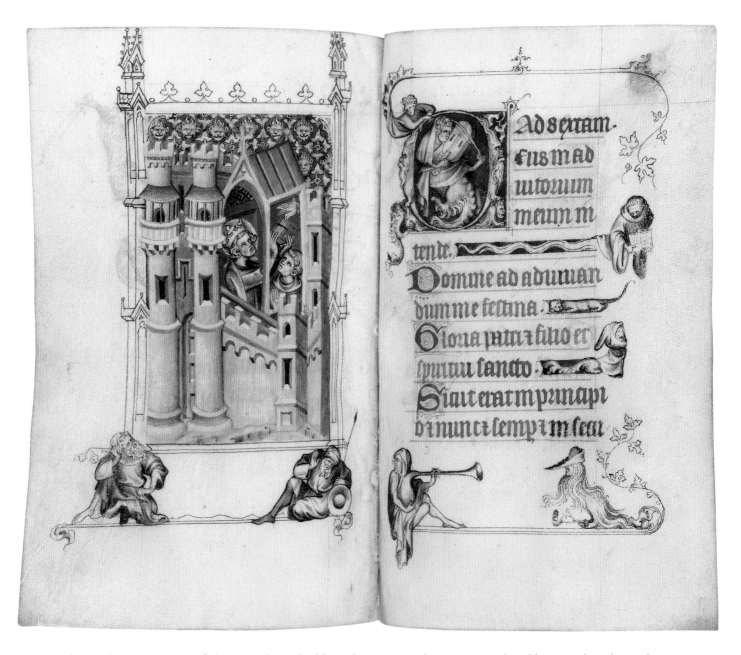

Rorimer knew the importance of these works and, although the Metropolitan Museum had not previously purchased illuminated manuscripts, he convinced the administration and major patron John D. Rockefeller Jr. to acquire them for the Cloisters. In the same year as the purchase, Rorimer recalled that "[w]hen I was at the Castle of Neuschwanstein near Füssen, I found some Rothschild manuscripts in a wastepaper basket, where they were no doubt concealed in the hope that they might be overlooked."[30]

Other objects deposited at Neuschwanstein Castle were less readily identifiable on lists of confiscated works, such as a rare platinum sugar bowl by French eighteenth-century master goldsmith Marc-Etienne Janety (fig. 196). While this work was known to have belonged to David David-Weill, its Nazi-era history has only recently been uncovered.[31] The collector's assistant, Marcelle Minet, had carefully inventoried and stored the collection before the war. In December 1945 she discovered the same crates containing the works she painstakingly had packed and labeled prior to their confiscation located at the Munich Central Collecting Point, one of the four primary holding locations for displaced art.[32]

Rorimer remained in Europe until early 1946 as chief of the United States Seventh Army / Western Military District. For his service protecting monuments and displaced works of art in the weeks before the end of the war and in establishing central collecting points at Munich and Wiesbaden, he was awarded the Bronze Star, the Belgian Croix de Guerre, the French Legion of Honor, and the Cross of the Commander of the Order of Denmark (fig. 197).

His experience as a field officer in the MFAA provided Rorimer with firsthand knowledge of many restituted collections and a unique perspective on their cultural significance beyond their art historical value. Later in his career he pursued the acquisition of previously restituted artworks for the Metropolitan Museum, notably objects from the collection of Czech Jewish sugar merchant Oscar Bondy that had been selected for Hitler's planned museum in Linz and other institutions in the Reich. The Bondy pieces were restituted to his widow, Elisabeth, beginning in 1948. Rorimer purchased an exceedingly rare bishop's mitre and a bone reliquary in the form of a purse, both made of precious materials and originally from the famous Abbey of Saint Peter in Salzburg, directly from Elisabeth in 1953.[33] Such textiles and reliquaries that had once belonged to church treasuries were poorly represented at the Cloisters when it opened in 1938. Rorimer prioritized the acquisition of these objects in the years after the end of the war and later featured them in a gallery he called the treasury.[34]

Many other works from the Bondy collection passed through the Blumka Gallery, which was operated by a fourth-generation Jewish family that had been forced to flee Vienna in 1939 for New York. In 1969 Leopold and Ruth Blumka gave a fifteenth-century silver tabernacle embellished with scenes from the Life of Christ rendered in mother-of-pearl, acquired from Elisabeth, to the Museum in honor of its centennial celebrations (fig. 198).[35] This gift symbolized the Blumka family's gratitude to the United States, "which has become our well-beloved home, and gave us the chance to live in liberty and equality."[36] Today fifty-five artworks that once belonged to Oscar Bondy are in the Museum's collection, including fifteen medieval pieces, later decorative objects, furniture, musical instruments, and paintings.

Other previously restituted medieval works acquired during Rorimer's tenure are two finely executed silver beakers confiscated from the Frankfurt collection of Baron Maximilian von Goldschmidt-Rothschild in 1938 (fig. 199). Although many objects in the Goldschmidt-Rothschild collection were restituted after the war, the postwar German

198. Possibly Master Pertoldus (Berthold Schauer?) (Austrian). Triptych with scenes from the Passion of Christ, 1494. Silver, gilded silver, mother-of-pearl, bone, cold enamel. Gift of Ruth and Leopold Blumka, 1969

199. Hans Greiff (German). Covered beaker, ca. 1470. Silver, gilded silver, enamel, glass. The Cloisters Collection, 1950

200. Edith Standen's uniform. American, 1945. Wool, metal. Gift of Edith A. Standen, 1988

government initially restricted the return of the beakers, which came from the town treasury of Ingolstadt and were deemed to be objects of national cultural importance.[37] Finally released in 1949 to the collector's heirs, the beakers came to the Museum in 1950, contributing to the growing collection of secular goldsmiths' work at the Cloisters.

Edith A. Standen was one of the few women monuments officers tasked with the overwhelming job of returning stolen artworks to their rightful owners (see pp. 172–73). She joined the Women's Army Corps in 1943, and from March 1946 to August 1947 served as the temporary officer in charge of the Central Collecting Point in Wiesbaden, Germany (fig. 200). There, she was responsible for sorting, cataloguing, and restituting thousands of artworks belonging to German collections, including sixteen Berlin state museums and seventeen private owners.[38] Proud and principled, Standen was the only woman to sign the Wiesbaden Manifesto written in 1945 to protest the United States military's decision to transfer 202 paintings from Wiesbaden to the National Gallery of Art in Washington, D.C., for storage rather than returning them to their owners immediately. This daring action, going against official military policy, illustrates Standen's fortitude and dedication. She and the other twenty-three signatories to the document believed that "safeguarding" the paintings, a term often used by the Nazis to justify their despoiling of collections, was simply another form of unlawfully taking possession of cultural property.[39] In 1949, two years after her return to the United States, Francis Henry Taylor hired Standen, and she spent the rest of her career as a curator of European tapestries at the Metropolitan Museum. Always self-deprecating, Standen described her role as a monuments officer as being that of "a dwarf standing on the shoulders of giants."[40] She was, however, the only woman among the monuments and archives staff to receive a Bronze Star for her extraordinary efforts.[41]

Following the end of hostilities in 1945 and a gradual return to normality, the Metropolitan Museum was eager to document the war's devastating impact on cultural heritage and to present this information to the public with the aim of helping to prevent such destruction from happening again. As part of its seventy-fifth-anniversary celebrations during the spring of 1946, the Museum honored General Dwight D. Eisenhower for his oversight of the preservation of monuments and the repatriation of objects stolen by the Nazis during World War II. More than ten thousand visitors

201. General and Mrs. Eisenhower leave the
Metropolitan Museum after the former
president was made an honorary fellow for
life for his efforts to save art treasures
overseas during World War II, 1946

saw or heard the ceremony through the Museum's public
address system (fig. 201). In his speech, "Art in Peace and
War," Eisenhower expressed appreciation to the Museum
for honoring his "small part" in protecting monuments but
credited "the officers and men of the combat echelons,
whose veneration for priceless treasures persisted even in
the heat and fears of battle."[42] Additionally, the Museum

held four separate exhibitions between 1946 and 1947 that
each addressed the conflict's impact on European art.[43]

Today the Metropolitan Museum's collection contains
numerous works that had been restituted to owners or their
heirs by monuments staff. While some of these were well
known to Rousseau, Rorimer, and Standen, others have
only recently been identified or acquired.[44] The Museum's

202. Orthostat reliefs on display at the Metropolitan Museum (excavated Tell Halaf, Syria), ca. 10th–9th century B.C. Basalt, limestone, paint. Rogers Fund, 1943

dedication to protecting cultural objects, documenting World War II–era histories, and restituting stolen art owes much to the standards set by these individuals more than seventy years ago.

The Tell Halaf Reliefs

In 1943 the Metropolitan Museum acquired four stone blocks carved with images of fantastic creatures and animals, as well as scenes of hunting and ceremonial banqueting (fig. 202). The remarkable history of these objects not only reveals much about the period when they were created but

also provides a lens to the varied fate of art during World War II. Dated to the early first millennium B.C., they constitute a tiny fraction of what was uncovered in the early twentieth century at the site of Tell Halaf in present-day Syria. Traveling from Syria to Berlin and then to New York, these reliefs are inextricably linked to Baron Max von Oppenheim and his identity as a German national. The perhaps unexpected role of the Metropolitan Museum in this narrative elucidates how collecting practices reflect the reality of their times and can appear mysterious when left unexamined. The story also provides an entry to the debates concerning the safeguarding of art today.

The blocks were created as architectural decoration, and three are made from basalt and the fourth from limestone painted a reddish hue. Each block is carved on one or more sides with self-contained, isolated images in low, flat relief without much detail or modeling. One is carved on three sides: the largest side has a hunt scene with a driver and a bowman standing in a chariot drawn by a horse, while below them is a running lion, and above, a flying bird; a volute palmette adorns the edges of the slab. Another depicts a dynamic scene of a lion with bared teeth biting the neck of a deer; both animals balance on their hind legs with forelegs intertwined in an almost embrace-like stance. A third block is filled with an arresting image of a winged, human-headed lion, who stares directly at the viewer. A fourth, with reliefs on two sides, shows a male figure holding a lotus blossom seated before two bull-men supporting a winged sun disk; on the shorter edge of the block, a male figure clasps a mace. Traces of cuneiform inscriptions appear on each block, some of which clearly read "Palace of Kapara." Displayed as they are today in a museum setting they exist as isolated representatives of the past, removed from their original context.

The carved blocks were excavated at the site of Tell Halaf in northeastern Syria at the headwaters of the Khabur

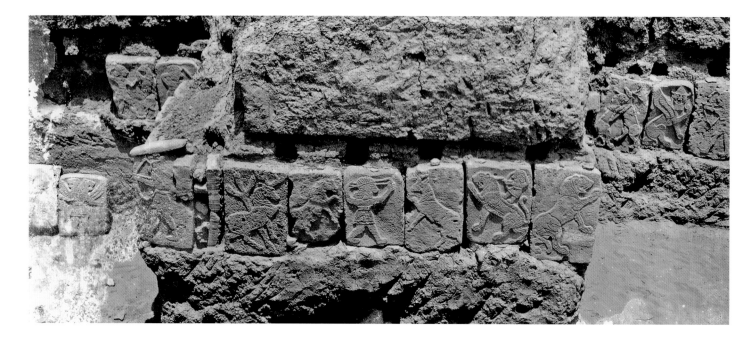

River.[45] First settled in the Late Neolithic period, the site was a substantial city by the end of the second millennium B.C. when a number of small but powerful Aramaean city-states rose to prominence. Also referred to as Neo-Hittite because of their ties to the earlier Hittites of Anatolia, these rival city-states were gradually brought under the control of the great Assyrian Empire. Tell Halaf is identified as the ancient city of Guzana, the capital of Bit-Bahiani, although little is known about its rulers due to a paucity of written sources. Excavations revealed a walled citadel on which a number of public buildings stood, including one identified as the Western Palace, or Palace of Kapara.[46] Erected atop a high mud-brick platform and decorated with monumental art, the structure is identified by its ground plan as a *hilani*, a Neo-Hittite architectural form composed of two parallel long rooms, accessed through a columned entrance. The building's outer walls were ornamented with over two hundred sculpted slabs including relatively small blocks (called "small orthostats" in the literature) made of alternating dark gray basalt and red-painted limestone. Found largely anchored in the masonry of the back of the building, which faced the city, they are carved with abbreviated compositions featuring animals and mythological figures, as well as scenes of war and everyday life (fig. 203). Carved in the late tenth or ninth century B.C., the reliefs appear to have embellished an earlier building and were then reused on the walls of the Palace of Kapara. This reuse may explain

the apparent lack of a unifying principle governing their arrangement.

The excavations that revealed the Palace of Kapara and its rich sculptural output were organized and led by Baron Max von Oppenheim, a complex character described as an amateur archaeological explorer and eccentric outsider, also notable for his reputation as a German political agent.[47] Born into a prominent Cologne banking family, von Oppenheim became increasingly interested in the Middle East while working as a consular official in Cairo from 1896 to 1909, when he was known as "the Kaiser's spy." Political historians point to his role in an Imperial German plan to mobilize the Muslim populations during World War I in order to weaken its British rival's overseas empire. His purported continued involvement in the political arena later in life was reported in a 1941 article published in the *New York Times*, which identified "Max von Oppenheim, a distinguished archeologist and astute propagandist," as one of three Germans responsible for Nazi agitation in Syria.[48]

Von Oppenheim first encountered Tell Halaf in 1899 while traveling through the region of Syria, at the time under Ottoman rule, in connection with planning for the construction of the Berlin–Baghdad railway. He stayed at the site for three days during which a number of statues were uncovered by the local workers he had hired to explore the rumors of stone statues in the mound. These were promptly reburied since von Oppenheim did not have

permission to excavate. After securing a permit, or firman, from the Ottoman authorities, he returned to Tell Halaf in 1911 and, using his own funds, directed excavations through 1913 with over five hundred local workers. Digging stopped with the outbreak of World War I, and von Oppenheim did not return to Tell Halaf until 1927, when preparations for new excavations were made. By 1929 this second excavation campaign was complete and included an official division of the finds with the French mandate authorities who had taken control over Syria after the defeat of the Ottomans in the war.[49]

On July 15, 1930, the day von Oppenheim turned seventy, the Tell Halaf Museum opened in a former iron foundry in Berlin-Charlottenburg, presumably with the Metropolitan Museum's four blocks on display.[50] Although the Berlin museum received a positive public reception, it appears that von Oppenheim was facing financial difficulties and was considering the sale of the Tell Halaf objects. In the spring of 1931 he traveled to the United States to visit a number of museums, and, as reported in the New York Times, "to study the Near Eastern archaeological exhibits at the Metropolitan Museum of Art."[51] He returned in November and stayed through May 1932, giving a series of illustrated lectures in cities including Baltimore, Boston, Chicago, Philadelphia, Princeton, and Washington, D.C. In fact, he presented "The Wonders of the Tell Halaf" in a public lecture at the Metropolitan Museum, attended by ninety-five people on December 15, 1931.[52] During this trip von Oppenheim arranged for selected antiquities and artworks, including reliefs from Tell Halaf, to be sent to him in New York, where he hoped to drum up interest in the finds and identify potential buyers. Unable to sell these works, he left them in storage in 1932 at Hahn Brothers Fireproof Warehouses in New York.

On December 11, 1941, the United States declared war on Germany. Seven days later Congress passed the First War Powers Act, giving the chief executive the power to vest (seize, or take over the title to) the property—including businesses—of any foreign country or national. Shortly afterward the Alien Property Custodian (APC) was established as an independent agency by Executive Order 9095 to aid this process.[53] In early 1943 the APC's Division of Investigation and Research began inquiries into von Oppenheim's property, which had remained in storage at Hahn Brothers for over ten years, and on April 27, Vesting Order Number 1330 was issued. By authority of the APC, von Oppenheim's property was vested, "to be held, used, administered, liquidated, sold, or otherwise dealt with in the interest of and for the benefit of the United States."[54] In September a notice of a public sale with sealed bids appeared in the New York Times and New York Herald Tribune, and the APC circulated a list of von Oppenheim's property separated into three lots—one of which consisted of "eight Hittite reliefs, stone." The sealed bids were opened on October 20, and the Metropolitan Museum's offer was the higher of the two received for the reliefs, four of which were then sold to the Walters Art Museum, Baltimore, as per a previous arrangement.[55]

Archival research has revealed some of the backstory of the Metropolitan Museum's involvement in this process, particularly the role of Ambrose Lansing, curator in the Department of Egyptian Art. Not only did Lansing meet with an agent of the APC to view the property at Hahn Brothers in August 1943, he also provided an appraisal of the objects, although without accepting a fee for his services. Interestingly, in a letter dated September 7, Lansing wrote to the APC about who might want to acquire such material, stating, "Your problem is made difficult by the fact that the most important objects in the Oppenheim collection are the Hittite reliefs. These have practically no artistic value, their interest being purely archaeological."[56] Soon after, the purchase of the reliefs by the Museum was recommended by curators from the Ancient Near Eastern and Egyptian Art departments (presumably including Lansing), and it was Lansing who submitted the bid to the APC on October 19 in time for the deadline the next day.

It is exceedingly difficult to fully assess how the Museum and its staff viewed their interaction with wartime agencies like the APC beyond the few clues offered by the limited written archival documentation. Clearly the institution benefited, but there is no explicit comment or discussion on the APC and its effect on acquisitions. While the APC was active in the United States during both world wars, remarkably little has been written about its impact on the art market and museums, the beneficiaries of this system. Brief references exist to cases such as the seizure of approximately four hundred artworks by the APC in 1944 from the Buchholz Gallery owned by German Curt Valentin. These works were subsequently sold at auction in January 1945 and currently can be found in the collections of the Museum of Modern Art, New York, the National Gallery of

Art, Washington, D.C., and the Metropolitan Museum, among others.[57] Similarly the assets of Yamanaka and Co., a firm specializing in Asian art, were seized in 1942, including a reported twenty thousand works of art.[58] Sales of the seized Yamanaka stock took place, and the Metropolitan Museum appears to have purchased pieces from sales in 1943 and 1944.[59] Only with further research, exploration, and contextualization can the impact of these wartime actions on collecting practices begin to be adequately examined.[60]

The story of the four Tell Halaf reliefs is part of this history as well as a conduit to larger issues. In a letter dated November 24, 1943, the APC officially awarded the sale of "antiques formerly owned by Baron Max von Oppenheim to the Metropolitan Museum of Art."[61] Ironically, just days before, on the night of November 22–23, during an air raid by the British Royal Air Force, an incendiary bomb hit the Tell Halaf Museum in Berlin. After the collapse of the roof and rapid spread of fire, the blaze continued to smolder at extremely high temperatures, ranging from 850 to 980 degrees Celsius. Almost all of the limestone works were destroyed, and when firefighters arrived on the scene, water intended to extinguish the fire struck the basalt sculptures, causing the majority to explode from the change in temperature. More than twenty-seven thousand fragments were collected in nine tractor loads and stored in the basement of the Pergamon Museum. In 2001 a project was begun to restore the lost works as von Oppenheim himself had hoped would happen, and since then, remarkably, more than thirty sculptures have been pieced back together (fig. 204).[62]

Today as conversations continue about the safeguarding of art and the role museums can play, the Tell Halaf material is a useful case study to consider as part of the debate. It is not possible to simply say art in conflict zones will be safer in museums outside those areas—frequently code for the suggestion to remove art from the Middle East to museums in Europe and the United States. There is no easy solution, yet it is clear the more that is known about the history of an object the better equipped everyone is to participate in such discussions. Provenance research, which uncovers essential object and owner histories, is a vital part of this work that can provide opportunities for exploring collecting practices and help inspire new forms of engagement. For instance, works of art created by contemporary artists that focus on the modern history of ancient Middle Eastern objects can reanimate these objects and expand the possibilities of how to look and think about them.[63] Through such interventions, objects in museums become dynamic participants in dialogue with the contemporary world in which they continue to exist.

The histories of the monuments men and the reliefs from Tell Halaf poignantly reveal the complicated fate of art during wartime. Continued study and publication of the restitution stories of works confiscated during World War II will help lead to thoughtful and transparent discussions of their fate, the fate of their owners, and the extraordinary efforts of the monuments men and women as well as of those who have built upon their significant contributions in subsequent decades. The Metropolitan Museum is committed to tracing these stories through ongoing research on the permanent collection and engaged in presenting this information as part of the institution's educational mission.

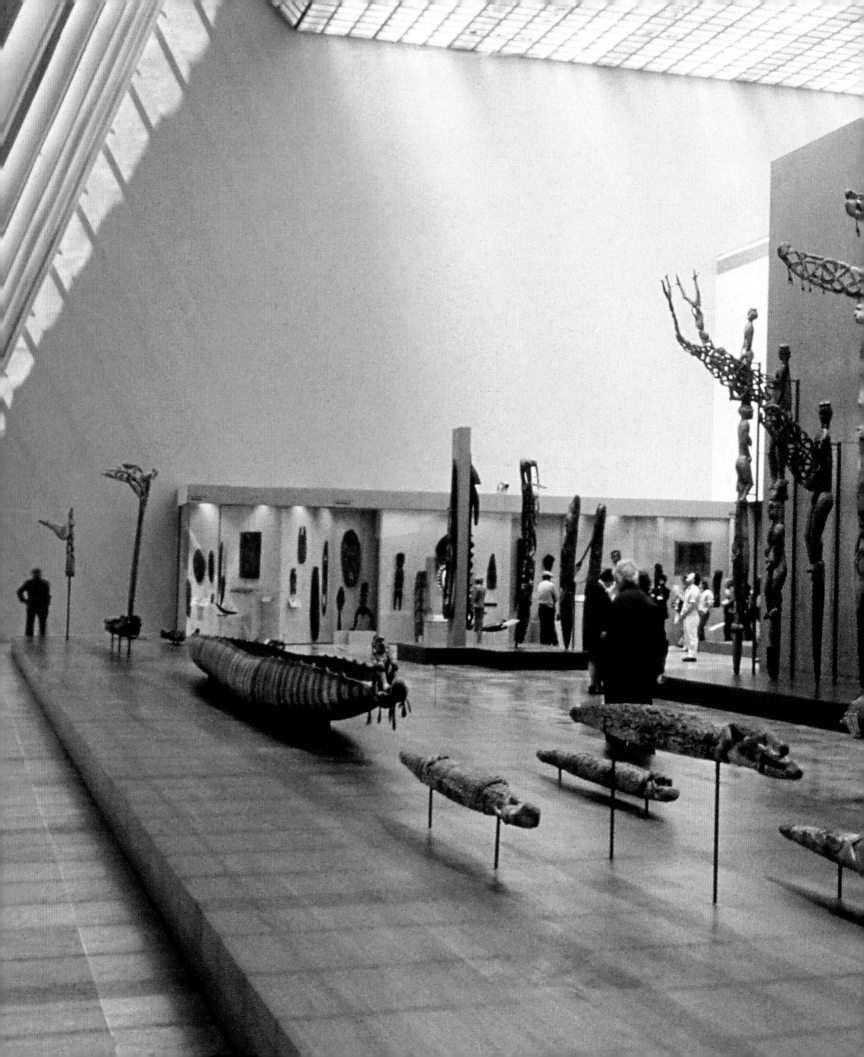

The
Centennial Era

The Evolution of the Encyclopedic Museum

Laura D. Corey

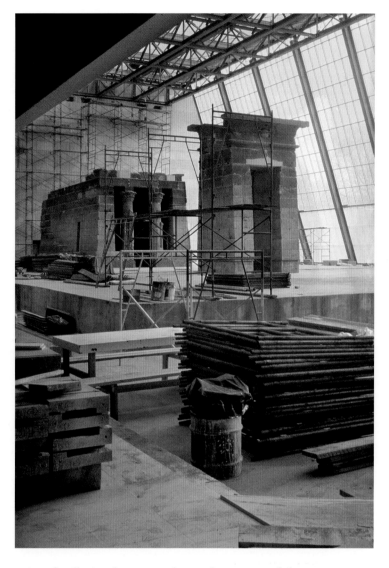

The Metropolitan Museum's centennial was celebrated in 1970 with great fanfare and marked by reflection on the past, present, and future of the institution. In an essay for the *Bulletin*, president of the board of trustees C. Douglas Dillon proudly proclaimed that "in just one hundred years, the goals of the Museum's founders have largely been achieved. . . . The works of art in this museum now range in an almost unbroken line through five thousand years of civilization in all parts of the world . . . a truly breath-taking achievement."[1] Among the milestones lauded on this occasion were the monumental recent gifts of the Temple of Dendur from Egypt in 1967 (fig. 205); the Michael C. Rockefeller Memorial Collection of so-called Primitive Art in 1969; and Robert Lehman's esteemed collection of more than 2,600 works of western European art, announced at the Centennial Benefactors' Dinner later that year.[2] A new master plan laid the groundwork for expansion necessitated by these major additions and motivated by an overarching desire to become a more encyclopedic institution. Broader political and cultural forces spurred the Museum to direct resources to its non-Western and contemporary collections. After World War II, as the nexus of the art world gravitated to New York with an influx of artists, scholars, collectors, and collections from abroad, the public and academic communities gradually began to adopt a more international, less Eurocentric, perspective on the history of art. The Vietnam War, in turn, heightened awareness of cultures to the east. It was in this climate that the Museum rededicated itself to Asian art, led by Dillon and curator Wen Fong, with a

suite of galleries that opened over the course of the 1980s and into the 1990s. Under the direction of German émigré Richard Ettinghausen, new galleries debuted in 1975 that presented the largest permanent display of Islamic art ever shown in the Western hemisphere. In the late 1960s, the Department of the Arts of Africa, Oceania, and the Americas was established, filling "the last major gap in the Metropolitan's holdings";[3] its Michael C. Rockefeller Wing was unveiled in 1982 with major gifts from the Museum of Primitive Art, the Rockefeller family, and other collectors, as well as objects that had been on loan to the American Museum of Natural History since 1914.

This was a booming period at the Museum, carried out under the hum of construction and through the clamor of crowds flocking to blockbuster exhibitions, from the

glittering *Treasures of Tutankhamen* to legendary fashion editor Diana Vreeland's stylish and star-studded program for the Costume Institute (fig. 206).⁴ With the creation of a department devoted to contemporary art in 1967, Henry Geldzahler and later Lowery Stokes Sims pushed the Museum to commit to confronting the art of its time, culminating in the opening of the Lila Acheson Wallace Wing in 1987. At the same moment, the institution began to interact more directly with contemporary visual and performing artists for educational programming, not only on Fifth Avenue but throughout the five boroughs of New York City in an effort to reach a broader audience.

The centennial era is remembered for its lavish celebrations (fig. 207) and headline-grabbing acquisitions, but it was also a period when the Museum actively engaged with the changing world outside its walls, where New York struggled with social upheaval and political decline. Both incited by and in spite of these challenges, the Metropolitan Museum broached its second century with renewed investment in the diversity of the collection and engagement with the community. While the path forward was not always smooth, it resulted in tremendous growth that endured into the 1980s, under the leadership of directors Thomas P. F. Hoving and Philippe de Montebello.

207. Garry Winogrand (American).
*Metropolitan Museum of Art Centennial
Ball, New York City, New York*, 1970, printed
1974. Gelatin silver plate. Gift of William
Berley, 1978

208. Japanese ceramics display on
Great Hall Balcony, 1933

209. Buddha offering protection. Indian
(probably Bihar), late 6th–7th century.
Copper alloy. Purchase, Florance
Waterbury Bequest, 1969

A Rededication to Asian Art

Maxwell K. Hearn

In 1970, when the Museum celebrated its centennial, one of the most conspicuous lacunae in its public spaces was Asian art. The only artworks on view were the Chinese ceramics around the Great Hall Balcony and the early Chinese Buddhist sculpture in the adjacent hall. These spaces had included a display of Asian art (fig. 208) from the moment Richard Morris Hunt's grand Fifth Avenue entrance opened in 1902—demonstrating an early interest in "Oriental art" that long preceded the formal creation of a Department of Far Eastern Art in 1915 (the name only changed to Department of Asian Art in 1983). In the ensuing decades, as the building expanded along Fifth Avenue with the wings designed by McKim, Mead and White, Asian art occupied a significant portion of the second-floor galleries north of the Great Hall. But by the 1960s the presence of Asian art was in decline as rooms were ceded to other collections or to special exhibitions, despite the acquisition of such notable works as the sculpture of Buddha offering

protection, purchased by the Museum in 1969 (fig. 209). As the leadership began to contemplate what the Museum's second century should look like, it became apparent that the Asian art department was the weakest in staff, collections, and gallery space. It was C. Douglas Dillon, president of the board of trustees, who argued that the Museum could not ignore Asia, and he became personally involved in the institution's efforts to reassert the encyclopedic goals espoused by its founders.

Since the Museum's infancy, individual donations have defined its unusual strengths in Asian art. The foundations of the Asian holdings were built by generations of civic-minded collectors and patrons—Samuel P. Avery, Stephen Whitney Phoenix, Heber R. Bishop, Benjamin Altman, J. Pierpont Morgan, Henry Osborne and Louisine Havemeyer, Abby Aldrich Rockefeller—many of whom

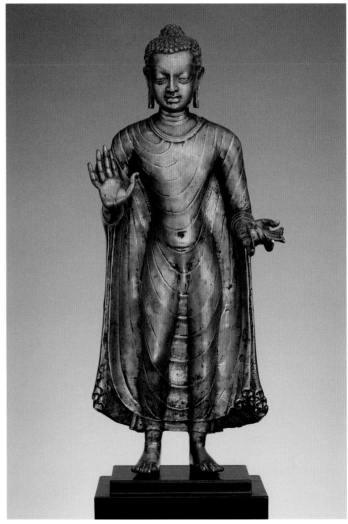

left entire collections to the Museum.[1] Each collection in turn reflects the taste of both an individual and an era. Despite the unique richness of the Museum's collection by the 1960s, its displays lacked a coherent narrative. Constructing a holistic story of Asian art would require both a new level of curatorial expertise and the ability to collect works exemplifying Asia's indigenous aesthetic ideals.

Dillon had a candidate in mind to lead the Museum's rededication to Asian art: a Princeton University professor named Wen Fong.[2] They had met some years earlier when Dillon was serving as the U.S. secretary of the treasury. The young professor had found himself in Dillon's office arguing that Princeton's acquisition of a collection of archaic Chinese bronzes from Japan—at the time, importing any Chinese property was illegal—was legitimate because of the exception to this ban for educational materials.

Deeply committed to teaching students with original works of art, Fong persuaded Dillon that the bronzes were indeed educational.

Director Thomas Hoving, who knew Fong from when they were both graduate students in medieval art at Princeton, readily endorsed Dillon's choice. In 1971 Fong began a three-decade-long career as head of the Asian art department. The results were stunning. By 2000 the Museum had opened some fifty galleries devoted to Asian art, creating what is arguably the largest and most comprehensive presentation of Asian art in the world.[3]

Fong immediately set about building the staff and acquiring new works. Recognizing the daunting scale of the Museum's needs, he advocated going after entire collections: for example, twenty-five early Chinese paintings from C. C. Wang (fig. 211) and more than thirty Indian

211. Zhao Mengfu (Chinese). *Twin Pines, Level Distance*, Yuan dynasty (1271–1368), ca. 1310. Handscroll; ink on paper. Ex coll.: C. C. Wang Family, Gift of The Dillon Fund, 1973

212. Han Gan (Chinese). *Night-Shining White*, Tang dynasty (618–907), ca. 750. Handscroll; ink on paper. Purchase, The Dillon Fund Gift, 1977

The Centennial Era

and Southeast Asian sculptures from the Pan-Asian Collection.[4] Dillon, whose only previous exposure to Chinese painting had been the wallpaper in his dining room, became a vital ally for Fong in these pursuits, helping the Museum acquire 136 Chinese paintings over the course of twenty years (fig. 212).[5]

Fong's energy was infectious. In 1975 Brooke Russell Astor, inspired by fond memories of courtyard houses from her childhood in Beijing, where her father had commanded the Marine Detachment at the American Legation,

helped the Museum acquire a suite of Ming dynasty furniture and establish a period setting for it. Inspired by Jayne Wrightsman's French period rooms and the discovery of a light well adjacent to where the furniture was temporarily displayed, Astor and the curators imagined a traditional Chinese reception hall facing a garden courtyard as an ideal place for their permanent installation. The Astor Court and Ming furniture room (fig. 210) opened in 1981 together with the flanking Douglas Dillon Galleries for Chinese painting and calligraphy.[6]

214. Kano Sansetsu (Japanese). *Old Plum*, Edo period (1615–1868), 1646. Four sliding-door panels (*fusuma*); ink, color, gold, and gold leaf on paper. The Harry G. C. Packard Collection of Asian Art, Gift of Harry G. C. Packard, and Purchase, Fletcher, Rogers, Harris Brisbane Dick, and Louis V. Bell Funds, Joseph Pulitzer Bequest, and The Annenberg Fund Inc. Gift, 1975

The Centennial Era

The ambitious size of the new galleries posed a problem. Chinese paintings, executed on silk or paper, are light sensitive and need to be rotated. When the galleries opened, the department did not have enough fine paintings to change over all the works even once. Nevertheless, Fong's calculated risk paid off when New York collector John M. Crawford Jr. walked into the new galleries. "At last a space big enough for my collection," he exclaimed. The same year, Crawford promised over two hundred outstanding paintings and calligraphies (fig. 213) to the Museum. Sixteen years later, in 1997, the collection of Chinese paintings had grown so significantly that Dillon, together with trustee Oscar L. Tang, supported the renovation and expansion of these galleries.

In 1975 Fong also challenged the Museum with another staggering opportunity: the offer of over four hundred works of Japanese art—prehistoric pottery, Buddhist sculpture, courtly and literati painting (fig. 214), and the full range of decorative arts—from dealer Harry G. C. Packard.[7] Hoving assembled all of the Museum's curators in a storeroom where a selection of Packard pieces was on view. After thirty minutes Hoving asked the curators to vote on whether to commit all of the institution's unrestricted acquisition funds for the next five years to purchase the collection. Recognizing how these objects would enable the Museum to present a comprehensive survey of Japanese art, the curators voted yes. Twelve years later, in 1987, the Packard objects, importantly augmented with works from earlier generations of collectors, were placed on view in the newly inaugurated Arts of Japan Galleries—the largest display space for Japanese art outside of Japan.

As the Museum demonstrated its renewed commitment to Asian art through the addition of new curatorial specialists and galleries—curator (and later department chair) James C. Y. Watt was instrumental in this process—other major donors and collectors were inspired to add their support. Charlotte and John C. Weber gave both works of art

and funds to create galleries devoted to ancient Chinese art that opened in 1988. Florence and Herbert Irving supported new galleries to display the department's growing holdings of paintings (fig. 215), decorative arts, and sculpture from South and Southeast Asia in 1994 as well as galleries for Chinese decorative arts in 1997, donating hundreds of pieces to help fill these spaces. By 1998, with the inauguration of the Arts of Korea Gallery, the Museum had completed an entire wing devoted to Asian art.

Underpinning all of these acquisitions and new galleries has been the fundamental goal of creating an ever more coherent narrative of Asian cultures. Since the 1970s the department has published over one hundred books, catalogues, *Bulletins*, and symposium volumes, and advanced scholarship through groundbreaking special exhibitions. Shows such as *The Great Bronze Age of China* (1980) and *Age of Empires: Art of the Qin and Han Dynasties* (2016) highlighted new archaeological discoveries that changed our understanding of early Chinese culture. Likewise, *Lost Kingdoms: Hindu-Buddhist Sculpture of Early Southeast Asia* (2014) provided insight into ancient Southeast Asian civilizations, while *The Tale of Genji: A Japanese Classic Illuminated* (2019) chronicled a thousand years of art inspired by the world's first novel.[8]

Thanks to the Museum's long history, in which the passions and expertise of many individuals have guided its acquisitions, the Asian art collection today is admirably diverse, encompassing works from every major Asian culture and spanning nearly five millennia of development. But diversity is not the same as completeness. The collection will always be a work in progress. In the next fifty years, the department's goal, benefiting from the continued support of generous collectors and benefactors, will be to go beyond inherited definitions of Asian art to embrace the full spectrum of both traditional and contemporary forms of expression in service of the Museum's ever-expanding encyclopedic mission.

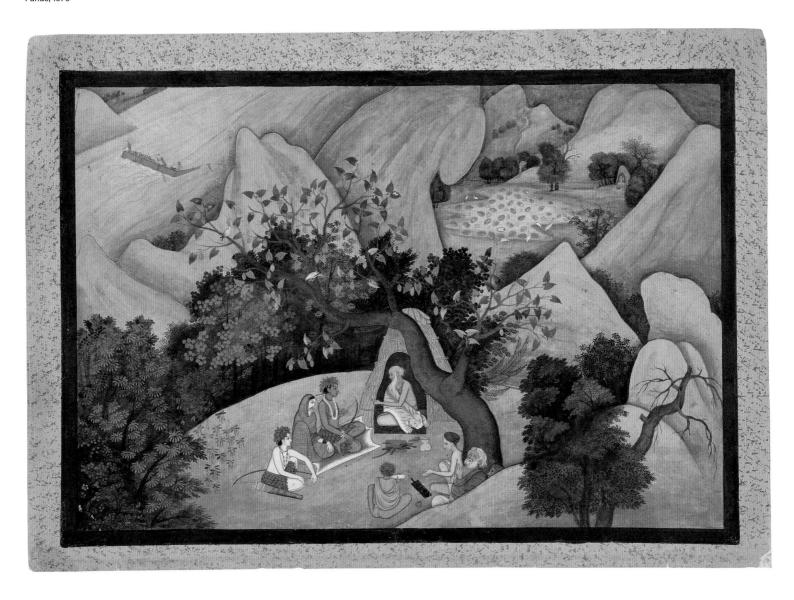

216. Displays of early and
medieval Islamic art, 1976

217. Tile with Qur'anic inscription from Sura 36
(Ya-Sin): 15. Iran (probably Kashan), Ilkhanid period
(1258–1353), second half 13th century. Stonepaste,
molded and luster-painted on opaque white glaze
under transparent glaze. H. O. Havemeyer Collection,
Gift of Horace Havemeyer, 1940

Transforming Islamic Art

Navina Najat Haidar

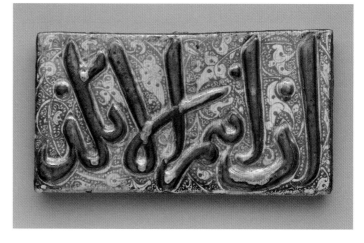

It was a historic moment in 1975 when the Metropolitan Museum unveiled powerful and substantially enlarged galleries dedicated to Islamic art on the second floor of the southeastern wing (fig. 216). In doing so, the institution had endorsed a burgeoning field of art history and given it grand scale. While the Museum had already taken steps in this direction by establishing a department and spaces for Islamic art in 1963, it became a pioneer ahead of every other Western museum with the expansion. The critics and the public alike were awed by the beauty of the collection and by the conceptual force of the category of Islamic art.[1] This benchmark reframed the art of the Middle East, North Africa, and parts of the Indian subcontinent, moving past the lenses of exotica, Orientalism, or decorative art that had shaped the Western view of those cultures in the earlier part of the century. It also conveyed the sense of an authentic voice of a region that defined itself through its own cultural values and its rising position in world affairs, bolstered by the oil boom.

The simple and bold statement of Islamic department chairman Richard Ettinghausen—"Islamic art is one of the finest manifestations of Islamic civilization"[2]—encompassed the spirit of the moment, distilling notions of art, religion, and culture into a single, timeless essence. In this sense, however, Islamic art stood somewhat mysteriously aloof from the taxonomies of geography, periodization, or typology that defined most other fields of art history and

curatorial departments. Instead, it embraced a wide variety of styles and types of objects, loosely linked by religion and culture. In order to bring together that artistic diversity into a cohesive and legitimate whole, the central premise of the galleries was to identify and emphasize any unities that pervaded artistic production from Spain to India, from the seventh to the eighteenth century, the rough parameters of the field at that time. Geometric ornament and vegetal arabesques were distinguished as the unifying decorative language that crossed all borders, while calligraphy was presented as the most revered art form everywhere (fig. 217). These ideas defined the field and influenced the museum world profoundly.

The theme of artistic unity was expressed most effectively in displays of early and medieval art from the central Islamic lands (the Middle East, Spain, and North Africa),

218. Late Medieval gallery with post-
Nasrid Spanish ceiling installed above
the "Simonetti" Mamluk carpet, 1976

219. Islamic art galleries, 1976

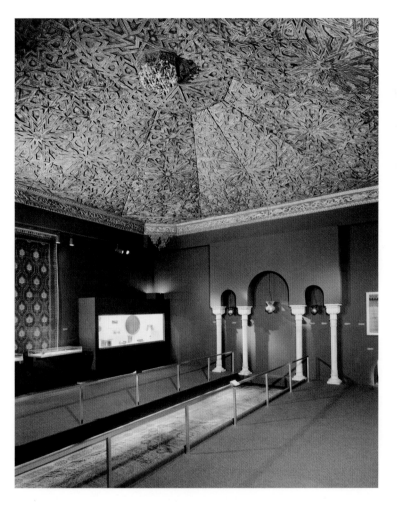

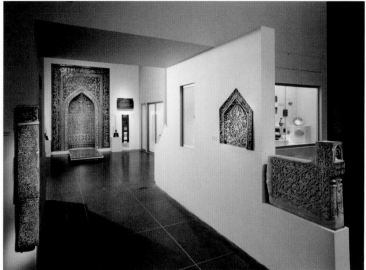

where objects from the Umayyad, Abbasid, Seljuq, Fatimid, Ayyubid, Mamluk, and Nasrid dynasties, among others, were presented in shared spaces, while works from the later Safavid, Ottoman, and Mughal empires were given their own galleries. Unity was also underscored by bringing together objects in different media ornamented with the same motif. Among such motifs were the distinctive abstract leaf forms that developed in ninth-century Samarra, Iraq. Characterized by a double S-curve or natural rounded shapes, these fronds appear in symmetrical and repeated designs on the surface of ceramic bowls and glass fragments and were carved onto stucco wall panels and wooden doors. This important "beveled" style was heralded not just for its distinctive aesthetic impact, but it was also seen as a break from the classical ornament of the preceding era. A truly "Islamic" style had been born, and the Museum's galleries recognized this new visual language as one of the essential elements that made up the Abbasid golden age.

Through their displays, the galleries were prescient in exploring stylistic and cultural exchanges across geographic and cultural boundaries, themes that have grown in importance over time. A dramatic space that brought together works of art from the western and eastern frontiers of the Islamic world was centered on the late medieval period (fig. 218). Here, a large carved, painted, and gilded wooden Spanish ceiling of the early sixteenth century, executed in the so-called mudéjar style,[3] was installed above a long sunken platform upon which the five-medallion "Simonetti" carpet, an Egyptian Mamluk-period masterpiece,[4] was displayed. The harmony of interlocked medallions and interlaced stars in the ceiling above and carpet below made a powerful statement about the shared aesthetics of the Mediterranean and created a meaningful setting for the smaller decorative arts, textiles, and works on paper on view nearby.

The galleries emphasized the importance of the religious arts, showing Islam as a unifying cultural and spiritual force. Qur'an pages and calligraphic folios from a variety of periods and places were arranged around a large prayer niche, creating the atmosphere of a sacred space (fig. 219). The arts of the book were presented as among the most prestigious courtly traditions and as a mark of the intellectual and literary life of the Islamic courts (fig. 220). In an innovative departure from Europeanizing vertical hanging customs, fine paintings and illuminated folios were placed on angled decks and chairs were provided for visitors, who were invited to sit and closely inspect these masterpieces.

205

In the fifty years that followed the centennial installation of Islamic art, a great evolution has come about in the field. The historical scope now comprises a wider slice of late antiquity at one end and nineteenth-century, modern, and contemporary art at the other. The geographic parameters have expanded to include Southeast Asia, sub-Saharan Africa, the Indian Ocean, and Chinese Central Asia. Approaches, methodologies, theories, and technical studies have evolved within the field of Islamic art, while nationalist discourses and changing geopolitics have influenced outside perceptions of it.[5] So much so that the definition of the field has changed, with the emphasis shifting from unity to diversity. It is this diversity that is championed in the new Islamic

galleries, opened in 2011. Nonetheless, the new spaces are still indebted to the foundations that were laid in 1975. An introductory space for collection masterpieces, a special area for Nishapur archaeological material, and angled displays for the book arts with seating for visitors are among the lasting legacies.

Enduring through the installations and interpretive approaches of the last century, there has remained one constant—the object. The inlaid metal candlesticks of medieval Egypt and Syria as well as the late Persian swan-necked glass bottles that first enchanted early benefactors such as Edward C. Moore have also inspired later acquisitions. These have included bequests from J. Pierpont Morgan

222. "Star Ushak" carpet. Turkey (Ushak), Ottoman period (ca. 1299–1923), late 15th–early 16th century. Wool (warp, weft, and pile), symmetrically knotted pile. Gift of Joseph V. McMullan, 1958

(fig. 221), Benjamin Altman, Theodore M. Davis, Alexander Smith Cochran, James F. Ballard, Joseph V. McMullan (fig. 222), and Henry Osborne and Louisine Havemeyer (see fig. 156), as well as gifts in celebration of the Museum's centennial, notably the seventy-six extraordinary painted folios from an early sixteenth-century copy of Abu'l Qasim Firdausi's *Shahnama* presented by Arthur A. Houghton Jr. (fig. 223).[6] Since then the collection has continued to grow in new directions, achieving ever new relevance for the remarkable artistic legacy of Islam.

Recovering the Missing Chapters

Joanne Pillsbury

In 1870 George Fiske Comfort, one of the founders of the Metropolitan Museum, stated that "[a]n ideal museum must . . . be cosmopolitan in its character; and it must present the whole stream of art-history in all nations and ages, as represented in the three great arts, of architecture, sculpture, and painting, in the minor arts, and in the many applications of art to industry, by the adornment of every material production which comes from the hand of man."[1] Despite early attempts to address this goal, it would be over a century before the lofty ideal of representing the art history of all cultures and ages was more truly realized. Prior to 1970, the Museum, by and large, did not see the artistic traditions of Africa, Oceania, and Native America as worthy of inclusion in the collection. The art of the ancient Americas (Latin America before the arrival of Europeans), also called Precolumbian, has a more complex history at the institution, extending from a robust presentation of thousands of works in the late nineteenth century to its nearly complete banishment from the halls from about 1914 until the time of the centenary.

The first gifts of Precolumbian and Native American art came within three years of the Museum's founding in 1870, with additional significant gifts and purchases in the following two decades (see "The Founding Decades"). Other artifacts were presented by diplomats, missionaries, soldiers, and artists, such as "an ancient idol from Kauai, Sandwich Islands [Hawaii]" given in 1876 by Captain Henry Erben of the United States Navy.[2] The largest number of works from Africa and Oceania arrived with Mary Elizabeth Adams

Brown's collection of musical instruments (see "Art for All"); indeed, by 1903, that African collection was sufficiently large to warrant its own room. Particular attention was also paid to the acquisition of American antiquities, which reflects a broader move toward hemispheric unity in the nineteenth century, one that was deeply entangled with political—and emergent national—ambitions toward Latin America. In 1882 the Museum's first president, John Taylor Johnston, declared that "the antiquities of our own continent should form a prominent feature in an American Museum." He also acknowledged the functional nature of many of these works as a complement to their status as fine art: "In gold and other metals, in stone, in textile fabrics and in pottery, are found works which sufficiently indicate the possession by ancient Americans of many useful arts, and a cultivation of the love of beauty, measured by an independent standard which, however distinct from ours, nevertheless proves the presence of intellectual and art loving races of men."[3]

The rising tide of interest in what Johnston called "old American art" brought in a number of major works and supporters (fig. 224). The Hudson River School painter Frederic Edwin Church became an enthusiastic advocate for the creation of a department devoted to what he called "Ancient Art of the New World" and donated a splendid pair of Toltec panels depicting an eagle grasping a trilobed object in its talon (fig. 34).[4] Church also supported the acquisition in 1900 of a collection of some sixteen hundred Mexican antiquities assembled by Italian diplomat Luigi Petich.

Acquisitions slowed considerably in the early twentieth century, however, and the Museum began to reconsider the place of Precolumbian works within a fine arts institution. Letters between Robert W. de Forest, then the Museum's secretary and vice president, and Henry Fairfield Osborn, director of the American Museum of Natural History, New York, betray an increasing unease on the part of the Metropolitan Museum with its ancient American collection. In a 1911 letter to de Forest, Osborn wrote, "Our lines of demarcation are perfectly clear: historic peoples belong to The Metropolitan Museum; prehistoric peoples and prehistoric and primitive works of art may well come here."[5] The two men had come to an agreement: When it came to antiquities, the Metropolitan Museum would focus on the Mediterranean world and Asia, and the American Museum of Natural History would be responsible for everything else. Soon afterward plans were drawn up to exchange their respective holdings in these areas.

In 1914 Edward Robinson, director of the Metropolitan Museum, sent most of the ancient American collection—which by that point numbered some two thousand items—across Central Park to the American Museum of Natural History. Ancient Peruvian gold and silver were held back, at least for a few decades, but they were ultimately sent on long-term loan to the Brooklyn Museum in 1935 at the behest of Herbert Spinden, a pioneering Brooklyn curator with strong interests in the arts of the Americas. The decision to relegate the arts of the indigenous Americas, Africa, and Oceania to the realm of a natural history museum reflected the attitude of the day that these cultural traditions existed outside of history. At that time the decipherment of Meso-american writing systems was in its infancy; it would take another fifty years for the historical dimensions of Maya inscriptions to be identified. An understanding of archaeo-logical stratigraphy—the idea that things lower in the ground were older—was not yet widespread, and radiocarbon dating methods would not be developed for close to sixty years.

In some ways, this history is an idiosyncratic saga of the Museum's collecting and its evolving institutional identity. On a deeper level, however, this history is also about shifting definitions of what is considered "fine art," and the recognition of the arts of Africa, Oceania, and the Americas as part of global narratives. The rise of the use of the term "primitive" to describe these fields in the first decades of the twentieth century could not have helped the case for their inclusion at the Metropolitan Museum, an institution that, by that time, prided itself on a growing collection of Euro-pean masterpieces and its overall sense of discernment in the fine arts. In such a context, the nearly complete absence of artists' names as part of the documentation of African, Oceanic, and Precolumbian works, and the unfamiliar nature of their traditions of patronage, would have likely mitigated against an embrace of them as fine art. Interest-ingly, however, textiles from all three areas continued to be collected, in part to fulfill the Museum's mission to educate and inspire contemporary industries (see fig. 51).

Broader currents in New York and beyond also had a bearing on the reception of the arts of non-Western cultures. In the wake of the 1913 Armory Show, the arts of Africa, Oceania, and the Americas were increasingly seen through the lens of modernism, a movement the Metropolitan Museum still viewed with skepticism (see "Reckoning with Modernism"). Indeed, the Museum of Modern Art, New York (MoMA), was born, in part, out of frustration caused by the Metropolitan Museum's refusal to entertain contem-porary art, and, later in the century, it would be MoMA that would mount the most important exhibitions of the arts of Africa, Oceania, and the Americas.

The Metropolitan Museum was not entirely without advocates for the arts of these three regions, however, and occasionally gifts from these areas were accepted, such as a bronze rooster from the court of Benin, Nigeria, which came as part of the bequest of Mary Stillman Harkness in 1950.[6] Nevertheless, these works were isolated in the absence of a sustained program of study and support, as were the small number of modest exhibitions of Precolumbian art mounted at the Museum in the 1950s and 1960s. Nelson Aldrich Rockefeller, who joined the board of trustees in 1930, made various attempts to increase the Museum's engagement with these fields, but for almost forty years he was largely rebuffed.[7] With the encouragement of René d'Harnoncourt, director of MoMA, Rockefeller founded a cultural organization devoted to the arts the Metropolitan Museum largely ignored. The Museum of Primitive Art, located in a brownstone across the street from MoMA, opened its doors in 1957 and became an important springboard for the research and appreciation of the arts of Africa, Oceania, and the Americas.

In the meantime, there was a growing acknowledgment at the Metropolitan Museum that the Precolumbian collection should not have been annexed to the American Museum of Natural History.[8] Dudley Easby, a lawyer who had previously worked with Rockefeller and became secretary of the Metropolitan Museum in 1945, began to lay the groundwork with Director James J. Rorimer to rebuild the Precolumbian collection through select purchases and major gifts of ancient Peruvian ceramics and goldwork from Nathan Cummings and Alice K. Bache, respectively (fig. 225, middle). A few long-term loans were recalled from the Brooklyn Museum and the American Museum of Natural History and installed in an exhibition on archaeology at the Junior Museum, a museum-within-a-museum geared toward children and families.

Easby may have helped ignite the Museum's renewed engagement with Precolumbian art, but it was ultimately the influence of Nelson Rockefeller, and the promise of his collection, that led to the institution's decision to embrace the arts of Africa, Oceania, and the indigenous Americas on a permanent and continuous basis. In 1967 René d'Harnoncourt, acting on behalf of Rockefeller, brokered a deal with Director Thomas Hoving to create a department encompassing the collections of the Museum of Primitive Art and

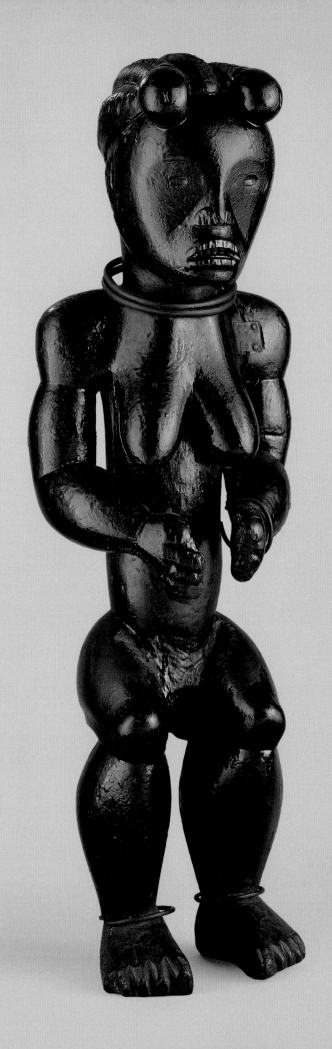

Rockefeller's personal collection. The agreement was celebrated in 1969 with an exhibition of works drawn from the Museum of Primitive Art, and in that same year Easby became consultative chairman of the new Department of Primitive Art (renamed the Department of the Arts of Africa, Oceania, and the Americas in 1991). *Before Cortés: Sculpture of Middle America*, a major exhibition of ancient Mesoamerican sculpture, including many works acquired by the Metropolitan Museum in its first decades, followed in 1970 as part of the centenary celebrations.

The Museum of Primitive Art closed in December 1974, and its staff, library, and 3,500 works were transferred to the Metropolitan Museum, where they joined the some 2,300 works already in the collection, including art recalled from other institutions, and a recent gift of close to eighty Dogon sculptures from Lester Wunderman (fig. 228). The Michael C. Rockefeller Wing was dedicated to the memory of Nelson's son, who lost his life on a collecting expedition in New Guinea in 1961 (figs. 226–27, 229–31). Although closely involved in the planning of the wing, Nelson himself did not live to see it open to the public in 1982. The wing, designed by Kevin Roche John Dinkeloo and Associates as a pendant to the one housing the Temple of Dendur on the Museum's north end, provided nearly an acre of exhibition space and featured a dramatic glass curtain wall on the south facade that enclosed the spectacular Asmat *bisj* poles (see pp. 190–91), collected by Michael Rockefeller, and the ceiling of a ceremonial house from New Guinea, commissioned by the Museum.

The installation was intended to be the antithesis of an ethnographic display and to make the case that so-called

229. Horn player. Nigeria, Court of Benin, Edo peoples, 1550–1680. Brass. The Michael C. Rockefeller Memorial Collection, Gift of Nelson A. Rockefeller, 1972

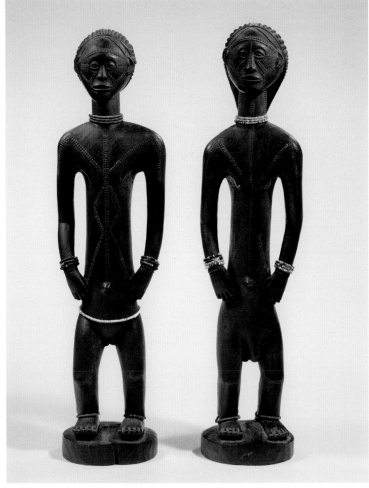

230. Standing male and female figures. Democratic Republic of the Congo, Lake Tanganyika region, Tabwa peoples, 18th–19th century. Wood, beads. The Michael C. Rockefeller Memorial Collection, Purchase, Nelson A. Rockefeller Gift, 1969

primitive art belonged in the context of a fine art museum. The walls and cases were painted with a muted beige palette, works were bathed in dramatic spotlights, and supporting documentation was kept to a minimum. The works were organized by geography, and to a lesser extent chronology—a reflection of the still nascent knowledge of the art history of these regions—and emphasis was placed on single, outstanding examples of great aesthetic merit. In certain places, works were grouped by medium, such as the "treasury" of ancient American gold, an installation that would be expanded significantly in the 1990s with the addition of the Jan Mitchell gift of Precolumbian gold.

Visited by half a million people in its first year, the new installation signaled that the Museum had become encyclopedic, as the idea was then understood.[9] Four decades later,

we recognize that the term "encyclopedic" requires constant scrutiny and revision. Yet, undeniably, the Metropolitan Museum's embrace of the arts of Africa, Oceania, and the Americas has had a notable impact on museums and the practice of art history. In the 1981–82 annual report, Director Philippe de Montebello stated that "[a]t long last, the arts of Africa, Oceania, and the Native Americas have shed their image as ethnography or exotica and speak to us . . . in the universal language of aesthetics and of significant form."[10] Since 1982 the Museum's holdings of the arts of these areas have doubled in size, and the institution has mounted some fifty scholarly exhibitions illuminating the histories and meanings of the artistic traditions of Africa, Oceania, and the Americas, laying a new foundation upon which future endeavors can rise.

231. Body mask. New Guinea, Papua Province, Asmat people, mid-20th century. Fiber, sago palm leaves, wood, bamboo, feathers, seeds, paint. The Michael C. Rockefeller Memorial Collection; Gift of Nelson A. Rockefeller and Mrs. Mary C. Rockefeller, 1965

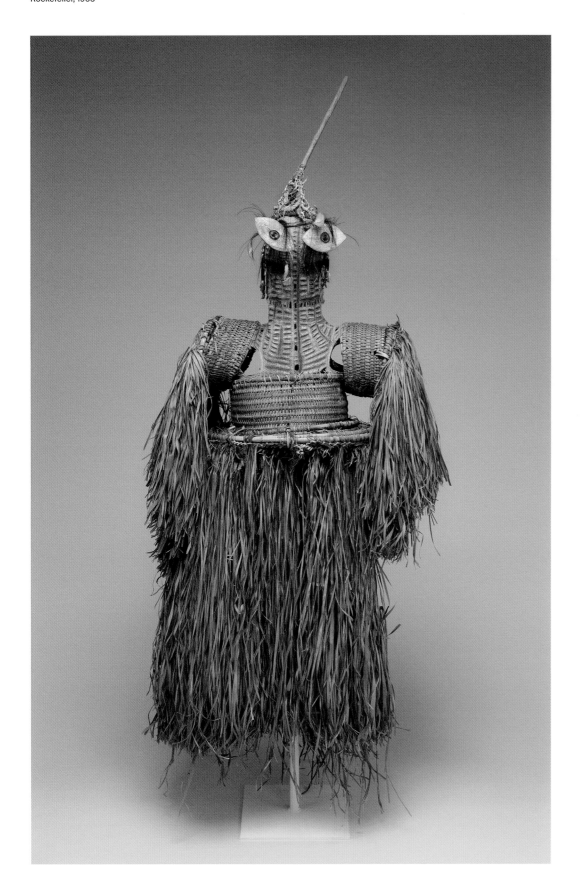

A Seat at the Table

Kelly Baum

In 1964 Henry Geldzahler, then associate curator in the Department of American Painting and Sculpture, delivered a memo to Director James J. Rorimer, urging him to develop a coherent, systematic policy on twentieth-century art. "If the museum sees as its function coverage of the entire history of significant art," he wrote, "then it would seem arbitrary and unfortunate to stop short of the art of our own time." Moreover, "[t]he discontinuity and isolation of modern art at the other New York museums create an inbred and essentially artificial separation between today's art and the art of even the recent past," a problem the Metropolitan Museum, he believed, was uniquely positioned to rectify due to the historical and international breadth of its collection.[1] Geldzahler went on to suggest that Rorimer establish a department devoted to twentieth-century painting and sculpture from the United States and Europe. Although Rorimer failed to heed Geldzahler's call, his successor, Thomas Hoving, did, albeit on different terms, creating instead a Department of Contemporary Arts in 1967, three years before the Museum's centenary, and appointing Geldzahler to oversee it.[2] The story of the department's founding, likewise its first decade, has consistently privileged Geldzahler as its sole creative agent—the singular, almost miraculous force behind the Museum's engagement with the art of the present. Yet, as pivotal a role as Geldzahler played, his efforts were preceded and, later, amplified by two other individuals: Robert Beverly Hale and Lowery Stokes Sims. Each of these three curators played an instrumental part in building the core holdings of modern art before, during, and soon after the department's founding, but only Sims made a consistent and concerted effort to reach beyond a narrow community of white male artists,

thereby laying the groundwork for a more diverse, expansive collection.

The conditions for an independent program in contemporary art were formed in 1948, when a second attempt at a merger with the Whitney Museum of American Art failed, prompting the Metropolitan Museum to more actively collect and exhibit contemporary American art (see "Reckoning with Modernism").[3] During the decades of its agreement with the Whitney, the Metropolitan Museum outsourced responsibility for contemporary art to its partner institution, allowing the Whitney to purchase works for what was to have been a single collection. When the Whitney annulled the agreement, the Metropolitan Museum was forced to fill the resulting curatorial and intellectual void. To this end, it hired Hale, a professor at the Art Students League, in 1949, as associate curator to oversee a new department devoted to American art both past and present.[4] (The Museum's decision to focus solely on contemporary American art reflects the nationalist fervor of the postwar years, a moment when New York was asserting its global dominance in aesthetics and politics.) It was this department that Geldzahler joined as an assistant curator in 1960.[5] With few dedicated curatorial projects and little in the way of serious institutional support, Geldzahler spent much of his time at galleries and studios. He was already close to some of the New York School artists, especially Helen Frankenthaler, Hans Hofmann, and Robert Motherwell, but upon his arrival at the Museum, he also made inroads with the avant-garde. Besides befriending Andy Warhol, whose *Mona Lisa* he bought for himself and later donated to the Museum (fig. 232), he also participated in some of Claes Oldenburg's films and Happenings in the early 1960s (fig. 233).

On October 24, 1967, in a memo to Kevin Roche, one of the architects responsible for the Museum's 1970 master plan, Geldzahler laid out an ambitious, future-facing proposal for what would become, in 1987, the Lila Acheson Wallace Wing.[6] This memo provides a window onto his initial plans for the new department. Geldzahler recommended designating galleries for theatrical backdrops, contemporary fashion, and World's Fair ephemera, which would be interspersed with period rooms and more conventional galleries devoted to early twentieth-century art and postwar American paintings. He called for no less than three theaters: two for film and one that functioned like a "television studio, with no fixed seating and unlimited technical

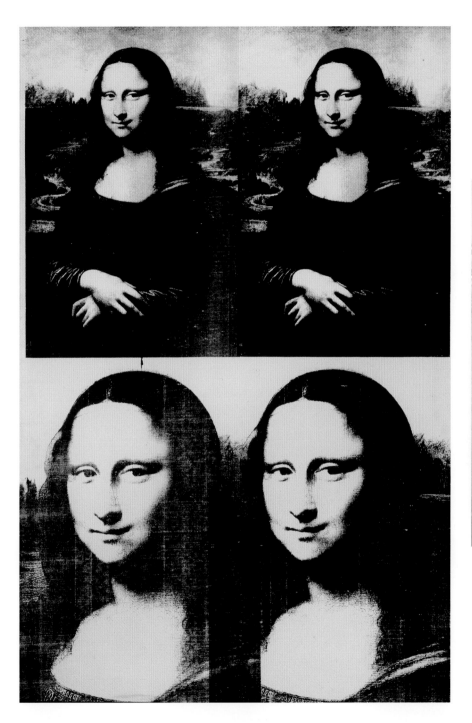

possibilities, for lighting sound and moveable props." Geldzahler also envisioned a gallery specifically for "light shows and mixed media manifestations." Unfortunately, very few of his original ideas ultimately came to pass.

Geldzahler tended to police the boundaries between his curatorial responsibilities and his extra-institutional activities fairly carefully: as a gay, Jewish curator specializing in a field tolerated only on paper by the director and the board, his position at the Museum was relatively precarious.[7] Despite their collaboration, for instance, Geldzahler never acquired a work by Oldenburg for the Museum, and Warhol initially entered the collection by way of a gift—from Geldzahler, as it turns out. Yet neither Geldzahler's desire for self-preservation nor the conservatism of the trustees

234. Barnett Newman (American).
Concord, 1949. Oil and masking tape on
canvas. George A. Hearn Fund, 1968

The Centennial Era

235. Ellsworth Kelly (American). *Blue Green Red*, 1963. Oil on canvas. Arthur Hoppock Hearn Fund, 1963

accounts entirely for his choices as a curator. Indeed, when it came to acquisitions, he favored abstract paintings and sculptures, whether expressionist, color field, or hard-edge, by American artists with established critical records, including Richard Diebenkorn, Morris Louis, Barnett Newman (fig. 234), Ad Reinhardt, Mark Rothko, and Clyfford Still. Along with the acquisitions that Hale and Geldzahler made between 1949 and 1966, including pieces by Arshile Gorky, Ellsworth Kelly (fig. 235), Willem de Kooning, and Jackson Pollock, those works form the backbone of the Museum's

collection of modern art. It is only in hindsight, of course, that such choices seem like safe bets. To the trustees, at least, they certainly constituted risks at the time. Still, it bears considering that Geldzahler collected in this vein for decades, long after Minimal, Conceptual, Post-Minimal, and Land art had radicalized the art world.

Geldzahler's sometimes limited perspective on contemporary art also impacted his exhibitions, including the groundbreaking *New York Painting and Sculpture: 1940–1970*, organized as part of the Museum's centennial celebrations

(fig. 236).[8] While this remarkable survey of recent artistic practice took many risks, placing the work of young Neo-Dada, Pop, and Minimal artists like Jasper Johns, Warhol, and Donald Judd alongside recently canonized painters such as Gorky and Pollock, it ultimately distilled a very diverse community of artists into a homogenous cross section of mostly white male abstract painters and sculptors. To be fair, it was always Geldzahler's plan to focus on modernism in New York during and after World War II, prioritizing artists who had produced mature bodies of work by 1965. Yet, neither the show's provincialism nor its historical timeline account for his inclusion of only one female artist, Frankenthaler, and the exclusion of black artists altogether.

The public outcry over Geldzahler's refusal to recognize artists of color commenced almost immediately. In a letter dated December 31, 1969, the Black Emergency Cultural Coalition (BECC), formed in reaction to the Museum's exhibition *"Harlem on My Mind": The Cultural Capital of Black America, 1900–1968* (1969), contacted Hoving about the lack of black artists in all of its centennial exhibitions.[9] Around the same time, the Art Workers' Coalition (AWC), a left-leaning, antiestablishment group of artists, critics, and filmmakers, distributed a flyer criticizing the racial bias of

Geldzahler's show.[10] It also circulated hundreds of modified one-dollar bills that paint an unflattering portrait of the prejudices underwriting "The United States Art World." Declaring itself "Not valid for black, Puerto Rican or female artists," the bill features Nelson Aldrich Rockefeller's visage instead of George Washington's and Geldzahler's signature where that of the treasurer of the United States would have appeared (fig. 237). Overall, the bill implicates the Museum in a more general critique of the dominant art world, characterizing the latter as a kind of caste system that serves exclusively the interests of wealthy white males, whether artists, curators, collectors, or trustees.

Geldzahler attempted to justify his omission of artists of color from *New York Painting and Sculpture* in a statement titled "An Open Letter to Black Artists." (It is not clear if this statement was ever issued.) The letter is rife with contradictions. On the one hand, Geldzahler recognized the importance of black artists and decried their underrepresentation in New York museums. On the other, he maintained that black art represented a "unique tradition" best shown separately from modern art: since no black artists contributed to the history of "radically innovative modernist art"—a statement based on prejudice as much as ignorance—none was included in *New York Painting and Sculpture*. (Around the same time, Geldzahler jotted down an even more unvarnished retort to his critics on a sheet of paper now among his archives at Yale: "Black painting and sculpture is clearly not as good as white."[11]) It hardly matters that Geldzahler's open letter made a case for investing in arts education and underwriting the training of more black artists: its racial bias is clear. Nevertheless, whether from a personal change of belief or as a result of external pressure, Geldzahler soon took small steps to right his previous wrongs, requesting funds, for instance, to acquire the work of living black artists for the Museum in 1970.[12]

238. Romare Bearden (American). *The Woodshed*, 1969. Cut and pasted printed and colored papers, photostats, cloth, graphite, and sprayed ink on Masonite. George A. Hearn Fund, 1970

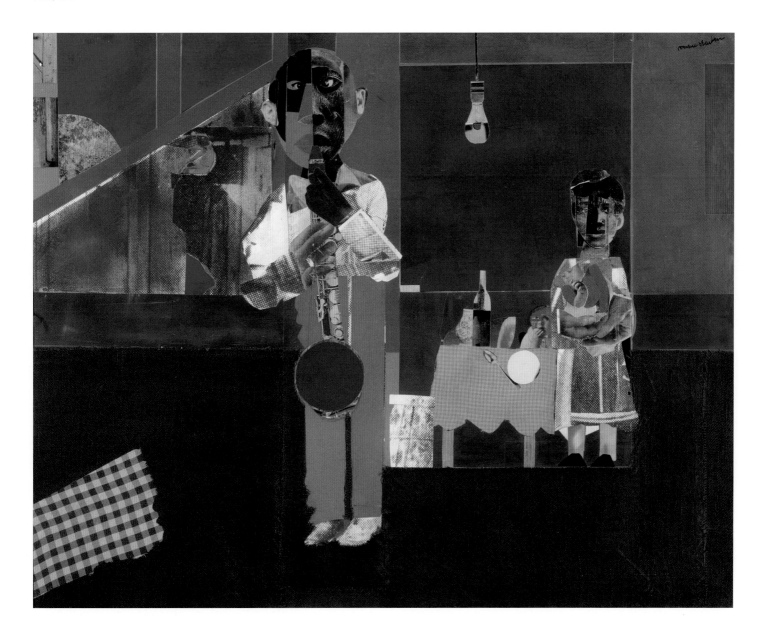

After the Department of Contemporary Arts was renamed the Department of Twentieth-Century Art in 1970, Geldzahler began to adopt a slightly more expansive curatorial purview. He made extensive acquisitions in decorative arts, reigniting a long-dormant program, and brought in a few fine works by African American artists, such as Romare Bearden (fig. 238) and Jack Whitten. He also organized shows that featured art produced throughout the century by artists active on both sides of the Atlantic Ocean, such as Jean Arp, Hans Hartung, and Francis Bacon. In the process, he convinced the administration to lift its long-held injunction against solo exhibitions by living artists.[13] Over the course of the 1970s, however, Geldzahler fell increasingly out of step with contemporary art, especially the idea- and language-based experiments that had supplanted the lush, tactile paintings he so prized. Recognizing he was no longer "contemporary" enough to serve as curator of contemporary art, Geldzahler accepted the post of New York city commissioner of cultural affairs in 1977, leaving the department in Lowery Sims's excellent hands.[14]

Sims had joined the Museum in 1972 as an employee in the Department of Community Programs.[15] Besides heeding the call of decentralization and overseeing outreach in New York's five boroughs, the department unofficially ran

interference between the Museum and its critics in the art world, including the AWC, Art Strike, and the BECC.[16] It also joined discussions with black artists and the director's office about how to better engage the black community.[17] The department in which Sims "studied," in other words, operated outside the rarefied world of Fifth Avenue, inter-acting closely with New York's varied communities, many of whom demanded both resources and structural change from what they perceived as an elitist, insular insti-tution that needed to share its wealth with smaller, under-funded organizations. Sims's experience in Community Programs undoubtedly helped shape her perspective on art and curating as much as her dissertation on Wifredo Lam and the international avant-garde. During her tenure in Community Programs, Sims pursued a variety of curatorial opportunities, organizing exhibitions for the Junior Museum, including two on the collectives En Foco and Black Photog-raphers. She also coordinated two external exhibitions on African American art from the collection, an experience about which she has expressed ambivalence (fig. 239).[18]

Committed to equity, diversity, and social justice, Sims realized that reform of the kind she wanted to effect at the Museum would occur only if she operated within a curato-rial department, so she soon sought a position working alongside Geldzahler.[19] In 1975 she was named assistant curator of twentieth-century art. She also served as interim chair of the department from 1977 to 1979.[20] When she left to assume the position of director at the Studio Museum in Harlem in 1999, Sims had worked at the Metropolitan Museum for twenty-seven years. Just as she had fought for a seat at the table herself, so too did she lobby on behalf of women artists and artists of color both outside and inside the institution. In the 1970s and 1980s Sims notably sup-ported such projects as Children's Art Carnival, an outreach program founded by Betty Blayton-Taylor in 1969, and Just Above Midtown (JAM), a gallery opened by Linda Goode Bryant in 1974 to showcase the work of black artists.[21] Sims

also reported on Third World women artists for *Women Art-ists News* in 1978 and participated in the protests against a racist exhibition at Artists Space in 1979.[22] During these years and beyond, Sims either shepherded or helped shep-herd into the collection through gift and purchase dozens of works by black, indigenous, and female artists, including Terry Adkins, Benny Andrews, Jean-Michel Basquiat, McArthur Binion, Betty Blayton-Taylor, Frank Bowling, Beverly Buchanan, Elizabeth Catlett, Barbara Chase-Riboud, Robert Colescott, Melvin Edwards, Sam Gilliam, Norman Lewis, Howardena Pindell, Faith Ringgold (see fig. 256), Betye Saar, and Kay WalkingStick, each one a "crime of opportunity," she has recalled.[23] Together with Hale and Geldzahler, who faced their own uphill battles bringing con-temporary art to an institution that was at best ambivalent and at worst hostile to it, Sims made an enormous, lasting contribution to the Museum. She was instrumental in bring-ing a distinctly inclusive, cosmopolitan perspective to the department, thereby squaring its mission more perfectly with that of the Museum's own quest to be an expansive, global institution.

Engaging with Artists

Maricelle Robles

Living artists have been critical partners in building the Metropolitan Museum throughout its history, making vital contributions through gifts to the collection, involvement on committees, participation in programming, and engagement in celebrations of and protests against the institution. Painters Eastman Johnson, Frederic Edwin Church, and John Frederick Kensett and sculptor John Quincy Adams Ward were founding trustees, and Church and Kensett served on the original hanging committee (see "Founding Decades" and "Creating a National Narrative"). Silversmith and benefactor Edward C. Moore was instrumental to the Museum's venture to open an art school in 1880, geared primarily to industrial practice with courses in woodwork, metalwork, and even carriage drafting and plumbing.[1] Although the school would close by the turn of the twentieth century, the institution's commitment to nurturing artists, designers, and craftspeople endured, not only through a variety of educational offerings but also in curatorial initiatives. In the 1905 annual report, president J. Pierpont Morgan and secretary Robert W. de Forest prioritized the creation of study collections (see "Art for All"). Beginning in the 1920s, curator Richard F. Bach organized a series of dynamic annual international design exhibitions in collaboration with manufacturers and makers, seeking to create records of American design and to inspire future innovation (see "Reckoning with Modernism"). Outreach to schools through tours and the circulation of visual material, such as lantern slides and small exhibitions, was carried out by various departments until 1941, when Director Francis Henry Taylor established the Department of Education and Museum Extension to oversee these activities.[2]

Nevertheless, while the Museum promoted using the collection for art and design education, it remained reluctant to engage with contemporary art or artists throughout much of its history. (Notable exceptions were the endowments provided by George A. Hearn for the purchase of works by American painters alive in or born after 1906, gifts that continue to fund acquisitions to this day.) In the 1950s, curator Robert Beverly Hale initiated a series of national juried exhibitions of contemporary American art, which fostered fierce debate among artists about the conservative bias of the Museum, most prominently through the open letter that was published on the front page of the *New York Times* on May 22, 1950, and signed by twenty-eight painters and sculptors including Louise Bourgeois, Adolph Gottlieb, Hans Hofmann, Barnett Newman, Jackson Pollock, and David Smith, who became known as the Irascibles.[3] As the Metropolitan Museum approached its centennial, the institution's involvement with contemporary artists expanded significantly. Director Thomas Hoving established the Department of Contemporary Arts in 1967 at the behest and under the leadership of curator Henry Geldzahler, who also lobbied successfully to lift the ban on solo exhibitions by living artists (see "A Seat at the Table"). Motivated further by a spirit of community engagement and educational outreach, the Museum began to develop a more responsive and reciprocal relationship with artists, marked by a greater commitment to acquisitions, exhibitions, commissions, and live arts programs.

In 1968 the Museum mounted a new traveling exhibition program to promote the integration of American art into American history studies in high schools. Organized by members of the Education Department under the direction of Harry S. Parker III, the two pilot shows were part of an effort to reach audiences outside the Museum's physical building and to support art education in high school curriculums nationally. Thirteen schools in New York, New Jersey, Connecticut, and Alabama participated in the program.[4] While the first show focused on American history from the revolution through the twentieth century, the second was conceived in partnership with six artists active in New York: Richard Anuszkiewicz, Helen Frankenthaler, Adolph Gottlieb, Nicholas Krushenick, Roy Lichtenstein, and George Segal.[5] Working with Rosa Esman, director of Tanglewood Press, each artist created a print that was screened onto an aluminum panel, thus producing a limited edition of

240. George Segal in his studio, working on his silkscreen for the high school exhibition, 1968

241. Demonstrators outside the Metropolitan Museum protesting the exhibition *Harlem on My Mind* on January 16, 1969

original works that could then be sent to the school venues.[6] An accompanying filmstrip based on interviews with the artists and photographs of their studios (fig. 240) was also provided to guide discussion of the works. The success of the 1968 traveling exhibitions led to an increased investment in shows of this nature in the Museum's centennial year and to the announcement that it would continue its high school initiative through a subscription service "designed to provide access to art where it has been unavailable previously and to respond to the eagerness of high schools to include art and art history within the ongoing curriculum."[7]

Yet Hoving's progressive outreach campaigns were not without their missteps. One of the most significant controversies in the Museum's history surrounds the exhibition *"Harlem on My Mind": The Cultural Capital of Black America, 1900–1968* (1969). Announced to the press in 1967, the show was the brainchild of guest curator Allon Schoener, who wanted to present Harlem's "achievements and contribution into American life and to the City."[8] Artists, particularly those based in Harlem, paid close attention to the project.[9] Soon after the exhibition was announced, Schoener assembled a Community Advisory Committee composed of officials and advisors from Harlem that held regular meetings at the Schomburg Center for Research in Black Culture at the New York Public Library in Harlem. As early as a year in advance of the opening, committee members, the Harlem

Cultural Council, and many prominent black artists withdrew their support of the exhibition, expressing frustration that their suggestions were largely ignored.[10] Indeed, a central point of contention was the exclusion of work by prominent black artists, such as Romare Bearden, Faith Ringgold, and Jacob Lawrence, all of whom were living in Harlem and creating works that would fit into Schoener's social narrative (the Museum's collection already included one work by Bearden and three by Lawrence).[11] Both Hoving and Schoener ignored the warnings and advice from artists and prominent community members and proceeded with an exhibition that had no paintings, drawings, or sculptures and instead displayed a social narrative of Harlem using reproductions of newspaper clippings, timelines, a soundscape of

street noises, and photographs of prominent leaders and anonymous Harlem residents—among them, images by James Van Der Zee and Gordon Parks. A week before the opening of *Harlem on My Mind*, a group of artists including Benny Andrews, Romare Bearden, Henri Ghent, Norman Lewis, Cliff Joseph, and Ed Taylor formed the Black Emergency Cultural Coalition (BECC) to organize protests against the Metropolitan Museum.[12]

On January 16, 1969, *Harlem on My Mind* opened to large crowds gathered outside the Metropolitan Museum and a daylong demonstration by the BECC (fig. 241). Negative

reviews of the exhibition by art critics and opinion pieces about its content appeared even before the show opened,[13] and further organized protests were staged throughout the show's sixteen-week run. The heavy press attention and the controversy did not deter visitors, and *Harlem on My Mind* was notably well attended.[14] In a statement issued later, the BECC laid out their grievances against the exhibition: "[Schoener and Hoving] omitted painters and sculptors who also contributed to the cultural development of Harlem, misused or otherwise ignored the body of black advisors to the exhibition . . . imported people from outside the

Harlem community to work on the exhibition and ended up producing an audio-visual exposition with neither logical sequence nor adequate explanatory information."[15] Beyond the show's failings, what was most significant about *Harlem on My Mind* was not the exhibition itself, but the actions and advocacy of the Black Arts community. They brought attention to the need for greater diversity and inclusion in museums, both on display and behind the scenes.

In conjunction with *Harlem on My Mind*, Hilde Limondjian, who had been hired in 1960 to work on the Museum's concerts and lectures series, booked Nina Simone to inaugurate a jazz program that sought to attract new audiences to the Museum. Then at the height of her success, Simone fully embraced her position as a popular black musician to raise awareness of social issues that plagued black communities across the United States.[16] According to accounts from protestors, Simone crossed the picket lines to perform two sold-out concerts in the Grace Rainey Rogers Auditorium on February 4 and 6, 1969.[17] William Kolodney had introduced a concert subscription series at the Museum in 1954, with poetry readings by T. S. Eliot, Sir Osbert and Dame Edith Sitwell, and Robert Frost, and performances by pianist Artur Rubinstein, violinist Isaac Stern, folk singer Burl Ives, and contralto Marian Anderson,[18] but Limondjian helped push the Museum to widen its purview, in step with changes in live arts programming across the country.[19]

As part of its centennial celebrations in 1970, the Museum planned for a year of spectacular festivities, and the programming promised to "employ art for inspiration, pleasure, and education."[20] Artists, composers, and performers enthusiastically showed their support through their craft: Robert Rauschenberg created a print to honor the event (fig. 242), while Frank Stella designed the official logo for the anniversary year (fig. 243). Esteemed American composers were invited to write fanfares for all five centennial exhibitions: Leonard Bernstein opened *Before Cortés: Sculpture of Middle America*; Virgil Thomson *New York Painting and Sculpture: 1940–1970*; Walter Piston *The Year 1200*; William Schuman *19th Century America*; and Aaron Copland *Masterpieces of Fifty Centuries*. On January 20, 1970, Twyla Tharp and her company performed *Dancing in the Streets of London and Paris, Continued in Stockholm and Sometimes Madrid* on the grand staircase (fig. 244) and in the galleries.[21] Jointly commissioned by the Wadsworth Atheneum and the Metropolitan Museum, the work was based on the simultaneity

of life and art, and the possible blurring of their boundaries.[22] Choreographed for public areas in which the audience members and dancers inhabited a shared space, Tharp's piece was never intended to be finished: the dancers and their movements could be adapted in response to different locations and the performers could respond to the spectators with improvised movements, but they must always maintain distance, or a sense of separation, from the audience.[23] *Dancing in the Streets* was the first experimental dance presented at the Museum. Today this legacy is carried forward through new commissions and premieres as part of MetLiveArts, notably with the Artist-in-Residence program, which in 2017–18 hosted its first choreographer, Andrea Miller, founder and artistic director of Gallim. In 2018–19, the performance series featured a commission from dancer and choreographer Silas Farley, entitled *Songs from the Spirit*, which included music composed for the work by residents of San Quentin State Prison.

During his tenure, Hoving pioneered innovations in education, programming, fundraising, and community relations, many of which are now commonplace in museum practice. In this environment, living artists were granted greater opportunities to exhibit and experiment in ways that altered the Museum and inspired the later expansion of the curatorial programming with contemporary artists (see "Broadening Perspectives"). Hoving believed that the most significant American export was the "freedom of our arts."[24] This ethos transformed, popularized, and codified a more open institution—one that continues to aspire to these ideals, both as a form of rededication to its origins and in a spirit of receptiveness to the spirit of change that artists can inspire.

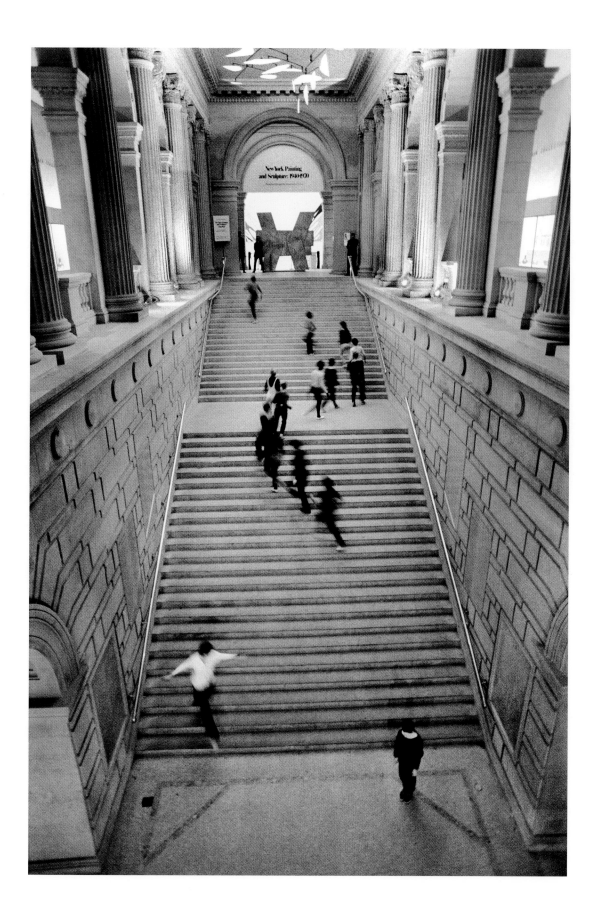

Broadening Perspectives

Max Hollein

Since its founding 150 years ago, the Metropolitan Museum has aspired to be a global museum. Conceived in the tumultuous aftermath of the American Civil War, the institution was established in part to secure the status of New York among the great cities of the world, the United States among the great nations. Unlike many of its European forebears, however—the Louvre, Prado, Hermitage, or the state museums in Germany and Austria—the Metropolitan Museum began life not as a princely collection but as the vision of private citizens. At the heart of their civic-minded endeavor was the goal of educating America's diverse populations—especially in New York, a city of immigrants whose roots crisscrossed geopolitical borders—about the history of their respective and newfound cultures. While recognizing the nationalist overtones and inherent noblesse oblige of the founders' ambitions, we can admire the spirited cosmopolitanism that was bred into the Museum's DNA from the very beginning. It is a legacy that still animates our mission to embrace art and audiences from around the world.

The idea of the encyclopedic museum, born of the Enlightenment, represented an effort to bring the cultures of the world together in one place and tell one compelling story about humankind and its development. The result was typically a somewhat linear narrative from Mesopotamia to Egypt to Greece and Rome, and beyond. Today that essential story has evolved and become more complex, as have the roles and responsibilities of such institutions. We recognize that there is, in fact, no single story of the cultures of the world. Rather, there is—as there always has been—a spectrum of connected, intersecting histories of the development of world culture that demand to be recovered and retold. As its mission, the Metropolitan Museum "collects, studies, conserves, and presents significant works of art across all times and cultures in order to connect people to creativity, knowledge, and ideas."[1] To that we can add a responsibility to broaden our own perspectives and engage with art from multiple viewpoints as we celebrate cultural diversity and achievement.

In the 150 years since the institution's founding, the definitions of "art," "audience," and even "museum" have evolved and become more fluid, never more rapidly than in our lifetimes, with the advent of globalization and the

ensuing explosion of new media and the Internet. Rather than ossifying into a relic of the past, the Metropolitan Museum has embraced the challenge of remaining relevant in a society that values connectivity and diversity. Early in his tenure as director, Thomas P. Campbell recognized the urgent need to upgrade the Museum's digital infrastructure and expand our online presence and outreach. Accordingly, access to information about our collection has grown exponentially, as we have sought to share our expertise and stimulate exchange with a larger constituency than our founders ever could have imagined. At the core of all our bustling activities remains the collection, however, and its growth throughout this period can be seen as a barometer of how an institution like the Metropolitan Museum, with such a deep, entangled, and sometimes contradictory history, can change and adapt in order to find its footing "across all times and cultures."

The early 1990s marked a turning point in that pursuit. Under the long and successful direction of Philippe de

Montebello, the Museum not only significantly expanded its collection but also completed its expansion into the physical limits of its footprint in Central Park, reflecting an ambition dating back to the Museum's first director, Luigi Palma di Cesnola, and fulfilling a master plan conceived in 1970 for its centenary. At that time, on what was then the eve of its 125th anniversary, the director could argue that the collection represented every type of art from every era and place across the globe and was close to embodying the encyclopedic ideal.[2] Even outside its own august walls and the pages of its publications, the Metropolitan Museum was well established as one of the preeminent art institutions in the world.[3]

Every generation brings a fresh outlook to what constitutes completeness, however, and in recent years the Museum's staff has been eagerly reexamining the long-standing categories and structures privileged by the encyclopedic museum model. Taking a deeper look at world cultures, they have brought renewed attention to areas previously underrepresented in our collection with landmark acquisitions of exquisite works of art. While the study of Asian art, for instance, has traditionally centered on China, Japan, and India, we now have galleries dedicated to Korea, Thailand, Indonesia, and Tibet, mirroring the greater recognition in society at large of Asia's burgeoning, multifaceted economy. Our Tibetan holdings now range from a sublime, exceedingly rare early medieval *Buddha Shakyamuni* (fig. 245) to one of the world's premier collections of arms and armor from this region (fig. 246).

247. Four Gospels. Armenian, 1434/35. Tempera and gold on paper; stamped leather binding. Purchase, Fletcher Fund, Hagop Kevorkian Fund Gift, in memory of Hagop Kevorkian, Tianaderrah Foundation, B.H. Breslauer Foundation, Aso O. Tavitian, Karen Bedrosian Richardson, Elizabeth Mugar Eveillard and Arax Simsarian Gifts and funds from various donors, 2010

248. Processional cross. Ethiopia, Amhara or Tigrinya peoples, 13th–14th century. Bronze. Purchase, 2005 Benefit Fund, 2011

249. Headdresses for a Bugis aristocrat. Attributed to Indonesia, Sulawesi, 19th–early 20th century. Fiber, gold. Purchase, Friends of Islamic Art Gifts and Lewis and Gemma Hall Gift, 2006

This increasingly multicentric perspective has expanded our field of vision beyond the tidy labels and artistic schools of traditional art history—ancient Greece, Tang or Song dynasty China, Renaissance Italy, nineteenth-century France, postwar New York—into an appreciation of world art that breaks through conventional lines of demarcation. In the process, visitors gain a deeper understanding of the cross-cultural dialogues and exchanges that were more vital to the development of art than geopolitical boundaries. A compelling Armenian manuscript, for example, was acquired as part of an effort over the past two decades to present the broad reach of the Byzantine Empire, from Armenia to North Africa, as central to the art of the Middle Ages (fig. 247). One hundred years after the Museum first purchased an Ethiopian prayer book and healing scroll for the documentary value of its text, which is written in the classical Geez language, our curators of African art began to systematically collect Ethiopian Coptic gospels, icons, and processional crosses for their artistic value (fig. 248). These devotional objects attest to the Aksumite Empire's adoption of Christianity as early as the fourth century and are evidence of the complex interrelationships between sub-Saharan Africa and Arabia, Egypt, and the eastern Mediterranean. The Department of Islamic Art has likewise focused on works that testify to exchanges across the Indian Ocean between Southeast Asia, India, the Middle East, and eastern Africa, offering an alternative to the usual emphasis on dynasties or regions. A pair of Indonesian headdresses woven with fine gold fibers—one with black trim, to be worn before pilgrimage to Mecca, and one with white trim for after—serves as a reminder of the great distances traveled by their wealthy patron and the Turkish fez style (fig. 249).

250. Andrea Zambelli "L'Honnesta" (Italian). Torah crown (*keter*) and pair of finials (*rimonim*), ca. 1740–50. Silver, parcel gilded. Walter and Leonore Annenberg Acquisitions Endowment Fund, 2016

251. Hebrew Bible. Spanish, 1300–1366. Ink, tempera, and gold on parchment; leather binding. The Cloisters Collection, 2018

Establishing connections between disparate traditions and geographies also meant addressing notable lacunae in the collection, even within our celebrated holdings of European art. Only in recent years, for example, have we prioritized Judaica, such as the virtuosic eighteenth-century Venetian Torah crown and associated pair of finials by Andrea Zambelli (fig. 250). Reunited in our galleries, they form one of the most important examples of European Judaica in any American encyclopedic museum. Among the Christian medieval manuscripts at the Cloisters, we now display a Hebrew Bible from fourteenth-century Spain adorned with decorative elements that intertwine Jewish, Christian, and Islamic influences (fig. 251).

From the other side of the Atlantic Ocean, a Guatemalan polychrome *Calvary* (fig. 252), made for an Italian-born merchant in the Spanish port city of Cádiz and brought from overseas at great expense, shares an opulence with the Indonesian headdresses and, like them, reminds us that their creators and original owners were participants in a sophisticated, integrated system of travel, trade, and exchange. The recent acquisition of the Guatemalan sculpture also advances the goal of representing the diverse cultures of colonial Latin America in our collection, a major initiative inaugurated in 2015 with the spectacular *Crown of the Andes*

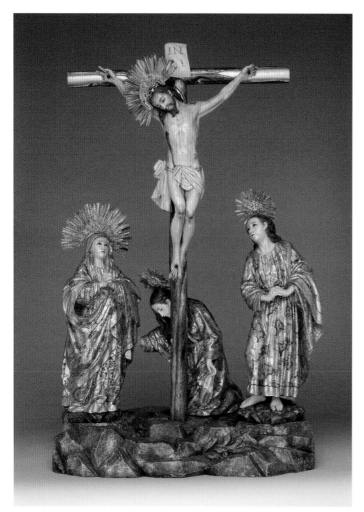

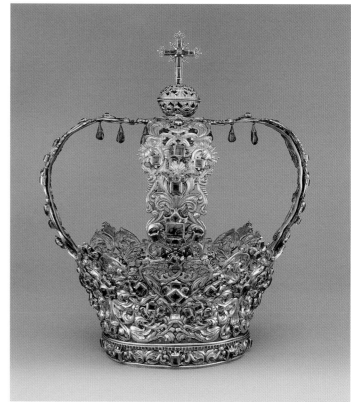

(fig. 253). One of the foremost examples of goldsmiths' work to survive from colonial Spanish America, the crown vividly manifests the cultural values and spiritual aspirations of a flourishing community in what is now Colombia, a region that possessed abundant deposits of gold and emeralds and whose wealth largely derived from mining.

In tandem with our efforts to traverse the globe in search of traditions we have historically either overlooked or ignored, the Museum has also turned its focus inward as part of a more critical look at the artistic heritage of our own country. Although the collection has included Native American art since its earliest years, the loan of a Pomo basket in 2016 (fig. 254) introduced a dialogue between Native and non-Native artists in the American Wing for the first time, setting the stage for the gift of the Charles and Valerie Diker Collection in 2017. The arrival of the Diker gift allowed us to

present a more holistic view of American art in general while fundamentally transforming our approach to the context in which we exhibit Native American art.[4] We have also sought to strengthen holdings of American folk art and works by nineteenth-century artists of color, such as Joshua Johnson's portrait of Maryland toddler Emma Van Name from about 1805, widely regarded as an icon of folk painting (fig. 255). The earliest known professional African American painter, Johnson was born into slavery and apparently self-taught. Although much more remains to be done, the presence of these works in the American Wing galleries signifies the Museum's commitment to bring together different voices, challenge entrenched ideas, and expand the story of American art to reflect the rich diversity of the population.

These initiatives go beyond the development and classification of our collections, speaking directly to the

question of what it means to be an encyclopedic museum in the twenty-first century. A greater emphasis on, and understanding of, our diverse audience has stimulated a more empathic interpretation of our role in the world, one in which we hope our visitors can see their own identities reflected in the works of art in our galleries. In the words of contemporary painter Kerry James Marshall, "For people of color, securing a place in the modern story of art is fraught with confusion and contradictions about what and who they should be—black artists, or artists who happen to be black. A modernist has always looked like a white man, in one way or another. Universality has, unquestionably, been his gift to bestow on others."[5] Indeed, as an institution that has long purported to be "universal," the Metropolitan Museum has been progressively coming to terms with its own role in perpetuating inequalities in the art historical canon and in

seeking to make amends. One of the trailblazers in that effort was curator Lowery Stokes Sims. Among the key acquisitions she championed was *Street Story Quilt* by activist artist Faith Ringgold, which presents a narrative of survival and redemption set in an apartment building in Harlem (fig. 256). Purchased just five years after it was created, Ringgold's large, brilliant quilt makes a strong statement on behalf of both the artist and the Museum about how to engage with social issues through art, particularly after the notoriety of *"Harlem on My Mind": The Cultural Capital of Black America, 1900–1968* (see "The Centennial Era").

This was a signal moment in the Museum's attempts to represent the diversity of contemporary society within its collection, all the more so because it was in part a reaction to external pressure from the arts community itself. We need to recognize that artists often act as highly attuned seismographs

256. Faith Ringgold (American). *Street Story Quilt*, 1985. Cotton canvas, with acrylic paint, ink marker, dyed and printed cotton, and sequins, sewn to cotton flannel backing. Arthur Hoppock Hearn Fund and funds from various donors, 1990

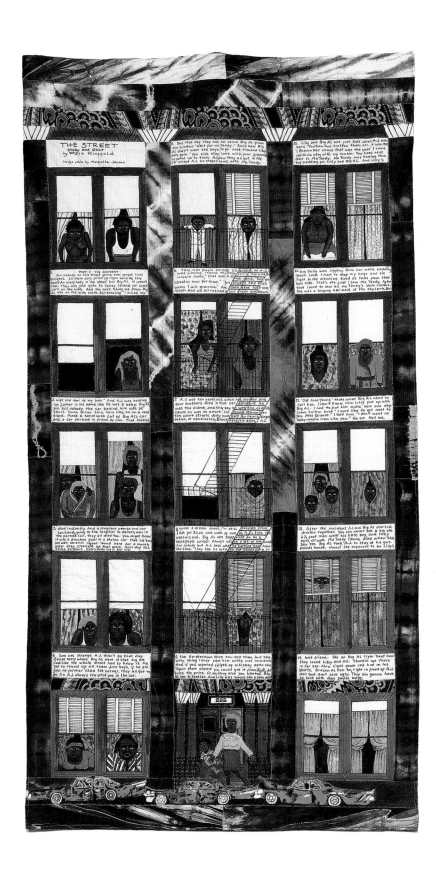

Broadening Perspectives

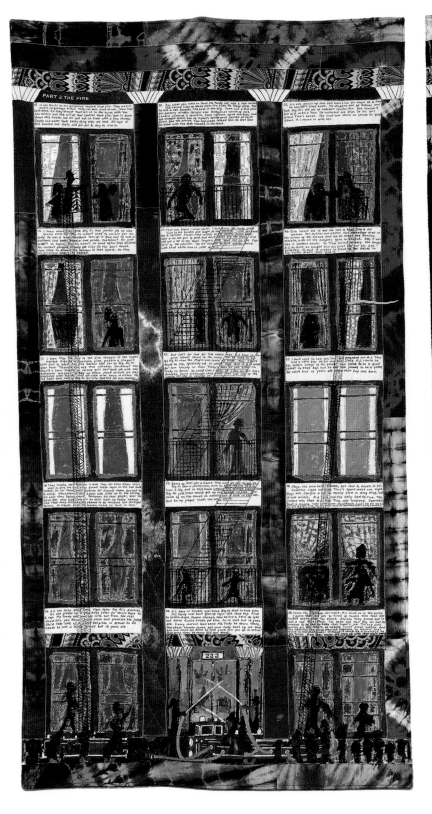

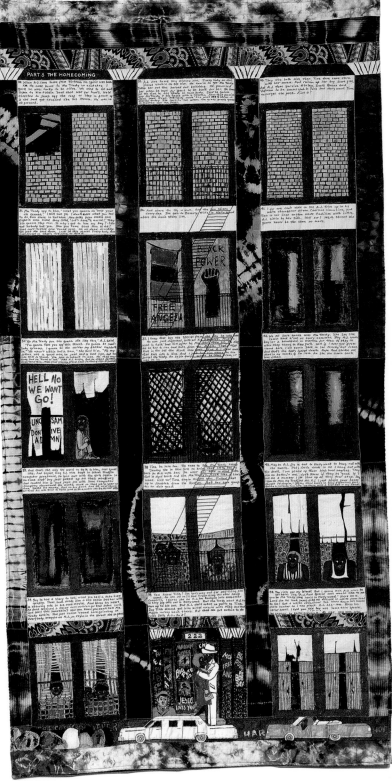

237

257. Guerrilla Girls. *Do Women Have to Be Naked to Get into the Met. Museum?* 1989. Screenprint on paper. Tate Collection, Great Britain. Purchased 2003

258. Carmen Herrera (Cuban). *Iberic*, 1949. Acrylic on canvas on board. Gift of Tony Bechara, in celebration of the Museum's 150th Anniversary, 2019

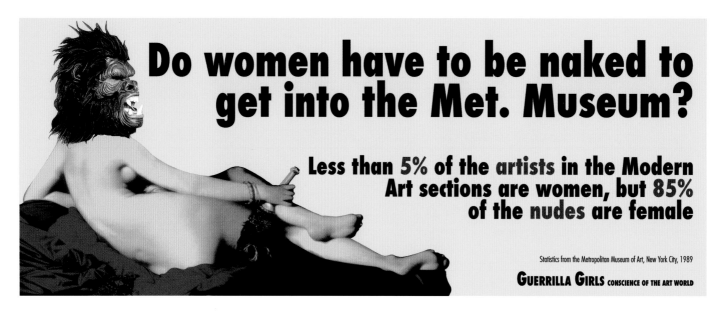

of cultural shifts both large and small, pointing the way forward through their works but also through their actions and advocacy. In 1989 the Guerrilla Girls issued their famously provocative print titled *Do Women Have to Be Naked to Get into the Met. Museum?*, citing statistics that women constitute less than five percent of the modern artists in the collection but eighty-five percent of the nude bodies on display (fig. 257). The Museum's current philosophy—to historical art and to the art of the present day—has been conscientiously multicultural and inclusive, and we will strive to continue to live up to this promise. Recent acquisitions by Carmen Herrera (fig. 258) and Mrinalini Mukherjee (fig. 259), to name just a few, reflect a resolve not only to bring prominence to women artists but also to acknowledge multiple strands of modernity, from Latin America to South Asia.

In an era of international biennials and unprecedented access to travel, the Metropolitan Museum has taken a deliberately global approach to contemporary art, which derives new meaning and nuance when viewed through the lens of an encyclopedic collection. The institution's major initiative at the Met Breuer (2016–20) was conceived to do just that, offering an array of powerful, revelatory, and unorthodox exhibitions, such as *Unfinished: Thoughts Left Visible* in 2016 and *Like Life: Sculpture, Color, and the Body (1300–Now)* in 2018, that leveraged the depth of our permanent collection to spark debate and offer fresh perspectives. As we look now to renovate our galleries for twentieth- and twenty-first-century art in our flagship Fifth Avenue building, opportunities for such trans-historic, cross-cultural experiments will become more common and increasingly fruitful.

260. El Anatsui (Ghanaian). *Dusasa II*, 2007. Found aluminum, copper wire, plastic disks. Purchase, The Raymond and Beverly Sackler 21st Century Art Fund; Stephen and Nan Swid and Roy R. and Marie S. Neuberger Foundation Inc. Gifts; and Arthur Lejwa Fund, in honor of Jean Arp, 2008

Broadening Perspectives

261. Ann Hamilton (American). *abc*, 1994.
Video, black-and-white, silent, 13 min.
Gift of Peter Norton Family Foundation,
2001

Conversely, just as the art of the past can help us understand the concerns of the present, contemporary art has the ability to lay bare the inadequacies of the encyclopedic museum and its outdated reliance on taxonomies of schools, regions, and media. In 2007–8 the Museum was in the vanguard of collecting the work of El Anatsui, one of the foremost contemporary African artists. Interweaving found materials with references to traditional Ghanaian tribal cloths as well as Western mosaics, tapestries, and chain mail, El Anatsui addresses pressing issues of everyday life, from rampant consumerism to alcohol abuse. His dazzling, textural hangings defy classification as sculptures, textiles, or even three-dimensional paintings. That *Between Earth and Heaven* and the monumental *Dusasa II* (fig. 260) were acquired almost simultaneously by two different curatorial departments is emblematic of the breakdown of such categorizations and the multivalent potential of great art.[6] The artist himself commented that seeing the former installed among historic African art leaves the impression that "the past is facing the present, and it shows that art creation didn't ever come to a stop in Africa."[7]

Recognizing the increasingly fluid boundaries between media during the 1990s, the Department of Photographs acquired Ann Hamilton's *abc* in 2001, our first work of video art—another medium that has since been collected by multiple departments but that the Museum was slower to acknowledge (fig. 261). Modest in scale, silent, and displayed on a monitor set flush into the wall, *abc* is a natural extension

of the photographic into the realm of moving imagery. Hamilton engages with a wide range of media in her artistic practice to forge new pathways of communication and affect specific to the feminine experience, based in qualities of touch, materiality, and the body.

Iris Van Herpen's skeleton dress pushes the boundaries of those qualities, and thus of the collection itself, in a radically different direction (fig. 262). Acquired in 2012, shortly after it was shown in the Dutch designer's debut haute couture collection, the dress was the first 3D-printed object acquired by the Costume Institute. Van Herpen rejects the binary opposition between ready-to-wear and haute couture, presenting instead a fusion of digital and

handmade practices that sets a new standard for the fashion industry and, at the same time, complicates notions about the functionality of fashion and fashion as sculpture. Her work has also inspired research into the long-term care and preservation of plastics, building on the Museum's strong foundation of conservation and scientific research.

Sometimes even a familiar object like a guitar can stretch the collection in unexpected ways. The superb *Four Seasons* guitars designed by John Monteleone draw upon a classical Spanish idiom yet incorporate steel strings, favored in jazz and other popular music (fig. 263). The ensemble represents a novel musical idea but also a new aspect of collecting musical instruments for the Museum, since the guitars are meant

to be played, not just displayed, and thereby to inspire musicians to extend the limits of their current practice.

Engaging with questions about the definition of art and how our collection can best develop to represent society today challenges us to move forward, to never become mired in any one time or mentality but to renew our commitment to strive for universality. As we embark on yet another era for our Museum, we will increasingly prioritize dialogues throughout our collection, pushing the limits of the encyclopedic model to better reflect our interconnected society and collective history. In recent years we have reconsidered the exterior of our stately Fifth Avenue building as a space to display contemporary art with the inauguration of

two ongoing series of site-specific commissions: the first for the Iris and B. Gerald Cantor Roof Garden (see pp. 228–29), launched in 2013, and the second for the sculptural niches on the facade, unveiled in 2019. By inviting artists to create original works of art inspired by our collection and site, we seek bold interventions that bring together past and present and solicit community interaction. We also understand the Metropolitan Museum as an institution that is not tethered to its physical presence in New York City but one that exists in the world at large. We may have reached our final physical boundaries in Central Park, but we continue to imagine myriad possibilities for meaningful contribution and exchange across the globe.

Works in the Exhibition

Preface

Grave stele with a little girl and doves
Greek, ca. 450–440 B.C.
Parian marble
H. 31¾ in. (80.6 cm)
Fletcher Fund, 1927 (27.45)
Fig. 1

Richard Avedon (American, 1923–2004)
Marilyn Monroe, Actress, New York City, May 6, 1957
Gelatin silver print
22¼ × 23¼ in. (56.5 × 59.1 cm)
Gift of the artist, 2002 (2002.379.11)
Fig. 2

Head of Bhairava
Nepalese, 16th century
Gilded copper, rock crystal, paint
H. 32 in. (81.3 cm), w. 36 in. (91.4 cm), D. 14 in. (35.6 cm)
Zimmerman Family Collection, Gift of the Zimmerman Family, 2012 (2012.444.2)
Fig. 3

Power figure (*Nkisi N'Kondi: Mangaaka*)
Republic of the Congo or Cabinda, Angola, Chiloango River region, Kongo peoples, Yombe group, 19th century
Wood, iron, resin, ceramic, plant fiber, textile, pigment
H. 46½ in. (118 cm), w. 19½ in. (49.5 cm), D. 15½ in. (39.4 cm)
Purchase, Lila Acheson Wallace, Drs. Daniel and Marian Malcolm, Laura G. and James J. Ross, Jeffrey B. Soref, The Robert T. Wall Family, Dr. and Mrs. Sidney G. Clyman, and Steven Kossak Gifts, 2008 (2008.30)
Fig. 4

Auguste Rodin (French, 1840–1917)
The Age of Bronze, modeled 1876, cast ca. 1906
Bronze
H. 72 in. (182.9 cm)
Gift of Mrs. John W. Simpson, 1907 (07.127)
Fig. 5

Vincent van Gogh (Dutch, 1853–1890)
La Berceuse (Woman Rocking a Cradle), 1889
Oil on canvas
36½ × 29 in. (92.7 × 73.7 cm)
The Walter H. and Leonore Annenberg Collection, Gift of Walter H. and Leonore Annenberg, 1996, Bequest of Walter H. Annenberg, 2002 (1996.435)
Fig. 6

Isamu Noguchi (American, 1904–1988)
Kouros, 1945
Marble
H. 117 in. (297.2 cm)
Fletcher Fund, 1953 (53.87a–i)
Fig. 7

The Founding Decades

John Frederick Kensett (American, 1816–1872)
Sunset on the Sea, 1872
Oil on canvas
28 × 41⅛ in. (71.1 × 104.5 cm)
Gift of Thomas Kensett, 1874 (74.3)
Fig. 23

Eastman Johnson (American, 1824–1906)
Christmas-Time, The Blodgett Family, 1864
Oil on canvas
30 × 25 in. (76.2 × 63.5 cm)
Gift of Mr. and Mrs. Stephen Whitney Blodgett, 1983 (1983.486)
Fig. 24

Anthony van Dyck (Flemish, 1599–1641)
Saint Rosalie Interceding for the Plague-Stricken of Palermo, 1624
Oil on canvas
39¼ × 29 in. (99.7 × 73.7 cm)
Purchase, 1871 (71.41)
Fig. 26

Francesco Guardi (Italian, 1712–1793)
The Grand Canal above the Rialto, late 1760s
Oil on canvas
21 × 33¾ in. (53.3 × 85.7 cm)
Purchase, 1871 (71.119)
Fig. 27

Jean Antoine Houdon (French, 1741–1828)
Benjamin Franklin, 1778
Marble
Overall: H. 23⅛ in. (58.7 cm), w. 14½ in. (36.8 cm), D. 11¼ in. (28.6 cm)
Gift of John Bard, 1872 (72.6)
Fig. 28

Head of a bearded man
Cypriot, early 6th century B.C.
Limestone
H. 35 in. (88.9 cm), w. 14 in. (35.6 cm), D. 23 in. (58.4 cm)
The Cesnola Collection, Purchased by subscription, 1874–76 (74.51.2857)
Fig. 29

Frank Waller (American, 1842–1923)
Interior View of the Metropolitan Museum of Art when in Fourteenth Street, 1881
Oil on canvas
24 × 20 in. (61 × 50.8 cm)
Purchase, 1895 (95.29)
Fig. 31

Camille Corot (French, 1796–1875)
Ville-d'Avray, 1870
Oil on canvas
21⅝ × 31½ in. (54.9 × 80 cm)
Catharine Lorillard Wolfe Collection, Bequest of Catharine Lorillard Wolfe, 1887 (87.15.141)
Fig. 32

Edouard Manet (French, 1832–1883)
Young Lady in 1866, 1866
Oil on canvas
72⅞ × 50⅝ in. (185.1 × 128.6 cm)
Gift of Erwin Davis, 1889 (89.21.3)
Fig. 33

Eagle relief
Toltec (Mexico), 10th–13th century
Andesite or dacite, paint
H. 27½ in. (69.9 cm), w. 29½ in. (74.9 cm), D. 3 in. (7.6 cm)
Gift of Frederic E. Church, 1893 (93.27.1)
Fig. 34

Vase with poems composed by the Qianlong emperor
Chinese, Qing dynasty (1644–1911), Qianlong mark and period (1736–95)
Porcelain painted with colored enamels and gilded (Jingdezhen ware)
H. (with cover) 9 in. (22.9 cm), w. 4½ in. (11.4 cm), D. 2¾ in. (7 cm)
Purchase by subscription, 1879 (79.2.612a, b)
Fig. 35

Pillow in the shape of an infant boy
Chinese, Qing dynasty (1644–1911), 18th–19th century
Jade (jadeite)
H. 4¾ in. (12.1 cm), w. 8¾ in. (22.2 cm), D. 4 in. (10.2 cm)
Gift of Heber R. Bishop, 1902 (02.18.426)
Fig. 36

Turban helmet
Turkish (possibly Istanbul), late 15th–16th century
Steel, iron, silver, gold
H. 11⅞ in. (30.2 cm), DIAM. 9 in. (22.9 cm)
Rogers Fund, 1904 (04.3.210)
Fig. 37

Inscribed by Yukinoshita Sadaiyé
(Japanese, active 17th century)
Armor (*gusoku*), 17th century
Iron, lacquer, silk, gilded copper
As mounted: H. 53 in. (134.6 cm),
w. 32 in. (81.3 cm), D. 20 in.
(50.8 cm)
Rogers Fund, 1904 (04.4.9a–l)
Fig. 38

Works not illustrated, by date

Plinth with the feet of a colossal male statue
Cypriot, middle or second half 6th
century B.C.
Limestone
H. 13⅛ in. (33.3 cm), w. 18 in.
(45.7 cm), D. 25 in. (63.5 cm)
The Cesnola Collection, Purchased
by subscription, 1874–76
(74.51.2683)

Water dropper in the shape of a crane
Chinese, Qing dynasty (1644–1911),
18th century
Agate
H. 2⅜ in. (6 cm), w. 3⅛ in. (7.9 cm),
D. 1¾ in. (4.4 cm)
Gift of Heber R. Bishop, 1902
(02.18.876a, b)

Franchi and Son (British)
Salver, 19th century, after a 1558–59
Flemish original
Silver on base metal
H. 1¾ in. (4.4 cm), w. 24¾ in.
(62.9 cm), D. 24¾ in. (62.9 cm)
Purchase, 1873 (73.8.46)

Art for All

Bracelet with lion-head finials
Cypriot, 5th century B.C.
Gold, copper alloy
DIAM. 3⅛ in. (7.9 cm)
The Cesnola Collection, Purchased
by subscription, 1874–76
(74.51.3559)
Fig. 39

Tiffany & Co. (American, founded
1837)
Bracelet with lion-head finials,
ca. 1878
Gold
DIAM. 2⅜ in. (6 cm)

Purchase, Martha J. Fleischman and
Barbara G. Fleischman Gifts, in
honor of Beth Carver Wees, 2018
(2018.383)
Fig. 40

Saùng-gauk
Burmese (Myanmar), 19th century
Wood, deerskin, paint, cotton cord,
metal, glass
H. 35⁵⁄₁₆ in. (89.7 cm), w. 34¼ in.
(87 cm), D. 8¹⁄₁₆ in. (20.5 cm)
The Crosby Brown Collection of
Musical Instruments, 1889
(89.4.1465a, b)
Fig. 41

Raven rattle
Native American, Tsimshian,
Skidegate, British Columbia,
Canada, 19th century
Cedar, pebbles, paint
H. 12³⁄₁₆ in. (31 cm), w. 4¹⁄₁₆ in.
(10.3 cm), D. 4⅛ in. (10.5 cm)
The Crosby Brown Collection of
Musical Instruments, 1889
(89.4.611)
Fig. 42

Cravat end
Flemish (Brussels), mid-18th
century
Linen, bobbin lace
13¼ × 17¹⁄₁₆ in. (33.7 × 43.3 cm)
Rogers Fund, 1926 (26.283)
Fig. 44

Voided velvet
Italian (possibly Genoa), second
half 17th century
Silk and metal-wrapped thread
24 × 22 in. (61.0 × 55.9 cm)
Rogers Fund, 1909 (09.50.1318)
Fig. 46

Noh costume (*Karaori*) with cherry blossoms and fretwork
Japanese, Edo period (1615–1868),
first half 18th century
Silk, brocaded twill
65½ × 64½ in. (166.4 × 163.8 cm)
Rogers Fund, 1919 (19.88.2)
Fig. 49

Chasuble (*Opus Anglicanum*)
English, ca. 1330–50
Silk velvet embroidered with silver,
silver-gilt, and colored silk
threads, with pearls
51 × 30 in. (129.5 × 76.2 cm)
Fletcher Fund, 1927 (27.162.1)
Fig. 50

Tunic with confronting catfish
Nasca-Wari (Peru), 800–850
Camelid hair, tapestry-weave
21½ × 43¼ in. (54.6 × 109.9 cm)
Gift of George D. Pratt, 1929
(29.146.23)
Fig. 51

Chair-seat cover
Indian for the European market,
1725–50
Cotton, painted resist and mordant,
dyed, with overpainting
30 × 27½ in. (76.2 × 69.9 cm)
Rogers Fund, 1927 (27.195.1)
Fig. 52

William Morris (British, 1834–1896)
Merton Abbey Works (British,
founded 1881)
Strawberry Thief, design registered
1883, printed 1917–23
Cotton, indigo discharged and
block-printed
108 × 37 in. (274.3 × 94.0 cm)
Purchase, Edward C. Moore Jr.
Gift, 1923 (23.163.11)
Fig. 53

Albrecht Dürer (German, 1471–1528)
Samson Rending the Lion,
ca. 1497–98
Woodcut
Sheet: 16 × 11⅞ in. (40.6 × 30.2 cm)
Gift of Georgina W. Sargent, in
memory of John Osborne
Sargent, 1924 (24.63.111)
Fig. 54

Edouard Vuillard (French,
1868–1940)
Printed by Auguste Clot (French,
1858–1936)
Published by Ambroise Vollard
(French, 1866–1939)
Interior with Pink Wallpaper I, from
the series *Paysages et Intérieurs*,
1899
Color lithograph; fourth state of
four
Sheet: 15⁷⁄₁₆ × 12¹⁄₁₆ in. (39.2 ×
30.7 cm)
Harris Brisbane Dick Fund, 1925
(25.70.14)
Fig. 56

Dagobert Peche (Austrian,
1887–1923)
Flammersheim & Steinmann,
Cologne
Wiener Werkstätte (Austrian)
The Rose (*Die Rose*), 1922

Machine roll-printed wallpaper
Sheet: 37¹⁵⁄₁₆ × 21¹³⁄₁₆ in. (96.4 ×
55.4 cm)
Gift of Wiener Werkstätte of
America, Inc., 1923 (23.236[40])
Fig. 57

Martin Schongauer (German,
ca. 1435/50–1491)
Christ Carrying the Cross,
ca. 1475–80
Engraving
Sheet: 11⅜ × 16⅞ in. (28.9 ×
42.9 cm)
Purchase, The Sylmaris Collection,
Gift of George Coe Graves, by
exchange, 1935 (35.27)
Fig. 58

Margaret Neilson Armstrong
(American, 1867–1944)
Bronze Bells, Fritillaria atropurpurea, May 2, 1912
Watercolor and brown ink over
graphite
Sheet: 13¹¹⁄₁₆ × 9¹⁵⁄₁₆ in. (34.8 ×
25.2 cm)
Gift of Helena Bienstock, Cynthia
MacKay Keegan and Frank E.
Johnson, 2010 (2010.341.2[2])
Fig. 59

Joseph Mallord William Turner
(British, 1775–1851)
The Lake of Zug, 1843
Watercolor over graphite
Sheet: 11¾ × 18⅜ in. (29.8 ×
46.6 cm)
Marquand Fund, 1959 (59.120)
Fig. 60

Michelangelo Buonarroti (Italian,
1475–1564)
Studies for the Libyan Sibyl (recto);
Studies for the Libyan Sibyl and a Small Sketch for a Seated Figure
(verso), ca. 1510–11
Red chalk, accents of white chalk
(recto); soft black chalk or possi-
bly charcoal (verso)
Sheet: 11⅜ × 8⁷⁄₁₆ in. (28.9 ×
21.4 cm)
Purchase, Joseph Pulitzer Bequest,
1924 (24.197.2)
Fig. 61

Domenico del Barbiere (Italian,
1506–1565)
Two Flayed Men and Their Skeletons, ca. 1540–45
Engraving
Sheet: 9½ × 13¼ in. (24.1 × 33.6 cm)

The Elisha Whittelsey Collection,
The Elisha Whittelsey Fund, 1949
(49.95.181)
Fig. 62

Antoine Watteau (French,
1684–1721)
Seated Woman Holding a Fan,
ca. 1717
Red, black, and white chalk
Sheet: 8⅜ × 8⅛ in. (21.3 × 20.6 cm)
Gift of Ann Payne Blumenthal, 1943
(43.163.23)
Fig. 63

**Fan design with Republican
assignats**
French, ca. 1795
Etching
Sheet: 11¼ × 19½ in. (28.6 × 49.5 cm)
Harris Brisbane Dick Fund, 1938
(38.91.56)
Fig. 64

Works not illustrated, by date

Engaged capital
French, late 12th century
Limestone
H. 11⅝ in. (29.5 cm), w. 9¾ in.
(24.8 cm), D. 17½ in. (44.5 cm)
The Cloisters Collection, 1925
(25.120.47)

Hans Schlaffer of Ulm (German,
active ca. 1470–75)
The Sudarium, ca. 1470–75
Hand-colored woodcut
Sheet: 11¹¹⁄₁₆ × 8⅛ in. (28.1 ×
20.6 cm)
Harris Brisbane Dick Fund, 1941
(41.47)

Albrecht Dürer (German, 1471–1528)
**Woodblock for *Samson Rending
the Lion*,** ca. 1497–98
Pear wood
H. 15⅜ in. (39.1 cm), w. 11 in.
(27.9 cm), D. 1 in. (2.5 cm)
Gift of Junius Spencer Morgan, 1919
(19.73.255)

Cesare Vecellio (Italian, 1521–1601)
*Corona delle Nobili et Virtuose
Donne: Libro I–IV,* 1601
Woodcut
Sheet: 5½ × 7¹¹⁄₁₆ in. (14 × 19.5 cm)
Rogers Fund, 1918 (18.67.2[39])

Border
Italian or Flemish, 17th century
Linen, bobbin lace
22 × 6½ in. (55.9 × 16.5 cm)

Gift of Mrs. William H. Bliss, 1915
(15.59)

Attributed to Alphonse (Antoine)
Sax (Belgian, 1822–1874)
Cornet-trompe in D, ca. 1862
Brass
L. (without mouthpiece) 11¹⁵⁄₁₆ in.
(33.9 cm)
The Crosby Brown Collection of
Musical Instruments, 1889
(89.4.1105)

Edouard Vuillard (French,
1868–1940)
Printed by Auguste Clot (French,
1858–1936)
Published by Ambroise Vollard
(French, 1866–1939)
Interior with Pink Wallpaper II,
from the series *Paysages et
Intérieurs,* 1899
Color lithograph; second state of
two
Sheet: 15⁷⁄₁₆ × 12³⁄₁₆ in. (39.2 × 31 cm)
Harris Brisbane Dick Fund, 1925
(25.70.19)

Sesando
Javanese, Nusa Tenggara, Timor
Island (Indonesia), late 19th
century
Bamboo, teak wood, palm
(Borassus flabellifera), wire
H. 22¹⁄₁₆ in. (56 cm), w. 24 in.
(61 cm), D. 12³⁄₁₆ in. (31 cm)
The Crosby Brown Collection of
Musical Instruments, 1889
(89.4.1489)

Margaret Neilson Armstrong
(American, 1867–1944)
White Valerian, Valeriana sitchensis,
July 14, 1909
Watercolor and brown ink over
graphite
Sheet: 13¹¹⁄₁₆ × 9¹⁵⁄₁₆ in. (34.8 ×
25.2 cm)
Gift of Helena Bienstock, Cynthia
MacKay Keegan and Frank E.
Johnson, 2010 (2010.341.2[19])

Princely Aspirations

Rembrandt van Rijn (Dutch,
1606–1669)
The Toilet of Bathsheba, 1643
Oil on wood
22½ × 30 in. (57.2 × 76.2 cm)
Bequest of Benjamin Altman, 1913
(14.40.651)
Fig. 66

**Vase with immortals offering the
peaches of longevity**
Chinese, Qing dynasty (1644–1911),
Kangxi period (1662–1722)
Porcelain, overglaze enamels
H. 29 in. (73.7 cm)
Bequest of Benjamin Altman, 1913
(14.40.331)
Fig. 67

Peter Peck (German, 1503–1596)
Ambrosius Gemlich (German,
active ca. 1520–50)
**Double-barreled wheellock pistol
made for Emperor Charles V,**
ca. 1540–45
Steel, gold, cherrywood, staghorn
L. 19⅜ in. (49.2 cm)
Gift of William H. Riggs, 1913
(14.25.1425)
Fig. 68

Filippo Negroli (Italian, 1510–1579)
Burgonet, dated 1543
Steel, gold, textile
H. 9½ in. (24.1 cm), w. 7⅝ in.
(18.6 cm), D. 11½ in. (29.2 cm)
Gift of J. Pierpont Morgan, 1917
(17.190.1720)
Fig. 69

Léopold Stevens (French, 1866–1935)
*Interior View of the Hoentschel
Collection at 58 Boulevard
Flandrin, Paris,* ca. 1903–6
Oil on canvas
29¹⁵⁄₁₆ × 31½ in. (76 × 80 cm)
Purchase, The James Parker
Charitable Foundation Gift, 2019
(2019.55)
Fig. 70

Georges Jacob (French, 1739–1814)
Gilded by Louis-François Chatard
(French, ca. 1749–1819)
Armchair (*fauteuil*), 1788
Walnut, carved and gilded; gold
brocaded silk (not original)
H. 39⅜ in. (100 cm), w. 29½ in.
(74.9 cm) D. 25⅝ in. (65.1 cm)
Gift of J. Pierpont Morgan, 1906
(07.225.107)
Fig. 71

**Door from the *grand cabinet* of
Hôtel de Belle-Isle, Paris**
French, 18th century
Oak, carved, painted, and gilded
H. 130 in. (330.2 cm), w. 33½ in.
(85 cm), D. 3⅜ in. (8.6 cm)
Gift of J. Pierpont Morgan, 1906
(07.225.463b)
Fig. 72

**Panel from the *cabinet intérieur* of
the Château de Chanteloup,
France**
French, 1771–75
Oak, carved, painted, and gilded
H. 30 in. (76.2 cm), w. 44¾ in.
(113.7 cm), D. 2.5 in. (6.35 cm)
Gift of J. Pierpont Morgan, 1906
(07.225.464e)
Fig. 73

Statuette of a young woman
Etruscan, late 6th century B.C.
Bronze
H. 11⁹⁄₁₆ in. (29.4 cm)
Gift of J. Pierpont Morgan, 1917
(17.190.2066)
Fig. 76

Ennion (Roman, active first half
1st century)
Jug, first half 1st century
Glass
H. 7¼ in. (18.4 cm), DIAM. (maxi-
mum) 4³⁄₁₆ in. (10.6 cm)
Gift of J. Pierpont Morgan, 1917
(17.194.226)
Fig. 77

**Plate with the Battle of David
and Goliath**
Byzantine, 629–30
Silver
DIAM. 19⁷⁄₁₆ in. (6.6 cm), H. 2⅝ in.
(49.4 cm)
Gift of J. Pierpont Morgan, 1917
(17.190.396)
Fig. 78

Etienne Bobillet (Franco-
Netherlandish, active 1453)
Paul Mosselman (Franco-
Netherlandish, active 1453)
Mourners, ca. 1453
Alabaster
.386: H. 15³⁄₁₆ in (38.6 cm), w. 5⁵⁄₁₆ in.
(13.5 cm), D. 3⅞ in. (9.8 cm); .389:
H. 15³⁄₁₆ in. (38.6 cm), w. 5⁷⁄₁₆ in.
(13.8 cm), D. 3⅝ in. (9.2 cm)
Gift of J. Pierpont Morgan, 1917
(17.190.386, .389)
Fig. 79

Book cover(?) with ivory figures
Spanish, before 1085
Gilded silver with pseudo-filigree,
glass and stone cabochons, cloi-
sonné enamel, ivory with traces
of gilding on pine support
H. 10¼ in. (26.1 cm), w. 7½ in.
(19 cm), D. 1¼ in. (3.1 cm)

Gift of J. Pierpont Morgan, 1917
(17.190.33)
Fig. 80

Medici Porcelain Factory (Italian,
ca. 1575–ca. 1587)
Ewer (brocca), ca. 1575–87
Soft-paste porcelain
H. 8 in. (20.3 cm), w. 4¼ in.
(10.8 cm), D. 4⅞ in. (12.4 cm)
Gift of J. Pierpont Morgan, 1917
(17.190.2045)
Fig. 81

Gerhard Emmoser (German, active
1556–84)
Celestial globe with clockwork
Austrian (Vienna), 1579
Case: partially gilded silver, gilded
brass; movement: brass, steel
H. 10¾ in. (27.3 cm), w. 8 in.
(20.3 cm), D. 7½ in. (19.1 cm)
Gift of J. Pierpont Morgan, 1917
(17.190.636)
Fig. 82

Johannes Vermeer (Dutch,
1632–1675)
Young Woman with a Lute,
ca. 1662–63
Oil on canvas
20¼ × 18 in. (51.4 × 45.7 cm)
Bequest of Collis P. Huntington,
1900 (25.110.24)
Fig. 83

Sir Thomas Lawrence (British,
1769–1830)
*Elizabeth Farren, Later Countess of
Derby*, 1790
Oil on canvas
94 × 57½ in. (238.8 × 146.1 cm)
Bequest of Edward S. Harkness,
1940 (50.135.5)
Fig. 84

Simone Martini (Italian, died 1344)
Saint Ansanus, ca. 1326
Tempera on wood, gold ground
22⅝ × 15 in. (57.5 × 38.1 cm)
Robert Lehman Collection, 1975
(1975.1.13)
Fig. 85

Simone Martini (Italian, died 1344)
Madonna and Child, ca. 1326
Tempera on wood, gold ground
23⅛ × 15½ in. (58.7 × 39.4 cm)
Robert Lehman Collection, 1975
(1975.1.12)
Fig. 86

Simone Martini (Italian, died 1344)
Saint Andrew, ca. 1326
Tempera on wood, gold ground
22½ × 14⅞ in. (57.2 × 37.8 cm)
Gift of George Blumenthal, 1941
(41.100.23)
Fig. 87

**Panel with grotesques from a set
of bed hangings**
Netherlandish, ca. 1550–60
Silk, wool, silver and silver-gilt
metal-wrapped threads
65½ × 80 in. (166.4 × 203.2 cm)
Gift of George Blumenthal, 1941
(41.100.385)
Fig. 88

Mounted vase
Chinese with French mounts, early
18th century (porcelain), ca. 1750
(mounts)
Hard-paste porcelain, gilded-bronze
mounts
H. 23⅜ in. (59.4 cm), w. 13¾ in.
(34.9 cm), D. 12½ in. (31.8 cm)
Gift of Mr. and Mrs. Charles
Wrightsman, 1971 (1971.206.22)
Fig. 89

Martin Gizl (Austrian, 1707–1786)
Ewer and stand (présentoir), 1758
Alpine ibex horn, gold, gilded
copper
Ewer: H. 12¹³⁄₁₆ in. (32.5 cm); stand:
17⁵⁄₁₆ × 14¹⁵⁄₁₆ in. (44 × 38 cm)
Purchase, Anna-Maria and Stephen
Kellen Foundation Gift, 2013
(2013.442.1, .2)
Fig. 90

Anthony van Dyck (Flemish,
1599–1641)
Queen Henrietta Maria, 1636
Oil on canvas
41⅝ × 33¼ in. (105.7 × 84.5 cm)
Bequest of Mrs. Charles
Wrightsman, in honor of
Annette de la Renta, 2019
(2019.141.10)
Fig. 91

Jean Auguste Dominique Ingres
(French, 1780–1867)
*Joséphine-Éléonore-Marie-Pauline de
Galard de Brassac de Béarn,
Princesse de Broglie*, 1851–53
Oil on canvas
47¾ × 35¾ in. (121.3 × 90.8 cm)
Robert Lehman Collection, 1975
(1975.1.186)
Fig. 92

Emile-Jacques Ruhlmann (French,
1879–1933)
"David-Weill" desk, ca. 1918–19
Amboyna, ivory, sharkskin, silk,
metal, oak, lumber-core ply-
wood, poplar, walnut, birch,
macassar ebony
H. 37½ in. (95.3 cm), w. 47½ in.
(120.7 cm), D. 29½ in. (74.9 cm)
Purchase, Edgar Kaufmann Jr. Gift,
1973 (1973.154.1)
Fig. 94, not in exhibition

Works not illustrated, by date

**Cosmetic box of Kemeni and
mirror of Reniseneb**
Egyptian, ca. 1814–1805 B.C.
Excavated Egypt, Thebes, Asasif
Box: cedar, ebony and ivory veneer,
silver mounts; mirror: unalloyed
copper, gold, ebony; jars: traver-
tine (Egyptian alabaster)
Box: H. 8 in. (20.3 cm), w. 11¼ in.
(28.5 cm), D. 6¹⁵⁄₁₆ in. (17.7 cm)
Purchase, Edward S. Harkness Gift,
1926 (26.7.1438–.1442, .1351)

Amphora-shaped perfume bottle
Ca. 1390–1336 B.C.
From Egypt
Glass
H. 6 in. (15.3 cm), DIAM. 2⅜ in.
(6 cm)
Purchase, Edward S. Harkness Gift,
1926 (26.7.1177)

Ritual wine container (pou)
Chinese, Shang dynasty (ca. 1500–
1046 B.C.), 13th century B.C.
Bronze
H. 21¼ in. (54 cm), DIAM. 19½ in.
(49.5 cm)
Gift of J. Pierpont Morgan, 1917
(17.190.524a, b)

Attributed to the Euphiletos Painter
Panathenaic prize amphora
Greek, Attic, ca. 530 B.C.
Terracotta
H. 24½ in. (62.2 cm)
Rogers Fund, 1914 (14.130.12)

Striding Thoth
332–30 B.C.
From Egypt
Faience
H. 5⁹⁄₁₆ in. (14.1 cm), w. 1⁷⁄₁₆ in.
(3.6 cm), D. 2⅛ in. (5.4 cm)
Purchase, Edward S. Harkness Gift,
1926 (26.7.860)

**Belt buckle with paired felines
attacking ibexes**
Xiongnu, ca. 3rd–2nd century B.C.
From Mongolia or southern Siberia
Gold
H. 2⅝ in. (6.7 cm), w. 3⅛ in. (8 cm),
D. ⁷⁄₁₆ in. (1.1 cm)
Gift of J. Pierpont Morgan, 1917
(17.190.1672)

**Belt adornment with an eagle and
its prey**
Parthian or Kushan, ca. 1st–2nd
century
From Central Asia
Gold, turquoise inlay
2½ × 3⁷⁄₁₆ in. (6.3 × 8.7 cm)
Gift of J. Pierpont Morgan, 1917
(17.190.2055)

Cup with mounts
Bohemian, ca. 1350–80
Jasper, silver-gilded mount and foot
H. 4⅛ in. (10.5 cm), w. 4½ in.
(11.5 cm), D. 3⁷⁄₁₆ in. (8.8 cm)
Purchase, Mrs. Charles Wrightsman
Gift, in honor of Annette de la
Renta, 2000 (2000.504)

Ewer
German or Rhenish, ca. 1350–80
(ewer), ca. 1400 (mounts)
Jasper, silver-gilded mounts
H. 13¼ in. (33.7 cm), w. 6¾ in.
(17.1 cm), D. 5⁹⁄₁₆ in. (14.1 cm)
Gift of J. Pierpont Morgan, 1917
(17.190.610)

Antonio Rossellino (Italian,
1427–ca. 1479)
Madonna and Child with Angels,
ca. 1455–60
Marble with gilded details
28⅞ × 21⅛ in. (73.3 × 53.7 cm)
Bequest of Benjamin Altman, 1913
(14.40.675)

George Charles Williamson
(British, 1858–1942)
J. Pierpont Morgan (American,
1837–1913)
*Catalogue of the Collection of Jewels
and Precious Works of Art, the
Property of J. Pierpont Morgan*,
1910
Illustrated book
H. 15¾ in. (39 cm)
Watson Library, Presented
by J. Pierpont Morgan
(146.8 M821 Q)

Collecting through Excavation

Helmet
Japanese, 5th century
Excavated Ōtsuka-yama Kofun,
 Sakume-chō, Matsuzaka City,
 Mie Prefecture, Japan
Iron, copper, gold
H. 8½ in. (21.6 cm)
Fletcher Fund, 1928 (28.60.2)
Fig. 95

**Copy of an epistle of Severos,
 bishop of Antioch**
Coptic, ca. 509–640
Excavated Hermitage of
 Epiphanius, Egypt
Limestone, ink
H. 3¹³⁄₁₆ in. (9.7 cm), W. 4⅛ in.
 (10.5 cm), D. ⅞ in. (2.3 cm)
Rogers Fund, 1912 (12.180.62)
Fig. 97

**Censer with a lioness hunting
 a boar**
Coptic, 6th–7th century
Excavated Hermitage of
 Epiphanius, Egypt
Bronze
H. 5³⁄₁₆ in. (13.2 cm), W. 4⅛ in.
 (10.4 cm), D. 2¹⁄₁₆ in. (5.3 cm)
Rogers Fund, 1944 (44.20a, b)
Fig. 98

Funerary mask of Wah
Ca. 1981–1975 B.C.
Excavated Tomb of Wah, Thebes,
 Egypt
Cartonnage, wood, paint, gold foil
H. 26¾ in. (68 cm), W. 13¹⁄₁₆ in.
 (33.2 cm), D. 13⅛ in. (33.4 cm)
Rogers Fund and Edward S.
 Harkness Gift, 1940 (40.3.54)
Fig. 99

Broad collar of Wah
Ca. 1981–1975 B.C.
Excavated Tomb of Wah, Thebes,
 Egypt
Faience, linen thread
H. 13⁹⁄₁₆ in. (34.5 cm), W. 15⅜ in.
 (39 cm)
Rogers Fund and Edward S.
 Harkness Gift, 1940 (40.3.2)
Fig. 100

Scarab
Ca. 1981–1975 B.C.
Excavated Tomb of Wah, Thebes,
 Egypt

Silver, electrum, glazed steatite,
 linen cord
L. (overall) 16¹⁵⁄₁₆ in. (43 cm)
Rogers Fund and Edward S.
 Harkness Gift, 1940 (40.3.12)
Fig. 101

Seated statue of Hatshepsut
Ca. 1479–1458 B.C.
Excavated Deir el-Bahri, Egypt
Indurated limestone, paint
H. 83⅞ in. (213 cm), W. 19¹¹⁄₁₆ in.
 (50 cm), D. 46⅞ in. (119 cm)
Rogers Fund, 1929 (29.3.2)
Fig. 103

Catapult projectile
Before 1271
Excavated Montfort Castle,
 Palestine (near present-day
 ʿAkko, Israel)
Limestone
DIAM. 14½ in. (38.6 cm)
Gift of Clarence H. Mackay,
 Archer M. Huntington,
 Stephen H. P. Pell, and
 Bashford Dean, 1928 (28.99.42)
Illustrated in fig. 104

Keystone with carved plant motifs
German, ca. 1220–30
Excavated Montfort Castle,
 Palestine (near present-day
 ʿAkko, Israel)
Limestone
H. 20 in. (50.8 cm), W. 33 in.
 (83.8 cm), D. 21³⁄₁₆ in. (53.8 cm)
Gift of Clarence H. Mackay,
 Archer M. Huntington,
 Stephen H. P. Pell, and
 Bashford Dean, 1928 (28.99.2)
Fig. 105

Stone with matrices
German, ca. 1220–30
Excavated Montfort Castle,
 Palestine (near present-day
 ʿAkko, Israel)
Limestone
H. 8⅞ in. (22.5 cm), W. 4 in.
 (10.2 cm), D. 2½ in. (6.4 cm)
Gift of Clarence H. Mackay,
 Archer M. Huntington,
 Stephen H. P. Pell, and
 Bashford Dean, 1928 (28.99.10)
Fig. 106

Lamp with Arabic inscription
Syrian, before 1271
Excavated Montfort Castle,
 Palestine (near present-day
 ʿAkko, Israel)

Earthenware
H. 2¹⁄₁₆ in. (5.2 cm), W. 4⅝ in.
 (11.7 cm), D. 3⅛ in. (8 cm)
Gift of Clarence H. Mackay,
 Archer M. Huntington,
 Stephen H. P. Pell, and
 Bashford Dean, 1928 (28.99.16)
Fig. 107

**Wall decorations with floral
 patterns in four panels**
Sasanian, ca. 6th century
Excavated Ctesiphon, Iraq
Stucco
Set of four: 25½ × 25½ in. (64.8 ×
 64.8 cm)
Rogers Fund, 1932 (32.150.5–.8)
Fig. 108

**Bowl with inscription: "He who
 talks a lot, spills a lot"**
10th century
Excavated Nishapur, Iran
Earthenware, white slip with
 incised black slip decoration
 under transparent glaze
DIAM. 10¹³⁄₁₆ in. (27.5 cm)
Rogers Fund, 1940 (40.170.25)
Fig. 109

Mural fragment with a dog
12th century
Excavated Nishapur, Iran
Lime plaster, paint
H. 16⁹⁄₁₆ in. (42 cm), W. 9¹³⁄₁₆ in.
 (25 cm), D. 1⁹⁄₁₆ in. (4 cm)
Rogers Fund, 1948 (48.101.302)
Fig. 110

Female head
Assyrian, ca. 9th–8th century B.C.
Excavated Nimrud, Iraq
Ivory, gold
5⅜ × 3¼ in. (13.69 × 8.31 cm)
Rogers Fund, 1954 (54.117.2)
Fig. 111

**Figure of a man with an oryx, a
 monkey, and a leopard skin**
Assyrian, ca. 8th century B.C.
Excavated Nimrud, Iraq
Ivory
5⁵⁄₁₆ × 3 in. (13.5 × 7.6 cm)
Rogers Fund, 1960 (60.145.11)
Fig. 112

Standing female worshiper
Ca. 2600–2500 B.C.
Excavated Nippur, Iraq
Limestone, shell, lapis lazuli
H. 9¹⁵⁄₁₆ in. (25.2 cm), W. 3⅜ in.
 (8.5 cm), D. 2¹⁄₁₆ in. (5.2 cm)

Rogers Fund, 1962 (62.70.2)
Fig. 113

Works not illustrated, by date

Eye inlay for a statue
Sumerian, ca. 2600–2500 B.C.
Excavated Nippur, Iraq
Lapis lazuli, shell
H. ⅜ in. (0.9 cm), W. ⅝ in. (1.6 cm),
 D. ¼ in. (0.7 cm)
Rogers Fund, 1962 (62.70.84)

Base and feet of a worshiper
Ca. 2500–2350 B.C.
Excavated Nippur, Iraq
Gypsum alabaster
H. 2 in. (5.1 cm), W. 3¾ in. (9.4 cm),
 D. 4⅜ in. (11 cm)
Rogers Fund, 1959 (59.41.12)

Scarab and bead bracelet
Ca. 1981–1975 B.C.
Excavated Tomb of Wah, Thebes,
 Egypt
Lapis lazuli, carnelian, linen cord
L. (overall) 25⁹⁄₁₆ in. (65 cm)
Rogers Fund and Edward S.
 Harkness Gift, 1940 (40.3.14)

Bottle fragment
Coptic, 4th century
Excavated Kharga Oasis, Egypt
Glass
H. 5¼ in. (13.4 cm), W. 3¾ in.
 (9.5 cm), D. 1¾ in. (4.5 cm)
Rogers Fund, 1931 (31.8.42.68)

Glass fragments
Coptic, 4th–early 5th century
Glass
DIAM. (petri dish) 5¾ in. (14.6 cm)
Rogers Fund, 1908 (08.268.15a–c)

**Blade for a double-edged sword
 (ken)**
Japanese, 5th century
Excavated Kyūshū Island,
 Kumamoto Prefecture, Japan
Steel
L. 23½ in. (59.6 cm), W. 1½ in.
 (3.9 cm), D. ¼ in. (0.6 cm)
Gift of Bashford Dean, by
 exchange, 1906 (06.310.8)

**Architectural roundel with
 radiating palmettes**
Sasanian, ca. 6th century
Excavated Ctesiphon, Iraq
Stucco
28 × 28 in. (71.1 × 71.1 cm)
Rogers Fund, 1932 (32.150.1)

Bowl with a figure holding a fluted vessel, possibly a rhyton, and birds
10th century
Excavated Nishapur, Iran
Earthenware, polychrome decoration under transparent glaze (buff ware)
H. 3⅝ in. (9.2 cm), DIAM. 7⅞ in. (20 cm)
Rogers Fund, 1938 (38.40.290)

Ewer with hunting scenes and benedictory inscriptions
11th century
Excavated Nishapur, Iran
Bronze
H. 14⅛ in. (35.9 cm)
Rogers Fund, 1938 (38.40.240)

Fragment of mail
Probably European, before 1271
Excavated Montfort Castle, Palestine (near present-day 'Akko, Israel)
Steel
2 × 2¾ in. (5 × 7 cm)
Gift of Clarence H. Mackay, Archer M. Huntington, Stephen H. P. Pell, and Bashford Dean, 1928 (28.99.37)

Grisaille fragment with a face
Crusader, 1220–71
Excavated Montfort Castle, Palestine (near present-day 'Akko, Israel)
Stained glass
H. 1⁷⁄₁₆ in. (3.6 cm), w. 2½ in. (6.4 cm), D. ¹⁄₁₆ in. (0.2 cm)
Gift of Clarence H. Mackay, Archer M. Huntington, Stephen H. P. Pell, and Bashford Dean, 1928 (28.99.675)

Lamp
Crusader, 1220–71
Excavated Montfort Castle, Palestine (near present-day 'Akko, Israel)
Earthenware, glaze
H. 2⅛ in. (5.4 cm), w. 4⁵⁄₁₆ in. (11 cm), D. 2⅜ in. (6 cm)
Gift of Clarence H. Mackay, Archer M. Huntington, Stephen H. P. Pell, and Bashford Dean, 1928 (28.99.15)

Fragment
Crusader, 1226–71
Excavated Montfort Castle, Palestine (near present-day 'Akko, Israel)

Stained glass
H. ⅞ in. (2.3 cm), w. 1¼ in. (3.2 cm), D. ³⁄₁₆ in. (0.5 cm)
Gift of Clarence H. Mackay, Archer M. Huntington, Stephen H. P. Pell, and Bashford Dean, 1928 (28.99.616)

Fragment
Crusader, 1226–71
Excavated Montfort Castle, Palestine (near present-day 'Akko, Israel)
Stained glass
H. 1⅛ in. (2.9 cm), w. ⅞ in. (2.2 cm), D. ⅛ in. (0.3 cm)
Gift of Clarence H. Mackay, Archer M. Huntington, Stephen H. P. Pell, and Bashford Dean, 1928 (28.99.672)

Creating a National Narrative

Thomas Eakins (American, 1844–1916)
The Chess Players, 1876
Oil on wood
11¾ × 16¾ in. (29.8 × 42.6 cm)
Gift of the artist, 1881 (81.14)
Fig. 114

Winslow Homer (American, 1836–1910)
Northeaster, 1895, reworked by 1901
Oil on canvas
34½ × 50 in. (87.6 × 127 cm)
Gift of George A. Hearn, 1910 (10.64.5)
Fig. 115

John Singer Sargent (American, 1856–1925)
Madame X (Madame Pierre Gautreau), 1883–84
Oil on canvas
82⅛ × 43¼ in. (208.6 × 109.9 cm)
Arthur Hoppock Hearn Fund, 1916 (16.53)
Fig. 117

John Singleton Copley (American, 1738–1815)
Mrs. Jerathmael Bowers, ca. 1763
Oil on canvas
49⅞ × 39¾ in. (126.7 × 101 cm)
Rogers Fund, 1915 (15.128)
Fig. 118

Frederic Edwin Church (American, 1826–1900)
The Parthenon, 1871
Oil on canvas
44½ × 72⅝ in. (113 × 184.5 cm)
Bequest of Maria DeWitt Jesup, from the collection of her husband, Morris K. Jesup, 1914 (15.30.67)
Fig. 119

Sanford Robinson Gifford (American, 1823–1880)
A Gorge in the Mountains (Kauterskill Clove), 1862
Oil on canvas
48 × 39⅞ in. (121.9 × 101.3 cm)
Bequest of Maria DeWitt Jesup, from the collection of her husband, Morris K. Jesup, 1914 (15.30.62)
Fig. 120

James McNeill Whistler (American, 1834–1903)
Cremorne Gardens, No. 2, ca. 1870–80
Oil on canvas
27 × 53⅛ in. (68.6 × 134.9 cm)
John Stewart Kennedy Fund, 1912 (12.32)
Fig. 121

Daniel Chester French (American, 1850–1931)
Ralph Waldo Emerson, 1879, cast 1906–7
Bronze
H. 22½ in. (57.2 cm), w. 10¼ in. (26 cm), D. 9 in. (22.9 cm)
Gift of the artist, 1907 (07.101)
Fig. 122

Bessie Potter Vonnoh (American, 1872–1955)
A Young Mother, 1896, cast ca. 1906
Bronze
H. 14 in. (35.6 cm), w. 12½ in. (31.8 cm), D. 15½ in. (39.4 cm)
Rogers Fund, 1906 (06.306)
Fig. 123

Augustus Saint-Gaudens (American, 1848–1907)
Victory, 1892–1903, cast 1914 or after (by 1916)
Bronze, gilded
H. 38 in. (96.5 cm), w. 9½ in. (24.1 cm), D. 18½ in. (47 cm)
Rogers Fund, 1917 (17.90.1)
Fig. 125

Cabinet
American (Salem, Massachusetts), 1679
Red oak, white pine, black walnut, red cedar, maple
H. 18 in. (45.7 cm), w. 17 in. (43.2 cm), D. 10 in. (25.4 cm)
Gift of Mrs. Russell Sage, 1909 (10.125.168)
Fig. 127

Master Potter A
Basin
Puebla (Mexico), ca. 1650
Earthenware, tin-glazed
DIAM. 20¾ in. (52.7 cm)
Gift of Mrs. Robert W. de Forest, 1912 (12.3.1)
Fig. 128

Robert Wellford (American, 1775–1844)
Mantel
Probably Pennsylvania, ca. 1800
Wood, composition ornament, paint
H. 60⅝ in. (154 cm), w. 88 in. (223.5 cm), D. 9¾ in. (24.8 cm)
Gift of Mrs. Francis P. Garvan, 1966 (66.225)
Fig. 130

Fireboard
American, ca. 1800
Pine, paint
33⅝ × 46 in. (85.4 × 116.8 cm)
Rogers Fund, 1952 (52.15)
Fig. 130

Elizabeth Van Horne Clarkson (American, 1771–1852)
Honeycomb Quilt
New York, ca. 1830
Cotton
107⅝ × 98¼ in. (273.4 × 249.6 cm)
Gift of Mr. and Mrs. William A. Moore, 1923 (23.80.75)
Fig. 131

John Frederick Amelung (German, active in America 1784–ca. 1791)
New Bremen Glass Manufactory (New Bremen, Maryland, 1784–1795)
Covered goblet, 1788
Glass, blown and engraved
H. 11¼ in. (28.6 cm)
Rogers Fund, 1928 (28.52a, b)
Fig. 132

Paul Revere Jr. (American,
 1734–1818)
Teapot
Boston, 1796
Silver
H. 6¹/₁₆ in. (15.4 cm), w. 11⁵/₈ in.
 (29.5 cm), D. 3¾ in. (9.5 cm)
Bequest of Alphonso T. Clearwater,
 1933 (33.120.543)
Fig. 133

Caleb Gardner (American, died
 1761)
Easy chair
Newport, Rhode Island, 1758
Walnut, maple, wool, linen embroi-
 dered with wool and silk
H. 46³/₈ in. (117.8 cm), w. 32³/₈ in.
 (82.2 cm), D. 25⁷/₈ in. (65.7 cm)
Gift of Mrs. J. Insley Blair, 1950
 (50.228.3)
Fig. 134

Work not illustrated

John Quincy Adams Ward
 (American, 1830–1910)
George Washington, 1882, cast
 ca. 1911
Bronze
H. 23¾ in. (60.3 cm), w. 12³/₈ in.
 (31.4 cm), D. 10 in. (25.4 cm)
Rogers Fund, 1972 (1972.1a)

Visions of Collecting

Louis C. Tiffany (American,
 1848–1933)
Tiffany Glass and Decorating
 Company (American, 1892–1902)
Vase, 1893–96
Favrile glass
H. 13³/₈ in. (34 cm)
Gift of H. O. Havemeyer, 1896
 (96.17.36)
Fig. 135, first from left

Louis C. Tiffany (American,
 1848–1933)
Tiffany Glass and Decorating
 Company (American, 1892–1902)
Vase, 1893–96
Favrile glass
H. 4¹/₈ in. (10.5 cm)
Gift of H. O. Havemeyer, 1896
 (96.17.26)
Fig. 135, second from left

Louis C. Tiffany (American,
 1848–1933)
Tiffany Glass and Decorating
 Company (American, 1892–1902)
Vase, 1893–96
Favrile glass
H. 10³/₈ in. (26.4 cm), DIAM. 4½ in.
 (11.4 cm)
Gift of H. O. Havemeyer, 1896
 (96.17.11)
Fig. 135, third from left

Louis C. Tiffany (American,
 1848–1933)
Tiffany Glass and Decorating
 Company (American, 1892–1902)
Vase, 1893–96
Favrile glass
H. 9¹/₈ in. (23.2 cm), DIAM. 6⁵/₈ in.
 (16.8 cm)
Gift of H. O. Havemeyer, 1896
 (96.17.21)
Fig. 135, fourth from left

Louis C. Tiffany (American,
 1848–1933)
Tiffany Glass and Decorating
 Company (American, 1892–1902)
Peacock vase, 1893–96
Favrile glass
14¹/₈ × 11½ in. (35.9 × 29.2 cm)
Gift of H. O. Havemeyer, 1896
 (96.17.10)
Fig. 135, fifth from left

Edouard Manet (French, 1832–1883)
The Dead Christ with Angels, 1864
Oil on canvas
70⁵/₈ × 59 in. (179.4 × 149.9 cm)
H. O. Havemeyer Collection,
 Bequest of Mrs. H. O.
 Havemeyer, 1929 (29.100.51)
Fig. 137

Gustave Courbet (French,
 1819–1877)
Woman with a Parrot, 1866
Oil on canvas
51 × 77 in. (129.5 × 195.6 cm)
H. O. Havemeyer Collection,
 Bequest of Mrs. H. O.
 Havemeyer, 1929 (29.100.57)
Fig. 138

Edgar Degas (French, 1834–1917)
Cast by A. A. Hébrard et Cie
 Foundry (French, 1902–37)
*The Little Fourteen-Year-Old
 Dancer*, cast 1922, tutu 2018
Partially tinted bronze, cotton tarla-
 tan, silk satin, wood

Overall: H. 38½ in. (97.8 cm),
 w. 17¼ in. (43.8 cm), D. 14³/₈ in.
 (36.5 cm)
H. O. Havemeyer Collection,
 Bequest of Mrs. H. O.
 Havemeyer, 1929 (29.100.370)
Fig. 140

Edgar Degas (French, 1834–1917)
Dancers, Pink and Green, ca. 1890
Oil on canvas
32³/₈ × 29¾ in. (82.2 × 75.6 cm)
H. O. Havemeyer Collection,
 Bequest of Mrs. H. O.
 Havemeyer, 1929 (29.100.42)
Fig. 141

Edgar Degas (French, 1834–1917)
Woman Having Her Hair Combed,
 ca. 1886–88
Pastel
29¹/₈ × 23⁷/₈ in. (74 × 60.6 cm)
H. O. Havemeyer Collection,
 Bequest of Mrs. H. O.
 Havemeyer, 1929 (29.100.35)
Fig. 142

Edgar Degas (French, 1834–1917)
Dancer Adjusting Her Slipper, 1873
Graphite heightened with black
 and white chalk
Sheet: 13 × 9⁵/₈ in. (33 × 24.4 cm)
H. O. Havemeyer Collection,
 Bequest of Mrs. H. O.
 Havemeyer, 1929 (29.100.941)
Fig. 143

Mary Cassatt (American, 1844–1926)
Mother and Child (The Oval Mirror),
 ca. 1899
Oil on canvas
32¹/₈ × 25⁷/₈ in. (81.6 × 65.7 cm)
H. O. Havemeyer Collection,
 Bequest of Mrs. H. O.
 Havemeyer, 1929 (29.100.47)
Fig. 144

Mary Cassatt (American, 1844–1926)
Lady at the Tea Table, 1883–85
Oil on canvas
29 × 24 in. (73.7 × 61 cm)
Gift of the artist, 1923 (23.101)
Fig. 145

Claude Monet (French, 1840–1926)
La Grenouillère, 1869
Oil on canvas
29³/₈ × 39¼ in. (74.6 × 99.7 cm)
H. O. Havemeyer Collection,
 Bequest of Mrs. H. O.
 Havemeyer, 1929 (29.100.112)
Fig. 146

Paul Cézanne (French, 1839–1906)
*Mont Sainte-Victoire and the
 Viaduct of the Arc River Valley*,
 1882–85
Oil on canvas
25¾ × 32¹/₈ in. (65.4 × 81.6 cm)
H. O. Havemeyer Collection,
 Bequest of Mrs. H. O.
 Havemeyer, 1929 (29.100.64)
Fig. 147

El Greco (Domenikos
 Theotokopoulos) (Greek,
 1540/41–1614)
Cardinal Fernando Niño de Guevara,
 ca. 1600
Oil on canvas
67¼ × 42½ in. (170.8 × 108 cm)
H. O. Havemeyer Collection,
 Bequest of Mrs. H. O.
 Havemeyer, 1929 (29.100.5)
Fig. 148

Inscribed by Bairyūken Kiyotatsu
 (Japanese, active late 18th
 century)
Sword guard (*tsuba*), late 18th
 century
Iron, gold, copper
H. 3¼ in. (8.3 cm), w. 3 in. (7.6 cm),
 D. ³/₁₆ in. (0.5 cm)
H. O. Havemeyer Collection,
 Bequest of Mrs. H. O.
 Havemeyer, 1929 (29.100.1045)
Fig. 149

Katsushika Hokusai (Japanese,
 1760–1849)
*Under the Wave off Kanagawa
 (Kanagawa oki nami ura)*, also
 known as *The Great Wave*, from
 the series *Thirty-Six Views of
 Mount Fuji (Fugaku sanjūrurokkei)*,
 Edo period (1615–1868),
 ca. 1830–32
Polychrome woodblock print; ink
 and color on paper
10¹/₈ × 14¹⁵/₁₆ in. (25.7 × 37.9 cm)
H. O. Havemeyer Collection,
 Bequest of Mrs. H. O.
 Havemeyer, 1929 (JP1847)
Fig. 150

Kitagawa Utamaro (Japanese,
 ca. 1754–1806)
Courtesan with a fan, Edo period
 (1615–1868), ca. 1795–96
Polychrome woodblock print; ink
 and color on paper
14¾ × 9¾ in. (37.5 × 24.8 cm)

H. O. Havemeyer Collection, Bequest of Mrs. H. O. Havemeyer, 1929 (JP1663)
Fig. 151

Tea caddy (chaire)
Japanese, Edo period (1615–1868), 17th century
Stoneware, natural ash glaze (Bizen ware)
H. 3¼ in. (8.3 cm), DIAM. 2½ in. (6.4 cm)
H. O. Havemeyer Collection, Bequest of Mrs. H. O. Havemeyer, 1929 (29.100.664)
Fig. 152

Tea bowl with leaf decoration
Chinese, Southern Song dynasty (1127–1279)
Stoneware, black and brown glaze, pigment (Jizhou ware)
H. 2⅛ in. (5.4 cm), DIAM. 5⅝ in. (14.3 cm)
H. O. Havemeyer Collection, Bequest of Mrs. H. O. Havemeyer, 1929 (29.100.220)
Fig. 153

School of Ogawa Haritsu (Ritsuō) (Japanese, 1663–1747)
Writing box (suzuribako) with mice and fan, Edo period (1615–1868), 18th century
Lacquered wood with gold, silver, green *hiramaki-e*, gold and silver foil application, ceramic, ivory, and pewter inlays
H. 1¾ in. (4.4 cm), W. 8⅛ in. (20.6 cm), D. 10⅛ in. (25.7 cm)
H. O. Havemeyer Collection, Bequest of Mrs. H. O. Havemeyer, 1929 (29.100.703)
Fig. 154

Kshitigarbha
Korean, Goryeo dynasty (918–1392), first half 14th century
Hanging scroll; ink, color, and gold on silk
Image: 33¼ × 14½ in. (84.5 × 36.8 cm)
H. O. Havemeyer Collection, Gift of Horace Havemeyer, 1929 (29.160.32)
Fig. 155

Panel composed of cross- and star-shaped tiles with Qur'anic verses
Iran (probably Kashan), Ilkhanid period (1258–1353), ca. 1260–70

Stonepaste, luster-painted on opaque white glaze under transparent glaze
H. 28 in. (71.1 cm), W. 40 in. (101.6 cm), D. 1½ in. (3.8 cm)
H. O. Havemeyer Collection, Gift of Horace Havemeyer, 1941 (41.165.22)
Fig. 156

Edgar Degas (French, 1834–1917)
The Dance Class, 1874
Oil on canvas
32⅞ × 30⅜ in. (83.5 × 77.2 cm)
Bequest of Mrs. Harry Payne Bingham, 1986 (1987.47.1)
Fig. 157

Paul Cézanne (French, 1839–1906)
Still Life with a Ginger Jar and Eggplants, 1893–94
Oil on canvas
28½ × 36 in. (72.4 × 91.4 cm)
Bequest of Stephen C. Clark, 1960 (61.101.4)
Fig. 158

Claude Monet (French, 1840–1926)
Camille Monet on a Garden Bench, 1873
Oil on canvas
23⅞ × 31⅝ in. (60.6 × 80.3 cm)
The Walter H. and Leonore Annenberg Collection, Gift of Walter H. and Leonore Annenberg, 2002, Bequest of Walter H. Annenberg, 2002 (2002.62.1)
Fig. 159

Louis C. Tiffany (American, 1848–1933)
Hair ornament, ca. 1904
Gold, silver, platinum, black opals, boulder opals, demantoid garnets, rubies, enamel
H. 3¼ in. (8.3 cm)
Gift of Linden Havemeyer Wise, in memory of Louisine W. Havemeyer, 2002 (2002.620)
Fig. 160

Works not illustrated, by date

Bowl with benedictory inscriptions: "consummate blessing" and "glory"
Syria (probably Raqqa), 12th century
Stonepaste, underglaze-painted, glazed (transparent colorless), luster-painted

H. 4¹¹⁄₁₆ in. (11.9 cm), DIAM. 9¼ in. (23.5 cm)
H. O. Havemeyer Collection, Gift of Horace Havemeyer, 1948 (48.113.6)

Tile with Qur'anic inscription from Sura 36 (Ya-Sin): 9
Iran (probably Kashan), Ilkhanid period (1258–1353), second half 13th century
Stonepaste, molded and luster-painted on opaque white glaze under transparent glaze
H. 6⅛ in. (15.5 cm), W. 11 in. (28 cm), D. 1 in. (2.5 cm)
H. O. Havemeyer Collection, Gift of Horace Havemeyer, 1940 (40.181.15)

Sword guard (tsuba)
Japanese, ca. 1615–1868
Iron, copper
DIAM. 3⁵⁄₁₆ in. (8.4 cm), D. ¼ in. (0.6 cm)
H. O. Havemeyer Collection, Bequest of Mrs. H. O. Havemeyer, 1929 (29.100.1043)

Reckoning with Modernism

Alfred Stieglitz (American, 1864–1946)
Georgia O'Keeffe—Hands and Thimble, 1919
Palladium print
9¼ × 7¼ in. (23.5 × 18.4 cm)
Gift of Mrs. Rebecca S. Strand, 1928 (28.129)
Fig. 161

Paul Strand (American, 1890–1976)
Blind Woman, New York, 1916
Platinum print
13⅜ × 10⅛ in. (34 × 25.7 cm)
Alfred Stieglitz Collection, 1933 (33.43.334)
Fig. 162

Charles Sheeler (American, 1883–1965)
Doylestown House—The Stove, 1917
Gelatin silver print
9⅛ × 6⁷⁄₁₆ in. (23.1 × 16.3 cm)
Alfred Stieglitz Collection, 1933 (33.43.259)
Fig. 163

Alfred Stieglitz (American, 1864–1946)
Georgia O'Keeffe, 1918
Platinum-palladium print

9⅝ × 7¹¹⁄₁₆ in. (24.5 × 19.6 cm)
Gift of David A. Schulte, 1928 (28.127.1)
Fig. 164

Alfred Stieglitz (American, 1864–1946)
Georgia O'Keeffe—Hand and Breasts, 1919
Palladium print
7³⁄₁₆ × 9⅛ in. (18.2 × 23.1 cm)
Gift of Mrs. Alma Wertheim, 1928 (28.130.1)
Fig. 165

Gertrude Käsebier (American, 1852–1934)
Blessed Art Thou Among Women, 1899
Platinum print
9¹⁄₁₆ × 5³⁄₁₆ in. (23 × 13.2 cm)
Alfred Stieglitz Collection, 1933 (33.43.132)
Fig. 166

Edward J. Steichen (American, born Luxembourg, 1879–1973)
The Flatiron, 1904
Gum bichromate over platinum print
18¹³⁄₁₆ × 15⅛ in. (47.8 × 38.4 cm)
Alfred Stieglitz Collection, 1933 (33.43.43)
Fig. 167

Edward J. Steichen (American, born Luxembourg, 1879–1973)
The Flatiron, 1904, printed 1909
Gum bichromate over platinum print
18¹³⁄₁₆ × 15⅛ in. (47.8 × 38.4 cm)
Alfred Stieglitz Collection, 1933 (33.43.39)
Fig. 168

Edward J. Steichen (American, born Luxembourg, 1879–1973)
The Flatiron, 1904, printed 1905
Gum bichromate over platinum print
19⅝ × 15⁵⁄₁₆ in. (49.9 × 38.9 cm)
Alfred Stieglitz Collection, 1933 (33.43.44)
Fig. 169

Jean E. Puiforcat (French, 1897–1945)
Tea and coffee service, ca. 1922
Silver, lapis lazuli, ivory, gold
Purchase, Edward C. Moore Jr. Gift, 1923 and 1925 (23.177.1ab–3; 25.230.1ab–4)
Fig. 170

Dagobert Peche (Austrian,
1887–1923)
Wiener Werkstätte (Austrian)
Bird-shaped box, 1920
Silver, coral
H. 7⅜ in. (18.7 cm), W. 4⅞ in.
(12.4 cm), D. 2¾ in. (7 cm)
Purchase, Edward C. Moore Jr.
Gift, 1922 (22.188ab)
Fig. 171

Paul Poiret (French, 1879–1944)
La Maison Martine (French)
Textile, ca. 1920
Printed linen
75½ × 52½ in. (191.8 × 133.4 cm)
Purchase, Edward C. Moore Jr.
Gift, 1923 (23.14.9)
Fig. 172

Emile-Jacques Ruhlmann (French,
1879–1933)
"Etat" cabinet, designed 1922,
manufactured 1925–26
Macassar ebony, amaranth, ivory,
oak, lumber-core plywood, pop-
lar, chestnut, mahogany, silvered
brass
H. 50¼ in. (127.6 cm), W. 33¾ in.
(85.7 cm), D. 14 in. (35.6 cm)
Purchase, Edward C. Moore Jr.
Gift, 1925 (25.231.1)
Fig. 173

Clayton Knight (American,
1891–1969)
Stehli Silks Corporation (American)
"Manhattan" textile, 1925
Printed silk
25¼ × 24¾ in. (64.1 × 62.9 cm)
Gift of Stehli Silks Corporation,
1927 (27.150.3)
Fig. 174

Edward Hald (Swedish, 1883–1980)
Orrefors Glasbruk (Swedish)
**"Cactus Exhibition"
(Kaktusutstallningen) vase**, 1926
Glass
Vase: H. 7¼ in. (18.4 cm), DIAM.
7⅝ in. (19.4 cm); tray: DIAM.
8¾ in. (22.2 cm)
Purchase, Edward C. Moore Jr.
Gift, 1927 (27.96.3ab)
Fig. 175

Eliel Saarinen (American, born
Finland, 1873–1950)
Chair, 1929
Black walnut, leather (not original)

H. 43⅜ in. (110.2 cm), W. 17½ in.
(45.7 cm), D. 18 in. (48.3 cm)
Gift of Lenore Ann Cisney, 1982
(1982.197)
Fig. 176

Pablo Picasso (Spanish, 1881–1973)
Gertrude Stein, 1905–6
Oil on canvas
39⅜ × 32 in. (100 × 81.3 cm)
Bequest of Gertrude Stein, 1946
(47.106)
Fig. 178

Vasily Kandinsky (French, born
Russia, 1866–1944)
Improvisation 27 (Garden of Love II),
1912
Oil on canvas
47⅜ × 55¼ in. (120.3 × 140.3 cm)
Alfred Stieglitz Collection, 1949
(49.70.1)
Fig. 179

Constantin Brancusi (French, born
Romania, 1876–1957)
Sleeping Muse, 1910
Bronze
H. 6¾ in. (17.1 cm), W. 9½ in.
(24.1 cm), D. 6 in. (15.2 cm)
Alfred Stieglitz Collection, 1949
(49.70.225)
Fig. 180

Charles Demuth (American,
1883–1935)
I Saw the Figure 5 in Gold, 1928
Oil, graphite, ink, and gold leaf on
paperboard (Upson board)
35½ × 30 in. (90.2 × 76.2 cm)
Alfred Stieglitz Collection, 1949
(49.59.1)
Fig. 181

Georgia O'Keeffe (American,
1887–1986)
Cow's Skull: Red, White, and Blue,
1931
Oil on canvas
39⅞ × 35⅞ in. (101.3 × 91.1 cm)
Alfred Stieglitz Collection, 1952
(52.203)
Fig. 182

Eliel Saarinen (American, born
Finland, 1873–1950)
International Silver Co., Wilcox
Silver Plate Co. Division
(American)
Tea service, ca. 1932–35
Electroplated nickel silver, brass,
Bakelite

Tea urn: H. 14½ in. (36.8 cm),
W. 14½ in. (36.8 cm), D. 11 in.
(19.7 cm); small tray: H. ⅝ in.
(1.59 cm), DIAM. 17⅝ in. (44.5 cm);
creamer: H. 3 in. (7.6 cm), W. 6 in.
(15.2 cm), D. 3⅞ in. (9.8 cm);
sugar bowl: H. 6¾ in. (17.1 cm),
W. 6 in. (15.2 cm), D. 3⅞ in.
(9.8 cm); large tray: H. ½ in.
(1.27 cm), DIAM. 20⅜ in. (51.4 cm)
Purchase, Mr. and Mrs. Ronald
Saarinen Swanson and John C.
Waddell Gifts, and Gift of Susan
Dwight Bliss, by exchange, 1999
(1999.27.1a–c–5)
Fig. 183

Donald Deskey (American,
1894–1989)
Deskey-Vollmer Inc. (American)
Lamp, 1927
Chrome-plated metal, glass
H. 12¼ in. (31.1 cm), W. 4⅜ in.
(11.1 cm), D. 5⅝ in. (14.3 cm)
John C. Waddell Collection, Gift of
John C. Waddell, 2014 (2014.744)
Fig. 184

El Lissitzky (Russian, 1890–1941)
Runner in the City, ca. 1926
Gelatin silver print
5³⁄₁₆ × 5¹⁄₁₆ in. (13.1 × 12.8 cm)
Ford Motor Company Collection,
Gift of Ford Motor Company
and John C. Waddell, 1987
(1987.1100.47)
Fig. 185

László Moholy-Nagy (American,
born Hungary, 1895–1946)
Fotogramm, 1926
Gelatin silver print
9⁷⁄₁₆ × 7¹⁄₁₆ in. (23.9 × 17.9 cm)
Ford Motor Company Collection,
Gift of Ford Motor Company
and John C. Waddell, 1987
(1987.1100.158)
Fig. 186

Man Ray (American, 1890–1976)
Compass, 1920
Gelatin silver print
4⅝ × 3⅜ in. (11.7 × 8.6 cm)
Ford Motor Company Collection,
Gift of Ford Motor Company
and John C. Waddell, 1987
(1987.1100.40)
Fig. 187

Fernand Léger (French, 1881–1955)
The Village, 1914
Oil on canvas
31½ × 39½ in. (80 × 100.3 cm)
Leonard A. Lauder Cubist
Collection, Purchase, Leonard A.
Lauder Gift, 2013 (2013.271)
Fig. 188

Pablo Picasso (Spanish, 1881–1973)
**Woman in a Chemise in an
Armchair**, late 1913–early 1914
Oil on canvas
59 × 39⅛ in. (149.9 × 99.4 cm)
Leonard A. Lauder Cubist
Collection, Gift of Leonard A.
Lauder, in celebration of the
Museum's 150th Anniversary,
2019
Fig. 189

Works not illustrated, by date

Alfred Stieglitz (American,
1864–1946)
Georgia O'Keeffe—Torso, 1918
Gelatin silver print
9⁵⁄₁₆ × 7⅜ in. (23.6 × 18.8 cm)
Gift of Mrs. Alma Wertheim, 1928
(28.130.2)

Ilonka Karasz (American, born
Hungary, 1896–1981)
Paye & Baker Mfg. Co. (American)
Bowl, ca. 1928
Electroplated nickel silver
H. 2⅜ in. (6 cm), DIAM. 4¼ in.
(10.8 cm)
John C. Waddell Collection, Gift of
John C. Waddell, 2000
(2000.600.11)

Walter von Nessen (American,
born Germany, 1899–1943)
Chase Brass & Copper Company,
Inc. (American)
**"Continental Coffee-Making
Service,"** 1934
Chrome-plated copper, composition
Coffee maker: H. 9⅝ in. (24.4 cm),
W. 6⅜ in. (16.2 cm), D. 3⅞ in.
(9.8 cm); sugar bowl: H. 3⅞ in.
(9.8 cm), DIAM. 3 in. (7.6 cm);
creamer: H. 2⅞ in. (7.3 cm),
W. 5⅛ in. (13 cm), D. 3 in. (7.6 cm)
John C. Waddell Collection, Gift of
John C. Waddell, 2002
(2002.585.4a–d–.6)

Fragmented Histories

Leonard Heinrich (German, 1900–1966)
The Metropolitan Museum of Art, Armor Workshop (American, founded ca. 1909)
Model T-21 E2 helmet prototype, 1945
Aluminum
H. 7 in. (17.8 cm), w. 9⁷⁄₁₆ in. (24 cm), D. 10¾ in. (27.3 cm)
Museum Accession, 2016 (2016.628)
Illustrated in fig. 190

Virgin and Child with the Young Saint John the Baptist
Northern French, ca. 1525–50
Marble, partially gilded
H. 27¼ in. (69.2 cm), w. 13½ in. (34.3 cm), D. 13½ in. (34.3 cm)
Purchase, Joseph Pulitzer Bequest, 1959 (59.12)
Fig. 191

Attributed to Jean de Touyl (French, died 1349/50)
Reliquary shrine, ca. 1325–50
Gilded silver, translucent enamel, paint
Open: H. 10 in. (25.4 cm), w. 16 in. (40.6 cm), D. 3⅝ in. (9.2 cm)
The Cloisters Collection, 1962 (62.96)
Fig. 192

Jean Siméon Chardin (French, 1699–1779)
Soap Bubbles, ca. 1733–34
Oil on canvas
24 × 24⅞ in. (61 × 63.2 cm)
Wentworth Fund, 1949 (49.24)
Fig. 193

Jean Pucelle (French, active 1319–34)
The Hours of Jeanne d'Evreux, Queen of France, ca. 1324–28
Grisaille, tempera, and ink on vellum
Folio: 3⅝ × 2⁷⁄₁₆ in. (9.2 × 6.2 cm)
The Cloisters Collection, 1954 (54.1.2)
Fig. 195

Marc-Etienne Janety (French, 1739–1820)
Sugar bowl, 1786
Platinum, blue glass
H. 5¹⁄₁₆ in. (12.9 cm), w. 7¼ in. (18 cm), D. 3⅞ in. (9.3 cm)

Purchase, Gift of Dr. and Mrs. A.L. Garbat, Manya Garbat Starr and Julian A. Garbat, by exchange, and Harris Brisbane Dick Fund, 1974 (1974.164a–c)
Fig. 196

Possibly Master Pertoldus (Berthold Schauer?) (Austrian, active late 15th century)
Triptych with scenes from the Passion of Christ, 1494
Silver, gilded silver, mother-of-pearl, bone, cold enamel
Open: H. 27⅜ in. (69.5 cm), w. 9⅞ in. (25.1 cm), D. 7¼ in. (18.4 cm)
Gift of Ruth and Leopold Blumka, 1969 (69.226)
Fig. 198

Hans Greiff (German, active ca. 1470–1516)
Covered beaker, ca. 1470
Silver, gilded silver, enamel, glass
H: 14⅜ in. (36.5 cm)
The Cloisters Collection, 1950 (50.7.1a, b)
Fig. 199

Edith Standen's uniform
American, 1945
Wool, metal
Gift of Edith A. Standen, 1988 (1988.78.2a–l)
Fig. 200

Orthostat relief of a lion-hunt scene
Ca. 10th–9th century B.C.
Excavated Tell Halaf, Syria
Basalt, paint
H. 22¹⁄₁₆ in. (56 cm), w. 27³⁄₁₆ in. (69 cm), D. 8⁷⁄₁₆ in. (21.5 cm)
Rogers Fund, 1943 (43.135.2)
Fig. 202, first from left

Orthostat relief of a lion attacking a deer
Ca. 10th–9th century B.C.
Excavated Tell Halaf, Syria
Limestone, paint
H. 28⅜ in. (72.01 cm), w. 17½ in. (44.5 cm), D. 8⁷⁄₁₆ in. (21.49 cm)
Rogers Fund, 1943 (43.135.3)
Fig. 202, second from left, not in exhibition

Orthostat relief of a winged human-headed lion
Ca. 10th–9th century B.C.
Excavated Tell Halaf, Syria
Basalt
H. 26⅛ in. (66.5 cm), w. 14¾ in. (37.49 cm), D. 7⅞ in. (19.99 cm)
Rogers Fund, 1943 (43.135.4)
Fig. 202, third from left, not in exhibition

Orthostat relief of a seated figure holding a lotus flower
Ca. 10th–9th century B.C.
Excavated Tell Halaf, Syria
Basalt
H. 26¾ in. (68 cm), w. 42⅛ in. (107 cm), D. 20¹⁄₁₆ in. (51 cm)
Rogers Fund, 1943 (43.135.1)
Fig. 202, fourth from left

The Centennial Era

The Evolution of the Encyclopedic Museum

Yves Saint Laurent (French, born Algeria, 1936–2008)
Yves Saint Laurent, Paris (French, founded 1961)
Dress, fall/winter 1965–66
Wool
Gift of Mrs. William Rand, 1969 (C.I.69.23)
Fig. 206

Garry Winogrand (American, 1928–1984)
Metropolitan Museum of Art Centennial Ball, New York City, New York, 1970, printed 1974
Gelatin silver print
8¾ × 12⅞ in. (22.1 × 32.7 cm)
Gift of William Berley, 1978 (1978.660.12)
Fig. 207

Work not illustrated

Cristobal Balenciaga (Spanish, 1895–1972)
House of Balenciaga (French, founded 1937)
Coat, ca. 1966
Wool
Gift of Countess Edward Bismarck, 1981 (1981.249.3)

A Rededication to Asian Art

Buddha offering protection
Indian (probably Bihar), late 6th–7th century
Copper alloy
H. 18½ in. (47 cm), w. 6⅛ in. (15.6 cm), D. 5⅝ in. (14.3 cm)
Purchase, Florance Waterbury Bequest, 1969 (69.222)
Fig. 209

Zhao Mengfu (Chinese, 1254–1322)
Twin Pines, Level Distance, Yuan dynasty (1271–1368), ca. 1310
Handscroll; ink on paper
Image: 10⁹⁄₁₆ × 42⁵⁄₁₆ in. (26.8 × 107.5 cm)
Ex coll.: C. C. Wang Family, Gift of The Dillon Fund, 1973 (1973.120.5)
Fig. 211

Han Gan (Chinese, active ca. 742–56)
Night-Shining White, Tang dynasty (618–907), ca. 750
Handscroll; ink on paper
Image: 12⅛ × 13⅜ in. (30.8 × 34 cm)
Purchase, The Dillon Fund Gift, 1977 (1977.78)
Fig. 212

Mi Fu (Chinese, 1051–1107)
Poem Written in a Boat on the Wu River, Northern Song dynasty (960–1127), ca. 1095
Handscroll; ink on paper
12¼ × 18 ft. 3¼ in. (31.1 × 556.9 cm)
Gift of John M. Crawford Jr., in honor of Professor Wen Fong, 1984 (1984.174)
Fig. 213

Kano Sansetsu (Japanese, 1589–1651)
Old Plum, Edo period (1615–1868), 1646
Four sliding-door panels (*fusuma*); ink, color, gold, and gold leaf on paper
Overall of all four panels: 68¾ × 191⅛ in. (174.6 × 485.5 cm)
The Harry G. C. Packard Collection of Asian Art, Gift of Harry G. C. Packard, and Purchase, Fletcher, Rogers, Harris Brisbane Dick, and Louis V. Bell Funds, Joseph Pulitzer Bequest, and The Annenberg Fund Inc. Gift, 1975 (1975.268.48a–d)
Fig. 214

First Generation after Nainsukh, likely the painter Nikka (Indian)
Rama, Sita, and Lakshmana at the Hermitage of Bharadvaja, folio from a dispersed Ramayana series, ca. 1780
Opaque watercolor and ink on paper
Page: 9¹⁵⁄₁₆ × 14¹⁄₁₆ in. (25.2 × 35.7 cm)
Seymour and Rogers Funds, 1976 (1976.15)
Fig. 215

Transforming Islamic Art

Tile with Qur'anic inscription from Sura 36 (*Ya-Sin*): 15
Iran (probably Kashan), Ilkhanid period (1258–1353), second half 13th century
Stonepaste, molded and luster-painted on opaque white glaze under transparent glaze
H. 5¹¹⁄₁₆ in. (14.5 cm), w. 10¹³⁄₁₆ in. (27.5 cm), D. 1¼ in. (3.2 cm)
H. O. Havemeyer Collection, Gift of Horace Havemeyer, 1940 (40.181.14)
Fig. 217

Assad Ibn Kariba Launches a Night Attack on the Camp of Malik Iraj, folio from the *Hamzanama* (*The Adventures of Hamza*)
Attributed to Basavana, Shravana, and Tara
India, Mughal period (1526–1858), ca. 1564–69
Ink, opaque watercolor, and gold on cloth
27 × 21¼ in. (68.6 × 54 cm)
Rogers Fund, 1918 (18.44.1)
Fig. 220

Swan-necked bottle (*ashkdan*)
Iran, Qajar period (1785–1925), 19th century
Glass
H. 15 in. (38.1 cm), DIAM. (maximum) 4⁵⁄₁₆ in. (11 cm)
Gift of J. Pierpont Morgan, 1917 (17.190.829)
Fig. 221

"Star Ushak" carpet
Turkey (Ushak), Ottoman period (ca. 1299–1923), late 15th–early 16th century
Wool (warp, weft, and pile), symmetrically knotted pile

169½ × 91½ in. (430.5 × 232.4 cm)
Gift of Joseph V. McMullan, 1958 (58.63)
Fig. 222

Kai Khusrau Rides Bihzad for the First Time, folio from the *Shahnama* (*Book of Kings*) of Shah Tahmasp
Attributed to Qasim ibn 'Ali
Iran (Tabriz), Safavid period (1501–1722), ca. 1525–30
Opaque watercolor, ink, silver, and gold on paper
Page: 18⅝ × 12⅝ in. (47.3 × 32.1 cm)
Gift of Arthur A. Houghton Jr., 1970 (1970.301.33)
Fig. 223

Works not illustrated, by date

Qur'an manuscript
Syria or Iraq, Abbasid period (750–1258), late 9th–early 10th century
Ink, opaque watercolor, and gold on parchment
4 × 6¾ in. (10.2 × 17.1 cm)
Gift of Philip Hofer, 1937 (37.142)

Two ends of a balustrade
Iran, Ilkhanid period (1258–1353), A.H. 703/A.D. 1303–4
Limestone
.1: H. 27⅞ in. (70.8 cm), w. 5¼ in. (13.3 cm), D. 32½ in. (82.6 cm); .2: H. 26¼ in. (66.7 cm), w. 5¼ in. (13.3 cm), D. 31 in. (78.7 cm)
Fletcher Fund, 1932 (32.15.1, .2)

Mosque lamp made for Amir Qawsun
'Ali ibn Muhammad al-Barmaki
Egypt, Mamluk period (1250–1517), ca. 1329–35
Glass, blown, enameled, and gilded
H. 14⅛ in. (35.9 cm), DIAM. (maximum) 10¹⁄₁₆ in. (25.6 cm)
Gift of J. Pierpont Morgan, 1917 (17.190.991)

Tile panel in the shape of a prayer niche (*mihrab*) with Qur'anic inscriptions
Iran (Kashan), Ilkhanid period (1258–1353), early 14th century
Stonepaste, luster-painted
46 × 28 in. (116.8 × 71.1 cm)
Gift of J. Pierpont Morgan, 1917 (17.190.2040a, b)

The Feast of Sada, folio from the *Shahnama* (*Book of Kings*) of Shah Tahmasp
Attributed to Qasim ibn 'Ali and Sultan Muhammad
Iran (Tabriz), Safavid period (1501–1722), ca. 1525–30
Opaque watercolor, ink, silver, and gold on paper
Page: 18½ × 12½ in. (47 × 31.8 cm)
Gift of Arthur A. Houghton Jr., 1970 (1970.301.2)

Official signature (*tughra*) of Sultan Suleiman the Magnificent
Turkey (Istanbul), Ottoman period (ca. 1299–1923), ca. 1555
Ink, opaque watercolor, and gold on paper
20½ × 25⅜ in. (52.1 × 64.5 cm)
Rogers Fund, 1938 (38.149.1)

Inkwell with floral and animal imagery
Iran, Safavid period (1501–1722), 16th century
Brass; lid cast, body worked, engraved, and chased, inlaid with silver
H. 3⅝ in. (9.2 cm)
Rogers Fund, 1941 (41.120a, b)

Jahangir and his Father, Akbar, folio from the Shah Jahan Album
Attributed to Balchand
India, Mughal period (1526–1858), ca. 1630
Ink, opaque watercolor, and gold on paper
15⅜ × 10⅜ in. (39 × 26.3 cm)
Purchase, Rogers Fund and The Kevorkian Foundation Gift, 1955 (55.121.10.19)

Rosette Bearing the Names and Titles of Shah Jahan, folio from the Shah Jahan Album
India, Mughal period (1526–1858), ca. 1630–40
Ink, opaque watercolor, and gold on paper
15³⁄₁₆ × 10⁷⁄₁₆ in. (38.6 × 26.5 cm)
Purchase, Rogers Fund and The Kevorkian Foundation Gift, 1955 (55.121.10.39)

Screen (*jali*)
India (probably Gujarat), ca. 1700
Marble
H. 56½ in. (143.5 cm), w. 30½ in. (77.5 cm), D. 2½ in. (6.4 cm)
Edward Pearce Casey Fund, 1985 (1985.240.2)

Hanging ornament for a mosque
Turkey (Kutahya), 19th century
Stonepaste, polychrome painted under transparent glaze
H. 9¹⁄₁₆ in. (23 cm), DIAM. 9¹⁵⁄₁₆ in. (25.2 cm)
Bequest of Benjamin Altman, 1913 (14.40.726)

Recovering the Missing Chapters

Double crocodile pendant
Panama, Coclé (Macaracas), 8th–10th century
Gold, quartz
H. 1½ in. (3.8 cm), w. 1½ in. (3.8 cm), D. 1⅛ in. (2.8 cm)
The Michael C. Rockefeller Memorial Collection, Bequest of Nelson A. Rockefeller, 1979 (1979.206.733)
Fig. 225, left

Double-bat-head figure pendant
Panama, Coclé (Parita), 12th–14th century
Gold, greenstone
H. 4½ in. (11.4 cm), w. 4½ in. (11.4 cm), D. 2⅜ in. (6 cm)
Gift and Bequest of Alice K. Bache, 1966, 1977 (66.196.32)
Fig. 225, middle

Double crocodile pendant
Panama, Coclé (Macaracas), 8th–12th century
Gold, shell
H. 3¾ in. (9.5 cm), w. 3 in. (7.6 cm), D. 1½ in. (3.8 cm)
Jan Mitchell and Sons Collection, Gift of Jan Mitchell, 1991 (1991.419.17)
Fig. 225, right

Seated female figure from a reliquary ensemble
Gabon or Equatorial Guinea, Fang peoples, Okak group, 19th–early 20th century
Wood, metal
H. 25³⁄₁₆ in. (64 cm), w. 7⅞ in. (20 cm), D. 6½ in. (16.5 cm)
The Michael C. Rockefeller Memorial Collection, Gift of Nelson A. Rockefeller, 1965 (1978.412.441)
Fig. 226

Mirror-bearer
Guatemala or Mexico, Maya,
 6th century
Wood, red hematite
H. 14⅛ in. (35.9 cm), W. 9 in.
 (22.9 cm), D. 9 in. (22.9 cm)
The Michael C. Rockefeller
 Memorial Collection, Bequest of
 Nelson A. Rockefeller, 1979
 (1979.206.1063)
Fig. 227

**Female figure with mortar and
 pestle**
Mali, Dogon peoples, 16th–early
 20th century
Wood, iron
H. 22¼ in. (56.5 cm), W. 4⅜ in.
 (11.1 cm), D. 6⅛ in. (15.5 cm)
Gift of Lester Wunderman, 1979
 (1979.541.12)
Fig. 228

Horn player
Nigeria, Court of Benin, Edo
 peoples, 1550–1680
Brass
H. 24¹³⁄₁₆ in. (63 cm), W. 11⁹⁄₁₆ in.
 (29.4 cm), D. 6¾ in. (17.2 cm)
The Michael C. Rockefeller
 Memorial Collection, Gift of
 Nelson A. Rockefeller, 1972
 (1978.412.310)
Fig. 229

Standing male and female figures
Democratic Republic of the Congo,
 Lake Tanganyika region, Tabwa
 peoples, 18th–19th century
Wood, beads
.592: H. 18½ in. (47 cm), W. 8⅜ in.
 (21.3 cm), D. 3⁷⁄₁₆ in. (8.7 cm); .591:
 H. 18³⁄₁₆ in. (46.3 cm), W. 4¾ in.
 (12.1 cm), D. 3¾ in. (9.5 cm)
The Michael C. Rockefeller
 Memorial Collection, Purchase,
 Nelson A. Rockefeller Gift, 1969
 (1978.412.592, .591)
Fig. 230

Body mask
New Guinea, Papua Province,
 Asmat people, mid-20th century
Fiber, sago palm leaves, wood,
 bamboo, feathers, seeds, paint
H. 89 in. (226.1 cm), W. 32 in.
 (81.3 cm), D. 23½ in. (59.7 cm)
The Michael C. Rockefeller
 Memorial Collection; Gift of
 Nelson A. Rockefeller and
 Mrs. Mary C. Rockefeller, 1965
 (1978.412.1274)
Fig. 231

A Seat at the Table

Andy Warhol (American,
 1928–1987)
Mona Lisa, 1963
Acrylic and silkscreen on canvas
44 × 29 in. (111.8 × 73.7 cm)
Gift of Henry Geldzahler, 1965
 (65.273)
Fig. 232

Barnett Newman (American,
 1905–1970)
Concord, 1949
Oil and masking tape on canvas
89¾ × 53⅝ in. (228 × 136.2 cm)
George A. Hearn Fund, 1968
 (68.178)
Fig. 234, not in exhibition

Ellsworth Kelly (American,
 1923–2015)
Blue Green Red, 1963
Oil on canvas
91 × 82 in. (231.1 × 208.3 cm)
Arthur Hoppock Hearn Fund, 1963
 (63.73)
Fig. 235

Bruce Davidson (American, born
 1933)
*People in the Galleries, Metropolitan
 Museum of Art*, 1969
Gelatin silver print
Gift of the Centennial Committee,
 1974 (1974.513.47)
Fig. 236, not in exhibition

Romare Bearden (American,
 1911–1988)
The Woodshed, 1969
Cut and pasted printed and colored
 papers, photostats, cloth, graph-
 ite, and sprayed ink on Masonite
40½ × 50½ in. (102.9 × 128.3 cm)
George A. Hearn Fund, 1970
 (1970.19)
Fig. 238

Work not illustrated

Max Beckmann (German,
 1884–1950)
The Beginning, 1946–49
Oil on canvas
Overall of all three panels: 69 ×
 125½ in. (175.3 × 318.8 cm)
Bequest of Miss Adelaide Milton de
 Groot (1876–1967), 1967
 (67.187.53a–c)

Engaging with Artists

Robert Rauschenberg (American,
 1925–2008)
Universal Limited Art Editions
Centennial Certificate MMA, 1969
Color lithograph
Sheet: 36 × 25 in. (91.4 × 63.5 cm)
Florence and Joseph Singer
 Collection, 1972 (69.630)
Fig. 242

Broadening Perspectives

Buddha Shakyamuni
Tibetan, 12th century
Brass with colored pigments
H. 15½ in. (39.4 cm), W. 10⁷⁄₁₆ in.
 (26.5 cm), D. 8⅝ in. (21.9 cm)
Zimmerman Family Collection,
 Purchase, Lila Acheson Wallace,
 Oscar L. Tang, Anthony W. and
 Lulu C. Wang and Annette de la
 Renta Gifts, 2012 (2012.458)
Fig. 245

Saddle plates
Tibetan or Chinese, ca. 1400
Iron, gold, lapis lazuli, turquoise
H. 10⅞ in. (27.6 cm), L. 23½ in.
 (59.7 cm), W. 13¾ in. (34.9 cm)
Purchase, Gift of William H. Riggs,
 by exchange, and Kenneth and
 Vivian Lam Gift, 1999
 (1999.118a–g)
Fig. 246

Four Gospels
Armenian, 1434/35
Tempera and gold on paper;
 stamped leather binding
H. 11¹⁄₁₆ in. (28.1 cm), W. 7⅝ in.
 (19.4 cm), D. 3⅜ in. (8.5 cm)
Purchase, Fletcher Fund, Hagop
 Kevorkian Fund Gift, in memory
 of Hagop Kevorkian, Tianaderrah
 Foundation, B.H. Breslauer
 Foundation, Aso O. Tavitian,
 Karen Bedrosian Richardson,
 Elizabeth Mugar Eveillard and
 Arax Simsarian Gifts and funds
 from various donors, 2010
 (2010.108)
Fig. 247

Processional cross
Ethiopia, Amhara or Tigrinya peo-
 ples, 13th–14th century
Bronze
H. 12¹³⁄₁₆ in. (32.5 cm), W. 6¹¹⁄₁₆ in.
 (17 cm), D. 1 in. (2.5 cm)
Purchase, 2005 Benefit Fund, 2011
 (2011.159)
Fig. 248

Headdresses for a Bugis aristocrat
Attributed to Indonesia, Sulawesi,
 19th–early 20th century
Fiber, gold
H. 3½ in. (8.9 cm), W. 7½ in.
 (19.1 cm), D. 6½ in. (16.5 cm)
Purchase, Friends of Islamic Art
 Gifts and Lewis and Gemma Hall
 Gift, 2006 (2006.187, .196)
Fig. 249

Andrea Zambelli "L'Honnesta"
 (Italian, active 1732–72)
Torah crown (*keter*), ca. 1740–50
Silver, parcel gilded
H. 10¹³⁄₁₆ in. (27.5 cm), W. 12⅜ in.
 (31.4 cm), D. 12⅜ in. (31.4 cm)
Director's Fund, 2013 (2013.443)
Fig. 250

Andrea Zambelli "L'Honnesta"
 (Italian, active 1732–72)
Pair of Torah finials (*rimonim*),
 ca. 1740–50
Silver, parcel gilded
.416: H. 26⁹⁄₁₆ in. (67.5 cm),
 W. 6³⁄₁₆ in. (15.7 cm), D. 6 in.
 (15.2 cm); .417: H. 26¹¹⁄₁₆ in.
 (67.8 cm), W. 6 in. (15.2 cm),
 D. 6 in. (15.2 cm)
Walter and Leonore Annenberg
 Acquisitions Endowment Fund,
 2016 (2016.416, .417)
Fig. 250

Hebrew Bible
Spanish, 1300–1366
Ink, tempera, and gold on parch-
 ment; leather binding
Folio: 9⁵⁄₁₆ × 7¹⁵⁄₁₆ in. (23.7 ×
 20.1 cm)
The Cloisters Collection, 2018
 (2018.59)
Fig. 251

Calvary
Guatemalan, ca. 1790
Wood, paint, gilded silver, glass,
 hair
H. 21⅝ in. (55 cm), W. 36¼ in.
 (92 cm), D. 13⅜ in. (34 cm)

Purchase, Harris Brisbane Dick and
Gallagher Funds, Nancy Dunn
Revocable Trust Gift, and The
Edward Joseph Gallagher III
Memorial Collection, Edward J.
Gallagher Jr. Bequest, 2019
(2019.43a–g)
Fig. 252

*Crown of the Virgin of the
Immaculate Conception*, known
as the *Crown of the Andes*
Popayán (Colombia), ca. 1660 (dia-
dem), ca. 1770 (arches)
Gold, repoussé and chased;
emeralds
H. 13½ in. (34.3 cm), DIAM. of body:
13¼ in. (33.7 cm)
Purchase, Lila Acheson Wallace
Gift, Acquisitions Fund and Mary
Trumbull Adams Fund, 2015
(2015.437)
Fig. 253

Basket
Native American, Pomo, northern
California, ca. 1890–1910
Sedge root, redbud shoots, willow
H. 20 in. (50.8 cm), DIAM. 18 in.
(45.7 cm)
Gift of Charles and Valerie Diker,
2016 (2016.738.1)
Fig. 254

Joshua Johnson (American,
ca. 1763–ca. 1824)
Emma Van Name, ca. 1805
Oil on canvas
29 × 23 in. (73.7 × 58.4 cm)
Purchase, Nancy Dunn Revocable
Trust Gift, 2016 (2016.116)
Fig. 255

Faith Ringgold (American, born
1930)
Street Story Quilt, 1985
Cotton canvas, with acrylic paint,
ink marker, dyed and printed cot-
ton, and sequins, sewn to cotton
flannel backing
90 × 144 in. (228.6 × 365.8 cm)
Arthur Hoppock Hearn Fund and
funds from various donors, 1990
(1990.237a–c)
Fig. 256

Carmen Herrera (Cuban, born
1915)
Iberic, 1949
Acrylic on canvas on board
DIAM. 40 in. (101.6 cm)
Gift of Tony Bechara, in celebra-
tion of the Museum's 150th
Anniversary, 2019 (2019.13)
Fig. 258

Mrinalini Mukherjee (Indian,
1949–2015)
Palmscape IX, 2015
Bronze
H. 43½ in. (110 cm), w. 24¾ in.
(63 cm), D. 9⅝ in. (24.5 cm)
Purchase, Lila Acheson Wallace
Gift, 2019
Fig. 259

El Anatsui (Ghanaian, born 1944)
Dusasa II, 2007
Found aluminum, copper wire,
plastic disks
H. 236 in. (599.4 cm), w. 288 in.
(731.5 cm), D. 2 in. (5.1 cm)
Purchase, The Raymond and
Beverly Sackler 21st Century Art
Fund; Stephen and Nan Swid and
Roy R. and Marie S. Neuberger
Foundation Inc. Gifts; and
Arthur Lejwa Fund, in honor of
Jean Arp, 2008 (2008.121)
Fig. 260

Ann Hamilton (American, born
1956)
abc, 1994
Video, black-and-white, silent, 13
min.
Gift of Peter Norton Family
Foundation, 2001 (2001.270)
Fig. 261

Iris Van Herpen (Dutch, born 1984)
Ensemble, fall/winter 2011–12
Polyamide, leather, acrylic
Purchase, Friends of The Costume
Institute Gifts, 2012 (2012.560a–d)
Fig. 262

John Monteleone (American, born
1947)
Winter from *The Four Seasons* (serial
number 200), 2002
Tyrolean maple, Tyrolean spruce,
curly red maple, Macassar ebony,
sterling silver, mother-of-pearl,
diamond, nickel plating, natural
blonde nitro-cellulose
lacquer finish
44 × 18 in. (111.8 × 45.7 cm)
Purchase, Abraham J. & Phyllis
Katz Foundation Gift, in memory
of Michael Allan Katz, 2017
(2017.179.1)
Fig. 263, first from left

John Monteleone (American, born
1947)
Summer from *The Four Seasons*
(serial number 202), 2004
Big-leaf maple, Tyrolean spruce,
African red padauk, Macassar
ebony, red coral stones, mother-
of-pearl, ruby, diamond, gold
plating, red nitro-cellulose
lacquer finish
44½ × 18 in. (113 × 45.7 cm)

Purchase, Abraham J. & Phyllis
Katz Foundation Gift, in mem-
ory of Michael Allan Katz, 2017
(2017.179.3)
Fig. 263, third from left

John Monteleone (American, born
1947)
Autumn from *The Four Seasons*
(serial number 203), 2005
Big-leaf maple, Tyrolean spruce, koa,
Macassar ebony, curly red maple,
stainless steel, spiny oyster coral
stone, mother-of-pearl, diamond,
gold plating, golden-brown
nitro-cellulose lacquer finish
44½ × 18 in. (113 × 45.7 cm)
Purchase, Abraham J. & Phyllis
Katz Foundation Gift, in memory
of Michael Allan Katz, 2017
(2017.179.4)
Fig. 263, fourth from left

John Monteleone (American, born
1947)
Spring from *The Four Seasons* (serial
number 201), 2006
Red-tiger maple, Tyrolean spruce,
Macassar ebony, curly red maple,
mother-of-pearl, red abalone
shell, turquoise, diamond, gold
plating, blue nitro-cellulose
lacquer finish
45 × 18 in. (114.3 × 45.7 cm)
Purchase, Abraham J. & Phyllis
Katz Foundation Gift, in memory
of Michael Allan Katz, 2017
(2017.179.2)
Fig. 263, second from left

Notes

Abbreviations
MMA
The Metropolitan Museum of Art
MMAB
The Metropolitan Museum of Art Bulletin
OSR, MMA Archives
Office of the Secretary Records, The Metropolitan Museum of Art Archives

An Edifice for Art

1 Olmsted and Vaux to Henry G. Stebbins, February 1872, Appendix B, Letter 2: "Examination of the Design of the Park and of Recent Changes Therein," *Second Annual Report of the Board of Commissioners of the Department of Public Parks for the Year Ending May 1, 1872* (New York: William C. Bryant and Co., 1872), p. 100.
2 Report of Advisory Committee of Architects, June 28, 1872, Building files, OSR, MMA Archives.
3 Calvin Tomkins, *Merchants and Masterpieces: The Story of the Metropolitan Museum of Art*, rev. ed. (New York: Henry Holt, 1989), p. 60.
4 John Taylor Johnston to Luigi Palma di Cesnola, July 11, 1884, Building Wings A and B file, OSR, MMA Archives.
5 Building Committee Minutes, April 5, 1895, Building files, OSR, MMA Archives.
6 Henry G. Marquand to Cesnola, August 7, 1895, Building files, OSR, MMA Archives.
7 Cesnola to Marquand, November 5, 1895, Building files, OSR, MMA Archives.
8 "The Amplified Art Museum," *New York Evening Post*, December 23, 1902, p. 4; [Montgomery Schuyler], "Architectural Appreciations— No. I: The New Metropolitan Museum of Art," *Architectural Record* 12, no. 3 (August 1902), p. 306.
9 McKim, Mead and White to William Church Osborn, chairman, Building Committee of the Metropolitan Museum, March 6, 1908, as printed in *In the Matter of the Change of Levels of the Metropolitan Museum of Art* (New York: MMA, 1908), p. 14; pamphlet in Building Wing E file, OSR, MMA Archives.
10 Augustus Saint-Gaudens to Charles McKim, July 6, 1905, as quoted in Leland M. Roth, *McKim, Mead & White, Architects* (New York: Harper and Row, 1983), p. 296.
11 MMA 13.183.3.
12 MMA 26.59.1.
13 E[dward] R[obinson], "The New Wing," *The Wing of Decorative Arts*, supplement to *MMAB* 5, no. 3 (March 1910), p. 6.
14 Robert W. de Forest describing John D. Rockefeller Jr., as quoted in Timothy B. Husband, *Creating the Cloisters, MMAB* 70, no. 4 (Spring 2013), p. 30.
15 Francis Henry Taylor, *Babel's Tower: The Dilemma of the Modern Museum* (New York: Columbia University Press, 1945), p. 23.
16 MMA 41.190.482.
17 MMA 68.154.
18 Kevin Roche John Dinkeloo and Associates, "Metropolitan Museum of Art Master Plan Report," July 15, 1971, Building files, OSR, MMA Archives.

The Founding Decades

1 "Foreign Intelligence: France," *Times* (London), July 7, 1866, p. 10; Winifred E. Howe, *A History of The Metropolitan Museum of Art: With a Chapter on the Early Institutions of Art in New York*, [vol. 1] (New York: MMA, 1913), pp. 99–106; John Ott, "Metropolitan, Inc.: Public Subsidy and Private Gain at the Genesis of the American Art Museum," in *New York: Art and Cultural Capital of the Gilded Age*, ed. Margaret R. Laster and Chelsea Bruner (New York: Routledge, 2019), pp. 122–38.
2 Howe, *History of the Metropolitan Museum*, p. 100, quoted from John Jay to Museum director Luigi Palma di Cesnola, August 30, 1890.
3 George Fiske Comfort, quoted in *A Metropolitan Art-Museum in the City of New York: Proceedings of a Meeting Held at the Theatre of the Union League Club, Tuesday Evening, November 23, 1869* (New York: Printed for the Art Committee of the Union League Club, 1869), p. 15.
4 Howe, *History of the Metropolitan Museum*, p. 107.
5 MMA 70.1.
6 Katharine Baetjer, "Extracts from the Paris Journals of John Taylor Johnston," *Apollo* 114, no. 238 (December 1981), pp. 410–17.
7 MMA 22.207.
8 MMA 09.95.
9 Katharine Baetjer, "Buying Pictures for New York: The Founding Purchase of 1871," *Metropolitan Museum Journal* 39 (2004), pp. 161–245.
10 Ibid., p. 177.
11 Howe, *History of the Metropolitan Museum*, p. 149.
12 Elizabeth McFadden, *The Glitter and the Gold: A Spirited Account of the Metropolitan Museum of Art's First Director, the Audacious and High-Handed Luigi Palma di Cesnola* (New York: Dial Press, 1971), pp. 131–39.
13 MMA 77.8.46.
14 Ibid., p. 184 and passim; Howe, *History of the Metropolitan Museum*, pp. 180–81.
15 Morrison H. Heckscher, *Creating Central Park, MMAB* 65, no. 3 (Winter 2008).
16 Ibid., p. 66.
17 Morrison H. Heckscher, *The Metropolitan Museum of Art: An Architectural History, MMAB* 53, no. 1 (Summer 1995), p. 11.
18 Howe, *History of the Metropolitan Museum*, pp. 182–83.
19 Ibid., p. 219.
20 Ibid., pp. 218–19.
21 Rebecca A. Rabinow, "Catharine Lorillard Wolfe: The First Woman Benefactor of the Metropolitan Museum," *Apollo* 147, no. 433 (March 1998), pp. 48–55.
22 MMA 31.45.
23 MMA 07.122.
24 MMA 89.21.2; Frances Weitzenhoffer, "First Manet Paintings to Enter an American Museum," *Gazette des Beaux-Arts*, ser. 6, 97 (March 1981), pp. 125–29.
25 MMA 89.21.1.
26 Samuel P. Avery to Luigi Palma di Cesnola, [March 21, 1889], Erwin Davis, OSR, MMA Archives.
27 Esmée Quodbach, "Collecting Old Masters for New York: Henry Gurdon Marquand and The Metropolitan Museum of Art," *Journal of Historians of Netherlandish Art* 9, no. 1 (Winter 2007), https://jhna.org/articles/collecting-old-masters-new-york-henry-gurdon-marquand-metropolitan-museum-of-art/; and idem, "An Unsung Hero: Henry Gurdon Marquand and His 1889 Gift to The Metropolitan Museum of Art," in Laster and Bruner, *New York: Art and Cultural Capital of the Gilded Age*, pp. 105–21.
28 MMA 91.26.12.
29 MMA 91.26.5.
30 MMA 89.15.16.
31 MMA 91.26.9.
32 Sally B. Brown, *A Gift of Sound: The Crosby Brown Collection of Musical Instruments, MMAB* 76, no. 1 (Summer 2018), p. 5.
33 Cesnola to Gen. George B. McClellan, April 17, 1884, box 1, folder 2, Luigi Palma di Cesnola collection, MMA Archives.
34 MMA 90.29; MMA 95.14.123; MMA 86.3.
35 MMA 82.1.1–.31.
36 Frederic Edwin Church to Cesnola, July 10 and September 5, 1893, Frederic E. Church, OSR, MMA Archives; Ronda Kasl, "An American Museum: Representing the Arts of Mexico at The Metropolitan Museum of Art," in *The Americas Revealed: Collecting Colonial and Modern Latin American Art in the United States*, ed. Edward J. Sullivan (New York: Frick Collection; University Park: Pennsylvania State University Press, 2018), pp. 80–82, fig. 30, p. 166 nn. 8, 11.
37 For more on Moore, see the forthcoming book by Medill Higgins Harvey, ed., *Collecting Inspiration: Edward C. Moore at Tiffany & Co.*, exh. cat. (New York: MMA, 2020).
38 "Charter . . . Passed April 13, 1870," *Charter, By-Laws, Mission Statement: The Metropolitan Museum of Art* (New York: MMA, 2011), p. 3.
39 Maxwell K. Hearn, *Asian Art at the Metropolitan Museum, MMAB* 73, no. 1 (Summer 2015), p. 4.

40 Ibid., p. 10.

41 Stuart W. Pyhrr, *Of Arms and Men: Arms and Armor at the Metropolitan 1912–2012*, *MMAB* 70, no. 1 (Summer 2012), pp. 7–10.

42 MMA 03.27.

43 MMA 03.14.1–.19.

44 MMA 03.23.1–.55. For more on the Rogers Fund, see https://www.metmuseum.org/blogs/now-at-the-met/features/2011/this-weekend-in-met-history-july-2.

45 Winifred E. Howe, *A History of The Metropolitan Museum of Art*, vol. 2, *1905–1941: Problems and Principles in a Period of Expansion* (New York: Columbia University Press, 1946), p. 182.

46 [Robert W. de Forest?], "The Function of the Bulletin," *MMAB* 1, no. 1 (November 1905), p. 1.

Art for All

1 Daniel Chester French to William M. R. French, December 29, 1905, Daniel Chester French Family Papers, Manuscript Division, Library of Congress, Washington, D.C.

2 The Museum issued two annual reports for 1905: the *Annual Report of the Trustees of the MMA*, no. 35 (1905), contained the "Report of the Treasurer for the Year 1904," and the *Annual Report of the Trustees of the MMA*, no. 36 (1905), published in 1906, included the treasurer's report for 1905.

3 J. Pierpont Morgan and Robert W. de Forest, "Thirty-Fifth Annual Report of the Trustees," *Annual Report of the Trustees of the MMA*, no. 35 (1905), p. 10.

4 Ibid.

5 Ibid., pp. 11–12.

6 *Annual Report of the Trustees of the MMA*, no. 37 (1906), p. 14.

7 For more on Parkhurst, see Warren Sloat, *A Battle for the Soul of New York: Tammany Hall, Police Corruption, Vice, and Reverend Charles Parkhurst's Crusade against Them, 1892–1895* (New York: Cooper Square Press, 2002).

8 For a history of Mary Elizabeth Adams Brown's collection, see Sally B. Brown, *A Gift of Sound: The Crosby Brown Collection of Musical Instruments*, *MMAB* 76, no. 1 (Summer 2018).

9 For the history of the Department of Musical Instruments, see Rebecca Lindsey, *A Harmonious Ensemble: Musical Instruments at the Metropolitan Museum, 1884–2014*, https://metmuseum.atavist.com/musicalinstrumentshistory. The authors are greatly indebted to Rebecca Lindsey for her generosity in sharing her research on Frances Morris and her work with the Musical Instruments Collection.

10 Mary E. Brown and William Adams Brown, *Musical Instruments and Their Homes* (New York: Dodd, Mead, 1888).

11 Frances Morris to Luigi Palma di Cesnola, November 22, 1898, Frances Morris—Miscellaneous Correspondence, OSR, MMA Archives.

12 In the United States census for 1900, Frances Morris was listed as a "private secretary," her role with both the Browns and Rev. Parkhurst, rather than as a museum professional.

13 Morris wrote in the preface of her volume 2 catalogue that she intended that volume 1 would cover Asia and Africa; volume 3, Europe; and volume 4, historical groups and musicians' portraits.

14 M[ary] E[lizabeth] B[rown], Introduction, *Preliminary Catalogue of the Crosby-Brown Collection of Musical Instruments of All Nations*, Hand-Book no. 13 (New York: MMA, 1901), p. 9.

15 Ibid., p. 8.

16 Mary Elizabeth Brown to Edward Robinson, June 4, 1906, Frances Morris—Miscellaneous Correspondence, OSR, MMA Archives.

17 In January 1907 Morris asked the museum administration for permission to "give private instruction in laces to certain ladies for pay," which may be evidence that she had a fair amount of knowledge about lace prior to taking it on in 1906. The instruction was approved but not the pay. Edward Robinson to Frances Morris, January 8, 1907, Frances Morris—Miscellaneous Correspondence, OSR, MMA Archives.

18 Frances Morris, "The Development of Lace Collecting in America," in Frances Morris and Marian Hague, *Antique Laces of the American Collectors* (New York: Published for the Needle and Bobbin Club by William Helburn Inc., 1920–26), pt. 5, pp. 15–16.

19 Anna Clinch Cook married American artist James D. Smillie in 1881.

20 Eva Lovett, "The Lace Collection at the Metropolitan Museum," *International Studio* 29 (1906), p. lxxii.

21 Morris to John Crosby Brown, November 1, 1907, Musical Instruments departmental files.

22 The opening statement in *The Textile Collection and Its Use*, supplement to *MMAB* 10, no. 5 (May 1915), p. 2, reads: "This pamphlet is issued with the desire to inform all persons interested in the study, manufacture, or sale of textiles of the help given to them by The Metropolitan Museum of Art."

23 "Complete List of Accessions, February 20 to March 20, 1909," *MMAB* 4, no. 4 (April 1909), p. 73.

24 W[ilhelm] V[alentiner], "Principal Accessions," *MMAB* 4, no. 2 (February 1909), p. 30.

25 Unsigned typed memo, "Department of Textiles," May 11, 1910, Textiles, 1880 . . . 1918, OSR, MMA Archives.

26 Undated clipping from unidentified newspaper, ca. 1910, Textiles, 1880 . . . 1918, OSR, MMA Archives.

27 "Bequest of Mrs. Maria P. James," *MMAB* 6, no. 4 (April 1911), pp. 86–89.

28 Frances Morris, "A Mediaeval Vestment," *MMAB* 22, no. 12 (December 1927), pp. 300–310.

29 For more on Morris's exhibition, see Amelia Peck, "Trade Textiles at the Metropolitan Museum: A History," in *Interwoven Globe: The Worldwide Textile Trade, 1500–1800*, ed. Amelia Peck, exh. cat. (New York: MMA, 2013), pp. 2–11; and for the chair seat cover, see M[elinda] W[att], cat. 55, in ibid., pp. 209–10.

30 Henri Clouzot and Frances Morris, *Painted and Printed Fabrics: The History of the Manufactory at Jouy and Other Ateliers in France, 1760–1815; Notes on the History of Cotton Printing, Especially in England and America* (New York: MMA, 1927). Clouzot's portion, originally published in France, was translated by Morris for the Museum's catalogue; Joseph Breck, "Resignation of Miss Frances Morris," *MMAB* 24, no. 10 (October 1929), p. 266.

31 Morris to Edward Robinson, April 10, 1929, Frances Morris—Miscellaneous Correspondence, OSR, MMA Archives.

32 It may be assumed that the Museum felt justified in promoting Richter, who was educated at a prominent English secondary school and at Girton College, Cambridge, while Morris likely had no formal academic training past high school.

33 Frances Morris to Edward Robinson, May 17, 1929, Frances Morris—Miscellaneous Correspondence, OSR, MMA Archives.

34 Joseph Breck to the trustees, June 6, 1929, Frances Morris—Miscellaneous Correspondence, OSR, MMA Archives.

35 Morris to Breck, August 6, 1929, Frances Morris—Miscellaneous Correspondence, OSR, MMA Archives.

36 Correspondence in the MMA Archives between Breck and Morris over the years reveal that the two had a pleasant, collegial relationship, and Breck wrote about her in glowing terms when her resignation was announced in *MMAB* 24, no. 10 (October 1929), p. 266.

37 De Forest to Breck, August 9, 1929, Frances Morris—Miscellaneous Correspondence, OSR, MMA Archives.

38 Breck to de Forest, January 17, 1930, Mrs. John Crosby Brown Collection of Musical Instruments, OSR, MMA Archives.

39 Morris's catalogue of the textiles at Dumbarton Oaks was unfortunately never published. A copy of it remains in the Dumbarton Oaks Archive. Thanks to 2018–19 American Wing Tiffany Intern Kayli Rideout for discovering this previously unknown work by Morris.

40 Just before a large gift by William Loring Andrews of etchings by Seymour Hayden and James McNeill Whistler came into the Museum in 1883, collectors and the trustees lobbied the director, Edward Robinson, to set up a department of prints. In the MMA Archives there is a file labeled Prints Department Proposed—1882, 1890, 1897–98, 1911–12, 1916.

41 Andrews gave his collection to the Museum Library, which was then collecting prints (see MMA 83.1.1–.94). These works were transferred to the Department of Prints in 1920.
42 Ivins to Robinson, December 3, 1916, William M. Ivins Jr.—Miscellaneous Correspondence, OSR, MMA Archives. See S. R. Koehler, *A Chronological Catalogue of the Engravings, Dry-points and Etchings of Albert Dürer*, exh. cat. (New York: Grolier Club, 1897).
43 W[illiam] M. I[vins] Jr., "Five Years in the Department of Prints," *MMAB* 16, no. 12 (December 1921), p. 258.
44 The Museum purchased Morgan's collection of engravings by Dürer and his contemporaries (MMA 19.73.1–.127); Morgan gave his woodcuts (MMA 19.73.128–.254) and two woodblocks (MMA 19.73.255, .256).
45 W[illiam] M. I[vins] Jr., "The Museum Department of Prints," *MMAB* 12, no. 2 (February 1917), p. 24.
46 Ibid., p. 25.
47 Ivins, "Five Years in the Department of Prints," p. 262.
48 Ibid., pp. 259–60.
49 Elisabeth Luther Cary, "Down in the Basement: Metropolitan Museum's Modern Prints—Ask What You Want—No Red Tape," *New York Times*, April 5, 1931, sec. 8, p. 11.
50 W[illiam] M. I[vins] Jr., "The Museum Department of Prints," *MMAB* 12, no. 2 (February 1917), p. 24.
51 "Was gezeigt werden kann, kann nicht gesagt werden" (*Tractatus* 4.1212). Ivins also quoted this statement in "A Propos of the *Fabrica* of Vesalius," *Bulletin of the History of Medicine* 14, no. 5 (December 1943), p. 577; "What about the *Fabrica* of Vesalius?" in *Three Vesalian Essays to Accompany the* Icones Anatomicae *of 1934*, by Samuel W. Lambert, Willy Wiegand, and William M. Ivins Jr., History of Medicine 11 (New York: Macmillan, 1952), p. 50.
52 "The New Department of Prints," *MMAB* 12, no. 1 (January 1917), p. 2.
53 A. Hyatt Mayor, "William Mills Ivins, Jr., 1881–1961," *MMAB* 21, no. 6 (February 1963), p. 194.

54 Ivins, "The Museum Department of Prints," p. 23.
55 Ivins to Howard Mansfield, May 8, 1917, Print Department, 1916–21 . . . 1949, OSR, MMA Archives.
56 Mayor, "William Mills Ivins, Jr., 1881–1961," p. 196.
57 Ivins to Paul J. Sachs, February 26, 1916, Harvard University Art Museums Archives.
58 This is with some caveats: twentieth- and twenty-first-century drawings are in the Department of Modern and Contemporary Art and American design drawings are in the American Wing.
59 W[illiam] M. I[vins] Jr., "The Baillie Collection of Bookplates," *MMAB* 15, no. 11 (November 1920), pp. 246–48; idem, "A Woodblock by Brueghel," *Metropolitan Museum Studies* 5 (1934–36), p. 116.
60 Ivins to Henry Watson Kent, December 9, 1925, William M. Ivins Jr.—Miscellaneous Correspondence, OSR, MMA Archives.
61 Mayor, "William Mills Ivins, Jr., 1881–1961," p. 196.
62 MMA 38.91.1–.122.
63 W[illiam] M. I[vins] Jr., "Goya's Disasters of War," *MMAB* 19, no. 9 (September 1924), pp. 220–24, esp. p. 223.
64 William M. Ivins Jr., "On Education in a Museum," *MMAB* 29, no. 9 (September 1934), p. 149.
65 Ibid., pp. 148–51.

Princely Aspirations

1 "City Not to Get Art Collection Left by Morgan," *New York Times*, January 26, 1914, p. 1; Carroll Beckwith, "A Great Loss to Industrial Art," *New York Times*, April 19, 1915, p. 8.
2 In addition to the works in the exhibition, there were paintings previously lent by Morgan that were already on view in the Museum.
3 Edward Robinson, "The Morgan Collection," *MMAB* 8, no. 6 (June 1913), p. 116.
4 "Splendid Morgan Collection Now at Metropolitan," *New York Times*, February 15, 1914, sec. 5, pp. 1, 6.
5 Other institutions that benefited from his largesse include the Morgan Library and Museum, New York, and the Wadsworth Atheneum Museum of Art, Hartford, Connecticut.
6 Henry James writing anonymously in the *Atlantic Monthly* in June 1872, as quoted in Katharine Baetjer, "Buying Pictures for New York: The Founding Purchase of 1871," *Metropolitan Museum Journal* 39 (2004), p. 177.
7 Mallet figured in *Roderick Hudson* (first published serially in the *Atlantic Monthly* in 1875); see Sergio Perosa, "Henry James and Unholy Art Acquisitions," *Cambridge Quarterly* 37, no. 1 (March 2008), p. 155.
8 Henry James, *The American Scene* (New York: Harper and Brothers Publishers, 1907), p. 186. For an analysis of this passage and a discussion of James's point of view, see Perosa, "Henry James and Unholy Art Acquisitions," pp. 154–55.
9 Altman's estate was valued at $50 million, all of which was given away. In addition to the bequest to the Metropolitan Museum, Altman's will included gifts to Mount Sinai Hospital, the German Hospital (now Lenox Hill Hospital), and the New York Hebrew Educational Alliance. It also provided funds for the establishment of a foundation "to promote the social, physical and economic welfare, of the employees of B. Altman & Company." See *The Life & Legacy of Benjamin Altman: New York City Merchant Prince & Philanthropist* (New York: Altman Foundation, 2013), pp. 12, 23–24, 26–27; https://www.altmanfoundation.org/about/history/life-legacy/_res/id=File1/Life-Legacy-Benjamin-Altman.pdf.
10 See, for example, MMA 14.40.725.
11 See, for example, MMA 14.40.440a, b; MMA 14.40.469a, b.
12 As quoted in Esmée Quodbach, *The Age of Rembrandt: Dutch Paintings in The Metropolitan Museum of Art*, *MMAB* 65, no. 1 (Summer 2007), p. 35.
13 For more on Morgan, see Jean Strouse, *Morgan: American Financier* (New York: Random House, 1999); and Strouse, *J. Pierpont Morgan: Financier and Collector*, *MMAB* 57, no. 3 (Winter 2000).
14 Morgan's purchase was national news: "Gems from the Garland Collection of Oriental Porcelains Saved for New-York by J. P. Morgan," *New-York Tribune*, March 16, 1902, illus. suppl., pp. 1–2; "Garland Porcelains Promptly Purchased," *New York Times*, March 9, 1902, p. 13; "Morgan the Purchaser," *Los Angeles Herald*, March 9, 1902, p. 4. See also Strouse, *Morgan*, p. 494; Charles Molesworth, *The Capitalist and the Critic: J. P. Morgan, Roger Fry, and the Metropolitan Museum of Art* (Austin: University of Texas Press, 2016), pp. 34–35.
15 Fong Chow, "Chinese Porcelain in the Altman Collection," *MMAB* 20, no. 1 (Summer 1961), pp. 6–19.
16 Strouse, *Morgan*, pp. 494–96; Stuart W. Pyhrr, *Of Arms and Men: Arms and Armor at the Metropolitan, 1912–2012*, *MMAB* 70, no. 1 (Summer 2012), pp. 15–18.
17 Stuart W. Pyhrr and José-A. Godoy, *Heroic Armor of the Italian Renaissance: Filippo Negroli and His Contemporaries*, exh. cat. (New York: MMA, 1998), cat. 33, pp. 180–84.
18 Edward Robinson, "The Hoentschel Collection," *MMAB* 2, no. 6 (June 1907), pp. 94–98; Daniëlle Kisluk-Grosheide, "The Hoentschel Collection Comes to New York," in *Salvaging the Past: Georges Hoentschel and French Decorative Arts from The Metropolitan Museum of Art*, ed. Daniëlle Kisluk-Grosheide, Deborah L. Krohn, and Ulrich Leben, exh. cat., Bard Graduate Center (New York: Bard Graduate Center, MMA; New Haven: Yale University Press, 2013), p. 1.
19 Daniëlle Kisluk-Grosheide and Jeffrey Munger, *The Wrightsman Galleries for French Decorative Arts: The Metropolitan Museum of Art* (New York: MMA; New Haven: Yale University Press, 2010), no. 48, pp. 114–15.
20 See Daniëlle O. Kisluk-Grosheide, "Peregrinations of a *Lit à la Duchesse en Impériale* by Georges Jacob," *Metropolitan Museum Journal* 44 (2009), pp. 148–49, fig. 16; and Sarah Brown McLean, cat. 12, in Kisluk-Grosheide, Krohn, and Leben, *Salvaging the Past*, pp. 83–84.
21 William DeGregorio, cat. 50, in Kisluk-Grosheide, Krohn, and Leben, *Salvaging the Past*, p. 104.
22 On the Hoentschel collection overall see Kisluk-Grosheide,

Krohn, and Leben, *Salvaging the Past.* Part of the Hoentschel collection was to have been shipped on the Titanic but was off-loaded at the last minute.

23 Valentiner returned to his native Germany to serve in World War I. He came back to the United States and played a definitive role in shaping other American museums, including the Detroit Museum of Art (now the Detroit Institute of Arts), the Los Angeles County Museum of Art, the J. Paul Getty Museum, and the North Carolina Museum of Art, Raleigh. See Margaret Sterne, *The Passionate Eye: The Life of William R. Valentiner* (Detroit: Wayne State University Press, 1980).

24 "Emigration to America—First Tasks (Excerpt from Dr. Valentiner's incomplete autobiography [1890–1920])," in *Masterpieces of Art in Memory of William R. Valentiner 1880–1958,* exh. cat. (Raleigh: North Carolina Museum of Art, 1959), pp. 14–15.

25 "Charter . . . Passed April 13, 1870," *Charter, By-Laws, Mission Statement: The Metropolitan Museum of Art* (New York: MMA, 2011), p. 3.

26 Strouse, *Morgan,* pp. 504 (Berenson), 492 (McKim).

27 In several instances, Morgan eventually restituted works of art to countries from which dealers had either stolen them, like an *opus anglicanum* cope from Ascoli Piceno (Dagmar Wood, "English Mediaeval Embroidery," *Treasury* 4, no. 29 [February 1905], p. 477), or purchased them, like the bust of Saint Martin from Soudeilles, which he gifted to the Musée du Louvre; see Barbara Drake Boehm, *"Furta sacra?* L'histoire récente de quelques reliquaires médiévaux français et la Loi Combes," *Les Cahiers de Saint-Michel de Cuxa* 41 (2010), pp. 61–69.

28 Linda Horvitz Roth, "J. Pierpont Morgan, Collector," in *J. Pierpont Morgan, Collector: European Decorative Arts from the Wadsworth Atheneum,* ed. Linda Horvitz Roth, exh. cat. (Hartford, Conn.: Wadsworth Atheneum, 1987), p. 26, for the quotation, p. 37. He removed the portions of his collection housed in England only in 1912, after the U.S. import tax on works of art was repealed.

29 Germain Seligman, *Merchants of Art, 1880–1960: Eighty Years of Professional Collecting* (New York: Appleton-Century-Crofts, 1961), p. 73, as quoted in Roth, "J. Pierpont Morgan, Collector," p. 33.

30 MMA 17.190.134.

31 Jonathan Brown, *Kings & Connoisseurs: Collecting Art in Seventeenth-Century Europe,* Bollingen Series 35:43 (Princeton, N.J.: Princeton University Press, 1995), pp. 81, 148–49; Clare Vincent and Jan Hendrik Leopold with Elizabeth Sullivan, *European Clocks and Watches in The Metropolitan Museum of Art* (New York: MMA, 2015), no. 4, pp. 33–35.

32 MMA 16.30a, b.

33 Linda Wolk-Simon, *Raphael at the Metropolitan: The Colonna Altarpiece,* MMAB 63, no. 4 (Spring 2006); for the price, see pp. 55–57, fig. 73.

34 "Mr. Marquand's Great Gift: His Valuable Paintings to Go to the Metropolitan," *New York Times,* January 16, 1889, p. 4.

35 MMA 89.15.16.

36 MMA 89.15.19.

37 MMA 89.15.21.

38 On Marquand, see Cynthia Saltzman, *Old Masters, New World: America's Raid on Europe's Great Pictures, 1880–World War I* (New York: Viking, 2008), pp. 11–44; Esmée Quodbach, "Collecting Old Masters for New York: Henry Gurdon Marquand and the Metropolitan Museum of Art," *Journal of Historians of Netherlandish Art* 9, no. 1 (Winter 2017), DOI: 10.5092 /jhna.2017.9.1.2.

39 Saltzman, *Old Masters, New World,* p. 40.

40 Francis Haskell, "The Benjamin Altman Bequest," *Metropolitan Museum Journal* 3 (1970), pp. 259–80; Quodbach, *The Age of Rembrandt,* p. 28.

41 As quoted in ibid., p. 18.

42 Saltzman, *Old Masters, New World,* pp. 106–7.

43 Herbert L. Satterlee, *J. Pierpont Morgan: An Intimate Portrait* (New York: Macmillan, 1939), p. 434.

44 Berenson's impact on the taste for Sienese painting is discussed in Machtelt Brüggen Israëls, "The Berensons 'Connosh' and Collect Sienese Painting," in Carl Brandon Strehlke and Machtelt Brüggen Israëls, *The Bernard and Mary*

Berenson Collection of European Paintings at I Tatti (Florence: Villa I Tatti in collaboration with Officina Libraria, 2015), pp. 47–69; Philippe de Montebello, Foreword, in Keith Christiansen, Laurence B. Kanter, and Carl Brandon Strehlke, *Painting in Renaissance Siena, 1420–1500,* exh. cat. (New York: MMA, 1988), p. ix; and Alvin W. Pearson, Preface, in John Pope-Hennessy, assisted by Laurence B. Kanter, *The Robert Lehman Collection I: Italian Paintings* (New York: MMA, in association with Princeton University Press, 1987), p. vii.

45 See Fausto Nicolai, "More than an Expatriate Scholar: Frederick Mason Perkins as Art Adviser, Agent and Intermediary for American Collectors of the Twentieth Century," *Journal of the History of Collections* 28, no. 2 (July 2016), pp. 311–25; Fausto Nicolai, "'Primitives' in America: Frederick Mason Perkins and the Early Renaissance Italian Paintings in the Lehman and Blumenthal Collections," *Journal of the History of Collections* 31, no. 1 (March 2019), pp. 131–50.

46 Nicolai, "'Primitives' in America," pp. 133–36; Keith Christiansen, "Simone Martini's Altar-Piece for the Commune of Siena," *Burlington Magazine* 136 (March 1994), pp. 148–60.

47 Nicolai, "'Primitives' in America." Perkins used the term "really first-class" when trying to pique Blumenthal's interest in a painting by fifteenth-century Sienese artist Francesco di Giorgio (ibid., p. 132). Blumenthal used the term "pure" to describe the fourteenth-century paintings that he particularly admired (ibid.).

48 Laurence B. Kanter, "Publishing the Lehman Collection," in James R. Houghton and members of the staff, *Philippe de Montebello and The Metropolitan Museum of Art 1977–2008* (New York: MMA; New Haven: Yale University Press, 2009), pp. 65–67.

49 "The Planning and the Opening of the Centennial Celebration: October 1965–September 1969," *The History of the Centennial Celebration of The Metropolitan Museum of Art* (New York: MMA, 1972), pp. 17–18.

50 MMA 1977.10.

51 MMA 1981.238.

52 MMA 2014.250.

53 Edmond About, *Voyage à travers l'exposition des beaux-arts* (Paris, 1855), p. 134, as translated in Gary Tinterow, cats. 145, 146, in *Portraits by Ingres: Image of an Epoch,* ed. Gary Tinterow and Philip Conisbee, exh. cat. (New York: MMA, 1999), p. 451.

54 Daniëlle Kisluk-Grosheide, Introduction, in Kisluk-Grosheide and Munger, *The Wrightsman Galleries for French Decorative Arts,* pp. 10–21.

55 Michel David-Weill, with Patricia Boyer de Latour, *A Taste for Happiness,* trans. Sandra Smith (North Charleston, S.C.: CreateSpace, 2015), p. 33.

56 The Metropolitan Museum purchased the desk from Galerie du Luxembourg, Paris, in 1973.

57 Saltzman, *Old Masters, New World,* p. 17.

58 Henry James, *The Spoils of Poynton* (1897), as quoted in Perosa, "Henry James and Unholy Art Acquisitions," p. 156.

Collecting through Excavation

1 MMA 70.1.

2 "Department of Egyptian Art," *MMAB* 1, no. 12 (November 1906), pp. 149–50.

3 The terms Near East and Middle East refer to the same broad geographic region. The academic field has traditionally been known as ancient Near Eastern studies, hence the name of the Metropolitan Museum's Department of Ancient Near Eastern Art.

4 For their assistance with this essay, the author wishes to thank the Departments of Ancient Near Eastern Art, Archives, Arms and Armor, Egyptian Art, Islamic Art, Medieval Art and The Cloisters, and Objects Conservation, particularly Sarah Graff, Michael Seymour, James Moske, Angela Salisbury, Donald LaRocca, Diana Craig Patch, Janice Kamrin, Marsha Hill, Martina Rugiadi, Andrea Achi, Helen Evans, and Lisa Pilosi.

5 Luigi Palma di Cesnola to M. Bouriant, October 10, 1885, Antiquities—Egyptian, Purchase—Through G. Maspero 1885–88,

Correspondence and Reports, OSR, MMA Archives; Gaston Maspero to Cesnola, May 24, 1885, Purchases—Authorized—Antiquities (Egyptian)—Maspero, G., purchased . . . out of proceeds of sale of Cypriote Antiq., OSR, MMA Archives.

6 MMA 86.1.5a–c, MMA 86.1.6a; MMA 86.1.1a, b, MMA 86.1.2a, b, MMA 86.1.4.

7 Catharine H. Roehrig, "An Artisan's Tomb in New Kingdom Egypt," *Heilbrunn Timeline of Art History* (New York: MMA, 2000–), https://www.metmuseum.org/toah/hd/srvt/hd_srvt.htm (October 2004).

8 MMA 26.59.1.

9 "Principal Accessions: Primitive Japanese Armor," *MMAB* 2, no. 6 (June 1907), p. 107.

10 MMA 06.310.8.

11 M. Matano to Bashford Dean, November 20, 1906, Tokio Imperial Museum 1906 . . . 1930, OSR, MMA Archives.

12 Bashford Dean to Edward Robinson, October 26, 1927, Purchases—General—Hoopes, 1927–28, OSR, MMA Archives.

13 "Report of the Special Committee Appointed August 28 to Consider the Resignation of Dr. Robinson," *Museum of Fine Arts Bulletin* 4, no. 18 (1906), pp. 2–3.

14 Albert M. Lythgoe to Edward Robinson, January 19, 1906, Egyptian Expedition Archives, Department of Egyptian Art.

15 Robinson to Lythgoe, February 22, 1906, Egyptian Expedition Archives, Department of Egyptian Art.

16 Lythgoe to Robinson, February 26, 1906, Egyptian Expedition Archives, Department of Egyptian Art.

17 William M. Laffan to Robinson, February 28, 1906, Antiquities—Egyptian Department—Establishment of department and appointment of curator, 1906, OSR, MMA Archives.

18 Robinson to Lythgoe, March 27, 1906, Egyptian Expedition Archives, Department of Egyptian Art.

19 MMA 09.180.526; MMA 08.200.5.

20 A[lbert] M. L[ythgoe], "The Egyptian Expedition, II," *MMAB* 2, no. 7 (July 1907), pp. 113–17.

21 A[lbert] M. L[ythgoe], "The Egyptian Expedition, III," *MMAB* 2, no. 10 (October 1907), pp. 163–69.

22 D[iana] C[raig] P[atch], cats. 176–79, in *Ancient Egypt Transformed: The Middle Kingdom*, ed. Adela Oppenheim, Dorothea Arnold, Dieter Arnold, and Kei Yamamoto, exh. cat. (New York: MMA, 2015), pp. 237–43.

23 Arthur C. Mace and Herbert E. Winlock, *The Tomb of Senebtisi at Lisht* (New York: MMA, 1916).

24 Lythgoe to Robinson, March 9, 1907, Egyptian Expedition Archives, Department of Egyptian Art.

25 A[lbert] M. L[ythgoe], "The Oasis of Kharga," *MMAB* 3, no. 11 (November 1908), pp. 203–8.

26 MMA 31.8.42.68.

27 MMA 08.268.15a–c.

28 A[lbert] M. L[ythgoe], "The Egyptian Expedition," *MMAB* 4, no. 7 (July 1909), pp. 122–23.

29 H[erbert] E. W[inlock], "The Egyptian Expedition: The Monastery of Epiphanios at Thebes," *MMAB* 10, no. 7 (July 1915), pp. 138–50; H. E. Winlock and W. E. Crum, *The Monastery of Epiphanius at Thebes*, pt. 1 (New York: MMA, 1926); W. E. Crum and H. G. Evelyn White, *The Monastery of Epiphanius at Thebes*, pt. 2 (New York: MMA, 1926).

30 MMA 14.1.81.

31 H[erbert] E. W[inlock], "Excavations at Thebes 1919–1920," *The Egyptian Expedition 1918–1920*, pt. 2 of *MMAB* 15, no. 12 (December 1920), pp. 31–32.

32 H[erbert] E. Winlock, "The Mummy of Waḥ Unwrapped," *MMAB* 35, no. 12 (December 1940), pp. 253–59.

33 MMA 40.3.14.

34 Winlock to Lythgoe, February 5, 1928, Egyptian Expedition Archives, Department of Egyptian Art.

35 Dean to Robinson, with attachment "An expedition to Palestine, proposed for the spring of 1924," September 24, 1923, Palestine "Reconnaissance"—Correspondence and Reports, OSR, MMA Archives.

36 Robinson to Dean, September 27, 1923, Palestine "Reconnaissance"—Correspondence and Reports, OSR, MMA Archives.

37 Dean to Robinson, October 26, 1925, Palestine "Reconnaissance"—Correspondence and Reports, OSR, MMA Archives.

38 MMA 28.99.37.

39 Adrian J. Boas, "Archaeological Evidence for the Mamluk Sieges and Dismantling of Montfort: A Preliminary Discussion," in *Montfort: History, Early Research and Recent Studies of the Principal Fortress of the Teutonic Order in the Latin East*, ed. Adrian J. Boas, with the assistance of Rabei G. Khamisy, Medieval Mediterranean 107 (Leiden: Brill, 2017), p. 50; and Boas, "Stone, Metal, Wood and Worked Bone Finds from the 1926 Expedition," in ibid., pp. 197–99.

40 "Museum Quest for Crusaders' Relics Is Failure," *New York Herald Tribune*, September 19, 1927, clipping in Palestine "Reconnaissance"—Correspondence and Reports, OSR, MMA Archives.

41 Bashford Dean, *A Crusader's Fortress in Palestine: A Report of Explorations Made by the Museum 1926*, pt. 2 of *MMAB* 22, no. 9 (September 1927), p. 44.

42 MMA 28.99.675, .616, .672.

43 Nurith Kenaan-Kedar, "The Architectural Sculpture of Montfort Castle Revisited," in Boas, *Montfort*, pp. 273–81.

44 Dean, *A Crusader's Fortress in Palestine*, pp. 32, 34; Helmut Nickel, "Some Heraldic Fragments Found at Castle Montfort/Starkenberg in 1926, and the Arms of the Grand Master of the Teutonic Knights," *Metropolitan Museum Journal* 24 (1989), pp. 36–41; Andrea Wähning, "The Stone Matrices from Montfort: About Moulds, Tin Relief and the Polychrome of Shields in the Thirteenth Century," in Boas, *Montfort*, pp. 266–72.

45 MMA 28.99.15.

46 Boas, "Ceramic Finds," in Boas, *Montfort*, pp. 163–65.

47 Mark Wypisky and Lisa Pilosi, "Preliminary Compositional Study of Glass from the Crusader Castle at Montfort," in *Annales du 16e Congrès de l'Association Internationale pour l'Histoire du Verre, London, 7–13 September, 2003*, ed. Marie-Dominique Nenna (Nottingham: AIHV, 2005), pp. 194–98; David Whitehouse, Timothy B. Husband, Lisa Pilosi, Mary B. Shepard, and Mark T. Wypyski, "Glass in the Metropolitan Museum of Art from the 1926 Expedition," in Boas, *Montfort*, pp. 176–94.

48 Maurice S. Dimand, "Ctesiphon Statement," June 8, 1931, Ctesiphon—Excavations—Correspondence 1931, OSR, MMA Archives.

49 Caitlin Chaves Yates, "The Metropolitan Museum's Excavations at Ctesiphon," *Heilbrunn Timeline of Art History*, https://www.metmuseum.org/toah/hd/cphn/hd_cphn.htm (February 2018).

50 Dimand, "Ctesiphon Statement."

51 Elizabetta Valtz Fino, "Ctesiphon," in *Discovering the Art of the Ancient Near East*, ed. Yelena Rakic, *MMAB* 68, no. 1 (Summer 2010), pp. 12–16.

52 Joseph M. Upton to Joseph Breck, December 15, 1931, Ctesiphon—Excavations—Correspondence 1931, OSR, MMA Archives.

53 MMA 32.150.1; Dimand to Herbert E. Winlock, June 4, 1932, Ctesiphon—Excavations—Correspondence 1931, OSR, MMA Archives.

54 Chaves Yates, "The Metropolitan Museum's Excavations at Qasr-i Abu Nasr," *Heilbrunn Timeline of Art History*, https://www.metmuseum.org/toah/hd/qasr/hd_qasr.htm (June 2018).

55 Winlock to Charles K. Wilkinson, June 4, 1932, Ctesiphon—Excavations—Correspondence 1931, OSR, MMA Archives.

56 MMA 32.143.1, .2.

57 H[erbert] E. Winlock, "Assyria: A New Chapter in the Museum's History of Art," *MMAB* 28, no. 2 (February 1933), pp. 18–24; Michael Seymour, "The Assyrian Sculpture Court," *Heilbrunn Timeline of Art History*, https://www.metmuseum.org/toah/hd/nimr_2/hd_nimr_2.htm (December 2016).

58 MMA 40.170.131.

59 MMA 38.40.290.

60 MMA 38.40.240.

61 Parviz Holakooei, Jean-François de Lapérouse, Martina Rugiadi, and Federico Carò, "Early Islamic Pigments at Nishapur, North-Eastern Iran: Studies on the Paint Fragments Preserved at The Metropolitan Museum of Art," *Archaeological and Anthropological Sciences* 10, no. 1 (February 2018), pp. 175–95, https://doi.org/10.1007/s12520-016-0347-7 (June 4, 2016).

Notes

62 Sarah B. Graff, "Nimrud," in Rakic, *Discovering the Art of the Ancient Near East*, pp. 15–21.
63 Jean M. Evans, "Nippur," in ibid., pp. 23–27.
64 MMA 59.41.12; MMA 62.70.84.

Creating a National Narrative

1 MMA 72.3.
2 MMA 77.9a, b.
3 MMA 88.10.2, .3.
4 American-made musical instruments entered the collection in the 1880s but were displayed with other musical instruments. See "Art for All" in this volume.
5 *Annual Report of the Trustees of the MMA*, no. 35 (1905), pp. 8, 10.
6 Ibid., p. 13; reprinted in "Collections of American Art," *MMAB* 1, no. 1 (November 1905), pp. 5–6.
7 See, for instance, *Annual Report of the Trustees of the MMA*, no. 36 (1905), pp. 32–33. This practice continued through 1916.
8 *Annual Report*, no. 35, p. 12.
9 MMA 03.27.
10 Salmagundi Club petition, signed by 153 members, March 1904; and William T. Evans, Lotos Club, to Frederick Rhinelander, president, Metropolitan Museum, April 2, 1904, Paintings—American School, Petitions from Artists and Art Clubs, OSR, MMA Archives.
11 Robert W. de Forest to Joseph H. Thompson, secretary, Salmagundi Club, May 4, 1904 (copy), Paintings—American School, Petitions from Artists and Art Clubs, OSR, MMA Archives. The Museum published a list of its American paintings in "Paintings by American Artists in the Museum," *MMAB* 1, no. 10 (September 1906), pp. 131–35.
12 On Burroughs, see Gwendolyn Owens, "Pioneers in American Museums: Bryson Burroughs," *Museum News* 57, no. 5 (May–June 1979), pp. 46–53, 84; *Bryson Burroughs: Catalogue of a Memorial Exhibition of His Works*, exh. cat. (New York: MMA, 1935).
13 "Bryson Burroughs Dies; Noted Artist," *New York Times*, November 17, 1934, p. 15.
14 "George A. Hearn, One of the Rarest Types of Collectors," *New York Times*, December 7, 1913, sec. 10, p. 9. On Hearn, see Carrie Rebora Barratt, "George A. Hearn: 'Good American pictures can hold their own,'" *Magazine Antiques* 157, no. 1 (January 2000), pp. 218–23.
15 Hearn's original gift and list of donated paintings was reprinted in "Mr. George A. Hearn's Gift to the Museum, and to the Cause of American Art," *MMAB* 1, no. 3 (February 1906), pp. 33–37.
16 Hearn to the trustees, January 11, 1906, George A. Hearn—Gifts-Money, 1905–11, OSR, MMA Archives; reprinted in "Mr. George A. Hearn's Recent Gift to the Museum," *MMAB* 1, no. 7 (June 1906), p. 103.
17 "Gift of Mr. George A. Hearn," *MMAB* 6, no. 7 (July 1911), p. 146; and Barratt, "George A. Hearn," p. 219.
18 Bryson Burroughs, memorandum, October 26, 1906, Hearn Funds—Purchases Selected by George Hearn, 1906–13, OSR, MMA Archives.
19 Kevin J. Avery, *American Drawings and Watercolors in The Metropolitan Museum of Art*, vol. 1, *A Catalogue of Works by Artists Born before 1835* (New York: MMA, 2002), pp. 13–14.
20 B[ryson] B[urroughs], "The Hudson River School of Painters," *Paintings of the Hudson River School*, supplement to *MMAB* 12, no. 10 (October 1917), p. 3.
21 H. Barbara Weinberg, *Thomas Eakins and the Metropolitan Museum of Art*, *MMAB* 52, no. 3 (Winter 1994/95), esp. pp. 5–6, 37–42.
22 B[ryson] B[urroughs], "Recent Accessions: A Picture by Thomas Eakins," *MMAB* 11, no. 6 (June 1916), p. 132.
23 Burroughs to de Forest, July 1, 1927 (copy), Thomas Eakins, OSR, MMA Archives.
24 Stephanie L. Herdrich and H. Barbara Weinberg, "Introduction: The Formation of the Metropolitan's Collection of Sargent's Works," in *American Drawings and Watercolors in The Metropolitan Museum of Art: John Singer Sargent* (New York: MMA, 2000), pp. 1–15.
25 Sargent to Robinson, January 8, 1916, Paintings—Purchased, Sargent—Portrait of Madame X, OSR, MMA Archives.
26 H. Barbara Weinberg and Stephanie L. Herdrich, *John Singer Sargent in The Metropolitan Museum of Art*, *MMAB* 57, no. 4 (Spring 2000), p. 55.
27 Forbes Watson, "The Innocent Bystander," *American Magazine of Art* 28, no. 1 (January 1935), p. 43.
28 Mrs. Daniel Chester (Mary A.) French, *Memories of a Sculptor's Wife* (Boston: Houghton Mifflin, 1928), p. 192. See Thayer Tolles, "A History of the Metropolitan Museum's American Sculpture Collection," in *American Sculpture in The Metropolitan Museum of Art*, vol. 1, *A Catalogue of Works by Artists Born before 1865*, ed. Thayer Tolles (New York: MMA, 1999), esp. pp. xvi–xxii.
29 On French, see Harold Holzer, *Monument Man: The Life and Art of Daniel Chester French* (New York: Princeton Architectural Press, 2019).
30 "Who's Who in American Art," *Arts and Decoration* 8, no. 4 (February 1918), p. 176.
31 French to Robert W. de Forest, February 1, 1907 (copy), Daniel Chester French Family Papers, Manuscript Division, Library of Congress, Washington, D.C.
32 French to Royal Cortissoz, March 8, 1918, Royal Cortissoz Papers, Beinecke Rare Book and Manuscript Library, Yale University, New Haven, Conn.; and D[aniel] C[hester] F[rench], "Modern American Bronzes," *MMAB* 1, no. 10 (September 1906), p. 129.
33 French to Remington, March 8, 1907, Frederic Remington Art Museum, Ogdensburg, N.Y.
34 Florence Finch Kelly, "American Bronzes at the Metropolitan Museum: An Important Collection in the Process of Formation," *Craftsman* 11, no. 5 (February 1907), p. 545.
35 See Thayer Tolles, *Augustus Saint-Gaudens in The Metropolitan Museum of Art*, *MMAB* 66, no. 4 (Spring 2009), esp. pp. 50–60.
36 MMA 90.8.1, .2.
37 MMA 05.15.1–.3.
38 MMA 28.101.
39 French to Herbert Adams, August 21, 1915 (copy), Daniel Chester French Family Papers, Manuscript Division, Library of Congress, Washington, D.C.
40 "The Museum Auction Sale," *MMAB* 24, no. 1 (January 1929), pp. 2–3; and Calvin Tomkins, *Merchants and Masterpieces: The Story of the Metropolitan Museum of Art*, rev. ed. (New York: Henry Holt, 1989), p. 297.
41 MMA 33.61.
42 MMA 34.92.
43 Harry B. Wehle, "Trends in American Painting," *National Art Week and the Museum*, pt. 2 of *MMAB* 35, no. 1 (November 1940), p. 5.
44 MMA 98.1.3.
45 MMA 08.51.10.
46 Luke Vincent Lockwood, "English Furniture of the Eighteenth Century," *MMAB* 3, no. 6 (June 1908), pp. 111 fig. 3, 113.
47 Edward Hagaman Hall, *The Hudson-Fulton Celebration, 1909* (Albany: Printed for the State of New York by J. B. Lyon, 1910), vol. 1, p. 7.
48 Ibid.
49 Henry Watson Kent, *What I Am Pleased to Call My Education* (New York: Grolier Club, 1949), pp. 83–84.
50 For more on Halsey, see Wendy Kaplan, "R. T. H. Halsey: An Ideology of Collecting American Decorative Arts," *Winterthur Portfolio* 17, no. 1 (Spring 1982), pp. 43–53; and Peter M. Kenny, "R. T. H. Halsey: American Wing Founder and Champion of Duncan Phyfe," *Magazine Antiques* 157, no. 1 (January 2000), pp. 186–91.
51 For more on Bolles, see Frances Gruber Safford, "The Hudson-Fulton Exhibition and H. Eugene Bolles," *Magazine Antiques* 157, no. 1 (January 2000), pp. 170–75.
52 "Mrs. de Forest has succeeded in acquiring, after long negotiation, the panel sides of an eighteenth century Long Island Colonial room. . . . She is proposing to present it to the Museum, if it can be availed of in connection with our American section. . . . Mr. Kent has seen the room and has been conspiring with Mrs. de Forest to get it." Robert W. de Forest to William Valentiner, September 23, 1910, Mrs. Robert W. de Forest, Gifts and Loans, OSR, MMA Archives.
53 Robert de Forest was sometimes called "the First Citizen of New York" because of his many charitable activities. For more on his philanthropy, see his obituary,

"De Forest a Leader in Charities Here," *New York Times*, May 7, 1931, p. 14.

54 For more on Emily Johnston de Forest's collecting interests, see Alice Cooney Frelinghuysen, "Emily Johnston de Forest," *Magazine Antiques* 157, no. 1 (January 2000), pp. 192–97.

55 Emily Johnston de Forest to the trustees, March 29, 1911, Mrs. Robert W. de Forest—Gifts of Maiolica, OSR, MMA Archives.

56 For more on Emily de Forest's Mexican ceramics, see Ronda Kasl, "An American Museum: Representing the Arts of Mexico at The Metropolitan Museum of Art," in *The Americas Revealed: Collecting Colonial and Modern Latin American Art in the United States*, ed. Edward J. Sullivan (New York: Frick Collection; University Park: Pennsylvania State University Press, 2018), pp. 78–91.

57 Emily de Forest, "My Memories," unpublished manuscript, copy in the American Wing departmental files, p. 4.

58 H[enry] W. K[ent], "The American Wing in Its Relation to the History of Museum Development," *An American Wing for the Metropolitan Museum of Art, the Gift of Robert W. de Forest and Emily Johnston de Forest*, pt. 2 of *MMAB* 17, no. 11 (November 1922), p. 14.

59 For more on the process of designing the American Wing, see Amelia Peck, "Robert de Forest and the Founding of the American Wing," *Magazine Antiques* 157, no. 1 (January 2000), pp. 176–81.

60 Robert W. de Forest, "Address," *Addresses on the Occasion of the Opening of the American Wing* (New York: MMA, 1925), pp. 3–7, esp. p. 4.

61 R. T. H. Halsey, "Address," ibid., pp. 8–17, esp. p. 10.

62 Beth Carver Wees with Medill Higgins Harvey, *Early American Silver in The Metropolitan Museum of Art* (New York: MMA, 2013), pp. 12–16.

63 For more on Natalie K. Blair, see Morrison H. Heckscher, "Natalie K. Blair's 'museum rooms' and the American Wing," *Magazine Antiques* 157, no. 1 (January 2000), pp. 182–85.

64 Sylvia Yount, "Entangled Narratives: Encountering Native American Art in the American Wing," in

Gaylord Torrence, *Art of Native America: The Charles and Valerie Diker Collection*, exh. cat. (New York: MMA, 2018), pp. 15–23.

Visions of Collecting

1 H. O. Havemeyer to Luigi Palma di Cesnola, December 5 and December 6, 1881, Henry Osborne Havemeyer, OSR, MMA Archives; "Members of The Metropolitan Museum of Art, December 3rd, 1881: Patrons," *Annual Report of the Trustees of the MMA*, no. 12 (1881), p. 227.

2 The total number of Havemeyer works in the Museum's collection tallies nearly 4,500, including lifetime gifts and those from subsequent generations of the family. For in-depth information on the Havemeyers' collecting, see Alice Cooney Frelinghuysen, Gary Tinterow, Susan Alyson Stein, Gretchen Wold, and Julia Meech, *Splendid Legacy: The Havemeyer Collection*, exh. cat. (New York: MMA, 1993); and Frances Weitzenhoffer, *The Havemeyers: Impressionism Comes to America* (New York: Harry N. Abrams, 1986).

3 "Metropolitan Gets a Fortune in Art by Havemeyer Will," *New York Times*, January 16, 1929, p. 1.

4 Frank Jewett Mather, Jr., "The Havemeyer Pictures," *Arts* 16, no. 7 (March 1930), p. 452.

5 The files of historical clippings and ephemera in the MMA Archives for the Havemeyer bequest (box 100, folder 4) and the subsequent exhibition (box 5, folder 4) contain articles from New York newspapers including the *Times, Herald Tribune, Post,* and *Sun*; domestic newspapers from Boston, Baltimore, Charleston, Chicago, Dallas, Los Angeles, San Francisco, Salt Lake City, Seattle, and others; and international newspapers from Toronto, Paris, and Berlin.

6 "Close Havemeyer Exhibit," *New York Times*, November 4, 1930, p. 13. Louisine's only stipulation was that the credit line for each work read "H. O. Havemeyer Collection." In contrast, many other early donors, such as Catharine Lorillard Wolfe, George A. Hearn, Michael Dreicer, and Benjamin

Altman, required their gifts to be displayed together; see Calvin Tomkins, *Merchants and Masterpieces: The Story of the Metropolitan Museum of Art*, rev. ed. (New York: Henry Holt, 1989), pp. 72–73, 100–101, 173–74, 190, 206. The 1993 exhibition *Splendid Legacy: The Havemeyer Collection* is the only other occasion when a large selection of the works of art was reunited, together with loans of other objects once owned by the family, to celebrate the genesis of the collection.

7 Thanks are due Monika Bincsik, Diane and Arthur Abbey Associate Curator of Japanese Decorative Arts, for her insights on the Havemeyers' collecting of Asian art.

8 Louisine Havemeyer, *Sixteen to Sixty: Memoirs of a Collector*, rev. ed., ed. Susan Alyson Stein (New York: Ursus Press, 1993), pp. 269–70.

9 Degas, *Ballet Rehearsal*, ca. 1876, gouache and pastel over monotype, Nelson Atkins Museum of Art, Kansas City, Mo.; Monet, *The Drawbridge*, 1874, oil on canvas, Shelburne Museum, Shelburne, Vt.; Pissarro, *Fan Mount: The Cabbage Gatherers*, ca. 1878–79, gouache on silk, MMA 1994.105; and Cassatt, *Portrait of the Artist*, 1878, watercolor and gouache, MMA 1975.319.1. Louisine lent the Degas and the Cassatt to American Water Color Society exhibitions at the National Academy of Design in 1878 and 1880, respectively, and the Monet and Pissarro to dealer Paul Durand-Ruel's first Impressionist exhibition in New York in 1886. The quotation is from Havemeyer, *Sixteen to Sixty*, p. 249. The authors wish to thank Susan Alyson Stein, Engelhard Curator of Nineteenth-Century European Painting at the Metropolitan Museum, for her insights on the Havemeyer collection of French art. For more on Cassatt's role as advisor to the Havemeyers and other American collectors, see Laura Dickey Corey, "Mary Cassatt (1844–1926), American Tastemaker: Portrait of the Artist as Advisor" (PhD diss., Institute of Fine Arts, New York University, 2018).

10 Havemayer, *Sixteen to Sixty*, pp. 14, 25.

11 Ibid., pp. 88–89.

12 MMA 88.18; Samuel P. Avery to Cesnola, April 17, 1888, H. O.

Havemeyer Gift—Stuart George Washington for Carroll, OSR, MMA Archives. The Havemeyer portrait of Washington is one of the many painted by Stuart, but today is not considered the finest. The Museum purchased one of the earliest and best Washington portraits in 1907 (MMA 07.160).

13 MMA 29.100.3, .4. See Susan Alyson Stein, "Chronology," in Frelinghuysen et al., *Splendid Legacy*, p. 207.

14 "Art Gifts to the City," *New York Times*, December 9, 1888, p. 4.

15 *Part I. Pictures by Old Masters . . . Part II. Loan Collections . . . Part III. Modern Sculptures*, Hand-Book no. 6 (New York: MMA, 1890), pp. 15–16, nos. 1–14.

16 "Gifts and Loans to the Museum," *New York Times*, May 5, 1890, p. 4. For more on Henry Marquand and his collection, see "The Founding Decades" and "Princely Aspirations" in this volume.

17 Among the gifts the Havemeyers gave during their lifetimes are a portrait of the German scientist Baron Alexander von Humboldt by Julius Schrader in 1889 (MMA 89.20) and a landscape by Samuel Colman in 1893 (MMA 93.21), both donated by Harry with the credit line "Gift of H. O. Havemeyer." In 1923 Louisine gave Tiepolo's *The Glorification of the Barbaro Family* anonymously in memory of Oliver H. Payne (MMA 23.128).

18 Harry Havemeyer was proposed twice as a trustee, in 1903 and 1904. In 1891 Henry G. Marquand, then president of the board of trustees, had reported to Luigi Palma di Cesnola that Samuel Colman said Harry was "a hard man to get along with!—though very knowing—I fear he won't do." Marquand to Cesnola, June 23, 1891, Museum Administration, 1891, and memo from Jeanie James, archivist, to Susan Stein, European Paintings, October 8, 1992, Henry Osborne Havemeyer file, OSR, MMA Archives.

19 Havemeyer to Marquand, December 8, 1896, Henry Osborne Havemeyer file, OSR, MMA Archives.

20 Regrettably, the house was demolished shortly after Louisine's death when Tiffany's work was out

of favor. Little survives except for a few interior architectural elements and some furnishings, several of which are now in the Museum's collection (MMA 1992.125, MMA 1994.231, MMA 2000.623 [prototype for the frieze in the entry hall]).

21 See Alice Cooney Frelinghuysen, *Louis Comfort Tiffany at The Metropolitan Museum of Art, MMAB* 56, no. 1 (Summer 1998), pp. 55–67.

22 "Has America a Real Knowledge of Art?," *New York Times,* January 23, 1910, magazine sec., p. 2.

23 Louisine lent Rembrandt's *Herman Doomer* (MMA 29.100.1); *Portrait of an Old Woman,* then attributed to Rembrandt and now considered to be "Style of Jacob Backer" (MMA 29.100.2); and Pieter de Hooch's *The Visit* (MMA 29.100.7), under the name of Mrs. Henry (or in some cases H.) O. Havemeyer. *The Hudson-Fulton Celebration: Catalogue of an Exhibition Held in The Metropolitan Museum of Art* (New York: MMA, 1909), vol. 1, pp. 54, 89, 90.

24 Edward Robinson to Louisine Havemeyer, December 24, 1909, and Havemeyer to Robinson, December 26, 1909, Mrs. H. O. Havemeyer file, OSR, MMA Archives.

25 Havemeyer, *Sixteen to Sixty,* pp. 236–37. The Havemeyers acquired Manet's *Dead Christ with Angels,* 1864 (MMA 29.100.51), in 1903 from Durand-Ruel.

26 Havemeyer, *Sixteen to Sixty,* p. 196. Courbet's *Woman with a Parrot,* 1866 (MMA 29.100.57), was acquired by the Havemeyers in 1898 from Durand-Ruel.

27 B[ryson] B[urroughs], "A Recent Loan," *MMAB* 1, no. 9 (August 1906), p. 122.

28 "Sir Purdon Clarke on the 'Impressionists,'" *New York Times,* January 17, 1909, magazine sec., p. 5.

29 See Susan Alyson Stein, "Chronology," in Frelinghuysen et al., *Splendid Legacy,* pp. 264–69, 274–75. About 1914, Louisine began to campaign in earnest for women's suffrage, a cause about which she was passionate; see Louisine W. Havemeyer, "The Suffrage Torch, Memories of a Militant," *Scribner's Magazine* 71 (May 1922), p. 537.

30 The exhibition was titled *Loan Exhibition of Masterpieces by Old and Modern Painters.* See Rebecca A. Rabinow, "The Suffrage Exhibition of 1915," in Frelinghuysen et al., *Splendid Legacy,* pp. 89–95.

31 B[ryson] B[urroughs], "Nineteenth-Century French Painting," *MMAB* 13, no. 8 (August 1918), pp. 174–81.

32 B[ryson] B[urroughs], "Drawings by Degas," *MMAB* 14, no. 5 (May 1919), p. 115.

33 *Madame de Brayer* (MMA 29.100.118). Louisine also lent to exhibitions of Chinese pottery and sculpture in 1916; Japanese screens and paintings in 1917; the fiftieth-anniversary exhibition in 1920 (works by El Greco, Poussin, Millet, and Corot); and a Spanish paintings exhibition in 1928.

34 See Rebecca Rabinow, "Modern Art Comes to the Metropolitan: The 1921 Exhibition of 'Impressionist and Post-Impressionist Paintings,'" *Apollo* 152 (October 2000), pp. 3–12.

35 J[oseph] B[reck], "Sculptures by Degas on Loan," *MMAB* 18, no. 3 (March 1923), p. 59. The work had actually been shown at the Grolier Club, New York, the year before.

36 The transfer occurred in 1929.

37 The Museum of Fine Arts, Boston, hosted the first Monet retrospective in America in 1911 and by 1925 owned more than twenty paintings by Monet, five by Degas, and four by Pissarro; see Erica Hirshler, "Impressionism in Boston," in *Impressionism Abroad: Boston and French Painting,* exh. cat. (London: Royal Academy of Arts, 2005), pp. 17–39. Similarly, the Art Institute of Chicago held exhibitions of Manet, Monet, and Degas, and hosted the touring 1913 Armory Show. Chicago also accepted the extensive Impressionist collection of Bertha and Potter Palmer in 1922, and the Helen Birch Bartlett memorial collection of twenty-one Post-Impressionist pictures in 1926; see Jill Shaw and Dorota Chudzicka, "Impressionism and Post-Impressionism in Chicago," in Gloria Groom and Douglas Druick, *The Age of French Impressionism: Masterpieces from the Art Institute of Chicago* (Chicago: Art Institute of Chicago, 2010), pp. 11–25.

38 Walter Pach, *Ananias: Or the False Artist* (New York: Harper and Brothers, 1928).

39 Havemeyer, *Sixteen to Sixty,* p. 268.

40 "Havemeyer Art on View Tuesday," *New York Times,* March 9, 1930, sec. 2, pp. 1–2.

41 A. Hyatt Mayor, "The Gifts that Made the Museum," *MMAB* 16, no. 3 (November 1957), p. 100.

42 Degas, *The Milliner* (MMA 22.27.3), was acquired from the collection of Dikran Kelekian. See also Susan Alyson Stein, "The Metropolitan Museum's Purchases from the Degas Sales: New Acquisitions and Lost Opportunities," in *The Private Collection of Edgar Degas,* ed. Ann Dumas, Colta Ives, Susan Alyson Stein, and Gary Tinterow (New York: MMA, 1997), vol. 1, pp. 271–91.

43 Mary Cassatt to Louisine Havemeyer, [April 1913?], box 1, folder 11, Havemeyer Family Papers Related to Art Collecting, MMA Archives.

44 The drawings are identified as MMA 29.100.941 (fig. 143), MMA 29.100.942, MMA 29.100.943. Havemeyer, *Sixteen to Sixty,* pp. 251–52, 337 n. 370. Cassatt also gave Louisine a Degas monotype, *Girl Putting on Her Stockings* (MMA 29.107.54), in 1889, according to a note on the original mat.

45 See C[laire] V[incent], "The Havemeyers and the Degas Bronzes," in Frelinghuysen et al., *Splendid Legacy,* pp. 77–80.

46 MMA 22.16.17, .18, .21–.25. Two Cassatts from the Stillman collection, MMA 22.16.19 and MMA 22.16.20, have since been deaccessioned. See offer of gift form signed by Bryson Burroughs and Edward Robinson, January 12, 1922, Dr. Ernest G. Stillman, 1921–, OSR, MMA Archives. The Stillman bequest also included Courbets (MMA 22.16.13–.15) that James purchased because of Cassatt's influence on his taste.

47 The painting had been left in Louisine's care after the 1915 Knoedler exhibition and from 1918 was on loan to the Museum through Louisine and at Burroughs's request. See Burroughs to Mrs. Havemeyer, February 21, 1918, Mrs. H. O. Havemeyer, 1909 . . . 1923; Edward Robinson to Ernest G. Stillman, December 13, 1922, Dr. Ernest G. Stillman, 1921–; and Mary Cassatt to Burroughs, March 12,

1923, Mary Cassatt, 1923–, OSR, MMA Archives.

48 Pissarro, *Bather in the Woods* (MMA 29.100.126); Renoir, *By the Seashore* (MMA 29.100.125).

49 *Spring (Fruit Trees in Bloom),* MMA 26.186.1, bequeathed by Mary Livingston Willard in 1926, was the only Monet the Museum owned before the Havemeyer bequest.

50 The Monets include *Chrysanthemums* (MMA 29.100.106), *Bouquet of Sunflowers* (MMA 29.100.107), *Ice Floes* (MMA 29.100.108), *Haystacks (Effect of Snow and Sun)* (MMA 29.100.109), *The Four Trees* (MMA 29.100.110), and *Bridge over a Pond of Water Lilies* (MMA 29.100.113).

51 Katherine Cassatt to Alexander Cassatt, November 30, 1883, about *The Green Wave* (MMA 29.100.111), a painting Mary Cassatt bought for her family in 1883 that they then sold through Durand-Ruel to the Havemeyers in 1898. See Nancy Mowll Mathews, ed., *Cassatt and Her Circle: Selected Letters* (New York: Abbeville Press, 1984), p. 175.

52 Richard R. Brettell, cat. 14, in *A Day in the Country: Impressionism and the French Landscape,* exh. cat. (Los Angeles: Los Angeles County Museum of Art, 1984), p. 88; Douglas Cooper, "The Monets in the Metropolitan Museum," *Metropolitan Museum Journal* 3 (1970), p. 287.

53 Cézanne, *View of the Domaine Saint-Joseph* (MMA 13.66).

54 The five Cézanne paintings in the Havemeyer bequest were, in addition to *Mont Sainte-Victoire and the Viaduct of the Arc River Valley* (fig. 147), *Gustave Boyer in a Straw Hat* (MMA 29.100.65), *Still Life with Jar, Cup, and Apples* (MMA 29.100.66), *The Gulf of Marseilles Seen from L'Estaque* (MMA 29.100.67), and *Rocks in the Forest* (MMA 29.100.194). Louisine regretted following Cassatt's advice to sell two of her Cézannes in 1909. See Gary Tinterow, "The Havemeyer Pictures," in Frelinghuysen et al., *Splendid Legacy,* pp. 48–49.

55 Manet, *Boating* (MMA 29.100.115), and *The Dead Christ with Angels* (fig. 137).

56 Gary Tinterow, Geneviève Lacambre, Deborah L. Roldán, and Juliet Wilson-Bareau, *Manet/Velázquez: The French Taste for*

Spanish Painting (New York: MMA, 2003).

57 Havemeyer, *Sixteen to Sixty*, pp. 130–79.

58 El Greco, *The Adoration of the Shepherds* (MMA 05.42), and Goya, *Sebastián Martínez y Pérez* (MMA 06.289).

59 See *El Greco Comes to America: The Discovery of a Modern Old Master*, ed. Inge Reist and José Luis Colomer (New York: Frick Collection, Center for Spain in America; Madrid: Centro de Estudios Europa Hispánica, 2017), esp. Rebecca J. Long, "El Greco in Chicago: Building a Collection: Early Purchases by the Art Institute of Chicago," pp. 181–90.

60 The Havemeyers purchased the *Cardinal* in 1904, and Louisine bought the *View of Toledo* (MMA 29.100.6) in 1909. On the Havemeyers' Goyas, see Susan Alyson Stein, "Goya in The Metropolitan: A History of the Collection," in *Goya in the Metropolitan Museum of Art*, ed. Colta Ives and Susan Alyson Stein (New York: MMA, 1995), esp. pp. 45–55.

61 The Asian works in the bequest were selected presumably by Alan Priest, the recently appointed young curator, who was no doubt aided by Howard Mansfield, longtime trustee and serious collector of Japanese art. Approximately two thousand objects were sold at auction in 1930; *The Estate of Mrs. H. O. Havemeyer: [Part III], Japanese & Chinese Art*, sale cat., American Art Association, Anderson Galleries, New York, April 14–19, 1930. Thanks to Monika Bincsik for her insights on the Havemeyers' Japanese collection; see Monika Bincsik, "Discovering Japanese Art: American Collectors and the Met," *Orientations* 46, no. 2 (March 2015), pp. 15–18.

62 MMA 96.14.1–.2138. The *Bulletin* singled out the "large collection of sample pieces of Japanese silks presented in 1896 by Mr. and Mrs. H. O. Havemeyer, a group most helpful to students of Oriental designs"; *The Textile Collection and Its Use*, supplement to *MMAB* 10, no. 5 (May 1915), p. 6.

63 For a perceptive review of the Havemeyers' collecting of Asian Art, see Julia Meech, "The Other Havemeyer Passion: Collecting Asian Art," in Frelinghuysen et al., *Splendid Legacy*, pp. 129–50.

64 Ibid., pp. 133–39.

65 Havemeyer, *Sixteen to Sixty*, p. 73.

66 Ibid., p. 76.

67 H. O. Havemeyer to Luigi Palma di Cesnola, July 30, 1894, Henry Osborne Havemeyer file, OSR, MMA Archives.

68 Havemeyer, *Sixteen to Sixty*, pp. 79–80. It should be noted that in 1993, at the time of the large exhibition devoted to the Havemeyers' gifts, *Splendid Legacy*, the temmoku bowl was considered but rejected because it was thought to be late nineteenth-century Japanese; see Meech, "The Other Havemeyer Passion," p. 129. Currently the curatorial staff at the Museum deems it authentic, however, with an eleventh- or twelfth-century date.

69 An olive-green Ritsuō panel in the Havemeyer collection was inspiration for Colman's decorations of the Havemeyers' library.

70 B[arbara] B. F[ord], "Japanese Lacquers," in Frelinghuysen et al., *Splendid Legacy*, p. 163.

71 Hyung-Min Chung, "The Bodhisattva Ksitigarbha (Chijang Posal)," in Frelinghuysen et al., *Splendid Legacy*, pp. 158–59. Thanks to Joseph Scheier-Dolberg, Oscar Tang and Agnes Hsu-Tang Associate Curator of Chinese Paintings.

72 Maurice S. Dimand, *Loan Exhibition of Ceramic Art of the Near East* (New York: MMA, 1931).

73 Havemeyer, *Sixteen to Sixty*, p. 61.

74 MMA 62.98.1–.5.

75 Degas, given as part of the H. O. Havemeyer Collection by granddaughter Adaline Havemeyer Perkins (MMA 1971.185); Japanese daggers given by grandson Hon. Peter H. B. Frelinghuysen (MMA 1998.127.1, 2); Cassatt, given in the name of the family of Adaline Havemeyer Frelinghuysen (MMA 1992.235); and the Manet, partial gift of Hon. Peter H. B. Frelinghuysen (MMA 1999.442).

76 Goya (MMA 55.145.1, 55.145.2); Courbet (MMA 40.175); Degas (fig. 157).

77 Havemeyer, *Sixteen to Sixty*, pp. 263–64.

78 After Payne's death in 1917, the painting passed to his nephew Harry Payne Bingham (d. 1955) and then to his widow, Mrs. Harry Payne (Melissa Y.) Bingham (d. 1986), who lent the picture regularly to the Museum between 1957 and 1983 and bequeathed it upon her death. See paperwork for the summer loans from 1957 to 1983 in Mrs. Harry Payne (Melissa Yuille) Bingham, 1946–86; and for the bequest in 1987 in Mrs. Harry Payne (Melissa Yuille) Bingham—Bequest, 1986–, OSR, MMA Archives.

79 Michael Conforti, James A. Ganz, Neil Harris, Sarah Lees, and Gilbert T. Vincent, *The Clark Brothers Collect: Impressionist and Early Modern Paintings*, exh. cat. (Williamstown, Mass.: Sterling and Francine Clark Art Institute, 2006), esp. Sarah Lees, "Stephen C. and Susan V. Clark's Gifts and Bequests to Public Institutions," pp. 314–17.

80 The painting was sold by their son, Horace Havemeyer, in 1948 and then acquired by Clark.

81 John Russell, "Annenberg Picks Met for $1 Billion Gift," *New York Times*, March 12, 1991, pp. A1, C12. See also Susan Alyson Stein and Asher Ethan Miller, eds., *Masterpieces of Impressionism and Post-Impressionism: The Annenberg Collection*, new ed. (New York: MMA; New Haven: Yale University Press, 2009).

82 Linden Havemeyer Wise to Sharon H. Cott, Esq., Vice President, Secretary, and General Counsel, Metropolitan Museum, December 28, 2002, Linden Havemeyer Wise file, OSR, MMA Archives.

Reckoning with Modernism

1 Henry Watson Kent, "The American Museum and Paintings by Americans," typescript, 1937, Hearn Funds—General and Policy, OSR, MMA Archives.

2 Alfred Stieglitz to Ananda Coomaraswamy, Museum of Fine Arts, Boston, December 30, 1928; quoted in Malcolm Daniel, "Photography at the Metropolitan: William M. Ivins and A. Hyatt Mayor," *History of Photography* 21, no. 2 (Summer 1997), p. 112.

3 Weston J. Naef, *The Collection of Alfred Stieglitz: Fifty Pioneers of Modern Photography* (New York: MMA, 1978), p. 1. See also Daniel, "Photography at the Metropolitan," p. 111.

4 John Szarkowski, *Alfred Stieglitz at Lake George*, exh. cat. (New York: Museum of Modern Art, 1995), p. 12.

5 Sarah Greenough, *Alfred Stieglitz: The Key Set; the Alfred Stieglitz Collection of Photographs* (Washington, D.C.: National Gallery of Art; New York: Harry N. Abrams, 2002), vol. 1, p. xxiv.

6 Maria Morris Hambourg, "Lost and Found: The Emergence and Rediscovery of European Avant-Garde Photography," in Mitra Abbaspour, Lee Ann Daffner, and Maria Morris Hambourg, *Object: Photo; Modern Photographs, the Thomas Walther Collection 1900–1949*, exh. cat. (New York: Museum of Modern Art, 2014), p. 21.

7 MMA 28.130.2.

8 See Naef, *The Collection of Alfred Stieglitz*.

9 MMA 33.65.1–.591.

10 MMA 36.37.

11 MMA 37.14.1–.41, MMA 37.14.43–.57, MMA 38.34, MMA 39.22.1–.4.

12 MMA 41.142.1–.18, MMA 43.87.1–.27, MMA 44.75.1–.8, MMA 44.75.10–.11.

13 MMA 69.546.1–.2.

14 MMA 1974.602.1–.229.

15 "The Marketplace: Prints for Sale," in Editors of Time-Life Books, *Photography Year: 1973* (New York: Time-Life Books, 1972), pp. 149–50.

16 For more on photography's institutional, market, and academic acceptance in the 1980s, see Christopher Phillips, "The Judgment Seat of Photography," *October* 22 (Autumn 1982), pp. 27–63.

17 "Charter . . . Passed April 13, 1870," *Charter, By-Laws, Mission Statement: The Metropolitan Museum of Art* (New York: MMA, 2011), p. 3.

18 Robert W. de Forest, "Report of the Trustees for the Year MCMXVII," *Annual Report of the Trustees of the MMA*, no. 49 (1918), p. 29.

19 Richard F. Bach to Henry W. Kent, April 5, 1918, Richard F. Bach, 1918–19, OSR, MMA Archives.

20 Edward C. Moore Jr. to the trustees, June 16, 1922, Edward C. Moore Jr., OSR, MMA Archives.

21 MMA 22.180.1, .2.

22 Joseph Breck to the director and the committee on purchases, November 14, 1922, Purchases—Authorized—Metalwork—Scott & Fowles, 1922–23, OSR, MMA Archives.

23 R[ichard] F. B[ach], "American Industrial Art," *MMAB* 19, no. 1 (January 1924), p. 3.

24 Breck to Robert W. de Forest, July 4, 1925, Purchases—General—Breck, January–July 1925, OSR, MMA Archives.

25 For a more complete discussion of this purchase and the Museum's French Art Deco masterpieces, see Jared Goss, *French Art Deco* (New York: MMA, 2014); the *"Etat"* cabinet is cat. 55, pp. 196–98, 262.

26 Breck to Henry W. Kent, September 5, 1925, H. W. Kent, 1925 16/1 Breck, OSR, MMA Archives.

27 Robert W. de Forest, "Art in Everyday Life: A Radio Talk," *American Magazine of Art* 17, no. 3 (March 1926), pp. 127–29.

28 Joseph Breck, "Swedish Contemporary Decorative Arts," *MMAB* 22, no. 1 (January 1927), pp. 3–4.

29 See, e.g., "A Parade of Contemporary Achievements at the Metropolitan Museum," *Arts & Decoration* 42, no. 2 (December 1934), pp. 12–25.

30 Richard F. Bach, "Industrial Art Exhibitions: Appendix III," September 27, 1940, Exhibitions—American Industrial Art (1917–1940), Report by Bach, OSR, MMA Archives.

31 Richard F. Bach, "American Industrial Art," in *The Architect and the Industrial Arts: An Exhibition of Contemporary American Design, the Eleventh in the Museum Series* (New York: MMA, 1929), p. 23. For an extensive discussion of the Museum's involvement with modern design, see R. Craig Miller, *Modern Design in the Metropolitan Museum of Art, 1890–1990* (New York: MMA; Harry N. Abrams, 1990); and Christine Wallace Laidlaw, "The Metropolitan Museum of Art and Modern Design: 1917–1929," *Journal of Decorative and Propaganda Arts* 8 (Spring 1988), pp. 88–103.

32 "Metropolitan Plans Modern Art Exhibit," *Women's Wear Daily*, October 6, 1928, pp. 1, 12.

33 Richard F. Bach, "Contemporary American Industrial Art: 1940," in *Contemporary American Industrial Art 1940: 15th Exhibition*, exh. cat. ([New York: MMA, 1940]), p. 9.

34 MMA 10.76.1–.3.

35 MMA 13.66.

36 For more on the Armory Show, see Marilyn Satin Kushner and Kimberly Orcutt, eds., and Casey Nelson Blake, *The Armory Show at 100: Modernism and Revolution* (New York: New-York Historical Society; London: In association with D. Giles, 2013).

37 *George A. Hearn Gift to the Metropolitan Museum of Art in the City of New York and Arthur Hoppock Hearn Memorial Fund* (New York: Printed for MMA, 1913), p. x.

38 Rebecca A. Rabinow, "Modern Art Comes to the Metropolitan: The 1921 Exhibition of 'Impressionist and Post-Impressionist Paintings,'" *Apollo* 152 (October 2000), pp. 3–12.

39 Bryson Burroughs, "The Whitney Museum of American Art," *MMAB* 27, no. 2 (February 1932), pp. 42, 44.

40 Gertrude Vanderbilt Whitney papers, 1851–1975, bulk 1888–1942: series 4, Whitney Studio Club and Whitney Museum of American Art Files, box 12, folder 5: Coalition with Metropolitan Museum of Art, 1942–43, Archives of American Art, Smithsonian Institution, Washington, D.C.

41 "3 Museums to Exchange Art to 'Clarify Modern Trends,'" *New York Times*, September 22, 1947, pp. 1, 24.

42 Lisa Mintz Messinger, ed., *Stieglitz and His Artists: Matisse to O'Keeffe; The Alfred Stieglitz Collection in The Metropolitan Museum of Art*, exh. cat. (New York: MMA, 2011).

43 MMA 49.70.42.

44 Sanka Knox, "New Policy on Art Set Up by Museum: The Modern Plans Permanent Collection—'47 Agreement on 'Classics' at End," *New York Times*, February 15, 1953, p. 76.

45 See Sabine Rewald, *Paul Klee: The Berggruen Klee Collection in The Metropolitan Museum of Art* (New York: MMA, 1988).

46 MMA 1990.38.3.

47 See William S. Lieberman, ed., and Sabine Rewald, *Twentieth-Century Modern Masters: The Jacques and Natasha Gelman Collection* (New York: MMA, 1989).

48 MMA 1999.363.2.

49 MMA 1999.363.25.

50 MMA 2002.585.4a–d.

51 MMA 2000.600.11.

52 MMA 2000.600.1.

53 MMA 1998.537.28.

54 See Maria Morris Hambourg and Christopher Phillips, *The New Vision: Photography between the World Wars; Ford Motor Company Collection at The Metropolitan Museum of Art* (New York: MMA, 1989).

55 See Sabine Rewald with Magdalena Dabrowski, *The American Matisse: The Dealer, His Artists, His Collection; The Pierre and Maria-Gaetana Matisse Collection* (New York: MMA; New Haven: Yale University Press, 2009).

56 See Maria Morris Hambourg, Pierre Apraxine, Malcolm Daniel, Jeff L. Rosenheim, and Virginia Heckert, *The Waking Dream: Photography's First Century; Selections from the Gilman Paper Company Collection*, exh. cat. (New York: MMA, 1993).

57 Carol Vogel, "$1 Billion Gift Gives Met a New Perspective (Cubist)," *New York Times*, April 9, 2013, p. A1. See also Emily Braun and Rebecca Rabinow, eds., *Cubism: The Leonard A. Lauder Collection* (New York: MMA, 2014).

Fragmented Histories

1 "The Task of Museums in War Time," *MMAB* 36, no. 4 (April 1941), p. 82.

2 *MMAB* 5, no. 6 (February 1947), p. 148. The works were stored in a mansion near Philadelphia; see Barbara Marhoefer, "Whitemarsh Hall: A Palace in Ruin,"*New York Times*, January 29, 1978, sec. 8, pp. 1, 6. Newspaper sources suggest the number of works moved was closer to 15,000. See Thomas C. Linn, "15,000 of Its Works in Hiding Returned to Museum of Art," *New York Times*, April 23, 1944.

3 Francis Henry Taylor to curatorial department heads, June 16, 1943, James J. Rorimer Papers (1927–1966), series 3, Exhibitions, box 4, folder 10, Cloisters Library and Archives. The exhibition was called *War Art* and was on view August 18–September 19, 1943. It was one of several exhibitions presented in support of the war between 1942 and 1944.

4 On prototypes designed and fabricated by Grancsay and Heinrich, see Donald LaRocca, memo to Sharon Cott, October 14, 2016, Arms and Armor departmental files. For Model T21 E2 helmet prototype (MMA 2016.628), see https://www.metmuseum.org/art/collection/search/35865. Although the T21 prototype was never produced, American forces used another model developed by Grancsay and Heinrich.

5 Max Hollein, "The Met's Role in Protecting Cultural Heritage," *Now at The Met* (blog), November 7, 2018, https://www.metmuseum.org/blogs/now-at-the-met/2018/met-role-protecting-cultural-heritage.

6 Robert M. Edsel, Introduction, in Nancy H. Yeide, *Beyond the Dreams of Avarice: The Hermann Goering Collection* (Dallas, Tex.: Laurel Publishing, 2009), p. 2. Approximately twenty-one monuments staff were women. For a list of the Monuments Men, see https://www.monumentsmenfoundation.org/the-heroes/the-monuments-men.

7 Other Metropolitan Museum staff who served in the MFAA included Harry D. M. Grier, lecturer and assistant to the Museum's dean of education, and Theodore Heinrich, associate curator of paintings and curator of drawings. Horace H. F. Jayne served as special advisor on the Far East. See the press release "Monuments Men Who Saved Works of Art during World War II—Including Former Metropolitan Museum Director James J. Rorimer—Celebrated in New Gallery Itinerary, Display, and March 9 Event," February 5, 2014, https://www.metmuseum.org/press/news/2014/monuments-men.

8 For the form Rousseau filled out for the U.S. Civil Service Commission detailing his language qualifications and education, see box 26, folder 16, Theodore Rousseau records, MMA Archives. The Art Looting Investigation Unit of the OSS was created in 1944; James S. Plaut, "Investigation of the Major Nazi Art-Confiscation Agencies," in

The Spoils of War: World War II and Its Aftermath, the Loss, Reappearance, and Recovery of Cultural Property, ed. Elizabeth Simpson (New York: Harry N. Abrams, in association with the Bard Graduate Center for Studies in the Decorative Arts, 1997), p. 124. The OSS became the Central Intelligence Agency; Lynn H. Nicholas, "World War II and the Displacement of Art and Cultural Property," in ibid., p. 43.

9 OSS Art Looting Investigation Unit Reports, 1945–46, are on microfilm at the National Archives and Records Administration, eservices.archives.gov/orderonline, M1782. Reports by Rousseau are "Office of Strategic Services Art Looting Investigation Unit, APO 413, U.S. Army, Consolidated Interrogation Report, No. 2, 15 September 1945, The Goering Collection," as well as several Detailed Interrogation Reports of individuals.

10 Edsel, Introduction, in Yeide, *Beyond the Dreams of Avarice*, p. 2; as quoted from Robert Edwin Herzstein, *World War II: The Nazis* (Alexandria: Time Life Books, 1980), p. 107.

11 The sculpture was known as *Caritas* (Charity). Mme Léon Arnoult sold it at auction in 1942; *Succession de Madame Léon Arnoult*, Hôtel Drouot, Paris, sale cat., February 6, 1942, no. 122, ill. In 2000 the Metropolitan Museum learned that the work had been recuperated to the French government. Lorraine Karafel identified it as part of Göring's collection; see letters, notes, and publications, European Sculpture and Decorative Arts departmental files for MMA 59.12. For the provenance, see Ian Wardropper, *European Sculpture, 1400–1900, in The Metropolitan Museum of Art* (New York: MMA, 2011), cat. 20, p. 68. The provenance of the reliquary is discussed in Danielle Gaborit-Chopin, "The Reliquary of Elizabeth of Hungary at The Cloisters," in *The Cloisters: Studies in Honor of the Fiftieth Anniversary*, ed. Elizabeth C. Parker (New York: MMA in association with the International Center of Medieval Art, 1992), pp. 332, 351 n. 20. However, she was unaware of Edmond de Rothschild's ownership of the reliquary, which the present

author identified from the Munich Collecting Point property card, https://www.dhm.de/datenbank/ccp/, Munich no. 6301/2; there the owner is identified as Ed[mond] de Rothschild and the reliquary as having been confiscated by the Einsatzstab Reichsleiter Rosenberg (ERR). Both the sculpture and the shrine are among works listed as belonging to Göring that were recovered at Berchtesgaden; Günther Haase, *Die Kunstsammlung des Reichsmarschalls Hermann Göring: Eine Dokumentation* (Berlin: Edition q, 2000), pp. 66, 296 (sculpture), 300 (reliquary).

12 Ibid. According to Haase, Bornheim acquired the sculpture from a Paris dealer named Toulino.

13 For the confiscation of Rothschild collections in France, see Lynn H. Nicholas, *The Rape of Europa: The Fate of Europe's Treasures in the Third Reich and the Second World War* (New York: Alfred A. Knopf, 1994), pp. 125–33. For details on the confiscation of Edmond's and his wife's collections, see Rachel Boak, "The Collecting Tastes of Baroness Edmond de Rothschild," *Rothschild Archive: Review of the Year*, April 2010–March 2011, pp. 32, 37 nn. 18, 19. The reliquary was confiscated from and returned to Edmond de Rothschild's estate, since he died in 1934. See *Répertoire des biens spoliés en France durant la guerre, 1939–1945*, vol. 4, *Argenterie, céramique, objets précieux . . .* (Berlin: Imprimerie Nationale, [1947]), p. 290, no. 4806, ill. pl. 39.

14 Bernard Taper, "Investigating Art Looting for the MFA&A," in Simpson, *Spoils of War*, pp. 136–37.

15 On Rousseau's military honors, see "Notice of Separation from U.S. Naval Service," box 26, folder 17, Rousseau records, MMA Archives.

16 For this material, see box 26, folder 18, Rousseau records, MMA Archives.

17 The confiscation and restitution dates are found in "Cultural Plunder by the Einsatzstab Reichsleiter Rosenberg: Database of Art Objects at the Jeu de Paume," https://www.errproject.org/jeudepaume/card_view.php?CardId=54834. The price is documented on Deutsches Historisches Museum, "Database on the

'Munich Central Collecting Point,'" https://www.dhm.de/datenbank/ccp/, Munich no. 1588. For the provenance, see https://www.metmuseum.org/art/collection/search/435888.

18 Theodore Rousseau Jr., "A Boy Blowing Bubbles by Chardin," *MMAB* 8, no. 8 (April 1950), p. 227. Although the painting's confiscation was known when it was acquired by the Museum, details concerning its restitution remained unclear until 2000; see letters to and from Katharine Baetjer, curator, notes, and publications, European Paintings departmental files for MMA 49.24.

19 See the second edition of James J. Rorimer's *Survival: The Salvage and Protection of Art in War* (1950; note 23 below) in preparation by Anne Rorimer and Louis Rorimer (typescript, 2019), p. 14; Robert M. Edsel, *The Monuments Men: Allied Heroes, Nazi Thieves, and the Greatest Treasure Hunt in History* (New York: Center Street, 2009), pp. 75–76.

20 Edsel, *Monuments Men*, p. xviii; Simon Goodman, *The Orpheus Clock: The Search for My Family's Art Treasures Stolen by the Nazis* (New York: Scribner, 2015), p. 181.

21 Marie Hamon, "Spoliation and Recovery of Cultural Property in France, 1940–94," in Simpson, *Spoils of War*, p. 63.

22 See William D. Wixom, Introduction, in Barbara Drake Boehm, Abigail Quandt, and William D. Wixon, *The Hours of Jeanne d'Evreux* (Lucerne: Faksimile Verlag, 2000), pp. 11–12, 25–26 n. 10.

23 James J. Rorimer in collaboration with Gilbert Rabin, *Survival: The Salvage and Protection of Art in War* (New York: Abelard Press, 1950), pp. 184–85.

24 Ibid., p. 186.

25 Christopher de Hamel, *The Rothschilds and Their Collections of Illuminated Manuscripts* (London: British Library, 2005), pp. 42–43.

26 Ibid., p. 33.

27 Wixom, Introduction, in Boehm et al., *Hours*, pp. 25–26, n. 10.

28 Ibid, p. 13.

29 MMA 54.1.1a, b. See ibid., p. 14; de Hamel, *Rothschilds and Their . . . Illuminated Manuscripts*, p. 43; https://www.errproject.org/jeudepaume/card_view.php?CardId=18724.

30 James J. Rorimer to Richard Randall, January 18, 1954, Medieval Art and The Cloisters departmental files for MMA 54.1.2.

31 Christine Brennan identified the World War II history of this work: https://www.dhm.de/datenbank/ccp/, Munich no. 8010/2; and https://www.errproject.org/jeudepaume/card_view.php?CardId=53086.

32 "Marcelle Minet (1900–?)," https://www.monumentsmenfoundation.org/the-heroes/the-monuments-men/minet-marcelle.

33 MMA 53.19.1, .2. Rorimer and Elisabeth Bondy had hoped to also bring the Tassilo Chalice, an extremely rare eighth-century example, to the United States for the Metropolitan Museum, but Austrian authorities kept it as a national treasure, and it remains at Kremsmünster Abbey. See Elisabeth Bondy to Rorimer, April 24, 1952, Medieval Art and The Cloisters departmental file for MMA 53.19.2.

34 James J. Rorimer, "A Treasury at the Cloisters," *MMAB* 6, no. 9 (May 1948), pp. 237–60.

35 Rita Reif, "Antiques: Experts Note Blumka Contributions to Art," *New York Times*, September 1, 1973, p. 52; Leopold and Ruth Blumka to the Metropolitan Museum, November 18, 1969, Medieval Art and The Cloisters departmental files for MMA 69.226.

36 Leopold and Ruth Blumka to the Museum (as in note 35).

37 Christine E. Brennan and Katharina Weiler, "A Provenance Mystery: Two Medieval Silver Beakers at The Met Cloisters," *Collection Insights* (blog), December 17, 2018, https://www.metmuseum.org/blogs/collection-insights/2019/provenance-research-two-medieval-silver-beakers-the-cloisters.

38 Only one work of art in the Metropolitan Museum's collection is known to have passed through the Wiesbaden Central Collecting Point during Standen's tenure: Vincent van Gogh's *Roses*, MMA 1993.400.5, https://www.metmuseum.org/search-results#!/search?q=van%20gogh,%20roses.

39 Twenty-four officers signed the document, three added their names

but did not sign, and five others wrote letters in support of it. See Walter I. Farmer, "Custody and Controversy at the Wiesbaden Collecting Point," in Simpson, *Spoils of War*, pp. 133, 260 n. 7; https://www.monumentsmenfoundation.org/the-heroes/the-monuments-men/farmer-capt.-walter-i.

40 Edith A. Standen, "The Immediate Postwar Period, 1945–51: Introduction," in Simpson, *Spoils of War*, p. 123.

41 Bryce McWhinnie, "Defiant in the Defense of Art: 3 'Monuments Women' Push for Postwar Reforms," *Prologue* (National Archives and Records Administration) 47, no. 2 (Summer 2015), p. 29.

42 Gen. Dwight D. Eisenhower, "Art in Peace and War," *MMAB* 4, no. 9 (May 1946), pp. 222–23.

43 *Medieval Monuments in World War II*, curated by Margaret Freeman, was on view at The Cloisters, August 2, 1946–December 31, 1947, and included information and photographs taken in Europe by James J. Rorimer. The other three exhibitions were organized externally and traveled to the Metropolitan Museum: *Fine Arts Under Fire*, June 14–July 21, 1946, organized by *Life* magazine in cooperation with the Roberts Commission; *The War's Toll of Italian Art*, October 18–November 24, 1946, organized in collaboration with the American Committee for the Restoration of Italian Monuments; and *Paintings Looted from Holland: Returned through the Efforts of the United States Armed Forces*, July 1–July 31, 1947, organized by the Dutch government; see Melissa Bowling and James Moske, "In the Footsteps of the Monuments Men: Traces from the Archives at the Metropolitan Museum," *Now at The Met* (blog), January 31, 2014, https://www.metmuseum.org/blogs/now-at-the-met/2014/in-the-footsteps-of-the-monuments-men.

44 The most recent acquisition of a restituted work is the sculpture *Galatea*, by Max Klinger, MMA 2018.25a, b, https://www.metmuseum.org/art/collection/search/769187. I am grateful to Denise Allen, curator, European Sculpture and Decorative Arts, for calling this work to my attention.

45 There is a large amount of literature on Tell Halaf. For von Oppenheim's account, see Max von Oppenheim, *Tell Halaf: A New Culture in Oldest Mesopotamia*, trans. Gerald Wheeler (London: G. P. Putnam's Sons, 1933); von Oppenheim's dating of the sculptural works is not accepted today. For a more recent summary with relevant bibliographic citations, see Nadja Cholidis, "Syro-Hittite States: The Site of Tell Halaf (Ancient Guzana)," in *Assyria to Iberia: At the Dawn of the Classical Age*, ed. Joan Aruz, Sarah B. Graff, and Yelena Rakic, exh. cat. (New York: MMA, 2014), pp. 93–97.

46 See Alessandra Gilibert, "Death, Amusement and the City: Civic Spectacles and the Theatre Palace of Kapara, King of Gūzāna," *Kaskal: Rivista di storia, ambienti e culture del Vicino Oriente Antico* 10 (2013), pp. 35–68, for a recent interpretation of the Palace of Kapara as a theater palace.

47 For information about von Oppenheim and his role as a political agent, see Lionel Gossman, *The Passion of Max von Oppenheim: Archaeology and Intrigue in the Middle East from Wilhelm II to Hitler* (Cambridge: Open Book Publishers, 2013); Sean McMeekin, *The Berlin–Baghdad Express: The Ottoman Empire and Germany's Bid for World Power* (Cambridge, Mass.: Belknap Press of Harvard University Press, 2012). Some recent exhibitions in Germany have explored von Oppenheim's life and the Tell Halaf story; see *Abenteuer Orient: Max von Oppenheim und seine Entdeckung des Tell Halaf*, ed. Ulrike Dubiel, exh. cat., Kunst- und Ausstellungshalle der Bundesrepublik Deutschland (Bonn: Bundeskunsthalle; Tübingen: Wasmuth, 2014).

48 "3 Reich Plotters Try to Win Syria," *New York Times*, April 7, 1941, p. 8. Von Oppenheim's relationship with the Nazi regime has raised questions concerning his Jewish ancestry, particularly because early in his life anti-Semitism played a role in limiting his ability to advance in the imperial German foreign service. Von Oppenheim stayed in Germany during the Nazi regime without major incident, and after living through the war and suffering material hardship, he died

of old age in 1946. See Gossman, *Passion of Max von Oppenheim*, pt. 3, "'The Kaiser's Spy' Under National Socialism: 'Leben im NS-Staat,'" pp. 159–282; and pt. 4, "Max von Oppenheim's Relation to National Socialism in Context: Some Responses of 'Non-Aryan' Germans to National Socialism," pp. 283–335.

49 A division of the finds from the earlier campaign took place in 1927; however, some objects, including fourteen small orthostats, had already been removed from the site by 1914. While being transported in 1914, they were seized by a British warship in the Mediterranean and later sold to the British Museum.

50 The museum had opened unofficially in 1928 after von Oppenheim was unable to come to an agreement with the Berlin Royal Museum where he had hoped to display his finds. Objects from Tell Halaf were also sent to the National Museum in Aleppo, Syria.

51 "German to Study Ancient Finds Here," *New York Times*, May 9, 1931, p. 2.

52 "Notes: A Lecture on a Proto-Hittite Site," *MMAB* 26, no. 12 (December 1931), p. 297; "Statistical Tables 1931: Attendance—Special," *Annual Report of the Trustees of the MMA*, no. 62 (1931), p. 56. Unfortunately, there is no report of how the lecture was received.

53 The records of the Office of Alien Property Custodian are held in the National Archives, Washington, D.C. The APC was established in 1917 during World War I when it was created under the authority of the Trading with the Enemy Act "to assume control and dispose of enemy-owned property in the United States and its possessions"; https://www.archives.gov/research/guide-fed-records/groups/131.html#131.1.

54 Vesting Order Number 1330, signed by Leo T. Crowley, April 27, 1943, RG 131, Entry P 55, F-9-100-28-13842, Box 764, National Archives. Thanks to Anne Dunn-Vaturi, research associate, provenance, Department of Ancient Near Eastern Art, for obtaining these records and our many fruitful discussions about the APC and provenance work in general.

55 Walters Art Museum (21.15–18). Documentation for this arrangement exists in the archives of both the Walters and the Metropolitan Museums.

56 Ambrose Lansing to E. W. Fleishman, September 7, 1943, RG 131, Entry P 55, F-9-100-28-13842, Box 764, National Archives.

57 MMA Index of Historic Collectors and Dealers of Cubism, Valentin, Curt, https://www.metmuseum.org/art/libraries-and-research-centers/leonard-lauder-research-center/research/index-of-cubist-art-collectors/valentin. Four drawings in the Metropolitan Museum, MMA 65.191.1–.4, were apparently seized from Valentin by the APC before being given to the Museum in 1965.

58 Yumiko Yamamori, "Japanese Arts in America, 1895–1920, and the A. A. Vantine and Yamanaka Companies," *Studies in the Decorative Arts* 15, no. 2 (2008), p. 123.

59 The provenance for the objects in the Metropolitan Museum is given at https://www.metmuseum.org/art/collection: for MMA 43.49.1–.18, it is "Yamanaka & Co., New York, until 1943; sold to MMA"; for MMA 44.48.1–.33, "Yamanaka & Co., Kyoto and New York, until 1944; sold to MMA."

60 At least one other object in the Metropolitan Museum, an eighteenth-century French terracotta bust (MMA 19.29), was purchased from the APC in 1919.

61 Z. G. McGee, assistant chief of the APC Division of Liquidation, to Ambrose Lansing, November 24, 1943, Antiquities—Near Eastern Arch.—Purchases, Alien Property Custodian, 1943, OSR, MMA Archives.

62 On identifying and reassembling the fragments, see Nadja Cholidis and Lutz Martin, eds., *Tell Halaf: Im Krieg zerstörte Denkmaler und Ihre Restaurierung* (Berlin: De Gruyter, 2010).

63 An example is the work of Rayyane Tabet in which the story of Tell Halaf is central; see *Fragments/Bruchstücke/Rayyane Tabet* (Beirut, Lebanon: Kaph Books, 2018). An exhibition featuring Tabet's work, *Rayyane Tabet/Alien Property*, was on display in the Ancient Near Eastern Art galleries

at the Metropolitan Museum from October 30, 2019, to January 18, 2021; see Kim Benzel, Rayyane Tabet, and Clare Davies, *Rayyane Tabet/Alien Property*, MMAB 77, no. 2 (Fall 2019).

The Evolution of the Encyclopedic Museum

1 C. Douglas Dillon, "The Second Hundred Years," *MMAB* 28, no. 9 (May 1970), p. 369.
2 "The Planning and the Opening of the Centennial Celebration: October 1965–September 1969," *The History of the Centennial Celebration of The Metropolitan Museum of Art* (New York: MMA, 1972), pp. 15–18.
3 Dillon, "The Second Hundred Years," p. 369.
4 See Richard Martin and Harold Koda, *Diana Vreeland: Immoderate Style*, exh. cat. (New York: MMA, 1993).

A Rededication to Asian Art

1 For an overview of the formation of the Museum's Asian collections, see Maxwell K. Hearn, *Asian Art at the Metropolitan Museum*, *MMAB* 73, no. 1 (Summer 2015).
2 For Dillon's role in engaging Fong and their collaboration, see Calvin Tomkins, *Merchants and Masterpieces: The Story of the Metropolitan Museum of Art*, rev. ed. (New York: Henry Holt and Company, 1989), pp. 383–87.
3 Hired as a curatorial assistant in 1971, I have been privileged to witness these changes firsthand.
4 For the paintings purchased from C. C. Wang, see Wen C. Fong with catalogue by Marilyn Fu, *Sung and Yuan Paintings*, exh. cat. (New York: MMA, 1973). For the Pan-Asian Collection, see Pratapaditya Pal, *The Sensuous Immortals: A Selection of Sculptures from the Pan-Asian Collection* (Los Angeles: Los Angeles County Museum of Art, 1977).
5 For the Museum's early Chinese painting collection, see Wen C. Fong, *Beyond Representation: Chinese Painting and Calligraphy, 8th–14th Century* (New York: MMA; New Haven: Yale University Press, 1992). See also Maxwell K. Hearn and

Wen C. Fong, *Along the Riverbank: Chinese Paintings from the C. C. Wang Family Collection* (New York: MMA, 1999).
6 For an introduction to the collection of Chinese painting at the time of the opening of the Douglas Dillon Galleries, see Wen Fong and Maxwell K. Hearn, *Silent Poetry: Chinese Paintings in the Douglas Dillon Galleries*, MMAB 39, no. 3 (Winter 1981/82). For the creation of the Astor Court, see Alfreda Murck and Wen Fong, *A Chinese Garden Court: The Astor Court at The Metropolitan Museum of Art*, MMAB 38, no. 3 (Winter 1980/81).
7 For a profile of Harry C. G. Packard, see Julia Meech, "Who Was Harry Packard?," *Impressions: The Journal of the Japanese Art Society of America*, no. 32 (2011), pp. 82–113.
8 See Wen Fong, ed., *The Great Bronze Age of China: An Exhibition from the People's Republic of China* (New York: MMA, 1980); Jason Sun, *Age of Empires: Art of the Qin and Han Dynasties* (New York: MMA, 2016); John Guy, *Lost Kingdoms: Hindu-Buddhist Sculpture of Early Southeast Asia* (New York: MMA, 2014); John Carpenter and Melissa McCormick with Monika Bincsik and Kyoko Kinoshita, *The Tale of Genji: A Japanese Classic Illuminated* (New York: MMA, 2019).

Transforming Islamic Art

1 Oleg Grabar, "An Art of the Object," *Artforum* 14, no. 7 (March 1976), pp. 36–43; Amy Goldin, "Islamic Art: The Met's Generous Embrace," ibid., pp. 44–51.
2 Richard Ettinghausen, "Islamic Art," *MMAB* 33, no. 1 (Spring 1975), p. 4.
3 MMA 56.234.35.
4 MMA 1970.105.
5 Sheila S. Blair and Jonathan M. Bloom, "The Mirage of Islamic Art: Reflections on the Study of an Unwieldy Field," *Art Bulletin* 85, no. 1 (March 2003), pp. 152–84.
6 Priscilla P. Soucek, "Introduction: Building a Collection of Islamic Art at the Metropolitan Museum, 1870–2011," in *Masterpieces from the Department of Islamic Art in The Metropolitan Museum of Art*, ed. Maryam D. Ekhtiar, Priscilla P.

Soucek, Sheila R. Canby, and Navina Najat Haidar (New York: MMA, 2011), pp. 2–9.

Recovering the Missing Chapters

1 [George F. Comfort], "Art Museums in America," *Old and New* (Boston: H. O. Houghton and Co., 1870), vol. 1 (January–June 1870), p. 505.
2 As the Museum sought to redefine itself in the early twentieth century, however, some of these early works, including the Hawaiian sculpture, were deaccessioned.
3 John Taylor Johnston and Louis P. di Cesnola, "Annual Report," *Annual Report of the Trustees of the MMA*, no. 13 (1882), p. 242.
4 Frederic Edwin Church to Louis Palma di Cesnola, September 5, 1893, Frederic E. Church, OSR, MMA Archives.
5 Henry Fairfield Osborn to Robert W. de Forest, May 17, 1911, American Museum of Natural History—Gifts and Exchanges, OSR, MMA Archives.
6 MMA 50.145.47.
7 For a more extensive discussion of Rockefeller and the Museum of Primitive Art, see Alisa LaGamma, Joanne Pillsbury, Eric Kjellgren, and Yaëlle Biro, *The Nelson A. Rockefeller Vision: Arts of Africa, Oceania, and the Americas*, MMAB 72, no. 1 (Summer 2014).
8 Francis Henry Taylor to the board of trustees, October 23, 1952, Pre-Columbian, OSR, MMA Archives.
9 William B. Macomber, "Report of the President," *Annual Report of the Trustees of the MMA*, no. 112 (July 1, 1981–June 30, 1982), p. 5.
10 Philippe de Montebello, "Report of the Director," ibid., p. 8.

A Seat at the Table

1 Henry Geldzahler, memo to James J. Rorimer, 1964, box 1, folder 217, Henry Geldzahler Papers, Beinecke Rare Book and Manuscript Library, Yale University, New Haven.
2 The author is grateful to Kay Bearman for sharing her knowledge

of department history; James Moske and Angela Salisbury for their help in the MMA Archives; and Tayler Montague, summer 2018 MUSE intern, for her help with research.
3 For communication between the Metropolitan Museum and the Whitney Museum concerning the end of plans to merge, see material in box 11, folder 2, and box 16, folder 20, Francis Henry Taylor records, MMA Archives.
4 Interestingly, the Museum also considered a collaboration with the Solomon R. Guggenheim Museum, New York, in 1950–51. This is discussed in a memo, "Contemporary Art Center for M.M.A.," from Francis Henry Taylor, Preston Remington, and others to Metropolitan trustee Elihu Root Jr., November 26, 1951, Contemporary Art Center—Proposed 1951, OSR, MMA Archives.
5 For more on Geldzahler, see Calvin Tomkins, "Profiles: Moving with the Flow," *New Yorker*, November 6, 1971, pp. 58–113; and Paul Cummings, oral history interview with Geldzahler, January 27, 1970, Archives of American Art, Smithsonian Institution, Washington, D.C. The author is grateful to Kay Bearman for providing a copy of the transcript of the interview.
6 Geldzahler to Kevin Roche, with a copy to Hoving, October 24, 1967, Contemporary Art, 1967–68, box 30, folder 1, Thomas Hoving records, MMA Archives.
7 See Reuven Ferziger, "30 Minutes with Henry Geldzahler," *H. M. Arts* 1, no. 1 (February 1975), p. 9; copy in folder 205, Geldzahler Papers, Beinecke Library.
8 The exhibition was on view from October 18, 1969, to February 8, 1970. See Henry Geldzahler, *New York Painting and Sculpture: 1940–1970*, exh. cat. (New York: E. P. Dutton & Co., in association with the MMA, 1969), pp. 23–24.
9 Cliff Joseph and Benny Andrews, co-chairmen of the Black Emergency Cultural Coalition, to Hoving, December 31, 1969, Proposed Black Artists, 1968–70, box 39, folder 12, Hoving records, MMA Archives.
10 A copy of the AWC flyer is in box 49, folder 5, Hoving records,

MMA Archives (as is a copy of a flyer related to a January 12, 1971, protest). Geldzahler was specifically targeted by members of the AWC on several occasions, and the Museum was the subject of multiple protests in the late 1960s and 1970s by such groups as the AWC, Art Strike, and Women Artists in Revolution. See Alex Gross, "Will Culture Kill The Met?," *East Village Other* 5, no. 24 (May 12, 1970), pp. 11, 21; Susan E. Cahan, *Mounting Frustration: The Art Museum in the Age of Black Power* (Durham, N.C.: Duke University Press, 2016), pp. 104–5; Julia Bryan-Wilson, *Art Workers: Radical Practice in the Vietnam War Era* (Berkeley: University of California Press, 2009), pp. 208–12; and "Metropolitan Is Host to Antagonists," *New York Times*, October 21, 1970, p. 38.

11 Henry Geldzahler, "A Statement to Black Artists," undated draft typescript, probably 1969, and manuscript notes, box 4, folder 109, Geldzahler Papers, Beinecke Library.

12 Geldzahler to Thomas Hoving, Daniel Herrick, Ashton Hawkins, Harry Parker, and George Trescher, February 26, 1970, Contemporary Arts Department, 1967–May 1970, OSR, MMA Archives.

13 Henry Geldzahler, "Creating a New Department," in Thomas Hoving, *The Chase, the Capture: Collecting at the Metropolitan* (New York: MMA, 1975), pp. 219–34.

14 Ingrid Sischy, "An Interview with Henry Geldzahler (July 6, 1993)," in Henry Geldzahler, *Making It New: Essays, Interviews, and Talks* (New York: Turtle Point Press), p. 8.

15 On Sims's response to the affirmative action mandate that led to her hiring, see Angela Goodman, "Unusual Careers in the Arts: The Road Less Traveled," *Black Enterprise* (February 1979): 63. For more on Sims and the Department of Community Programs, see Cahan, *Mounting Frustration*, pp. 106, 256–63.

16 During the late 1960s and very early 1970s, the Museum engaged in detailed negotiations with the AWC on a variety of matters, some related to decentralization and resource sharing, others to racial and gender bias in their programs and collections. See material

in box 49, folder 5, and box 69, folder 6, Hoving records, MMA Archives.

17 See, for instance, an interdepartmental memorandum from Harry Parker to Thomas Hoving, March 19, 1973, summarizing a meeting "held to discuss future possibilities for meaningful involvement of the Black community with the Metropolitan Museum"; box 69, folder 7, Hoving records, MMA Archives.

18 See Lowery Stokes Sims, "Discrete Encounters: A Personal Recollection of the Black Art Scene of the 1970s," in *Energy/Experimentation: Black Artists and Abstraction 1964–1980*, ed. Kellie Jones, exh. cat. (New York: Studio Museum in Harlem, 2006), p. 48.

19 Lowery Stokes Sims in discussion with the author, March 7, 2019.

20 See C. Gerald Fraser, "A Young Met Curator Walks Esthetic Tightrope," *New York Times*, December 10, 1978, p. 117. See also Lowery Stokes Sims, "Benny Andrews: A Reminiscence," *Agni*, no. 66 (2007), pp. 38–40.

21 Linda Goode Bryant was a Rockefeller Fellow at the Metropolitan Museum about 1972. She recounts her experiences with Hoving and Geldzahler in Randy Kennedy, "Making Doors: Linda Goode Bryant in Conversation with Senga Nengudi," *Ursula* 1, no. 1 (Winter 2018), pp. 41–43; and Cahan, *Mounting Frustration*, p. 261.

22 See Lowery Stokes Sims, "Third World Women Speak," *Women Artists News* 4, no. 6 (December 1978), pp. 1, 10; and Grace Glueck, "'Racism' Protest Slated Over Title of Art Show," *New York Times*, April 14, 1979, p. 15.

23 Sims in discussion with the author, March 7, 2019.

Engaging with Artists

The author wishes to thank Laura D. Corey and Anne Blood Mann for their assistance in completing this essay.

1 Winifred Howe, *A History of The Metropolitan Museum of Art: With a Chapter on the Early Institutions of Art in New York* (New York: MMA, 1913), pp. 202–6.

2 Francis Henry Taylor, "Education and Museum Extension," *MMAB* 36, no. 9 (September 1941), pp. 179–81.

3 "18 Painters Boycott the Metropolitan; Charge 'Hostility to Advanced Art,'" *New York Times*, May 22, 1950, pp. 1, 15; B. H. Friedman, "The Irascibles: A Split Second in Art History," *Arts Magazine* 53, no. 1 (September 1978), pp. 96–102; Bradford R. Collins, "Life Magazine and the Abstract Expressionists, 1948–51: A Historiographic Study of a Late Bohemian Enterprise," *Art Bulletin* 73, no. 2 (June 1991), pp. 283–308.

4 "National Pilot High School Program of Metropolitan Museum Climaxes First Year with Spring Visit by 400 Participating Students," MMA press release, May 15, 1968; https://libmma.contentdm.oclc.org/digital/collection/p16028coll12/id/1856/rec/3.

5 Gottlieb did not produce a print for the editioned portfolio but he did participate in the exhibition. The Metropolitan Museum does not own an edition of the portfolio; the Museum of Modern Art has a full set in their collection (1394.1968.1–.5).

6 Harry S. Parker III, "In Search of Human Contact," *MMAB* 27, no. 4 (December 1968), pp. 205–10.

7 *Centennial Projects: Education Department, The Metropolitan Museum of Art* (New York: MMA, 1986), p. 15; https://libmma.contentdm.oclc.org/digital/collection/p15324coll10/id/230989.

8 "Harlem's Rich, Varied Sixty-Year History as Cultural Capital of Black America to Be Presented in a Major Exhibition by Harlem Community at Metropolitan Museum," MMA press release, November 16, 1967, copy in Loan Exhibitions—1969: Harlem on My Mind, Publicity, 1967–, OSR, MMA Archives.

9 Bridget R. Cooks, "Black Art and Artists: *Harlem on My Mind* (1969)," *American Studies* 48, no. 1 (Spring 2007), pp. 5–39.

10 For the Harlem Cultural Council's decision to remove their support of the show, see Grace Glueck, "Harlem Cultural Council Drops Support for Metropolitan Show," *New York Times*, November 23, 1968, p. 62.

11 Bearden, MMA 54.243.9; Lawrence, MMA 42.167, MMA 43.47.28, MMA 46.73.2.

12 Susan E. Cahan, *Mounting Frustration: The Art Museum in the Age of Black Power* (Durham, N.C.: Duke University Press, 2016), pp. 69–73.

13 Several negative reviews and opinion pieces appeared during the run of the exhibition. See, for example, John Canaday, "Getting Harlem Off My Mind," *New York Times*, January 12, 1969, sec. D, p. 25; Grace Glueck, "Art: 'Harlem on My Mind' in Slides, Tapes and Photos," *New York Times*, January 17, 1969, p. 28; and Cathy Aldridge, "'Harlem on My Mind': A Boxed-In Feeling," *New York Amsterdam News*, February 1, 1969, p. 38.

14 Cahan, *Mounting Frustration*, p. 99.

15 Benny Andrews and Cliff Joseph, open letter, n.d., in the Benny Andrews Archive, Studio Museum in Harlem, New York, as quoted in ibid., p. 70.

16 *What Happened, Miss Simone?*, directed by Liz Garbus, released on Netflix, June 24, 2015.

17 Sabra Moore, *Openings: A Memoir from the Women's Art Movement, New York City 1970–1992* (New York: New Village Press, 2016), pp. 4–5.

18 "Notes: Members' Programs," *MMAB* 13, no. 2 (October 1954), inside front cover.

19 While the Museum of Modern Art had held jazz events since 1960, the Whitney Museum of American Art, Los Angeles County Museum of Art, City Art Museum of St. Louis, and Museum of Contemporary Art Chicago all incorporated jazz into their concert series from 1968–69. See "Singers: More than an Entertainer," *Time* 93, no. 8 (February 21, 1969), p. 63.

20 *The Centennial Celebration of The Metropolitan Museum of Art, 1870–1970* (New York: MMA, 1970), p. 30.

21 The world premiere of this dance occurred on November 11, 1969, at the Wadsworth Atheneum Museum of Art, Hartford, Connecticut.

22 Reina Potaznik, "Unusual Dance Spaces" (senior seminar thesis, Barnard College, 2007), pp. 14–18.

23 Program notes from the premiere at the Wadsworth Atheneum Museum of Art; see the Twyla

Tharp Dance Foundation's website, https://www.twylatharp.org /works/dancing-streets-london -and-paris-continued-stockholm -and-sometimes-madrid.

24 Thomas Hoving, interview by Terry Gross, *Fresh Air*, WHYY, January 15, 1993, https:// freshairarchive.org/segments /changing-culture-moma.

Broadening Perspectives

For their invaluable assistance with this essay, the author wishes to thank Laura D. Corey and Dale Tucker.

1 This mission statement was approved by the trustees of the Museum on January 13, 2015; "Mission Statement," *Annual Report of the Trustees of the MMA*, no. 145 (July 1, 2014–June 30, 2015), p. 11.

2 Philippe de Montebello, *The Met and the New Millennium: A Chronicle of the Past and a Blueprint for the Future, MMAB* 52, no. 1 (Summer 1994).

3 In the preface to the revised edition of *Merchants and Masterpieces* (New York: Henry Holt, 1989), Calvin Tomkins wrote about the Museum, "That it is such a treasury—the greatest museum in the Western hemisphere and one of the half dozen greatest in the world—goes without saying" (p. 11).

4 Gaylord Torrence, *Art of Native America: The Charles and Valerie Diker Collection*, exh. cat. (New York: MMA, 2018).

5 Kerry James Marshall, "Shall I Compare Thee . . . ?," in *Kerry James Marshall: Mastry*, ed. Helen Molesworth, exh. cat. (Chicago: Museum of Contemporary Art

Chicago; New York: Skira Rizzoli, 2016), p. 73.

6 *Between Heaven and Earth* (MMA 2007.96) was acquired in 2007 by the Department of the Arts of Africa, Oceania, and the Americas. *Dusasa II* (MMA 2008.121) was acquired in 2008 by the Department of Nineteenth-Century, Modern, and Contemporary Art, which was created in 2004 and restructured again in 2012 to become the Department of Modern and Contemporary Art.

7 Barbara Pollack, "The New Razzle-Dazzle," *ARTNews* 107, no. 6 (June 2008), p. 117, posted online August 28, 2015, http://www .artnews.com/2015/08/28/the -new-razzle-dazzle-el-anatsui-on-his -gem-encrusted-tapestries-in-2008/.

Further Reading

The Archives, *Bulletin* (herein *MMAB*), and *Journal* of the Metropolitan Museum are vital resources for the history of the institution. The Archives' holdings include the records of the board of trustees, legal documents, Museum publications, office files of selected Museum staff, several collections of trustee and donor papers, architectural drawings, press clippings, and ephemera. The *Bulletin*, established in 1905, covers topics related to the institution and its collection and exhibitions; select issues are listed below. Since 1968, the *Metropolitan Museum Journal* has published original research on works in the collection. In-depth information about the works of art in the Museum is also found in collection catalogues, both in print and online.

The American Wing: 75 Years. Magazine Antiques 157, no. 1 (January 2000).

Aruz, Joan, and Yelena Rakic. "Exhibiting Interaction: Displaying the Arts of the Ancient Near East in Their Broader Context." In *Museums and the Ancient Middle East: Curatorial Practice and Audiences*, edited by Geoff Emberling and Lucas P. Petit, pp. 113–22. Milton Park, Oxfordshire, U.K.: Routledge, 2019.

Baetjer, Katharine. "Buying Pictures for New York: The Founding Purchase of 1871." *Metropolitan Museum Journal* 39 (2004), pp. 161–95.

Barnet, Peter, and Nancy Wu. *The Cloisters: Medieval Art and Architecture*. New York: MMA; New Haven: Yale University Press, 2005.

Bazin, Germain. *The Museum Age*. Translated by Jane van Nuis Cahill. New York: Universe Books, 1967.

Becker, Lawrence, and Deborah Schorsch. "The Practice of Objects Conservation in The Metropolitan Museum of Art (1870–1942)." *Metropolitan Museum Studies in Art, Science, and Technology* 1 (2010), pp. 11–37.

Braun, Emily, and Rebecca Rabinow, eds. *Cubism: The Leonard A. Lauder Collection*. New York: MMA, 2014.

Brown, Sally B. *A Gift of Sound: The Crosby Brown Collection of Musical Instruments. MMAB* 76, no. 1 (Summer 2018).

Burt, Nathaniel. *Palaces for the People: A Social History of the American Art Museum*. New York: Little, Brown, 1977.

Cahan, Susan E. *Mounting Frustration: The Art Museum in the Age of Black Power*. Durham, N.C.: Duke University Press, 2016.

Carbonell, Bettina Messias, ed. *Museum Studies: An Anthology of Contexts*. 2nd ed. Chichester, West Sussex, U.K.: Wiley-Blackwell, 2012.

Carrier, David. *Museum Skepticism: A History of the Display of Art in Public Galleries*. Durham, N.C.: Duke University Press, 2006.

Charter, By-Laws, Mission Statement: The Metropolitan Museum of Art. New York: MMA, 2011.

Conn, Steven. *Museums and American Intellectual Life, 1876–1926*. Chicago: University of Chicago Press, 1998.

———. *Do Museums Still Need Objects?* Philadelphia: University of Pennsylvania Press, 2010.

Cuno, James. *Who Owns Antiquity?: Museums and the Battle over Our Ancient Heritage*. Princeton, N.J.: Princeton University Press, 2008.

Daniel, Malcolm. "Photography at the Metropolitan: William M. Ivins and A. Hyatt Mayor." *History of Photography* 21, no. 2 (Summer 1997), pp. 110–16.

Danziger, Danny. *Museum: Behind the Scenes at The Metropolitan Museum of Art*. New York: Viking, 2007.

Druesedow, Jean L. *In Style: Celebrating Fifty Years of the Costume Institute. MMAB* 45, no. 2 (Autumn 1987).

Duncan, Carol. *Civilizing Rituals: Inside Public Art Museums*. London: Routledge, 1995.

Ekhtiar, Maryam D., Priscilla P. Soucek, Sheila R. Canby, and Navina Najat Haidar, eds. *Masterpieces from the Department of Islamic Art in The Metropolitan Museum of Art*. New York: MMA, 2011.

Evans, Helen C., Melanie Holcomb, and Robert Hallman. *The Arts of Byzantium. MMAB* 58, no. 4 (Spring 2001).

Fahy, Everett, ed. *The Wrightsman Pictures*. New York: MMA; New Haven: Yale University Press, 2005.

Fong, Wen C. *Beyond Representation: Chinese Painting and Calligraphy, 8th–14th Century*. New York: MMA; New Haven: Yale University Press, 1992.

Frelinghuysen, Alice Cooney, Gary Tinterow, Susan Alyson Stein, Gretchen Wold, and Julia Meech. *Splendid Legacy: The Havemeyer Collection*. Exh. cat. New York: MMA, 1993.

The Frick Collection Studies in the History of Art Collecting in America. New York: Frick Collection; University Park: Pennsylvania State University Press, 2014–.

Gammon, Martin. *Deaccessioning and Its Discontents: A Critical History*. Cambridge, Mass.: MIT Press, 2018.

Gardner, Albert Ten Eyck. "American Painting: The First Thirty Years." *MMAB* 23, no. 8 (April 1965), pp. 265–74.

Hambourg, Maria Morris, and Christopher Phillips. *The New Vision: Photography between the World Wars; Ford Motor Company Collection at The Metropolitan Museum of Art*. New York: MMA, 1989.

Hayes, William C. *The Scepter of Egypt: A Background for the Study of the Egyptian Antiquities in The Metropolitan Museum of Art*. 2 vols. Cambridge, Mass.: Harvard University Press for the MMA, 1953–59; revised printing, New York: MMA, 1990.

Hearn, Maxwell K. *Asian Art at the Metropolitan Museum. MMAB* 73, no. 1 (Summer 2015).

Hearn, Maxwell K., and Wen C. Fong. *Along the Riverbank: Chinese Paintings from the C. C. Wang Family Collection*. New York: MMA, 1999.

Heckscher, Morrison H. *The Metropolitan Museum of Art: An Architectural History. MMAB* 53, no. 1 (Summer 1995).

Hibbard, Howard. *The Metropolitan Museum of Art*. New York: Harrison House, 1986.

Hollein, Max. *Modern and Contemporary Art in The Metropolitan Museum of Art*. New York: MMA, 2019.

Houghton, James R., and members of the staff. *Philippe de Montebello and The Metropolitan Museum of Art 1977–2008*. New York: MMA; New Haven: Yale University Press, 2009.

Hoving, Thomas. *Making the Mummies Dance: Inside The Metropolitan Museum of Art*. New York: Simon & Schuster, 1993.

Hoving, Thomas; with essays by members of the staff. *The Chase, the Capture: Collecting at the Metropolitan*. New York: MMA, 1975.

Howe, Winifred E. *A History of The Metropolitan Museum of Art: With a Chapter on the Early Institutions of Art in New York*. New York: MMA, 1913.

———. *A History of The Metropolitan Museum of Art*. Vol. 2, *1905–1941: Problems and Principles in a Period of Expansion*. New York: Columbia University Press, 1946.

Husband, Timothy B. *Creating the Cloisters. MMAB* 70, no. 4 (Spring 2013).

Karageorghis, Vassos; in collaboration with Joan R. Mertens and Marice E. Rose. *Ancient Art from Cyprus: The Cesnola Collection in The Metropolitan Museum of Art*. New York: MMA, 2000.

Kisluk-Grosheide, Daniëlle, and Jeffrey Munger. *The Wrightsman Galleries for French Decorative Arts: The Metropolitan Museum of Art*. New York: MMA; New Haven: Yale University Press, 2010.

Kisluk-Grosheide, Daniëlle O., Wolfram Koeppe, and William Rieder. *European Furniture in The Metropolitan Museum of Art: Highlights of the Collection*. New York: MMA; New Haven: Yale University Press, 2006.

Kisluk-Grosheide, Daniëlle, Deborah L. Krohn, and Ulrich Leben, eds. *Salvaging the Past: Georges Hoentschel and French Decorative Arts from The Metropolitan Museum of Art.* Exh. cat., Bard Graduate Center. New York: Bard Graduate Center, MMA; New Haven: Yale University Press, 2013.

Koda, Harold, and Jessica Glasscock. "The Costume Institute at The Metropolitan Museum of Art: An Evolving History." In *Fashion and Museums: Theory and Practice*, edited by Marie Riegels Melchior and Birgitta Svensson, pp. 21–32. London: Bloomsbury Academic, 2014.

Komaroff, Linda. *Islamic Art in The Metropolitan Museum of Art: The Historical Context.* New York: MMA, 1992.

LaGamma, Alisa, Joanne Pillsbury, Eric Kjellgren, and Yaëlle Biro. *The Nelson A. Rockefeller Vision: Arts of Africa, Oceania, and the Americas.* MMAB 72, no. 1 (Summer 2014).

Laster, Margaret R., and Chelsea Bruner, eds. *New York: Art and Cultural Capital of the Gilded Age.* New York: Routledge, 2019.

Leona, Marco. "The Materiality of Art: Scientific Research in Art History and Art Conservation at the Metropolitan Museum." *MMAB* 67, no. 1 (Summer 2009), pp. 4–11.

Lindsey, Rebecca. *A Harmonious Ensemble: Musical Instruments at the Metropolitan Museum, 1884–2014.* MMA, January 9, 2015. https://metmuseum.atavist.com/musicalinstrumentshistory.

Macdonald, Sharon, ed. *A Companion to Museum Studies.* Blackwell Companions in Cultural Studies 12. Malden, Mass.: Blackwell Publishing, 2006.

Martin, Richard (Richard Harrison). *Our New Clothes: Acquisitions of the 1990s.* New York: MMA, 1999.

Mayor, A. Hyatt. "The Gifts That Made the Museum." *MMAB* 16, no. 3 (November 1957), pp. 85–107.

Mazer, Margaret A. "A History of Education at the Metropolitan Museum of Art from 1870 to 1985." Master's thesis, Bank Street College of Education, 1987.

McFadden, Elizabeth. *The Glitter and the Gold: A Spirited Account of the Metropolitan Museum of Art's First Director, the Audacious and High-Handed Luigi Palma di Cesnola.* New York: Dial Press, 1971.

Miller, R. Craig. *Modern Design in The Metropolitan Museum of Art, 1890–1990.* New York: MMA; Harry N. Abrams, 1990.

Molesworth, Charles. *The Capitalist and the Critic: J. P. Morgan, Roger Fry, and the Metropolitan Museum of Art.* Austin: University of Texas Press, 2016.

de Montebello, Philippe. *The Met and the New Millennium: A Chronicle of the Past and a Blueprint for the Future.* MMAB 52, no. 1 (Summer 1994).

Munger, Jeffrey. *European Porcelain in The Metropolitan Museum of Art.* New York: MMA, 2018.

Murase, Miyeko. *Bridge of Dreams: The Mary Griggs Burke Collection of Japanese Art.* Exh. cat. New York: MMA, 2000.

Murck, Alfreda, and Wen C. Fong, eds. *Words and Images: Chinese Poetry, Calligraphy, and Painting.* New York: MMA; Princeton, N.J.: Princeton University Press, 1991.

Naef, Weston J. *The Collection of Alfred Stieglitz: Fifty Pioneers of Modern Photography.* New York: MMA, 1978.

Oppenheim, Adela, Dorothea Arnold, Dieter Arnold, and Kei Yamamoto, eds. *Ancient Egypt Transformed: The Middle Kingdom.* Exh. cat. New York: MMA, 2015.

Parker, Elizabeth C., ed., with the assistance of Mary B. Shepard. *The Cloisters: Studies in Honor of the Fiftieth Anniversary.* New York: MMA, in association with the International Center of Medieval Art, 1992.

Picón, Carlos A., Joan R. Mertens, Elizabeth R. Milleker, Christopher Lightfoot, and Seán Hemingway. *Art of the Classical World in The Metropolitan Museum of Art: Greece, Cyprus, Etruria, Rome.* New York: MMA; New Haven: Yale University Press, 2007.

De Puma, Richard Daniel. *Etruscan Art in The Metropolitan Museum of Art.* New York: MMA, 2013.

Pyhrr, Stuart W. "Armor for America: The Duc de Dino Collection." *Metropolitan Museum Journal* 47 (2012), pp. 183–230.

———. *Of Arms and Men: Arms and Armor at the Metropolitan 1912–2012.* MMAB 70, no. 1 (Summer 2012).

Quodbach, Esmée. *The Age of Rembrandt: Dutch Paintings in The Metropolitan Museum of Art.* MMAB 65, no. 1 (Summer 2007).

———. "Collecting Old Masters for New York: Henry Gurdon Marquand and The Metropolitan Museum of Art." *Journal of Historians of Netherlandish Art 9*, no. 1 (Winter 2007). DOI: 10.5092/jhna.2017.9.1.2.

Rakic, Yelena, ed. *Discovering the Art of the Ancient Near East: Archaeological Excavations Supported by The Metropolitan Museum of Art, 1931–2010.* MMAB 68, no. 1 (Summer 2010).

Richter, Gisela M. A. "The Department of Greek and Roman Art: Triumphs and Tribulations." *Metropolitan Museum Journal* 3 (1970), pp. 73–95.

The Robert Lehman Collection. Vols. 1–15. New York: MMA, in association with Princeton University Press, 1987–2012.

Roehrig, Catharine H., with Renée Dreyfus and Cathleen A. Keller, eds. *Hatshepsut: From Queen to Pharaoh.* New York: MMA; New Haven: Yale University Press, 2005.

Rorimer, James J., in collaboration with Gilbert Rabin. *Survival: The Salvage and Protection of Art in War.* New York: Abelard Press, 1950.

Russell, John Malcolm. *From Nineveh to New York: The Strange Story of the Assyrian Reliefs in the Metropolitan Museum and the Hidden Masterpiece at Canford Manor.* New Haven: Yale University Press, in association with the MMA, 1997.

Saltzman, Cynthia. *Old Masters, New World: America's Raid on Europe's Great Pictures, 1880–World War I.* New York: Viking, 2008.

Schwarzer, Marjorie. *Riches, Rivals, and Radicals: 100 Years of Museums in America.* Rev. ed. Washington, D.C.: American Alliance of Museums, 2012.

Simmons, John E. *Museums: A History.* Lanham, Md.: Rowman & Littlefield, 2016.

Spira, Freyda, with Peter Parshall. *The Power of Prints: The Legacy of William M. Ivins and A. Hyatt Mayor.* New York: MMA, 2016.

Standen, Edith Appleton. *European Post-Medieval Tapestries and Related Wall-Hangings in The Metropolitan Museum of Art.* New York: MMA, 1985.

Stein, Susan Alyson, and Asher Ethan Miller, eds. *The Annenberg Collection: Masterpieces of Impressionism and Post-Impressionism.* New York: MMA; New Haven: Yale University Press, 2009.

Strouse, Jean. *J. Pierpont Morgan: Financier and Collector.* MMAB 57 no. 3 (Winter 2000).

Taylor, Francis Henry. *Babel's Tower: The Dilemma of the Modern Museum.* New York: Columbia University Press, 1945.

Tinterow, Gary. *The New Nineteenth-Century European Paintings and Sculpture Galleries.* New York, MMA, 1993.

Tomkins, Calvin. *Merchants and Masterpieces: The Story of the Metropolitan Museum of Art.* Rev. ed. New York: Henry Holt, 1989.

Torrence, Gaylord. *Art of Native America: The Charles and Valerie Diker Collection.* Exh. cat. New York: MMA, 2018.

Trask, Jeffrey. *Things American: Art Museums and Civic Culture in the Progressive Era.* Philadelphia: University of Pennsylvania Press, 2012.

Wardropper, Ian. *European Sculpture, 1400–1900, in The Metropolitan Museum of Art.* New York: MMA, 2011.

Wilkinson, Charles K., and Marsha Hill. *Egyptian Wall Paintings: The Metropolitan Museum of Art's Collection of Facsimiles.* New York: MMA, 1983.

Zanker, Paul, Seán Hemingway, Christopher S. Lightfoot, and Joan R. Mertens. *Roman Art: A Guide through The Metropolitan Museum of Art's Collection.* New York: Scala Arts Publishers, in association with the MMA, 2020.

Acknowledgments

The "making" of *Making The Met, 1870–2020* was an exceptional collaboration made possible by the expert staff who devote their time to this institution and its collections. I wish to thank everyone who participated in this prodigious endeavor, with special acknowledgment to those listed in the following pages, which could have encompassed the entire staff directory. It is not an understatement to say that projects like this one only come to life because of the efforts of those who work behind the scenes.

I express my sincere gratitude to our tenth director, Max Hollein, who has been a part of this team from the day he arrived in August 2018. I am thrilled he took on the task of writing the final chapter as one of his first commitments and have appreciated his keen eye overseeing the exhibition. This topic is also of great interest to Daniel H. Weiss, President and Chief Executive Officer, who has been fully engaged and supportive throughout the course of this project.

An advisory committee representing Archives, the Curatorial, Conservation, and Education Departments, and the Director's Office shaped the concepts for this catalogue and exhibition. These dedicated individuals engaged in months of spirited debate and thoughtful reflection on the past, present, and future of the Museum and how to best craft a meaningful narrative for our readers and visitors out of a complex, entangled history. For her leadership of the group, I particularly thank Quincy Houghton, Deputy Director for Exhibitions, as well as committee members Barbara Drake Boehm, Paul and Jill Ruddock Senior Curator, Department of Medieval Art and The Cloisters; Laura D. Corey, Senior Research Associate, Director's Office and Department of European Paintings; Douglas Eklund, Curator, Department of Photographs; Randall R. Griffey, Curator, Department of Modern and Contemporary Art; Morrison H. Heckscher, Curator Emeritus; Daniëlle O. Kisluk-Grosheide, Henry R. Kravis Curator, Department of European Sculpture and Decorative Arts; James Moske, Managing Archivist, Archives; Amelia Peck, Marica F. Vilcek Curator of American Decorative Arts, The American Wing, and Supervising Curator, Antonio Ratti Textile Center; Lisa Pilosi, Sherman Fairchild Conservator in Charge, Department of Objects Conservation; Joseph Scheier-Dolberg, Oscar Tang and Agnes Hsu-Tang Associate Curator of Chinese Paintings, Department of Asian Art; and former colleagues Ellenor M. Alcorn, Soyoung Lee, Maricelle Robles, and Catharine H. Roehrig.

The chapters in this book and the corresponding galleries in the exhibition were realized by the authors, who, in addition to

members of the advisory committee, include Katharine Baetjer, Curator Emerita; Kelly Baum, Cynthia Hazen Polsky and Leon Polsky Curator of Contemporary Art, Department of Modern and Contemporary Art; Christine E. Brennan, Senior Researcher and Collections Manager, Department of Medieval Art and The Cloisters; Alice Cooney Frelinghuysen, Anthony W. and Lulu C. Wang Curator of American Decorative Arts, The American Wing; Marilyn F. Friedman, design historian; Navina Najat Haidar, Nasser Sabah al-Ahmad al-Sabah Acting Curator in Charge, Department of Islamic Art; Maxwell K. Hearn, Douglas Dillon Chairman, Department of Asian Art; Joan R. Mertens, Curator, Department of Greek and Roman Art; Joanne Pillsbury, Andrall E. Pearson Curator, Department of the Arts of Africa, Oceania, and the Americas; Yelena Rakic, Associate Curator, Department of Ancient Near Eastern Art; Freyda Spira, Associate Curator, Department of Drawings and Prints; and Thayer Tolles, Marica F. Vilcek Curator of American Paintings and Sculpture. The project benefited immensely from their insights and the extensive research they undertook to enrich their stories. Together, we all reaped the immense rewards of the knowledge of our colleagues in the Thomas J. Watson Library, under the leadership of Kenneth Soehner, Arthur K. Watson Chief Librarian, and in our rich institutional archives; in addition to James Moske, who played a key role on the advisory committee, we are indebted to Melissa Bowling, Angela Salisbury, and former colleague Barbara File for tirelessly tracking down material, and to Julie Zeftel and Stephanie J. Post for their help with archival images. The authors have also mentioned other colleagues in their notes for their invaluable consultations.

This handsome catalogue was brought to fruition through the efforts of our brilliant colleagues in Publications and Editorial, under the direction of Mark Polizzotti, Peter Antony, Gwen Roginsky, and Michael Sittenfeld. Anne Blood Mann brought her indefatigable positive energy, sharp eye, and sensitive way with words to editing this volume, with the assistance of Nancy R. Cohen as a fellow editor and Margaret Aspinwall as bibliographer. I applaud Rebecca Sylvers and Miko McGinty at Miko McGinty Inc. for their creativity in designing the book. Christina Grillo and Josephine Rodriguez-Massop in Publications and Editorial, as well as Barbara J. Bridgers and her colleagues in Imaging, ensured the beauty of the illustrations. Briana Parker attentively edited and enhanced the exhibition didactics.

Every work of art in the exhibition was drawn from the rich collections of the Museum. The selection was a great feat, accomplished through deliberations across the curatorial body. I thank my colleagues for their advocacy and generosity in sharing knowledge about the works of art in their care. I am indebted to our primary lenders, the curatorial departments, especially the department heads and curatorial liaisons for their support. In addition to those listed above, they include, from The American Wing: Sylvia

Yount, Lawrence A. Fleischman Curator in Charge; Ancient Near Eastern Art: Kim Benzel, Curator in Charge; Arms and Armor: Pierre Terjanian, Arthur Ochs Sulzberger Curator in Charge, and Donald J. La Rocca; Arts of Africa, Oceania, and the Americas: Alisa LaGamma, Ceil and Michael E. Pulitzer Curator in Charge; The Costume Institute: Andrew Bolton, Wendy Yu Curator in Charge, and Karen Van Godtsenhoven; Drawings and Prints: Nadine M. Orenstein, Drue Heinz Curator in Charge; Egyptian Art: Diana Craig Patch, Lila Acheson Wallace Curator in Charge; European Paintings: Keith Christiansen, John Pope-Hennessy Chairman; European Sculpture and Decorative Arts: Sarah Lawrence, Iris and B. Gerald Cantor Curator in Charge; Greek and Roman Art: Seán Hemingway, John A. and Carole O. Moran Curator in Charge; Robert Lehman Collection: Dita Amory, Curator in Charge; Medieval Art and The Cloisters: C. Griffith Mann, Michel David-Weill Curator in Charge; Modern and Contemporary Art: Sheena Wagstaff, Leonard A. Lauder Chairman; Musical Instruments: Jayson Kerr Dobney, Frederick P. Rose Curator in Charge; and Photographs: Jeff L. Rosenheim, Joyce Frank Menschel Curator in Charge. We are grateful to the donors who contributed objects to the collection that we featured in the exhibition, with special thanks to Leonard A. Lauder and Tony Bechara, who gave paintings to the Museum in honor of the 150th anniversary. The works of art were supplemented by archival material, including war medals, insignia, and dog tags that belonged to our sixth director, James J. Rorimer, lent by his children Anne and Louis.

The innovative design for the exhibition was conceived by Fabiana Weinberg and Lauren Kenter with graphics by Daniel Koppich and Gina Shin. I acknowledge the entire Design Department, especially Daniel Kershaw, for bringing their imagination to this project through a series of lively charrettes early in the course of planning, and Richard Lichte, Candace Shacklette, and Maanik Singh Chauhan for their production work. I am grateful as well to the many individuals who oversaw the execution of these plans, especially our outstanding project manager Gillian Fruh and registrar Aislinn Hyde, who kept everything running smoothly in coordination with nearly every department across this complex institution. I extend my appreciation as well to the many colleagues in Buildings—under Tom Scally, Taylor Miller, and Gordon Hairston—and the curatorial and conservation departments, especially our logistical liaisons, technicians, mount-makers, and shops, for fastidiously preparing and installing the exhibition.

In addition to their work ensuring the safe presentation of the works in the exhibition, conservators and scientists brought their expert eyes to the study of the artworks on the checklist and contributed a series of illuminating conservation stories featured in the galleries and on the exhibition webpage. I especially want to acknowledge our liaisons and contributors, including Linda Borsch; Eric Breitung; Cristina B. Carr; Matthew Cumbie; Isabelle

Duvernois; Christine Giuntini; Charlotte Hale; Edward A. Hunter; Nora W. Kennedy, Sherman Fairchild Conservator in Charge, Department of Photograph Conservation; Jean-François de Lapérouse; Marco Leona, David H. Koch Scientist in Charge, Department of Scientific Research; Dorothy Mahon; Jennifer Perry, Mary and James Wallach Family Conservator of Japanese Art, Department of Asian Art; Glenn O. Petersen; Janina Poskrobko, Conservator in Charge, Department of Textile Conservation; Marina Ruiz-Molina; Sarah Scaturro; Anna Serotta; Marjorie Shelley, Sherman Fairchild Conservator in Charge, Department of Paper Conservation; and former colleagues Ann Heywood and Ellen Howe.

Our talented Digital Department developed creative features for this project. We are grateful to Sofie Andersen, Christopher Alessandrini, Melissa Bell, Paul Caro, Jennie Choi, Skyla Choi, Nina Diamond, Kate Farrell, Sumi Hansen, Robin Schwalb and their teams, as well as our partners at Acoustiguide for their work in the galleries and on our website. We extend gratitude to our colleagues in the Education Department, Marianna Siciliano, Emily Blumenthal, and Rebecca McGinnis, for overseeing the programming that complemented the exhibition; in Communications, Kenneth Weine, Ann M. Bailis, Jennifer Isakowitz, and Claire Lanier, for their promotional efforts; in Development, Clyde B. Jones III, Elizabeth Burke, and John L. Wielk, for securing corporate and foundation support; and in the Counsel's Office, H. Sujin Kim and Rebecca L. Murray for their close reading and advice. For assorted additional insights that helped shape the exhibition, I also thank my friends and colleagues, past and present, Philippe de Montebello, Director Emeritus; Denise Allen; Kay Bearman; Monika Bincsik, Diane and Arthur Abbey Associate Curator for Japanese Decorative Arts, Department of Asian Art; Emily Braun; Brian Oliver Butterfield; Elizabeth Cleland; Jennifer Farrell; Sarah Graff; Tim Healing; Sandra Jackson-Dumont, former Frederick P. and Sandra P. Rose Chairman, Department of Education; Christian Alexander Larsen; Emile Molin; Mary Rockefeller Morgan; Elyse Nelson; Chris Noey; Ria Roberts; Linda Horvitz Roth; Beth Saunders; Michael Seymour; Pari Stave; Bradley Strauchen-Scherer; Lowery Stokes-Sims; and Linden Havemeyer Wise.

Finally, the exhibition would not have been possible without the generous sponsorship of the Iris & B. Gerald Cantor Foundation and Bank of America, and I am grateful to the Diane W. and James E. Burke Fund, The Peter Jay Sharp Foundation, and the Doris Duke Fund for Publications that supported this catalogue.

From our first conversation through to the closing day of the exhibition, my most sincere thanks will go to Laura D. Corey. Her outstanding willingness to step up to every task, especially when my responsibilities in the Director's Office pulled my attention elsewhere, must be recognized. That she did so with creativity, rigor, organization, and good cheer contributed importantly to the success of this project.

Andrea Bayer
Deputy Director for Collections and Administration
The Metropolitan Museum of Art, New York

Contributors to the Catalogue

Katharine Baetjer

Curator Emerita, Department of European Paintings, The Metropolitan Museum of Art, New York

Kelly Baum

Cynthia Hazen Polsky and Leon Polsky Curator of Contemporary Art, Department of Modern and Contemporary Art, The Metropolitan Museum of Art, New York

Andrea Bayer

Deputy Director for Collections and Administration, The Metropolitan Museum of Art, New York

Barbara Drake Boehm

Paul and Jill Ruddock Senior Curator, Department of Medieval Art and The Cloisters, The Metropolitan Museum of Art, New York

Christine E. Brennan

Senior Researcher and Collections Manager, Department of Medieval Art and The Cloisters, The Metropolitan Museum of Art, New York

Laura D. Corey

Senior Research Associate, Director's Office and Department of European Paintings, The Metropolitan Museum of Art, New York

Douglas Eklund

Curator, Department of Photographs, The Metropolitan Museum of Art, New York

Alice Cooney Frelinghuysen

Anthony W. and Lulu C. Wang Curator of American Decorative Arts, The American Wing, The Metropolitan Museum of Art, New York

Marilyn F. Friedman

Design historian

Randall R. Griffey

Curator, Department of Modern and Contemporary Art, The Metropolitan Museum of Art, New York

Navina Najat Haidar

Nasser Sabah al-Ahmad al-Sabah Acting Curator in Charge, Department of Islamic Art, The Metropolitan Museum of Art, New York

Maxwell K. Hearn

Douglas Dillon Chairman, Department of Asian Art, The Metropolitan Museum of Art, New York

Morrison H. Heckscher

Curator Emeritus, The American Wing, The Metropolitan Museum of Art, New York

Max Hollein

Director, The Metropolitan Museum of Art, New York

Daniëlle O. Kisluk-Grosheide

Henry R. Kravis Curator, Department of European Sculpture and Decorative Arts, The Metropolitan Museum of Art, New York

Joan R. Mertens

Curator, Department of Greek and Roman Art, The Metropolitan Museum of Art, New York

Amelia Peck

Marica F. Vilcek Curator of American Decorative Arts, The American Wing, and Supervising Curator, Antonio Ratti Textile Center, The Metropolitan Museum of Art, New York

Joanne Pillsbury

Andrall E. Pearson Curator, Department of the Arts of Africa, Oceania, and the Americas, The Metropolitan Museum of Art, New York

Yelena Rakic

Associate Curator, Department of Ancient Near Eastern Art, The Metropolitan Museum of Art, New York

Maricelle Robles

Former Educator in Charge, Public Programs and Engagement, The Metropolitan Museum of Art, New York

Catharine H. Roehrig

Former Curator, Department of Egyptian Art, The Metropolitan Museum of Art, New York

Freyda Spira

Associate Curator, Department of Drawings and Prints, The Metropolitan Museum of Art, New York

Thayer Tolles

Marica F. Vilcek Curator of American Paintings and Sculpture, The American Wing, The Metropolitan Museum of Art, New York

Index

Photography Credits

THE MET 150

This catalogue is published in conjunction with *Making The Met, 1870–2020*, on view at The Metropolitan Museum of Art, New York, from March 30 through August 2, 2020.

The exhibition is made possible by the Iris & B. Gerald Cantor Foundation.

Lead corporate sponsorship is provided by Bank of America.

BANK OF AMERICA

The catalogue is made possible by the Diane W. and James E. Burke Fund, The Peter Jay Sharp Foundation, and the Doris Duke Fund for Publications.

Published by The Metropolitan Museum of Art, New York

Mark Polizzotti, Publisher and Editor in Chief
Gwen Roginsky, Associate Publisher and General Manager
Peter Antony, Chief Production Manager
Michael Sittenfeld, Senior Managing Editor

Edited by Anne Blood Mann, with Nancy E. Cohen
Designed by Rebecca Sylvers, Miko McGinty Inc.
Production by Christina Grillo
Bibliographic editing by Margaret Aspinwall
Image acquisitions and permissions by Josephine Rodriguez-Massop

Photographs of works in The Met collection are by the Imaging Department, The Metropolitan Museum of Art, unless otherwise noted.

Additional photography credits appear on page 287.

Typeset in Dante and Suisse Int'l by Tina Henderson
Printed on 150 gsm Perigord
Separations by Professional Graphics, Inc., Rockford, Illinois
Printed by Brizzolis, Madrid, Spain
Bound by Ramos, Madrid, Spain
Printing and binding coordinated by Ediciones El Viso, S.A., Madrid, Spain

Jacket illustrations: front, Great Hall, May 3, 1934; back, (clockwise) Broad collar of Wah (excavated Tomb of Wah, Thebes, Egypt), ca. 1981–1975 B.C. (fig. 100); Charles Demuth (American), *I Saw the Figure 5 in Gold*, 1928 (fig. 181); *Crown of the Virgin of the Immaculate Conception*, known as the *Crown of the Andes*, Popayán (Colombia), ca. 1660 (diadem), ca. 1770 (arches) (fig. 253); *Buddha Shakyamuni*, Tibetan, 12th century (fig. 245); and John Singer Sargent (American), *Madame X (Madame Pierre Gautreau)*, 1883–84 (fig. 117)

Page 2: Men hanging paintings, 1928; page 6: Information Desk, 1921; page 8: Staff in the Assyrian gallery with the Iamassu reliefs, 1958; page 10: Staff in the Lettering Shop, 1922; pages 16–17: Construction of the south facade of Wing J, April 2, 1915; pages 32–33: "Open, Sesame! The Sunday Opening of The Metropolitan Museum of Art," *Munsey's Weekly*, June 2, 1891; pages 48–49: A class in the textile galleries, June 13, 1920; pages 70–71: Girls looking at the Morgan collection of Chinese porcelain, May 31, 1913; pages 92–93: Progress of the work at Deir el-Bahri, with standing statues of Hatshepsut in the foreground, February 1, 1928. Photograph by Harry Burton; pages 108–9: Visitors in front of Emanuel Leutze's *Washington Crossing the Delaware*, ca. 1908–9; pages 128–29: Room with Degas sculptures, drawings, and prints, *The H.O. Havemeyer Collection*, 1930; pages 150–51: "A Room for a Lady," by Eliel Saarinen, from the *Thirteenth Annual Exhibition of Contemporary American Industrial Art*, 1934; pages 172–73: Edith A. Standen, Rose Valland, and a soldier converse while men prepare paintings for transportation, ca. 1946; pages 190–91: Michael C. Rockefeller Wing, 1982; pages 228–29: Alicja Kwade (German). *Para-Pivot I and II*, Iris and B. Gerald Cantor Roof Garden, The Metropolitan Museum of Art, 2019; page 244: Children looking at a cast of Auguste Rodin's *The Thinker*, 1913

The Metropolitan Museum of Art
1000 Fifth Avenue
New York, New York 10028
metmuseum.org

Distributed by
Yale University Press, New Haven and London
yalebooks.com/art
yalebooks.co.uk

Cataloguing-in-Publication Data is available from the Library of Congress.
ISBN 978-1-58839-709-6